The Great American Nude

AMERICAN ART & ARTISTS

SERIES EDITOR: BRENDA GILCHRIST

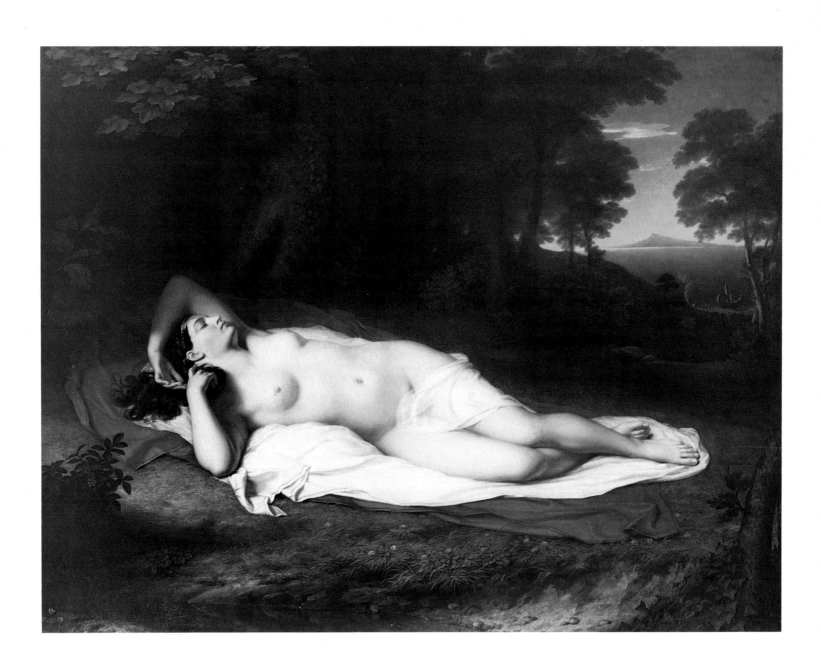

The Great American Nude

A History in Art

William H. Gerdts

Praeger Publishers

New York · Washington

FRONTISPIECE: John Vanderlyn. *Ariadne Asleep on the Island of Naxos.*
Ca. 1812–14. Oil on canvas.
Courtesy of the Pennsylvania Academy of the Fine Arts, Philadelphia.
Joseph and Sarah Harrison Collection, 1878.

Design by Joseph Bourke Del Valle

Published in the United States of America in 1974
by Praeger Publishers, Inc.
111 Fourth Avenue, New York, N.Y. 10003

Library of Congress Cataloging in Publication Data
Gerdts, William H
 The Great American Nude
 (American art & artists)
 Bibliography: p.
 1. Nude in art. 2. Art, American—History.
I. Title. II. Series.
N7574.4.G47 704.94'21 72–88496
ISBN 0–275–43510–5

Color illustrations printed in Great Britain
Printed in the United States of America

To the Memory of
Judy and Edouard Sandoz

Contents

Preface and Acknowledgments

IN WESTERN ART the human figure—male and female—has been consistently the primary subject matter of the artist. The figures appear both nude and clothed, of course, and at some times and in some cultures (particularly the medieval) the naked figure has been almost totally ignored. Nevertheless, during other periods, the nude has been considered the supreme vehicle of aesthetic expression: first in the classical world and again, more gradually and with more vicissitudes, from the Renaissance to our own times.

Since the latter period naturally encompasses the entire history of American art, it would seem to follow that the treatment of the nude may be taken as an accurate measure of the highest achievements in American painting and sculpture. This has manifestly not been so, of course. Moreover, should the knowledgeable layman be asked to name more than a handful of examples dating before the last several decades, he would undoubtedly be hard pressed. American examples are absent from Sir Kenneth Clark's brilliant exposition on the subject (*The Nude,* published in 1956), and, even more important, the categorical analysis of the possibilities of expressiveness inherent in the theme that forms the basis of Sir Kenneth's work is only tangentially applicable to the nude of American painting and sculpture.

Furthermore, there has been, until the present volume, no history of the treatment of the nude in American art, with the exception of the pioneering exhibition of paintings held at the Brooklyn Museum in 1961 and the useful catalogue issued to accompany that show. But the fact that the exhibition could be mounted in the first place assures us that there *is* an American tradition for the theme, and deeper study reveals a fascinating history, with highways and little explored or long neglected byways, some of which deserve investigation and re-evaluation.

Of course, for American art the definition of the subject must be relaxed, particularly in the case of the earliest examples, to include the partially clothed figure. Consideration has also been given here to American copies of European works and also to the life studies made by American student-artists in European ateliers. These I felt to be valid considerations since they are part of the history that is the object of this book. Also of interest are American attitudes toward the nude over the years—the attitudes not only of the artists but of their public and the critics; the attitudes not only to depictions of the nude but to the study of the nude; and the attitudes in general to the models, professional and amateur. These, in turn, involve larger issues—the prejudices and tabus that constitute one of the reasons why depictions of the nude have been relatively few in America. Other factors existed as well, of course: the absence of an artistic tradition founded in the concept of bodily expressiveness and bodily perfection; the overriding im-

portance of the landscape and frontier in our cultural ethos; and the varying degrees of repugnance for European domination of our aesthetic and cultural aspirations.

There is no real published bibliography of the subject, except the catalogue of the Brooklyn exhibition, and though numerous museums and private collections have individual examples of paintings and sculptures depicting the theme, there is no one collection devoted to it. But many people—collectors, commercial art dealers, and the staff members of institutions—have been extremely helpful to me as I accumulated information and selected the examples of painting and sculpture for study and presentation here. I regret that all of them cannot be mentioned individually. Among those who have been especially generous with their time and knowledge are Nelson C. White; William Truettner, and Robin Bolton-Smith of the National Collection of Fine Arts; Russell Burke, co-author with me of an earlier volume for Praeger Publishers on American still-life painting; James Ricau; John Maxon of the Art Institute of Chicago; Meredith Long; Donald Webster; and especially, as always, Theodore Stebbins, Jr., of the Yale University Art Gallery. Mention should be made, too, of Eleanore McSherry Fowble, whose thesis on the subject of the nude in American art up to 1850, prepared for the University of Delaware in 1967, I have rewardingly consulted. I am also very grateful to Helen Pratt for her competence and resourcefulness in obtaining illustrations; to Cherene Holland of Praeger Publishers for her patient attention to innumerable details; and to Joseph Del Valle for his imaginative designs for the jacket and book.

There are two individuals who deserve special acknowledgment, for without their efforts, interests, and enthusiasms this book would certainly not exist. They are Paul Magriel and the late Elizabeth McCausland, who planned a book very similar to this one, covering much, though not all, of the ground surveyed here, some twenty years ago. The book reached manuscript form, examples for illustration were chosen, and many photographs were accumulated, but then the project was abandoned, for in the mid-1950s, appreciation of American art was not so widespread as it is today (nor was, perhaps, the attitude of the public to nudity so casual as in these, our more permissive times). And so, the material languished, but it was presented to the Archives of American Art, where I had the opportunity to consult it. When this book was begun, Paul Magriel, with unparalleled generosity, turned over to me all of his notes and all of the photographs, some of which depict works subsequently lost. I would also like to thank Mr. Magriel for giving me the pleasure of viewing the superb small group of American paintings of the nude that he accumulated years ago, along with the finest collection of American still life ever assembled.

Even when the examples are limited to one nation during a relatively short period of time, no book dealing with an artistic theme such as the nude, can be said to be complete. The interpretation and emphasis in this work have been historical. I have tried to examine the different approaches to the theme and reactions to those approaches and to present depictions of the nude not only by those artists who were especially interested in the theme but also by painters and sculptors who produced only occasional examples and thus might otherwise not be considered when the subject came under discussion.

The textual emphasis and the number and choice of illustrations have been determined not only by my own investigations and interests but also by the advice and perceptive criticism of my editors, Brenda Gilchrist and Ellyn Childs of Praeger Publishers. As in our last joint enterprise, their enthusiasm and understanding contributed enormously to the publication, and no author could hope for more sympathetic cooperation than I have received. But their contributions were all on the positive side; inaccuracies and omissions are mine alone.

February, 1974

The Great American Nude

The Colonial Nude

IN THE SEVENTEENTH and eighteenth centuries, art in America was assigned a serviceable and useful function.[1] The myth that the early settlers were opposed to art has long been dispelled, but it is nevertheless true that in their eyes the beautiful went hand in hand with the useful. A silversmith might ply his craft with exquisite skill, imitating the sophisticated designs of his European peers, yet the object he made was not a work of mere decoration, no matter how decorated it might be. Similarly, the earliest American painting was functional, not merely decorative. True, the function was psychological and sentimental, for painting was almost entirely restricted to portraiture; nevertheless, meaning and purpose were preeminent. A portrait had several levels of meaning: It acted to remind the viewer of one who may have left for a long, hazardous journey overseas, who had been left behind in Europe, or who had departed "for good"—death being an ever-present threat in the new American colonies. Moreover, the portrait often was meant to be morally uplifting. The likeness of a statesman served to remind the viewer of the virtues of patriotism; that of a military figure could instill heroism; and that of such a minister as Cotton Mather, for example, provided religious inspiration. It is not surprising that many colonial portraits *are* of ministers and that quite a number of them were engraved for wider distribution.

Landscapes, genre and historical pictures, and still lifes were not popular subjects. Patronage did not exist for such works,

and, indeed, they were generally frowned upon as useless and frivolous objects. Certainly, painting the nude was even more problematical, for in the minds of the majority of early Americans such works combined functionlessness and indecency. Indeed, the sensuality implicit in the depiction of the nude was one of the factors that brought the first settlers to depart from the degenerate civilization of Europe and come to the shores of the New World.

Nudity, however, does occur in some of the earliest art of the New World—for example, in drawings by Jacques Le Moyne de Morgues (d. 1588) and John White (w. late sixteenth century).[2] Le Moyne de Morgues's watercolor of the Timucua Indian Chief Athore and his naked native tribesmen greeting the Laudonnière expedition in Florida in 1564 (*Colorplate 1*) is noteworthy for the contrast made between the elaborately clothed Europeans and the painted, tattooed, but scantily clothed natives.

Le Moyne de Morgues was one of the few survivors of the ill-fated Huguenot settlement on the St. Johns River in Florida, which was destroyed by the Spanish in 1565. After 1573 he settled as a Huguenot refugee in England, working closely with Sir Walter Raleigh and the Sidney family, and may have been the teacher of John White, the artist who accompanied the Raleigh settlement colony to Roanoke Island in 1587 and recorded the aborigines of Virginia; certainly, White, who never went to Florida, must have seen Le Moyne de Morgues's watercolors of the Florida Indians, since copies of them by White still exist. White's recordings of the Carolina Indians of the villages of Secotan and Pomeiooc (*Ills. 1–1 and 1–2*) depict the natives more fully clothed than their Florida counterparts, but a healthy indifference to their nakedness is also shown. Ironically, the most important depiction of White's granddaughter, Virginia Dare (*Ill. 1–3*), the first white child born in the colonies, who perished, presumably, at the hands of the Indians showed the girl fully grown but sharing the nudity of her captors (or did Louisa Lander [1826–1923], the sculptor of the mid-nineteenth-century statue, mean to suggest that the girl *did* reach maturity and was absorbed into Indian life?).

The Florida Indians went more naked than their Carolina counterparts, and the Indians of the North certainly wore more clothes than those of the South, but the use of nakedness as a symbol both for primitive man and for primitive savagery soon told hold of the American artistic consciousness. Benjamin West, almost 200 years after John White, included a near-naked Indian in his painting of the death of General Wolfe (*Ill. 1–5*), and John Vanderlyn, a generation later still, contrasted the savagery of the naked Indian with the defenselessness of the white—and fully clothed—Jane McCrea, who is about to be slaughtered (*Ill. 1–4*). The attitude toward the Indians in these two works is very different: West's noble Indian is a symbol of the New World where the war between the French and the English was being fought, and he is also a contemplative figure; Vanderlyn contrasts Indian savagery

with white nobility in a figure not unlike a classical Niobid. It is interesting that Vanderlyn has depicted the lady's garments in a state of revealing disarray, suggesting the possibility of sexual assault, in proof of the debased nature of the naked savage. But whether the Indian was portrayed as a noble savage or a savage murderer, nudity was his invariable attribute, and this naturally created another obstacle to the early depiction of the non-native nude in America.

And yet, recent scholarly and even pictorial discoveries have shown that the range of interest of the early artists in America was not limited exclusively to portraiture. Occasional landscapes, seascapes, and genre scenes by colonial painters are known, and even the nude has a place in the development of colonial art. The painting of such works was undoubtedly due to the ambitions of the artists themselves, rather than to the demands of their patrons. The depiction of the human figure was traditionally proof of the artist's ability, and as demonstration pieces they made good advertisement, even if they brought in little material reward. Moreover, such paintings were a necessary part of an artist's training. Beyond this, the depiction of the nude proved the artist's familiarity with the great traditions of European art from the Renaissance on and, before that, with the art of antiquity, which was devoted to the representation of the nude as the highest possible ideal.

A tiny but complete depiction of the nude that ranks as one of the first executed by an American artist is the drawing in pencil and wash by John Watson (1685–1758) of Hercules (*Ill. 1–6*).[3] The figure is one of a group of ideal drawings by Watson that has survived. Small as it is, it could hardly have advertised the breadth and ability of the artist, and it is probably one in a series of ideal subjects, some of which were enlarged into oil paintings and placed on the window shutters of Watson's gallery in Perth Amboy, New Jersey. It is unlikely that a nude would have been displayed on a shutter visible to the people of early eighteenth-century Perth Amboy, even if the subject was the noble one of Hercules, with his back discreetly turned to the spectator. But the drawing may well have served as the basis for an ideal painting enlargement displayed within the gallery.

The *Hercules* may have been copied from a painting Watson had seen in his native Scotland, or from a print. Virgil Barker, in fact, has commented that it "displays the typical copyist's unperceptive exaggeration of muscular contortions out of all proportion to the physical effort actually visible."[4] Engravings after works by European masters came to America in large numbers in the eighteenth century. Some of them served the early portraitists for poses, costumes, accessories, and backgrounds for their likenesses, but others are known to have been used as the basis for historical painting.* Certainly,

* The term "historical" is here used in its earlier connotation to mean not only subjects specially related to past history, but also to include allegorical, mythological, classical, and religious subjects, the branch of fine arts accorded the highest respect by the great European academicians, from Le Brun to Reynolds and David.

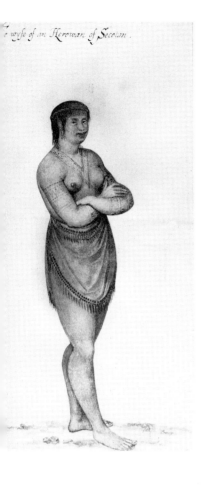

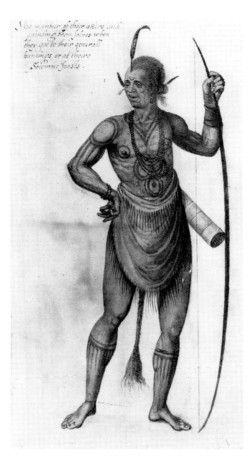

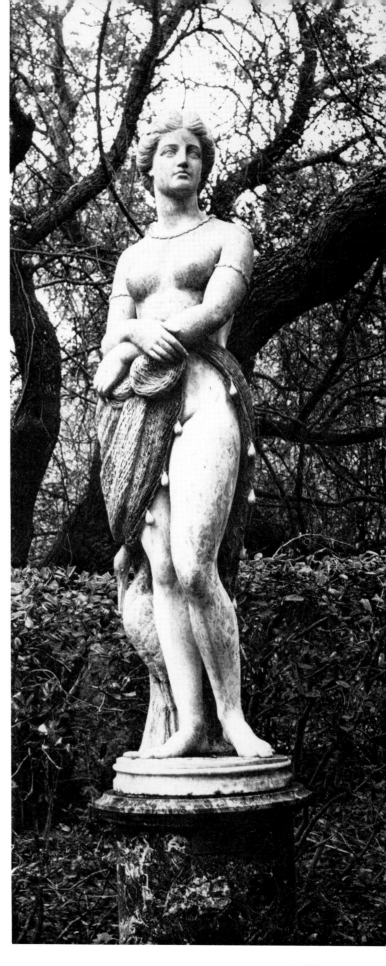

ABOVE LEFT

1-1. John White. *Indian Woman of Secotan*. Ca. 1584–87. Bodycolors and watercolor touched with gold over black lead. The British Museum, London.

ABOVE RIGHT

1-2. John White. *Indian in Body Paint*. Ca. 1584–87. Bodycolors and watercolor over black lead. The British Museum, London.

RIGHT

1-3. Louisa Lander. *Virginia Dare*. 1859. Marble. Elizabeth Gardens, Fort Raleigh National Historical Site, Roanoke Island, North Carolina.

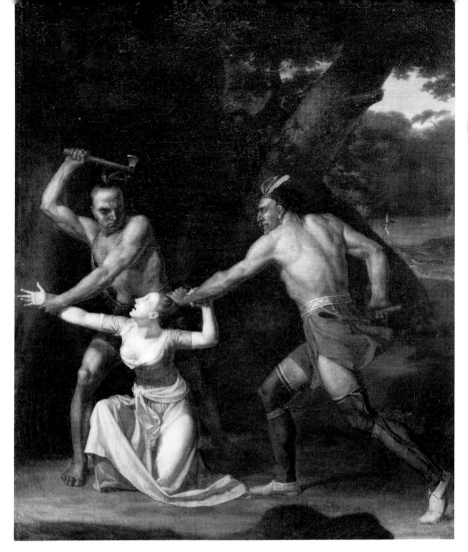

RIGHT

1-4. John Vanderlyn. *The Death of Jane McCrea.* 1804. Oil on canvas. Courtesy, Wadsworth Atheneum, Hartford, Connecticut.

BELOW

1-5. Benjamin West. *The Death of Wolfe.* 1770. Oil on canvas. The National Gallery of Canada, Ottawa. Canadian War Memorials Collection.

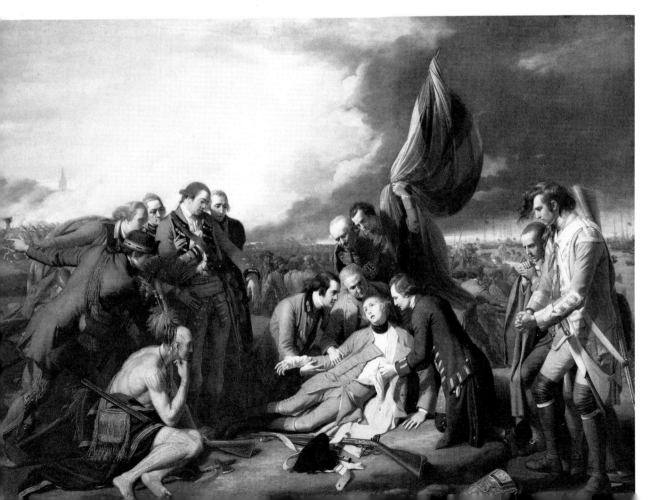

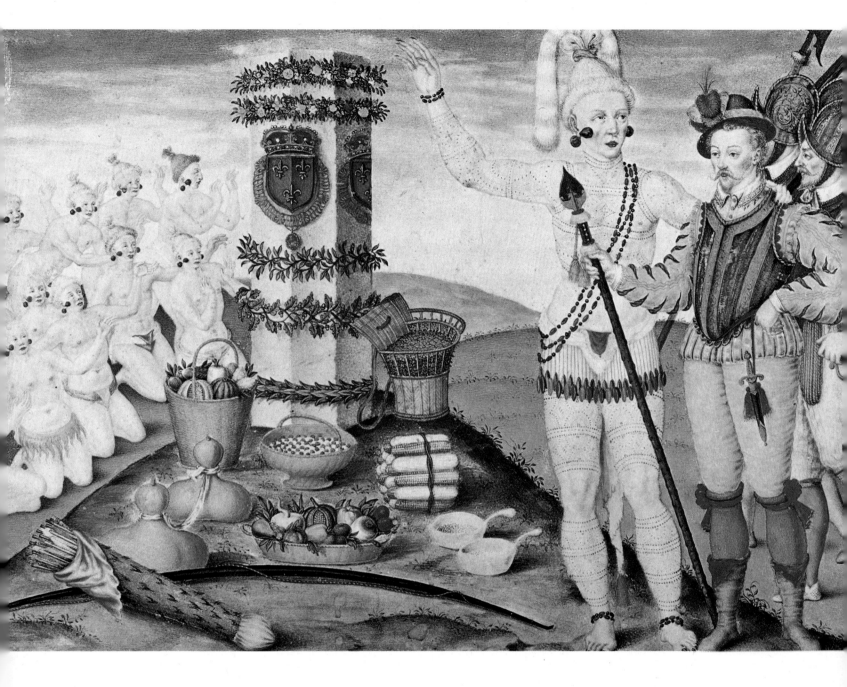

Colorplate 1. Jacques Le Moyne de Morgues. *René de Laudonnière with Chief Athore at the Mouth of the St. Johns River, North Florida.* 1564. Bodycolors and watercolor on vellum. Prints Division, The New York Public Library. Astor, Lenox and Tilden Foundations. Bequest of James Hazen Hyde.

FOLLOWING PAGE
Colorplate 2. John Singleton Copley. *The Forge of Vulcan.* 1754. Oil on canvas. Collection of Charles B. Chapman.

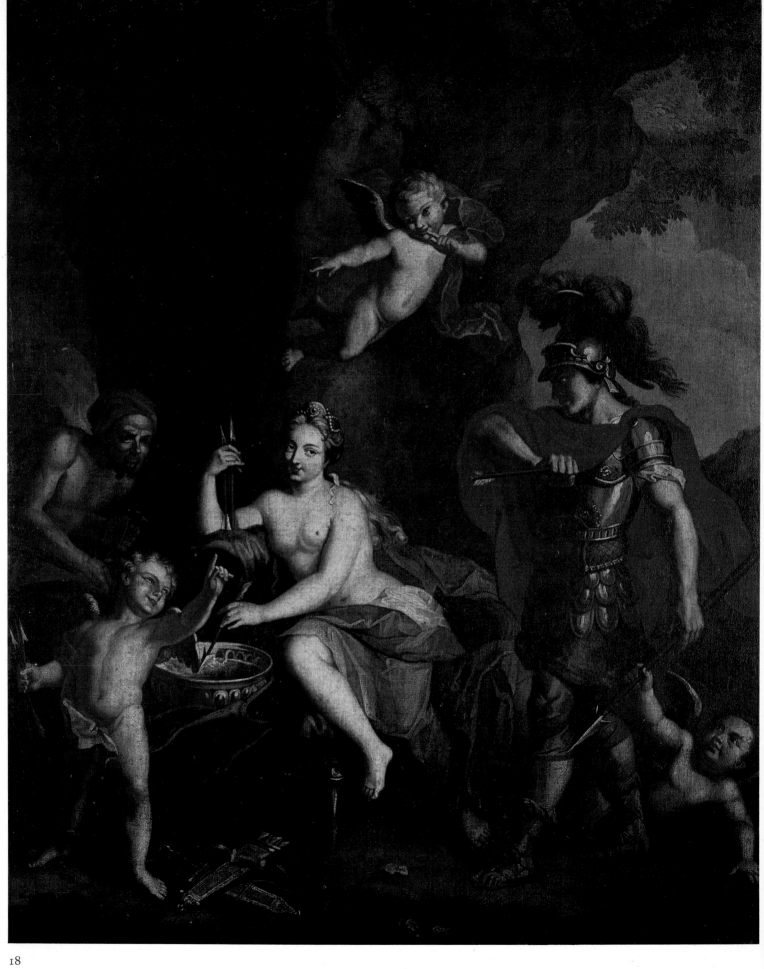

the large group of early eighteenth-century religious paintings from the upper Hudson River area that has survived derived from prints published in European bibles, and it is likely that such mythological subjects as Watson's *Hercules* have a similar derivation.

Two most ambitious oil paintings are the companion pieces painted by Gustavus Hesselius (1682–1755) about 1735–40.[5] Hesselius came to America from his native Sweden in 1711, and he qualifies as one of the earliest professional artists in the colonies, preceded only by Justus Englehardt Kühn and Henrietta Johnston. Hesselius first settled in Wilmington, Delaware, but he later moved to Philadelphia. It is surprising that he left only a handful of paintings. They include two of the earliest oil paintings of Indians, half-length portraits of the nearly naked chiefs of the Lenni-Lenape tribe, Lapowinsa and Tishcohan, painted in 1735 on the order of John Penn.

Hesselius is noteworthy as the earliest painter in America on record to undertake a good many examples of history painting. They include two classical pictures—one entitled *Bacchanalian Revel* and the other *Bacchus and Ariadne,* or *Pluto and Persephone* (*Ills. 1–7 and 1–8*). Both these paintings feature partially naked putti and female figures. Unfortunately, the artist's unfamiliarity with the painting of an integrated nude form is painfully evident. The different parts of the bodies—head, torso, limbs—seem to belong to individuals moving in different directions, and the proportions—long tapering limbs, small heads, high breasts, and long torsos—would suggest a mannerist derivation were the settings themselves not so completely baroque. Furthermore, the space is askew, with improbable rises and falls, multiple compositional axes, and awkward contrasts of crowded and empty spaces. These elements do contribute to the chaotic abandon inherent in the subject, but this is nullified by the primness of these supposedly wanton figures, a primness reinforced by the tight drawing. This tightness, in turn, may be due at least in part to a derivation from now lost engravings. Certainly, a print source is very likely, since the artist would not have found pictorial inspiration for classical subjects elsewhere in America, nor would models have been available for an original conception. The purpose of these works is also uncertain. They may have been commissioned by a particularly erudite—and daring—colonial settler in Philadelphia, but more likely they were composed as an exercise to increase the artist's skill.

We have no information as to the interest, disapproval, or popularity generated by the Hesselius classical paintings; undoubtedly, they were seen, but whether or not the pictures were employed to advertise the artist's abilities or were kept primarily for private consumption is not known. Other renderings of the nude certainly served as advertisements and for instruction. A case in point is the work of John Smibert (1688–1751), one of the most highly trained European artists to come to America in the early eighteenth century.[6] Smibert, born in Scotland, was recognized in England as an important artist, second only to Sir Godfrey Kneller, before he joined his

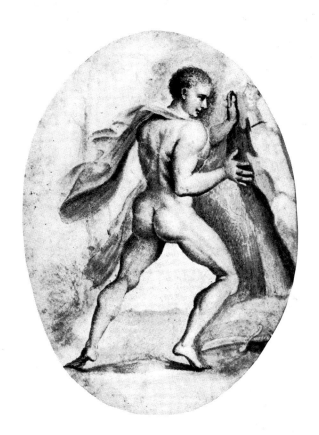

1–6. John Watson. *Hercules*. n.d. Pencil and wash on vellum. Whereabouts unknown.

friend Dean George Berkeley to found a college for the Indians in Bermuda. Without sufficient funds the plan collapsed early in 1728, after Berkeley and his party landed—first in Virginia and then in Newport, Rhode Island. Smibert, however, soon became established as a portrait painter of note in New England, and he settled in Boston at the end of the same year. Before coming to America he had traveled to Italy and spent his time chiefly in Florence and Rome, copying the works of the Old Masters. He brought this collection of copies with him; some, in fact, such as his copy of the Van Dyke portrait of Cardinal Bentivoglio and Poussin's *Continence of Scipio,* have survived.

Another work Smibert copied was the Titian *Venus and Cupid.* The picture must have figured in the first public exhibition of paintings held in America, which took place in Smibert's Boston painting rooms in 1730, where the artist gave the colony of Boston and visitors from other colonies a look at the copies of the great paintings of the Old Masters. Nor was this display a one-time occasion, for Smibert's house in Boston remained for over half a century the outstanding art center in New England, visited by many young artists, for whom the Smibert copy of the Titian *Venus and Cupid* would have constituted the first experience with the painting of the nude. John Singleton Copley was familiar with the Smibert copy of Titian, and, later, when Copley himself was in Italy,

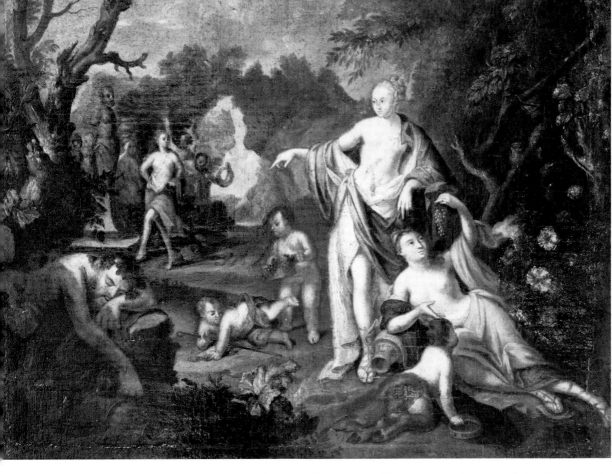

1–7. Gustavus Hesselius. *Bacchanalian Revel.* Ca. 1720. Oil on canvas. Courtesy of the Pennsylvania Academy of the Fine Arts, Philadelphia. Temple Fund Purchase, 1949.

1–8. Gustavus Hesselius. *Bacchus and Ariadne,* or *Pluto and Persephone.* Ca. 1720–30. Oil on canvas. The Detroit Institute of Arts. Gift of Dexter M. Ferry, Jr.

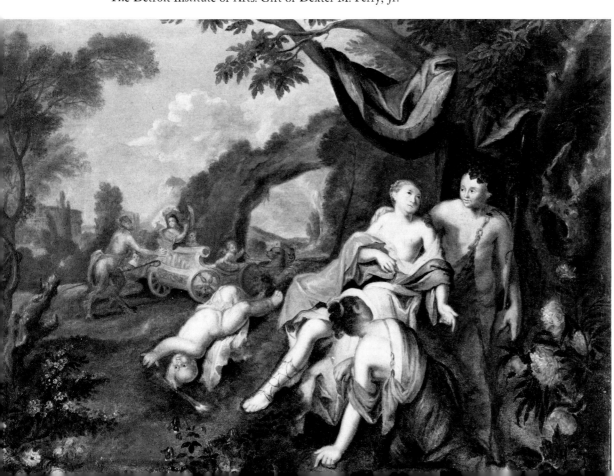

he acknowledged his familiarity with the painting when he wrote to his half-brother Henry Pelham:

> The picture of a Naked Venus and Cupid at Smibert's is Copy'd from one of Titiano's in the possession of the great Duke of Tuskany, which hangs over the celebrated Titian Venus, but is by no means equal to it.[7]

Young John Trumbull, before he went abroad, also visited Smibert's studio and copied and recorded Smibert's *The Education of Cupid* after the Titian in the Borghese Gallery in Rome.

Secondhand and sometimes even thirdhand acquaintance with Old Master paintings of the human figure may seem exceedingly inadequate in terms of aesthetic reward and instructional purpose. Yet such experience was better than no experience at all for young American artists. The first and second copyists had reproduced their models as faithfully as possible, and the act of copying the paintings was a step toward increased professionalism. Furthermore, such paintings, like the often spurious Old Masters that were included in early nineteenth-century collections and offered by art dealers for sale and put into public exhibitions, did have qualities, both aesthetic and technical, that could help both the artist and the layman better to know and understand the art of the past. From one point of view, it really did not matter whether the painting before them was an original or a copy, whether it was real or spurious.

In addition to the painted copies Smibert brought with him, there were several casts of antique sculpture. The celebrated nude Medici *Venus* was noticed by a number of visitors to Smibert's studio. In the poem published in the Boston *Daily Courant* of April 14, 1730, John Smibert's nephew Mather Byles mentions "the Breathing Statue"—in all probability a reference to this work. Copley's early sketchbook contains a copy of the Medici *Venus,* perhaps derived from Smibert's cast. It is interesting to note the importance such copies had for artists like Copley, and also the fact that they were received in Puritan Boston not only with no opprobrium, but with praise. The venerated art of antiquity was divorced from suggestions of prurience.

Robert Edge Pine, the English portrait and history painter, who was one of the few English artists to come to America after the Revolution (arriving in 1784), brought with him a plaster cast of the Medici *Venus.* Strangely enough, whereas Smibert's cast had been available for viewing, Pine had to keep his cast shut up in a case, accessible only to persons specifically interested in seeing it. William Dunlap, the earliest American art historian, mentions a letter of 1833 from Joseph Hopkinson in which the latter states that "the manners of our country, at that time, would not tolerate a public exhibition of such a figure."[8]

Although infrequently depicted during the colonial period, the nude nevertheless found its way into the *oeuvres* of many of the leading artists. Watson, Hesselius, and Smibert were only some of these. A Scottish traveler in America in 1744, Dr. Alexander Hamilton, visited the finest mid-eighteenth-century native American painter, Robert Feke (1707/9–52), on July 16, 1744, and noted that the artist had produced a painted copy of *The Judgement of Hercules.*[9] Now, this subject, in an engraving by Simon Gribelin, after a painting by an almost forgotten artist Paulo de Matthaeis, decorated the frontispiece of the essay by the Earl of Shaftsbury on "A Notion of the Historical Draught or Tablature of the Judgement of Hercules," included in a three-volume edition of Shaftsbury's *Characteristicks.* The Feke painting is lost today, but, judging from the Gribelin engraving, which was its source, it included an almost nude figure of Hercules and a partially nude female figure of Vice as well as a fully clothed figure of Virtue (*Ill. 1–9*). This was Feke's only known venture into grand-manner subjects, but the significance of the picture goes further. Shaftsbury's essay was to become a basis for early neoclassic repertory. Feke not only had the essay but must have read it and proceeded to emulate it, using the engraving as a model for an effort at the painting of a group figure composition with the nude. He found in it a subject with strong moral content in which, thanks to the essay as well as the engraving, the aesthetic ideology behind the composition was explicit.

The importance of Shaftsbury's essay and his creation of a specific model for history painting can be demonstrated in a work of far greater significance than Feke's lost picture. The same subject was chosen by Benjamin West (1738–1820) after he settled in London in 1763, and *The Choice of Hercules* of the following year was the result (*Ill. 1–10*).[10] This is West's earliest known neoclassic picture, after his exposure to the new idealism he found growing in Rome, nurtured by Gavin Hamilton and Anton Raphael Mengs. Stylistically, in fact, West's painting combines their early "soft-styled" neoclassicism with a specific debt to the central Apollo figure of Mengs's mural *Parnassus* in the Villa Albani in Rome and such famous examples of classical sculpture with which West was also familiar as the Farnese *Hercules* and the Vatican *Meleager.*

West's depiction of the scene corresponds quite as much as the Gribelin engraving to Shaftsbury's description, although he certainly did not base his composition upon the earlier one, for his is an original work, not a copy. Shaftsbury's advice that Hercules should be shown at the moment when Virtue's cause is already in the ascendancy over that of Vice is recognized by West, who shows Hercules turned toward Virtue and away from Vice. In both works, Vice is characterized by a "supine Air and Character of Ease and Indolence," and thus is seated on the ground, while, following Shaftsbury, Virtue stands "erect with one leg rais'd on a broken piece of ground or rock."

West's painting is one of the most up-to-date pictures of its time. It is a modernization, in every way, of Matthaeis's vignette, for the cluttered background, the complicated draperies, and the twisting figure of Hercules are all simplified and subdued in West's composition. At the same time, rococo sensual-

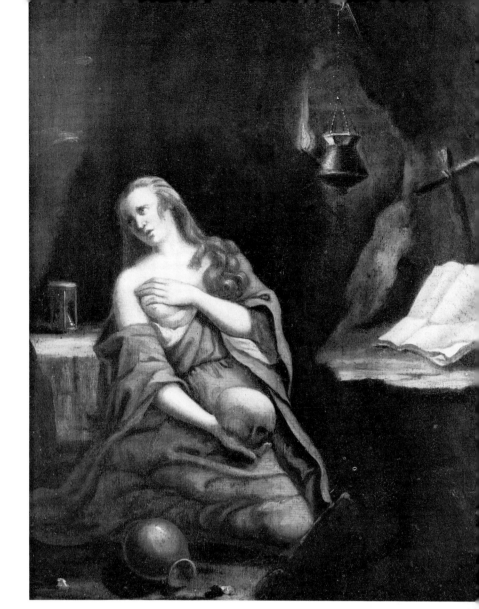

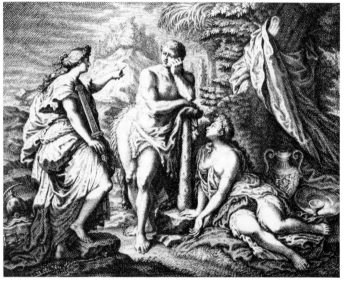

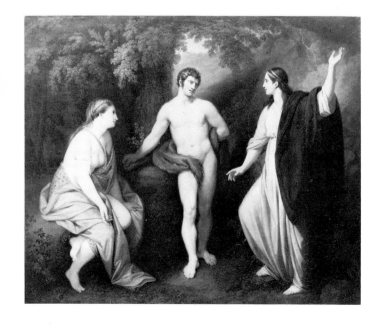

ABOVE LEFT

1–9. Simon Gribelin, after Paulo de Matthaeis. *The Judgement of Hercules*. Engraving from the 1714 edition of *Characteristicks* by the Earl of Shaftsbury.

OPPOSITE, BELOW LEFT

1–10. Benjamin West. *The Choice of Hercules*, 1764. Oil on canvas. The Victoria and Albert Museum, London.

ABOVE

1–11. William Williams. *Mary Magdalene*. 1767. Oil on panel. Private collection.

ity is left far behind, and the partial nudity of Vice is not made inviting in any way—not in pose, gesture, expression, or revelation. The heroic nudity of Hercules acknowledges its debt to antique sculpture so completely that even the left arm, which is partially hidden by the animal skin that winds about Hercules's body and conveniently, if illogically, covers his groin, appears almost broken off as in a classical marble.

Here nudity exists abstracted in time, for the figure of Hercules becomes a symbol of antique form, rather than a depiction of the naked body. It is also an idealized abstraction of human form, based upon the classical concept of the perfection of the human body and the superiority of classical interpretation over any possible modern one.

Another element in the interpretation is that the nude is utilized in combination with a theme of moral righteousness—Hercules's choice of the rocky path of Virtue over the easier one of Vice. This is, of course, totally consistent with the high purposefulness of neoclassicism and its aim of instruction rather than sensory gratification, which was to become a particularly strong element in the American interpretation of the nude. While European artists, particularly with the advent of romanticism, increasingly broke away from the moral restraints imposed upon nudity, American critics and the American public were to permit the nude only when its depiction was consistent with puritan and Christian ethics.

In colonial art, an example of the wedding of a morally acceptable subject with at least partial nudity can be seen in the *Mary Magdalene* of William Williams (1727–91), painted in Philadelphia in 1767 (*Ill. 1–11*).[11] Williams was an English artist who had come to America twenty years earlier and settled in Philadelphia. He is best known as the earliest instructor of Benjamin West and as a painter of charming portraits in a somewhat naive rococo manner. Williams appears to have been one of America's most versatile artists, and conversation groups in the manner of Arthur Devis and the English "Little Masters," landscapes, and religious pictures figure in the known *oeuvre* of Williams, which still includes scarcely more than a dozen paintings, despite his residence in the colonies until the Revolution.

A pair of pictures by Williams that has recently turned up represents figures of an Old Testament Sibyl and Mary Magdalene.[12] The two contrast in every way. The Sibyl is seated outdoors, the Magdalene in a cave; the *Sibyl* is a brightly colored panel painting with a Romanesque tower, symbolic of the synagogue, while the *Magdalene* is dark and dramatic with a bible, skull, and cross; the Sibyl is fully clothed in voluminous garments of rich, fine materials, the Magdalene, half-naked, with the globular shape of her breast compositionally repeated in the form of the skull and the overturned pot at her legs. In expression as well as compositional direction, too, the figures are opposite—the Sibyl a dreaming figure and the Magdalene in religious ecstasy.

The partial nudity of the Magdalene could scarcely offend. Her state of self-mortification suggests her sacrifice of the

elegant richness with which the companion Sibyl is endowed, thus underlining the superior virtue of her state of poverty (and nudity). Furthermore, the bleak setting in a cave and the isolation of the figure cut off from the world would deny any suggestion of impropriety. The purpose of the two panels, like the earlier ones of Gustavus Hesselius, is not known; they also may have been painted to advertise the artist's capabilities beyond the art of portraiture; or they may have been meant for use in a private home or chapel. Like the Hesselius also, it would seem likely that they were derived from now lost print sources. Their style is that of the late baroque period, almost a hundred years earlier, and suggests, therefore, an earlier engraving source. It is interesting to note that, on March 26, 1759, the *New York Mercury* advertised the sale of prints including such subjects as Magdalene, Cupid, Cleopatra, and the Finding of Romulus and Remus, all of which might have involved partial or complete nudity.

Imported European prints were also available to the young John Singleton Copley (1738–1815), and they were the basis of his three excursions into grand-manner painting. The three paintings, *Galatea, The Return of Neptune,* and *Forge of Vulcan,* are all believed to have been executed about 1754.[13] They suggest Copley's early bent for classical subjects; Boston, however, afforded the young artist little encouragement, and Copley turned, instead, to portraiture, the traditional form of art—and the only form of art for which there was great demand.

All three of these historical works involve the nude. The *Galatea* (*Ill. 1–14*) and the *Neptune* (*Ill. 1–12*) are near companion pictures; although they are not the same size, they balance in compositional directions and in subject, as well as in general format. The *Galatea* is painted after a print by Augustinus (*Ill. 1–13*) of a painting by Gregorio Lazarini; the *Neptune* from a print of 1749 by Simon François Ravanet after a painting by Andrea Casali. Despite the similarity of the paintings, however, they are strangely different in two respects. The *Galatea* is softly modeled, with a more diffused treatment of light and color, and the figures in general are quite limp. The *Neptune* is quite the opposite: The forms are sharp and crystalline; the outlines are precise and the figures seem bathed in studio lighting, although the models here are not from life but from the print. Relatively speaking, the *Galatea* may even be called typically late baroque or rococo, and the *Neptune* more formally neoclassic.

The other difference between the two involves the treatment of the nude figure and, specifically, the relationship of the paintings to the print sources. Of course, print sources, at best, presented certain handicaps to artists attempting to learn from them. For one, they offered the painter no clues as to the actual handling of paint, and, for another, black-and-white values in the prints had to be translated into color. In the *Galatea,* however, Copley has changed more than size, medium, and tonal values. Lazarini's Galatea is a rather languid young lady, almost totally nude except for a wisp of drapery above her

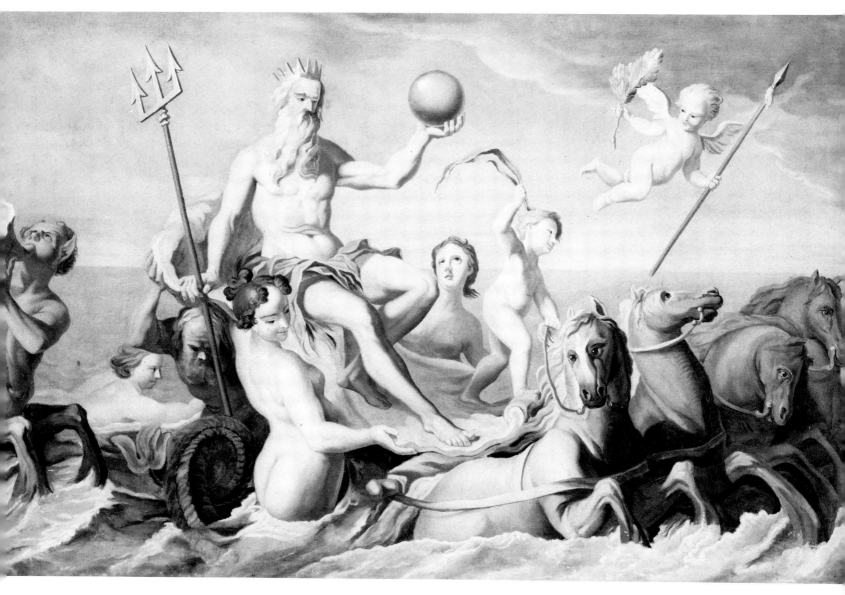

I-12. John Singleton Copley. *The Return of Neptune.* Ca. 1754. Oil on canvas. The Metropolitan Museum of Art, New York. Gift of Mrs. Orme Wilson, 1959, in memory of her parents, Mr. and Mrs. J. Nelson Borland.

thighs and part of a drapery swirl above her upraised arm. Copley has covered her completely with drapery, so that only one leg and part of each arm protrude. His decorous Galatea—also appearing slightly seasick—is thus at odds with her traditional representation, her seaborn iconography, and her companions. Here Copley is even more inconsistent. The female attendant behind Galatea is also well clothed, contrasting with the nudity of the full-breasted figure in the print. On the other hand, the attendants in the water at the left and the figure of Neptune, astride his horse at the right, are almost completely nude in the painting as in the print, though even here Copley throws more drapery across Neptune's mid-section and the most revealed female attendant at the left is plunged deeper into the water, thus concealing more of her anatomy.

By contrast, Copley's painting *The Return of Neptune* is exceedingly close to the Casali print,[14] perhaps because it centers around a nude male figure rather than a female figure; however, in both, the raised figure of Neptune is given further prominence by the female nudes rising from the water in both front and back, and here Copley has not shirked a pictorial display of the human figure. The greater smoothness of the female form compared to the more muscular Neptune—whose heroic body is crowned by an aged visage—is traditional, and the linear emphasis acquired from engraving to painting through the translation of the forward female attendant's contrapposto is strange, but there is certainly an element of

1–13. Augustinus, after Gregorio Lazarini. *Galatée Triomphe sur l'Onde.* n.d. Engraving. Courtesy, Museum of Fine Arts, Boston.

1–14. John Singleton Copley. *Galatea.* Ca. 1754. Oil on canvas. Courtesy, Museum of Fine Arts, Boston.

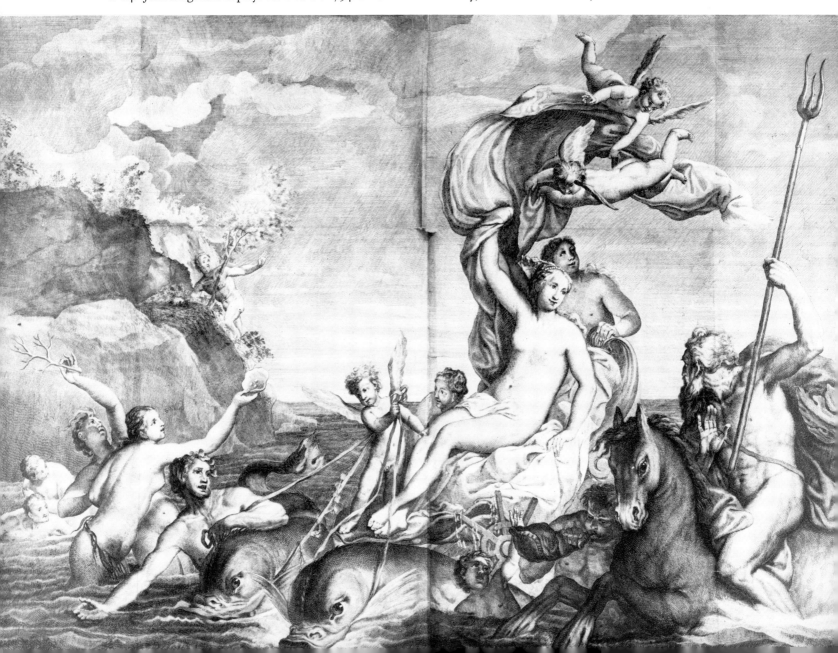

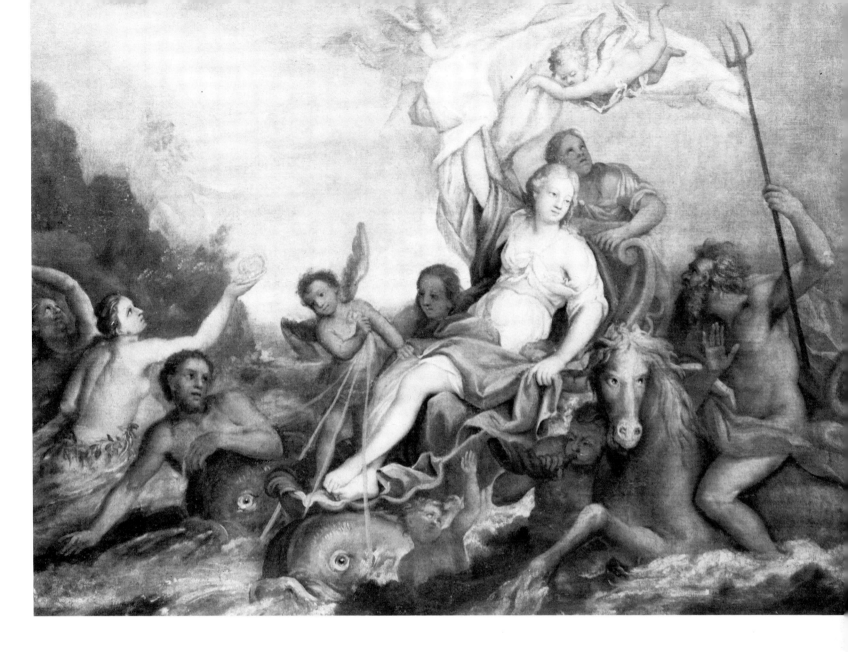

voluptuousness in this work that distinguishes it from the *Galatea*. One would be tempted, thus, to consider the *Neptune* a conceptual advance over the *Galatea*, yet the linearity of the *Neptune* suggests, if anything, more of a "first effort" than the more painterly *Galatea*, so that the matter of dating cannot be so easily resolved.

The dated *Forge of Vulcan* (*Colorplate 2*) is, in any case, the most complex and sophisticated rendering of the three.[15] Again based on a print source, an engraving by Nicholas Tardieu after Antoine Coypel, it is the most complete presentation of the nude form in colonial painting. In Copley's picture Mars is fully clothed in armor, but Venus is not only near-naked but posed somewhat voluptuously with a complex crisscrossing of limbs over her bending form. The figure of Vulcan contrasts in its masculinity and age. In the lower left is a figure of Cupid, stretching his naked body up while two nude putti play. There exists a drawing of a cherub variously dated early in Copley's colonial career or during his first year in Europe, and this, in the pose of the torso and in the bend of the head, as well as in its nudity, relates closely to the Cupid in *The Forge of Vulcan*.

There is no record of the reception of these paintings if, indeed, they were seen at all in colonial Boston. Certainly, they were not attempts by Copley to rival the Old Masters but rather relate to his self-education. Yet, considering his motivation for going to Europe at the time of the American Revolution in order to free himself from the constraints of portraiture and to enter into the field of history painting, these works stand as fascinating precursors of Copley's European career. At the same time, they are anomalies, for, once he became a practicing painter of grand-manner themes in England, classical subject matter is precisely what Copley did *not* undertake. He was to choose subjects, both of the present and past, with religious and literary themes, but he virtually abandoned the classical interests of his extreme youth. Thus, he was also to abandon the nude almost completely.

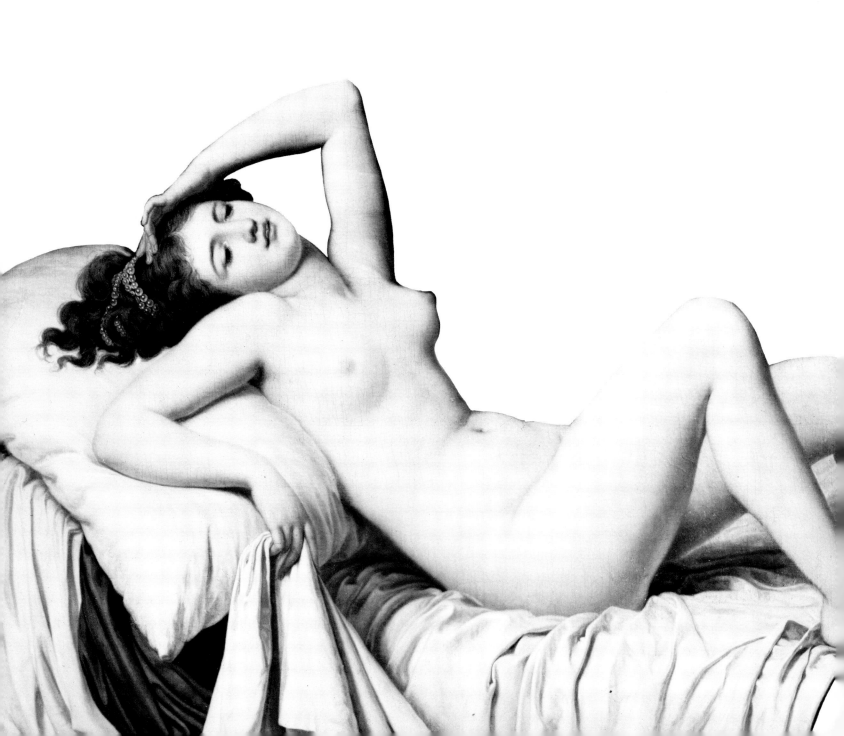

2

The Nude
Becomes Profitable

TOWARD THE END of his American career, when Copley was working in New York during the winter of 1770–71 and made a trip to Philadelphia, he noted a copy of a Titian *Venus* in the home of William Allen, the Chief Justice of Pennsylvania. He wrote to Henry Pelham:

> The Venus is fine in Colouring, I think beyond any Picture I have seen and the Joints of the Knees, Elbows, etc. very Read and no Gray trints anywhere to be found. the hair remarkably Yellow and I think the face much inferior to any other part of the figure in releiff and Colouring. there is no minuteness in the finishing; everything is bold and easey, but I must observe had I performed the Picture I should have been happrenensive the figures in the Background were too Strong. The Flesh is very Plump, soft and animated, and is possessed of a pleasing richness beyond what I have seen. In short there is such a flowery luxuriance in that Picture as I have seen in no other.[1]

The erotic possibilities of the nude undoubtedly intrigued some colonial painters, judging by Copley's comments. The prospect of spiritual alliance with the masters of the past and the influence of the hierarchy of subject matter drawn up by European academicians (in which history painting—including mythological and historical themes that engaged the nude—

was ranked higher than any other form of art) must also have predisposed many colonial artists to undertake the theme. Yet, the nude itself was simply not available. The body was there but carefully covered, for there were no academies in eighteenth-century America in which an artist could either study the nude from life, through original sculpture, or even in the form of casts. West's biographer John Galt records the problem the youthful artist faced when painting his primitive and precocious *Death of Socrates* in 1756 for his Philadelphia patron William Henry. The work, three decades in advance of David's famous rendering of the subject, is little concerned with the naked body, but West did wish to depict the slave presenting the fatal cup of hemlock to Socrates as partially undraped. Since he needed a model, he was forced to use a partially disrobed workman toiling at Henry's gunsmith shop. Professional models were seldom necessary in colonial America, but they were also unavailable.[2]

The first American to go abroad for training, as we have seen, was Benjamin West, who in his major compositions early in his career and, again, toward the end of his life, made extended use of the nude. His earlier treatments include, as we have noted, considerations of Indian subject matter, where the element of nudity was allied with that of primitive innocence, as in *The Death of Wolfe* of 1770, or, again, in *Penn's Treaty with the Indians* of 1772, where the Indian is depicted as innocent and noble. Indeed, since the Indian retained the in-

2–1. Benjamin West. *Air,* from *The Four Elements.* 1769. Oil on canvas. Royal Academy of Arts, London.

2–2. Benjamin West. *The Death of Hyacinthus.* 1770–71. Oil on canvas. Collection of Swarthmore College, Swarthmore, Pennsylvania.

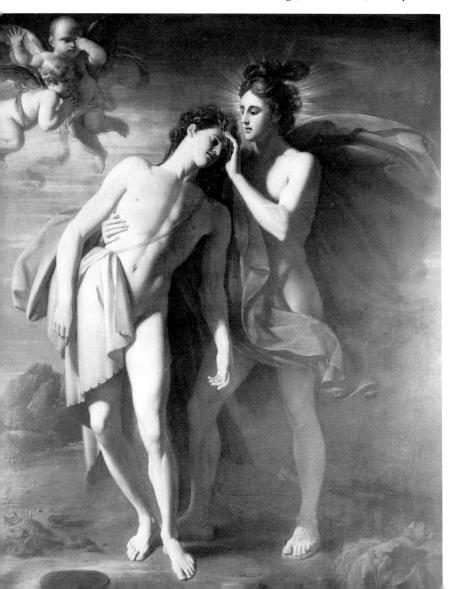

nocence of antiquity, he seemed ideally superior to modern man and was formally treated as an equivalent to the subjects of classical art by West and other neoclassicists. Undoubtedly, West's comment about the Farnese *Hercules,* "My God, how like it is to a young Mohawk warrior!"[3] was prompted principally by his perception of a similar heroic muscularity (and it was only in the Indian that West had had the opportunity to view the nudity that characterizes classical sculpture). But the remark may also have been an expression of the neoclassic concept of the nobility that is to be found in primitive and classical man. It is intriguing that West's depiction of the Indian nude is both more accurate and more aesthetically interesting than his treatment of nudes of any other ilk. While West is often credited with revolutionizing history painting by depicting Wolfe in contemporary costume, he was really indulging in another neoclassic ideal—that is, detailed accuracy in the depiction of costumes, accessories, and locales. The pendants to such a "modern" heroic death scene were those of the medieval Chevalier Bayard and the classical Epaminondas (also by West), and so Bayard is carefully clothed in medieval armor, while Epaminondas is almost totally nude.

Like his neoclassic contemporaries, West sought an ideal of beauty that might be found by selecting the best aspects of individual examples in nature, eliminating the accidental and the defective; or, as Joshua Reynolds advised, in those models of antique sculpture wherein the classical artist had already made the choice. Although West drew from numerous classical sculptures—the Farnese *Hercules* and the Vatican *Meleager* were the basis for his *Hercules*[4] and an Orestes sarcophagus relief underlay his own depiction of that theme—his stated ideals for the depiction of the male and the female nude were the *Apollo Belvedere* and the Medici *Venus.* Indeed, in his *Discourse of 1797,* he recommended that the student "make from the Apollo and the Venus a general measurement or standard for man and woman, taking the head and its features as the part by which you measure the division of those figures." This ideal of the re-creation of perfect beauty thus effectively denied the element of sensuality that had been so cultivated by the despised rococo aesthetic.[5]

The early nudes in West's art—usually male—are commonly rather flaccid and simplified. The figures are often small, dominated both by the general event in which they are participating and by the settings. But in the 1770s the figures in some of West's paintings took on a new grandeur and monumentality; they often tend to fill up the canvas, although nudity itself seems to be less apparent. This is true, for instance, of the *Venus Lamenting the Death of Adonis* of 1769, although the figures are still limp objects of pathos (the word is used here descriptively, not disparagingly!), and their nudity is quite limited. In fact, Aldous Huxley remarked that West's Venuses seemed to have undressed for the first time. At about this date, West depicted a series of painting of the allegories of the elements for the Royal Academy, which are among his more enticing nudes. Actually, they can be read in terms of

increasing nakedness, from the single revealed breast of Earth and Water to the half-nude Fire and then the almost totally revealed Air, the latter posed rather voluptuously with her sinuous form and outlines repeated in the curves of her drapery and the S-shaped curve of the peacock to her right (*Ill. 2–1*). She exhibits, in fact, what can only be described as a certain backsliding from neoclassic austerity to rococo sensuality!

Among other treatments of the nude by West in the early 1770s is the canvas of *Venus and Europa* of 1770. Here, a rather coy and rococo Venus, sleek and smooth, and accompanied by a naked Cupid, is approaching a sorrowing Europa with the bull seen in the middle distance. Europa is modestly gowned, through somewhat *déshabillée;* the picture is about as close as West was ever to come to standards of eighteenth-century sensuality. A very different presentation can be found in *The Death of Hyacinthus* (*Ill. 2–2*). The bereaved Apollo is holding the body of the youthful nude Hyacinthus, who has been killed by a quoit blown back upon him by a jealous zephyr, the West Wind. The picture offers the relatively rare dead nude theme, best known in art in the various Depositions, Lamentations, and *Pietàs* of Christ and such classical counterparts as the Dead Patrocluses and Hectors from the *Iliad*. Classical, grand-manner origins appear here to have made acceptable the depiction of an overtly homosexual theme, as has its mythological basis. The legend of Hyacinthus was recognized as symbolic of the tragedy of death at the first bloom of young manhood, and thus had a wider relevance.

Gradually, under the influence of Edmund Burke's theory of the Sublime, West's style began to change. Many of his later paintings involve figures far more dramatic in their facial expressions and gestures, in the formal manipulation of contrasts of light and shade, of scale, of spatial placement, and in the general activity among the participants. Some of these involve the nude again; actually, the naked figure seems to take an important place in a number of the major paintings executed by West in the last two decades of his life. An interesting contrast exists between his earlier and his later versions of *Venus and Adonis*. Where the version of 1769 depicts a gently mourning and modestly garbed Venus with a cupid, the later version of 1803 (*Ill. 2–3*) shows a distraught goddess, falling back from the supine Adonis, tearing out her long tresses, while attendant maidens, swans, doves, and cupids not only try to comfort her but also share in her grief. Her completely nude form dominates the composition, not only in its placement, but in its heroic scale, compared to the smallness of the subsidiary figures, which themselves occupy an impossibly limited and crowded space. Despite the simplified neoclassic outline of the figure, the handling of paint is far more vivid and impassioned than in West's earlier work, echoing the charged emotional subject and the state of the figures themselves. West was now able to endow the nude with emotional expressiveness if not with physical allure.

A similar frenzy is embodied in his painting of *Thetis Bringing Armor to Achilles* of 1806 (*Colorplate 3*), in which the

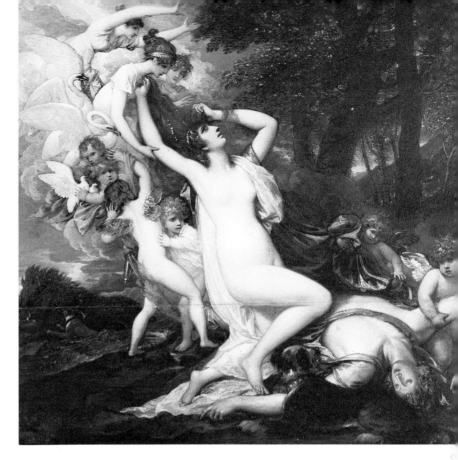

2–3. Benjamin West. *Venus Lamenting the Death of Adonis*. 1803. Oil on panel. Rutgers University Fine Arts Collection, New Brunswick, New Jersey.

2–4. Benjamin West. *Cupid and Psyche*. 1808. Oil on canvas. In the collection of the Corcoran Gallery of Art, Washington, D.C.

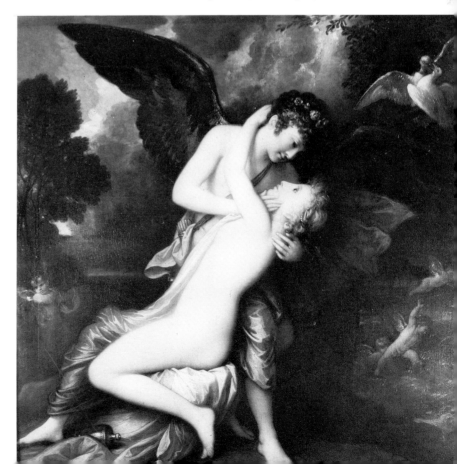

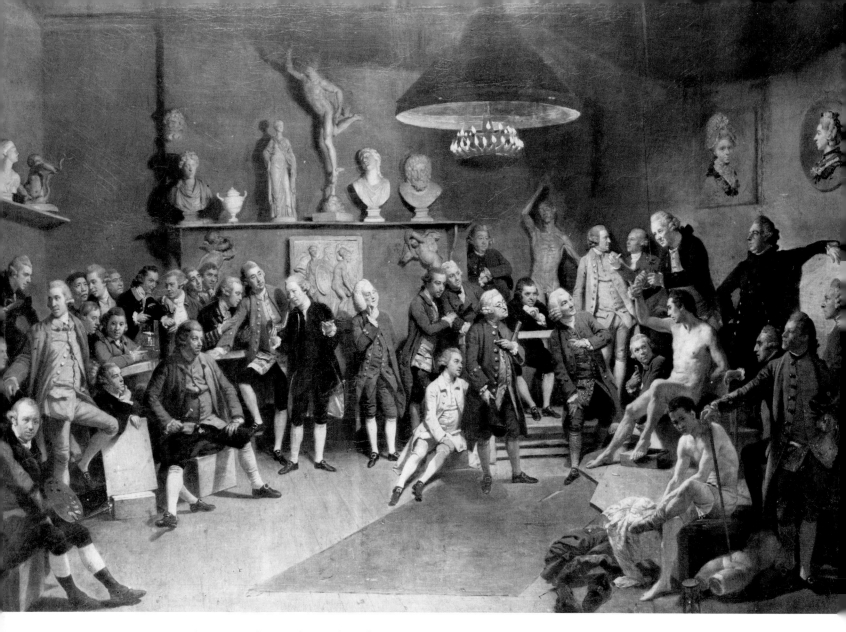

2–5. Johann Zoffany. *Life School at the Royal Academy.* 1772. Oil on canvas. Royal Collection, London.

soft, bending curves of Thetis contrast with the powerfully muscular body of Achilles, his limbs twisted in grief over the death of Patroclus. Later still, West was to pay homage to Eros himself, in such paintings as *Cupid and Psyche* of 1808 (*Ill. 2–4*) and *Omnia Vincit Amor* of 1811. The form of the yielding, nude Psyche is rather explicit for West, though the blandness of modeling and expression tends to offset the erotic impact. In the 1811 painting, where Cupid, accompanied by Venus and several cherubs, holds in check the elements of air, earth, and water while holding aloft the torch of "love, conquering all," the boneless youthfulness of Cupid seems to belie any suggestion of physical love. However, the dramatic intensity of these later pictures contrasts with the gentle pathos of West's earlier work and looks forward to the development of romanticism among artists of the next generation. The *Cupid and Psyche* is taken directly from Thomas Martyn's *The Antiquities of Herculaneum,* published in London in 1773, for

which West was one of the original subscribers.

Benjamin West is significant, not only as an example of the liberating influences afforded an American artist in the more sophisticated environment of Europe, but as a stimulus, both by example and by personal contact, for other American-born painters. West's studio attracted scores of young American painters of several generations who traveled to London to learn their profession under West's guidance. West's studio was the focal point of their European experience, but they also, of course, enjoyed the dazzling, unnerving exposure to masterpieces of the past and to a thoroughly professional artistic environment. There was also the opportunity to study at the Royal Academy in London. Such study included life classes at the Academy, and the importance of this phase of study for artists is made clear in the well-known painting of the founding members of the Royal Academy, an informal group portrait, painted by Johann Zoffany, in just such a class (*Ill. 2–5*). Even

in polished London art circles, however, decorum precluded the inclusion of the women members of the Academy in a group studying nude male models, and these ladies, Mary Moser and Angelica Kauffmann, are decorously memorialized by portraits upon the rear wall. It is the members of the Academy who appear, of course, not the students, but Benjamin West is conspicuously present. The nude was also to be seen and studied by students at the Royal Academy in the Antique Room, which was filled with casts of the great monuments of the classical world.

Gilbert Stuart, when a pupil of West's, seems not to have studied anatomy at the Academy nor attended the lectures given there by Dr. William Hunter, although he did hear Sir Joshua Reynolds's discourses on painting.[6] He studied anatomy with Dr. William Cumberland Cruikshank, whose lectures were intended for medical students and young surgeons. The artist's daughter Jane Stuart stated that her father studied at the life school, but this statement probably simply implies that the nude model was posed in one of West's painting rooms. Rembrandt Peale recalled that during his stay in London, between 1802 and 1803, he was expelled from the Royal Academy and that he and other students then hired Academy models for their private study. Later, Thomas Sully and Charles Bird King drew from both casts and live models at the Academy and, in 1809 and 1810, hired models in the evenings to pose in their painting rooms in London; in Paris, in the same decade, John Vanderlyn also used live models.

Copley was certainly concerned with the nude as part of his

2–6. John Singleton Copley. *Watson and the Shark*. 1778. Oil on canvas. The National Gallery of Art, Washington, D.C. Ferdinand Lammot Belin Fund, 1963.

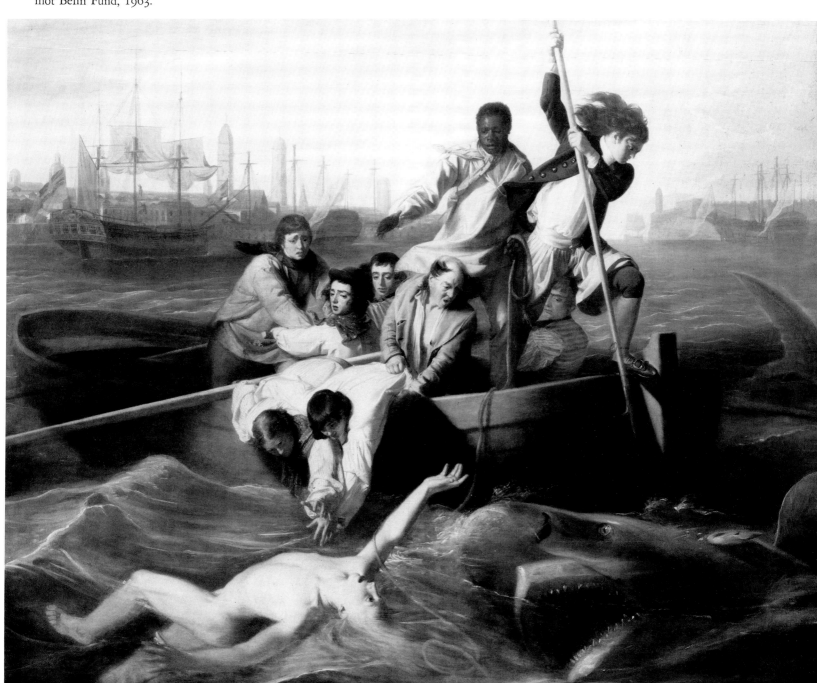

2–7. John Trumbull. *Nude Male.* 1780. Crayon. Collection of Fordham University, New York. Photograph courtesy Frick Art Reference Library.

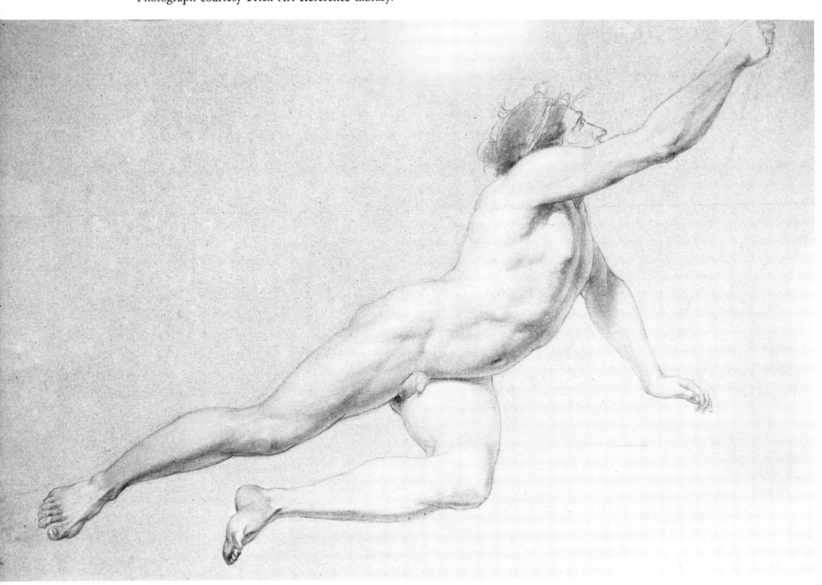

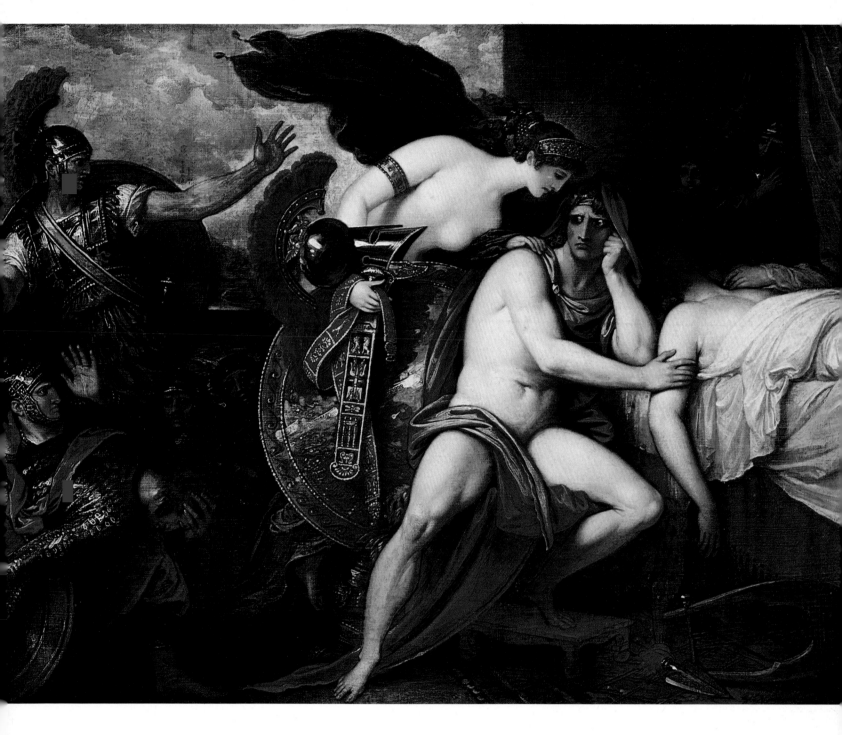

Colorplate 3. Benjamin West. *Thetis Bringing Armor to Achilles*. 1806. Oil on canvas. The New Britain Museum of American Art, New Britain, Connecticut.

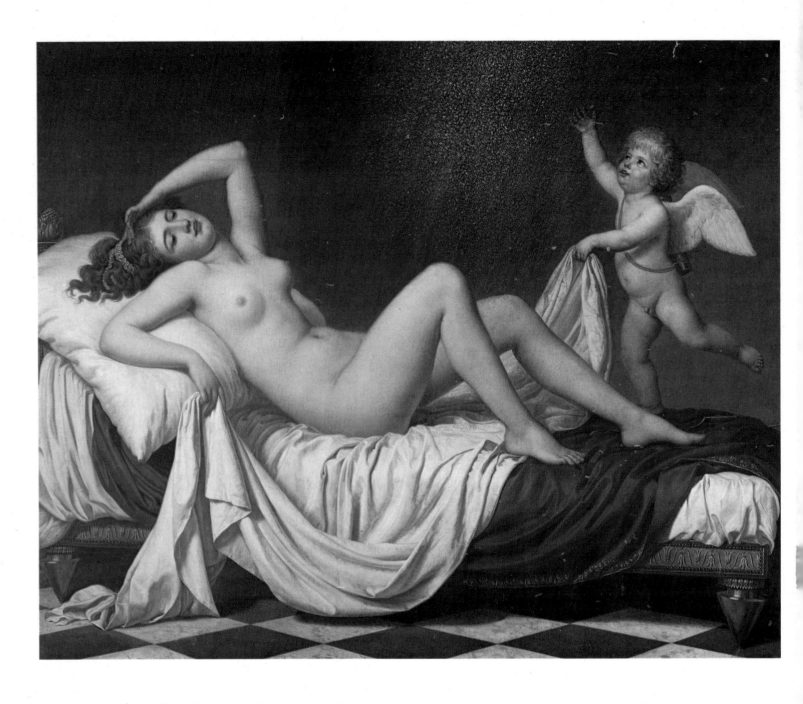

Colorplate 4. Adolph Ulrich Wertmüller. *Danaë and the Shower of Gold*. 1787. Oil on canvas. Nationalmuseum, Stockholm.

2–8. John Trumbull. *Nude Female*. 1784. Crayon. Yale University Art Gallery, New Haven, Connecticut.

2–9. John Trumbull. *Reclining Nude*. 1784. Chalk. Yale University Art Gallery, New Haven, Connecticut. Gift of the Yale University Art Gallery Associates.

artistic experience with the works of earlier periods. He visited the Royal Academy as early as 1774, when he first arrived in London on his way to Italy, and saw live models there. His concern with anatomy is suggested in a letter from Europe to Henry Pelham:

> And here I must advice you to procure an anatomical figure and lern the mussels, so that you would be able to draw a tolerable figure with all the mussels from your knowledge of the parts.[7]

But the nude is seldom to be found, either in Copley's finished historical pictures or in the many preparatory drawings for such pictures. This is unusual and would seem to be indicative of his straightforward reportorial and realistic method of working. Except for several drawings for *The Siege of Gibraltar* (1783–91), his figures were represented nude and nearly nude only if they were going to be shown so in the finished work; thus, they were not figure studies per se but sketches of details.[8]

Nudity figures importantly in only one of Copley's original historical works, the *Watson and the Shark* of 1778 (*Ill. 2–6*). Here, the naked figure of Brook Watson is shown floating in the water in Havana harbor, reaching up an arm toward his fellow seamen in the lifeboat for aid and rescue while a vicious shark is murderously approaching him. Although depictions of living individuals partially or fully nude occur more often in the late eighteenth century than either earlier or later, such subjects were almost invariably persons of established reputations; the uniqueness of Brook Watson's nudity is that he himself was, then, an ordinary seaman. Watson's nudity is somewhat incongruous, an example of romanticism and artistic license, for the young man could hardly have fallen overboard in the buff; on the other hand, the nudity is dramatically valid. It tends to underscore the helplessness of the victim about to be attacked by a monstrous creature, in contrast to his fully clothed fellows in the boat; it underlines, too, the role of Watson as the principal figure in the drama and at the same time allies both Watson and the picture itself with the antique tradition; indeed, Jules Prown has suggested a basis for the pose of the figure of Watson in the Villa Borghese *Gladiator*.

It is also true that the rather rigid compositional pyramid might have had a less visually forceful base if the clear line of Watson-and-shark were disturbed by fussy details of drapery; the sleek, smooth figure of the naked man is obviously a more powerful image than if it were encumbered by soaking garments. Nudity is here utilized for dramatic purposes, certainly not sensual ones. Copley never indulged in West's admittedly tame sensuality. His *Venus and Cupid* of about 1779, in spite of its tentative nudity, is maternal, not erotic, and its sources may indeed have been within the artist's own family.

John Trumbull, too, studied at the Royal Academy, but nudity figures very occasionally in his art. Some of his drawings from casts done in 1784 at the Royal Academy still exist. More interesting are those taken from life. Trumbull (1756–1843),

as is well known, was imprisoned in England during the American Revolution in retaliation for the execution of the British spy Major John André. Life for him during this period was far less unpleasant than one might imagine, however, and, due to influential English friends, Trumbull was even allowed to choose his own place of confinement. Moreover, his room was actually one of those given to the keeper of the prison, and Trumbull enjoyed such prison luxuries as the run of a small garden and valet service! His teacher, Benjamin West, not only procured a promise of personal safety from the king but also lent him his own copy of the Correggio *St. Jerome* for Trumbull to copy. Trumbull's conditions of imprisonment were so relaxed as to allow him even to employ a model; studies of the male nude done in prison and dated 1780 still survive (*Ill. 2–7*).[9]

Far more finished and far more beautiful is a group of drawings done by Trumbull on his return to London in 1784, after his release from prison (*Ills. 2–8 and 2–9*). These drawings of the nude appear unrelated to any of Trumbull's known paintings, though the figures are posed in "historical" attitudes. They are beautifully rendered, carefully modeled with a sense of form and a knowledge of anatomy. The execution in chalk on colored paper is sharp and accurate, yet the line has a vitality to it which takes the drawings beyond the average level of neoclassic figure studies. The male nudes have a heroic muscularity, and the female figures are sleekly sensual. The central figure of Hector in Trumbull's oil of *Priam Receiving the Body of Hector* of 1785 is a heroic, partially undraped figure, but nudity, partial or full, does not appear again in Trumbull's works until his wretched religious paintings 40 years later.[10]

Even less involved with the subject of the nude was Charles Willson Peale (1741–1827), though in 1776 he painted a copy of a Titian *Venus* or rather, more likely, copied West's copy of a Titian *Venus*, owned by William Allen. Peale also aided his brother, the painter James Peale (1749–1831), in copying another West copy of a Titian in 1782 (*Ill. 2–10*).[11] While a long way from the refined, full sensuality of a Titian, the James Peale nude is one of the most robust and fleshy to be found in the work of eighteenth-century American artists. In the languorous turn of the figure, the rippling anatomy, and the soft play of light upon the figure, it is a good deal closer to the ideals, if not the achievements, of Titian himself.

Henry Benbridge (1743–1812) was not a painter of historical subjects or of the nude, though he was one of the first Americans to spend a considerable period of time in Italy.[12] Owned by his descendants, however, is an undated canvas of *The Three Graces,* adapted from Rubens, a tightly intertwined grouping with a good deal of partial nudity. Family tradition has it that Benbridge's half-sisters were models for the heads of the Graces, while the bodies were posed for by a workman in Benbridge's stepfather's lumberyard. The juxtaposition renders grotesque the figures in the completed work, though, admittedly, they have a certain disjointedness that is almost a caricature of voluptuousness.

Another nude of the period by an American artist is the *Cupid* attributed to John Durand (w. 1763–82).[13] Durand's name first appears in a New York newspaper, where he advertised as an artist in 1763; on April 11, 1768, a lengthy notice in the *New York Gazette* emphasized the role he wished to play in the area of historical painting and also the purposes such an art form might serve—not only as ornament but as educational in historical and moral matters. Yet Durand is known today only as a portraitist. The *Cupid* (*Ill. 2–11*) is one of a group of works done for the Meade family of Virginia and taken to Kentucky in 1796.[14] The purpose of the *Cupid* is not known—it may have been done to advertise the artist's ability at history painting and may have been drawn from an engraving. There is also the possibility, of course, that it is a

family portrait—a member of the Meade family as Cupid, a conceit not unpopular in the eighteenth and nineteenth centuries: William Henry Rinehart's statue of Henry Elliott Johnston, Jr., as *Cupid with a Bow,* carved a century after the Durand, is a conspicuous example.

During the late eighteenth century, then, painting the nude related to and depended upon the individual artist's experiences in Europe—both in terms of training and familiarity with European art. It is, therefore, perhaps not surprising that the most important, even triumphant, appearance of the nude in America at the turn of the century was painted by a European artist, the Swedish Adolph Ulrich Wertmüller (1751–1811), who studied in Stockholm, Paris, and Rome before coming to America in 1794. Although he returned to Sweden in 1796,

2–10. James Peale, after Titian. *Venus and Cupid.* 1782. Oil on canvas. Private collection.

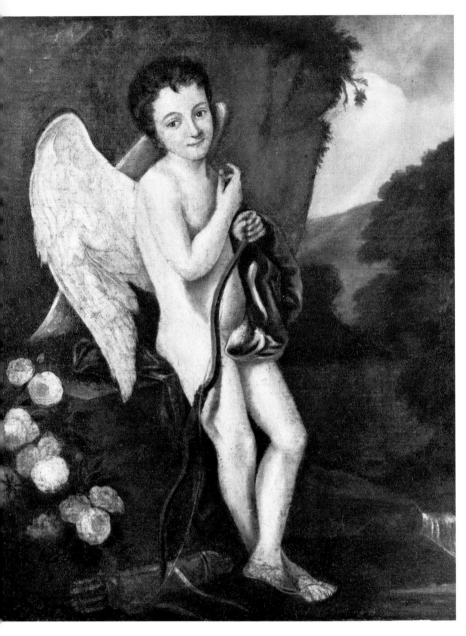

2–11. John Durand. *Cupid.* 1780. Oil on canvas. Collection of Mrs. Lucy Meade Wilkinson.

he settled permanently in America four years later. Wertmüller lived on a farm in Delaware, but he is associated with the cultural life of Philadelphia. He exhibited in the abortive Columbianum Gallery exhibition of 1795, in which Charles Willson Peale and others hoped to set up a native art institution.

In 1806 Wertmüller exhibited his large painting of Danaë in Philadelphia, undoubtedly the most sensational picture ever shown in America (*Colorplate 4*).[15] The picture had been painted in Paris in 1787 and exhibited with success, after the artist had studied with such neoclassic masters as Alexander Roslin and Joseph Marie Vien. Supposedly, three ladies of the French court modeled for the painting, and the head of Danaë

was said to have been taken from that of a Flemish countess. The subject is depicted completely nude, lying upon a classical bed, which is luxuriantly covered with a huge soft pillow, satin coverings, and rumpled sheets. Zeus, as a shower of gold, plunges toward her loins, and, lest any ambiguity remain, a figure of Cupid rushes toward Danaë. Danaë with legs apart, head and arms thrown back in mindless abandon, exhibits herself ready for intercourse. On the other hand, the scene also suggests postcoital ecstasy, an interpretation reinforced by the disheveled bed and the gesture of Cupid, which can be interpreted as one of triumphant farewell to the departing Zeus.

The Danaë subject was well known, even in America, and it was associated with the "approved" Old Master Titian, but here, in place of the soft luminosity of Titian's Renaissance style, Wertmüller presents the sharply outlined, sculpturally modeled neoclassic nude. Her sleek form and simplified outline, all the more strongly defined in contrast to the multiple irregularity of the creases of the bedclothes, are precursors of the erotic neoclassicism of Ingres's Odalisques. Small wonder that the work caused a furor in the new American republic and that critics and observers simply did not know how to handle their reactions. For the *Danaë* was recognized almost universally as a great and splendid work; yet its style and its subject did offend. To admire the picture was to condone and even to share licentiousness and decadence; yet, to castigate it was to admit to cultural and aesthetic ignorance.

The *Danaë* was publicly and continuously exhibited in Philadelphia, and in New York in 1810, and Wertmüller went on to several replicas of it, full length and details, and also similar paintings of Venus and Ariadne. It was one of the first of those public exhibitions of important and notorious single monumental works of art, which included Rembrandt Peale's famous *Court of Death,* that culminated in a rash of panorama exhibits during the first half of the nineteenth century. Visitors were admitted for 25 cents, and a day was usually set aside for ladies to view the picture privately.

In 1812 one critic wrote:

For some years, there has been exhibited in Philadelphia, a painting by Wertmüller, a Jupiter and Danaë. The painting has some merit in point of execution. I highly value the art of painting. It is a source of great pleasure. . . . But this noble art is basely perverted and abused, when it is made to pander to those desires, that public expediency requires to be controlled, and when employed to portray those scenes that public decorum requires to be shut out from the eye of day. Is it any credit to the art, or any credit to the city, that a picture should be publicly exhibited, which no modest woman would venture to contemplate in the presence of a man? And that particular days should be set apart by public advertisement, when the female sex have the exclusive privilege of indulging their culpable curiosity? A curiosity certainly excited rather by the nature of the subject than the merit

of the artist. Would Stuart's General Washington prove equally lucrative and attractive?

This is not all. The painting itself is a gross and impudent plagiarism. It is stolen . . . Reynolds stole. So did Fuseli. . . . But these men embellish what they borrow. . . . Wertmüller's painting affords decisive evidence of want of senses, want of taste, and want of decency.[16]

The *Danaë* continued to be exhibited in Philadelphia, however, and visitors flocked to see the great immoral painting. One of the most interesting comments about the picture was made by a visiting South Carolinian, writing from Philadelphia in April and May, 1812. In a letter to his wife on April 29, William Lowndes wrote:

I have just returned from seeing, but I ought not to tell you of it, a famous picture, of which I suppose you have heard, by Wertmüller. It is the picture, in a very licentious taste (though all the ladies go to see it), of Danaë, with a shower of gold breaking into her apartment. The gold, and the bars, and the absurdities of pagan mythology are kept out of view, and the attention is absorbed by the figure, not of a divinity—she breathes too much of human passion—but of an exquisitely beautiful woman, who has no dress other than a band of pearls for her hair. I do not mean, however, to give you a description of this fascinating picture, for though it may do you no harm to read it, it may do me some to write or think of it. I had so little taste as to think that if the painter had given her a little drapery (as transparent as he pleased) of cambric or lace, so that she might have thought herself covered, the effect of the picture would have been heightened.

Mrs. Lowndes seems to have been scandalized by the description, for her husband wrote again, on May 27:

I think that you were not in quite as good humor when you wrote your reflections on the Philadelphia Danaë as I was when I wrote the description. I do not remember now what I said about her, but there is a matronly gravity in your style, which makes me fear that your disgust towards the painter is joined to some little displeasure against the describer of the picture. He must be strangely unreasonable who is not satisfied that his wife should now and then scold him in proof of her modesty. And though I do not require such a proof of yours, yet I think your remarks on the painting, on the ladies who visit it, and the sensualists who admire it, perfectly just, and in a lady of Carolina natural.[17]

Since the exhibition of the picture continued, notices of it from the Quaker city continued to pour in. A letter to the *Port Folio* was published in January, 1814, commenting upon the "filth of mythology" descending upon the quiet, decent, moral city of Philadelphia:

For a long time past there has been exhibited a painting of no great merit as a work of art, but very indecent . . . and quite unfit for public inspection. It was however tolerated and, having become profitable to its owner, other artists thinking that a shower of gold might be had for some rival Danaë, have furnished the town with Venuses and Ledas from every corner. After these abortive efforts by minor manufacturers of pictures we have at last seen one of our most distinguished artists concentrate the whole force of his very respectable talents to produce a work of the same indecent character. Having satisfied his own imagination, the picture is offered for public exhibition.

Among the pictures the writer is referring to must have been the miniature *Venus* by Thomas Bishop of Philadelphia that was exhibited in 1811; Charles Robert Leslie's *Musidora,* after the picture by Benjamin West, exhibited in Philadelphia in 1813; and George Miller's head of the Medici *Venus,* probably a colored wax sculpture.

The *Danaë* itself, however, had been acquired by the early part of 1814 by the noted New York portrait painter John Wesley Jarvis, into whose studio visitors continued to troop to view the Wertmüller painting.[18] One of the visitors to Jarvis's studio was the youthful Henry Inman, who, according to Henry T. Tuckerman, decided on the basis of his viewing of the *Danaë* to turn his attention to the arts rather than to West Point.[19] A disapproving critic wrote in the *Analectical Magazine* in June, 1815, that the *Danaë* represented the pollution of art, which offended pure taste and the morality of art. Inman certainly didn't agree. He became apprenticed to Jarvis, and, years later, the *Danaë* came into his possession, though Jarvis had bequeathed it to his son Charles in his will. It seems that Inman acquired the picture in New Orleans; some of the time, however, it appears to have either remained with or returned to James McMurtrie, who was a close friend and business associate of Inman, who perhaps had actually continued to own the picture. In Inman's studio it was curtained from observation but was occasionally seen by visitors. It was also shown publicly in Washington, D.C., in 1829, and in 1850, after Inman's death, it was exhibited in the Pennington Building on 42nd Street in New York City. It was ultimately offered to the Museum of Fine Arts in Boston, which refused it, and in 1913 J. E. Heaton of New Haven donated the picture to the National Museum in Stockholm. Thus, by the nineteenth century, nudity might have been morally censurable but it could also be economically profitable.

3

Painted Nudes in the Early Nineteenth Century

BY THE BEGINNING of the nineteenth century, as the arts progressed in the United States, the nude found a more established, if still controversial, place in American art. Society in general, and even the newly formed art academies, still did not easily accept the nude living model. As early as 1794, when the artists of Philadelphia, headed by Charles Willson Peale, set up the short-lived Columbianum Gallery, they did so not only to offer works of art for public exhibition but also to found an academy for study, and arrangements were made to draw from life. When the person (a baker) who was first engaged to stand as the model found himself surrounded by new faces and penetrating eyes, he shrank from the scrutiny and precipitously fled. In this dilemma, Mr. Peale stripped and presented himself as the model to his fellow artists!

A compromise was generally effected, which had the added advantage of incorporating hallowed models from previous eras, in the form of plaster casts of masterpieces from the classical and the Renaissance world. One of John Vanderlyn's commissions on his second trip to Europe in 1803 was to acquire such works for the newly formed American Academy of the Fine Arts in New York City. The emphasis upon such works as the basis for artistic training underlined the aesthetic philosophy of the neoclassic era, for it not only supported the belief in the supremacy of the ancients but also tended to emphasize a sculptural interpretation of form in the training of painters. The casts acquired by the Academy were the standard ones

that had excited the admiration and veneration of the early neoclassicists from Johann Winckelmann and Benjamin West onward—in particular, the *Apollo Belvedere,* the *Venus de' Medici,* and the *Laocoön.* Charles Willson Peale, too, included casts of the nude from classical antiquity in the display in his gallery in Independence Hall. These exhibitions were open to the general public as well as to the aspiring art student, and this must have familiarized Americans with the nude and introduced a certain degree of toleration. The public seems to have been the major consideration of the exhibitors, however, and this may have been detrimental to artistic training, for even the display of plaster casts was not immune from problems. On October 31, 1832, the National Academy passed what was termed "the fig-leaf resolve,"[1] offered by Charles Cromwell Ingham, proposing that a statue in the Antique class, which had suffered mutilation, should have a plaster leaf placed upon it. The motion was adopted.

Published drawing books, meant to guide the art student in the rendering of anatomy, provided another glimpse of the nude. John Rubens Smith, in the preface to *A Key to the Art of Drawing the Human Figure,* published in Philadelphia in 1831, wrote:

> In a work of this kind on the human figure, no apology is necessary for the introduction of nudity, especially where the purity of intention is so very evident; " 'tis in

the mind of the observer that evil lies." Much might be said in corroboration, but all fastidious delicacy deserves not an argument, and good sense needs none. On the subject we conclude with remarking that it is impossible to draw a figure any ways clothed, without understanding its construction.

Art exhibitions, which were growing in number throughout the country, were also bringing the nude to the attention of the public. Not only did the relatively cosmopolitan eastern centers of Boston, New York, and Philadelphia witness this, but "western" Pittsburgh saw a painting of *Venus* by Robert Street (1796–1865) along with the wax *Venus* by the deceased George Miller (d. 1819). But while the nude was being seen, it was, of course, not always being approved. Even Charles Willson Peale, revealing the reticence of an older artist of an older generation, wrote to Thomas Jefferson concerning Wertmüller's *Danaë:*

> Howsoever well I love the art of Painting In my present Ideas I think that we should guard against familiarizing our Citizens to sights which only excite a blush in the most modest. . . . Therefore, at our last exhibition at the Academy of arts I advised and procured some old pictures of nudities to be put out of sight.[2]

The creation and exhibition of representations of the nude by Rembrandt Peale (1778–1860) also met with Charles Willson's disapproval. Rembrandt had established a museum in Baltimore after his return to America in 1810 from Europe, and the exhibits were various: including the skeleton of one of the mastodons that had been unearthed outside of Philadelphia earlier in the century; stuffed birds and beasts; Rembrandt's *The Grecian Beauty,* a statue of wax, colored like life; and particularly, his *Dream of Love* (painted shortly after his return), representing an elegant young female reclining in a grotto, repelling the enchantments of Love. Peale insisted in his advertisements in the Baltimore newspapers that his aim in exhibiting the last two pieces was to display the beauty, softness, symmetry, and grace of the female form.

The *Dream of Love* was earlier called *Jupiter and Io,* undoubtedly to give it a classical lineage and relate it to the then as now famous painting of the subject by Correggio. The earlier title, however, was probably too specialized for the general public. Peale explained in his own *Reminiscences* that *The Dream of Love* was based upon a French engraving. John Neal described it as follows:

> Originally the face of Jupiter was pressed to hers [Io's]— and no other part of his body could be seen through the smoke and cloud that enveloped them. This head was [later] blotted out and a naked cupid painted over the face of Io.[3]

Apparently, Peale came to feel that he had exposed too much flesh, for he repainted the picture, and it was then that he retitled it *The Dream of Love.*

Despite Rembrandt Peale's explanation of the painting's *raison d'être,* however, his father was still skeptical. He wrote to Rembrandt on June 4, 1815:

> I find by your letters to Rubens that you have made some important alterations in the [*Dream of Love*], but do what you will with it, still I have my doubts that you cannot be safe with making an exhibition of *nudities.* You know very well that it is all important to keep clear of every offence to religious societies; you must know that if they take it into their heads that such exhibitions are improper, their inveteracy knows no bounds, and your Establishment of the Museum may suffer irreparable injuries. . . . If you do exhibit the [two pieces], I hope it will not be in your House. I have been much mortified by the Exhibition of them at Rubens' when I heard it said that it ought to be presented as a public nuisance. Perhaps you may get them sold by a raffle, and let them be seen in some other place rather than in your Museum.[4]

The Dream of Love was shown not only in Baltimore but also in Philadelphia, at the same time the Wertmüller *Danaë* was on view, and in Boston. The public did indeed react against the picture, and the display of Peale's paintings in Boston seems surprisingly to have increased in popularity *after* the picture was taken out of the exhibition.

The Dream of Love was unfortunately destroyed by fire in New York in 1823. Rembrandt Peale's recently rediscovered *Roman Daughter* (*Colorplate 5*) is undoubtedly not so lavish a display of nudity, but it offers a fascinating if grotesque element of sensuality. Its subject, also called *Caritas Romana,* or *Roman Charity,* derives from antiquity. Known in medieval representations, it became an established element in both baroque and neoclassic iconography and was elaborated into a popular drama by the well-known late-eighteenth-century Scottish playwright Arthur Murphy. The subject was of high appeal to the neoclassicists—combining a political theme with the ultimate in filial piety and sensual overtones: An elderly Roman, imprisoned and left to die, is nourished by his lactating daughter on her visits to the prison. Though the theme was extremely popular in Europe in the late eighteenth and early nineteenth centuries, its sexual implications were too strong for most American artists, and it is not surprising that it was undertaken only by Rembrandt Peale, a fervent disciple of French neoclassicism. Even so, his heroine is an extremely modest lady. *The Roman Daughter* reveals only one breast— that was, after all, all that was necessary to nourish her father!

As if in anticipation of Peale's painting, and certainly reflecting the prevailing attitudes toward such a subject, a writer signing himself "Silva" in the July, 1806, issue of the *Monthly*

> Many circumstances, highly affecting in narration, are
> glaringly improper for the tablet of the painter. Of this
> class is the circumstance of the Grecian Daughter afford-
> ing nutriment to her aged parent. The story is barely
> tolerable in the hands of the serious dramatist; but on
> canvas, the figure of an old man, placed in the situation
> of an unconscious infant, is perfectly disgusting.

Rembrandt's brother Raphaelle Peale (1774–1825), in the
best known of his pictures, *After the Bath* of 1823 (*Ill. 3–1*),
arrived at a similar solution of near "un-nudity," by putting on
instead of taking off, so to speak. Raphaelle was primarily a
still-life painter, and though this picture has been usually clas-
sified as a still life, it is actually also a figure painting, or a
trompe l'oeil figure painting. It is a still life because it is a
painting of a painting, meant to be recognized as a work of art,
not a transcription of reality. The family story is that Raphaelle
painted it as a deception to fool, amuse, or irritate his wife.[5]
The figure is apparently nude, and the canvas seems to be
covered by a cloth, the idea being that Mrs. Peale would be
annoyed to think that her husband had painted a seductive
nude, and would try to remove the cloth—only to find that it,
too, was painted. The cloth actually hangs from a line, as
though the young lady behind were showering. The picture *is*
meant to titillate; the spectator is undoubtedly expected to
wish to remove the "curtain" to view the full charms hinted
at by the delicate foot and graceful arm.

A similar tame, sensual suggestion may be found in Charles
Bird King's (1785–1862) *Environs of Milan, Italy*, presum-
ably painted only a few years later than the Peale—at least
1828 is the date painted upon a *trompe l'oeil* catalogue that
covers part of a "painted painting" underneath (supposedly
by Salvator Rosa). The catalogue partially hides two figures,
one a kneeling male—recognizable by his extended legs in
pantaloons—the other a reclining woman with upraised hand
and legs exposed up to the thighs. Their activity, however, is
carefully concealed behind the leaflet, which announces an ex-
hibition of Charles Bird King's work. In other words, if you
want to see the "real thing," go to the exhibition (or to the
original by Salvator Rosa).

The Peales's excursions into the subject of the nude were
rare and tentative, and Rembrandt, after his stunning success
with his great moral allegory *The Court of Death* and later
with his "factory" output of Washington portraits, seems to
have returned to it no more.

The two major stimuli for the painting of the nude in
America in the early years of the nineteenth century were the
cosmopolitan teaching and example of Benjamin West and the
example, closer to home, of Wertmüller's *Danaë*. To both of
these, Philadelphia's artists seem to have been particularly re-
ceptive; William Russell Birch (1755–1834), an English art-
ist who settled in Philadelphia, for instance, painted a lovely

3–1. Raphaelle Peale. *After the Bath*. 1823. Oil on canvas. Nelson
Gallery–Atkins Museum, Kansas City, Missouri. Nelson
Fund.

enamel minature *Venus* about this time, which still survives
(*Ill. 3–2*).

Jeremiah Paul (d. 1820), another minor Philadelphia artist
in the circle of the Peale family, exhibited at the offices of the
engraver James Akin in 1811 another exhibition picture
stimulated by, and meant to rival, that of Wertmüller. He
stated specifically that the figures were "taken from living
models." William Dunlap passed it off, as indeed he passed
Paul himself off, very quickly: "Our ladies and gentlemen only
flock *together* to see pictures of naked figures when the subject
is Scriptural and called moral."[6]

When the subject was neither scriptural nor moral, pre-
sumably the reaction to it was mixed. Although William
Rush's sculptural depiction *The Nymph of the Schuylkill* of
about 1809 for Centre Square in Philadelphia is not nude, she
is quite diaphanously draped. An engaging painting by the
early genre painter John Lewis Krimmel (1789–1821) shows
crowds milling around the statue in front of the new Water-
works Building (*Ill. 3–3*). A little boy stares open-mouthed at
the nymph and is rebuked by his father, presumably for look-
ing at the somewhat immodestly draped figure. Meanwhile, the
boy's mother turns to take an oblique view of the figure's
contours, while her husband is otherwise engaged. The paint-

3–2. William Russell Birch. *Venus.* n.d. Enamel. Courtesy of the Pennsylvania Academy of the Fine Arts, Philadelphia.

ing is, in fact, an exploration of the diverse reactions to the public appearance of a piece of seminude statuary, with all the excitement, contrast, and liveliness that Krimmel could successfully muster.

Nudity and impurity were thought of in the nineteenth-century Anglo-Saxon world as Latin and, particularly, French; and, indeed, it was not English art that stimulated the painting of Paul's naked figure, but Wertmüller, while Rembrandt Peale's French artistic training can be held accountable for his excursions into nudity. Perhaps one should expect that the spiciest artistic experience along these lines ever recorded in nineteenth-century America occurred in the French culture of New Orleans. In his 1822 Journal[7] John James Audubon noted that in the previous year, he had been accosted on the street by a woman with a lovely body but veiled face, who mysteriously invited him to come to her apartment in half an hour.

She inquired of Audubon, "Have you ever drawn a full figure?"

"Yes."

"Naked?"

"Yes."

"I want you to draw my likeness and the whole of my form *naked,* but as I think you cannot work now, leave your Port Folio and return in one hour. Be silent." She made him promise never to reveal her name.

When Audubon returned, the woman went behind a curtain and disrobed. He recorded that "[when I] drew the curtain and saw this beauty, I dropped my black lead pencil." For ten days Audubon returned to her apartment to draw her picture, for about an hour each day, and little additions were made to the portrait by the lady herself. On the last visit, she put her own name at the foot of the drawing and Audubon's in a shaded area of drapery. She rewarded him with a beautiful gun and $125 for his work. Unfortunately, the picture has disappeared. It would be the only certain example of a nude American portrait from life that we know from the period.

It is also not surprising that the most famous foreign nudes imported for exhibition in the early part of the century were French; they were the two biblical canvases *The Temptation* and *The Expulsion* by Claude Marie Dubufe, originally painted for Charles X of France, just before he was deposed in 1830.[8] These paintings traveled from city to city in America, beginning their historic tour in 1832 in Boston, continuing on to New York, Philadelphia, Baltimore, Charleston, Augusta, and Savannah, and returning to Baltimore and Boston before being sent to New Orleans, where they were shown early in 1835. The original pictures, however, were destroyed by fire, but in 1857 Dubufe redid them, and they were shown again in New York City in 1860. Engravings of these versions exist, by Henry Thomas Ryall (*Ills. 3–4 and 3–5*).

The two pictures were pious and moral in subject, but the figures in them were naked, and they became a *cause célèbre* for proto-Comstockians and liberal-minded art lovers. The pictures were denounced by the cantankerous and aged John Trumbull, and a writer in the *New York Mirror,* calling himself "True Modesty," said, "indecency, beautiful though it may be, is indecency still."

William Dunlap, however, referred to the paintings as "very beautiful," and Benjamin Sill wrote in his diary in March, 1833, "I saw also Dubufe's splendid pictures of *The Temptation of Adam & Eve* and of *The Expulsion from Eden*—both admirable productions—beautifully drawn & colour'd with great chastity & finish—they are the best productions of the French School that I have seen."

In a letter to the Baltimore art patron Robert Gilmor of April 9, 1833, the portrait painter Henry Inman expressed the more liberal sentiments prevailing among the artists:

The Arts here are in great vogue, at present. —Two Thousand Dollars were recd. in one week by the exhibition of the "Adam and Eve" paintings, of which you must have heard, and they well deserve such attentions. You will share in my gratification, when I inform you that these productions have achieved a great victory over that certain squeamish factiousness, which formerly gov-

erned our ladies—Crowds of both sexes sit together for hours gazing upon these very nude figures with delight.[9]

On the whole, biblical subjects provided a safer environment for the nude than did classical subjects, whose heathen origins were always suspect. Thomas Cole (1801–48), the celebrated landscapist, painted a number of works with religious themes, and two of them involve the nude. These pictures were painted not in America but in the more congenial atmosphere of Italy. The *Dead Abel,* depicting the slain, partially nude young son of Adam and Eve, is a completed study—relating to a project that Cole conceived of in Florence in the winter of 1831–32, then abandoned—for a large painting of *Adam and Eve Finding the Body of Abel.* Cole did bring to completion, however, in 1834, an *Angel Appearing to the Shepherds,* in which the figures of the shepherds, rather minuscule within their landscape setting, are all only partially clothed. But Cole's original studies of these figures, which also survive, include one of a prostrate shepherd completely nude (*Ill. 3–6*). In a letter to John L. Morton, written from Florence on January 31, 1831, Cole said:

I am also painting a scripture subject, the Angel appearing to the Shepherds. I have of late been much engaged

3–3. John Lewis Krimmel. *Fourth of July in Center Square.* Ca. 1810–12. Oil on canvas. Courtesy of the Pennsylvania Academy of the Fine Arts, Philadelphia. Paul Beck Collection, 1845.

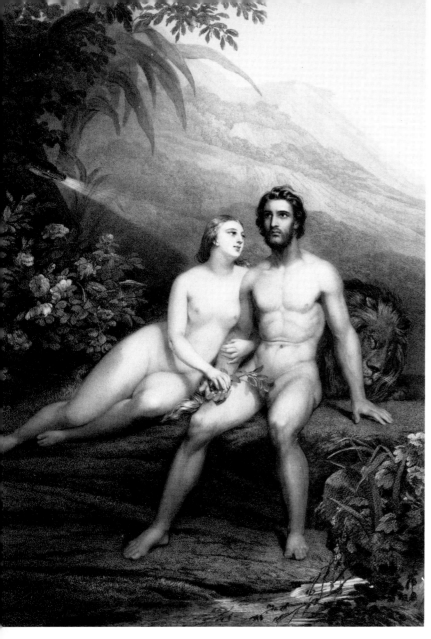

3-4. Henry Thomas Ryall, after Claude Marie Dubufe. *The Temptation*. 1860. Engraving. The British Museum, London.

3-5. Henry Thomas Ryall, after Claude Marie Dubufe. *The Expulsion*. 1860. Engraving. The British Museum, London.

with the study of the Nude, the facilities for which are greater here than I can expect to find elsewhere, and I am wishful to take advantage of the opportunity.[10]

Thus, even a landscape specialist concerned only with the correct depiction of ideal figures contained within a setting availed himself of the opportunity while abroad to study the human figure, in the hope of achieving both correct anatomy and suitable expressiveness. The expressive possibilities of the human body were certainly of concern to Cole in this painting, for the three shepherds are careful, contrasting representations of different stages of emotional reaction to the announcement of the angel.

The only other known painting by Cole featuring a nude figure involves a classical theme that intrigued a number of

the more romantic American artists during the nineteenth century, including Washington Allston, William Rimmer, and William Page. Cole's *Prometheus Bound* is a late canvas of 1846–47, one of the last works executed before his death (*Ill. 3–7*). Never more clearly a landscape painter, Cole dwarfs his nude Prometheus, chained to the cliffs, by the immensity of the jagged, hostile mountains. Cole's pupil Frederic Church, in fact, wrote much later in great admiration of the landscape and stated that he would prefer to see it without the figure. Cole's heirs apparently agreed with Church, for the figure was painted out until recently. It is interesting to note that, to increase the acceptability of his interpretation, Cole deliberately posed the figure of the chained Prometheus as he might have posed a crucified Christ.[11]

Prometheus was a natural subject for the romantic era. He

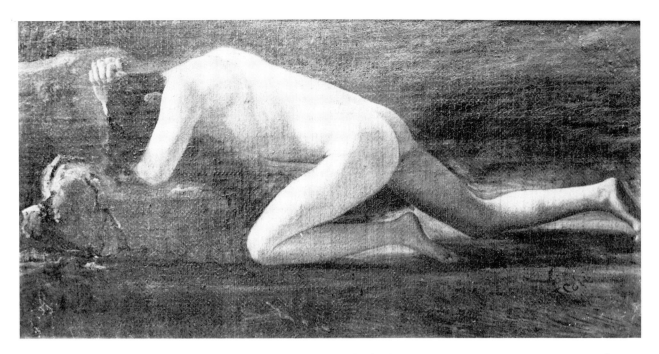

3–6. Thomas Cole. Study for *The Angel Appearing to the Shepherds*. 1831–32. Oil on canvas. Collection of Mrs. Charles Dare Story.

3–7. Thomas Cole. *Prometheus Bound*. 1846–47. Oil on canvas. Collection of Mr. and Mrs. John W. Merriam.

LEFT

3–8. Asher B. Durand. *Musidora*. 1825. Engraving. The Metropolitan Museum of Art, New York. Gift of Mrs. F. F. Durand, 1930.

BELOW

3–9. Washington Allston. *Study of a Seated Female Nude*. 1804–8. Chalk. Fogg Art Museum, Harvard University, Cambridge, Massachusetts. On loan from the Washington Allston Trust.

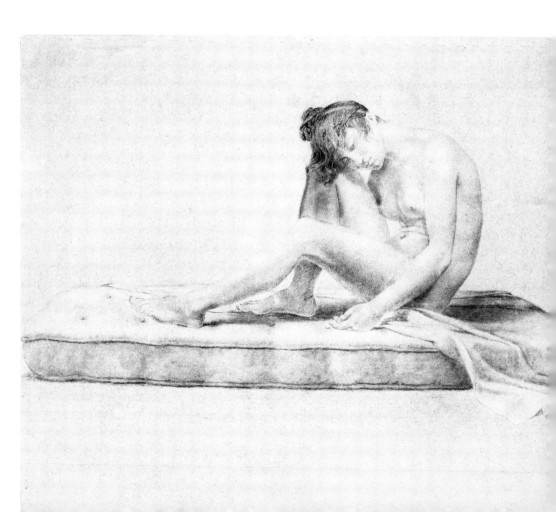

was treated in James Russell Lowell's poem, in Shelley's drama, and in Elizabeth Browning's translation from Aeschylus. As a figure who stood for the hopeless but heroic defiance of man against the gods (Jupiter is present here, symbolized as an eagle and as the Morning Star), Prometheus stood counterposed in classical legend to Pandora, who brought ills to man. Christian themes of redemption and sin could certainly be deduced here. At the same time, the Promethean story allowed the artist to introduce the heroic nude "naturally," while meaningfully representing defiant heroism.

If classical subjects were dangerous and biblical subjects relatively safe for early nineteenth-century artists bent on portraying the nude, literary subjects fell somewhere in between. The most popular authors in America, Washington Irving and James Fenimore Cooper, and the English Sir Walter Scott did not really offer suitable material. James Thompson's *The Seasons,* however, provided a popular theme in the form of Musidora, the subject not only of Thomas Sully's brush but of other American interpretations as well. In the poem, Musidora's young lover, Damon, comes upon her in the forest:

> For, lo! conducted by the laughing doves.
> This cool retreat his Musidora sought,
> Warm in her cheek the sultry season glowed,
> And rob'd in loose array, she came to bathe
> Her fervent limbs in the refreshing stream.

Thompson presents us, in his poem, with an extremely lovely idyllic occurrence, and Sully's *Musidora* is probably the most beautiful picture of a nude painted in America in the early nineteenth century (*Colorplate 6*). Sully (1783–1872) was the most famous and successful portrait painter in Philadelphia, the successor to Charles Willson Peale. His "fancy" pictures have never been studied nor given their due, and they comprise only a small fraction of his *oeuvre.* Sully's artistic orientation, unlike Rembrandt Peale's, was wholly English, and he was called, for good reason, "The American Lawrence." William Dunlap records that "the pictures of Titian did not afford him [Sully] great pleasure until Sir Wm. Beechey directed his attention to the *Ariadne.* . . ."[12] Sully's register of his paintings records a picture painted in 1813 called *Musidora,* after a copy by Charles Robert Leslie after Benjamin West; the Leslie itself was exhibited at the Pennsylvania Academy that year as *Venus Bathing: Musidora.* At the same time, Sully began a second *Musidora,* which was not completed until 1835. The picture is a beautiful study of the female nude, presented in a secluded landscape with tree trunks, rocks, and a pool. The glowing light, the smooth and sinuous form, the sleek brushwork are all typical of Sully at his best. Musidora turns away from the spectator shyly, and her seclusion is emphasized by the intimacy of her natural setting.

Sully appears to have painted a number of other nude and partially nude figures; some were copies, such as his *Danaë* of 1811, after Titian, and *Venus,* copied from Sir Joshua Reynolds, in 1865. Others were original compositions—several paintings of Venus, one executed in 1807, and a *Venus and Cupid* done in 1816. The *Musidora* seems to have inspired a number of "women and water" themes, including three pictures of mermaids, painted in 1836, 1859, and 1862, and a *Girls Bathing* of 1869, which may have been similar to one by Jerome Thompson (*see Ill. 4–9*). Sully also copied the bust from John Vanderlyn's *Ariadne* (*see Frontispiece*) in 1825–26, and much later, in 1861, he painted his own version of the subject.

In the late 1810s and the 1820s, before he turned to oil painting, Asher B. Durand (1796–1886) was probably the finest engraver in America. After establishing his preeminence in the field with his *Declaration of Independence* of 1823, after Trumbull, Durand designed and engraved a *Musidora* in 1825 (*Ill. 3–8*), a print of which was exhibited that year at the American Academy in New York City. As in Sully's painting, Durand's Musidora is posed in a deeply wooded and secluded glen, though she turns, heavy hipped and heavy breasted, toward the spectator. She has neither the grace nor the satiny smoothness of Sully's treatment or of Durand's own later engraving after John Vanderlyn's *Ariadne,* done in 1835. Yet, despite a pose rendered artificial by a dependence upon an engraving by Bartolomeo Cavaceppi after an antique *Venus,* Durand's *Musidora* is an original composition. The landscape shares equally in Durand's interest, and the engraving hints at the artist's future concern with landscape rather than figural compositions.

Washington Allston (1779–1843), who was America's finest historical painter, was, oddly enough, not an artist much concerned with the nude. Some partially draped figures can be found in several of his dramatic figural and landscape canvases, and the title figure in his great depiction *The Dead Man Revived by Touching the Bones of the Prophet Elisha* of 1811–13 reveals a powerful and heroic torso, which both suggests Allston's cogent understanding of the Old Masters and also makes him one of the most powerful figure artists of the early part of the century.

Allston's treatment of the nude is best expressed in the many finished figure drawings that survive (*Ills. 3–9 and 3–10*). In them there is a precision of form and modeling, a sense of weight, that allies Allston's style to the European neoclassic tradition. In their heaviness, the drawings are even closer to the German than the French artists of the early nineteenth century, many of whom became Allston's friends during his early years in Rome.

Allston's pupil Samuel F. B. Morse (1791–1872), on the other hand, was to achieve his greatest critical acclaim for two studies of the nude. In London with Allston in 1811, Morse conceived of a great painting of Hercules as an original composition, having earlier made a careful drawing from a cast of the muscular Farnese *Hercules.* With this in mind, he not only began work upon a large canvas but also, echoing the sound technique of his teacher, made a small model of his

figure in clay (*Ills. 3–11 and 3–12*). Unlike the classical statue, Morse's figure is not standing and immobile but is shown in his death throes, struggling against the poisoned shirt of Nessus. While the subject and the muscularity of Morse's painted and sculptured renditions may derive from the Farnese warrior, the pose and the conception are more closely related to the *Laocoön.*

The painting was exhibited at the Royal Academy where, among the approximately 2,000 pictures, Morse's was chosen by critics as one of the finest, while the sculpture, shown at the Society of Arts, won for the young American a gold medal, all the more surprising and spectacular because, as Dunlap reminds us, the two nations, Great Britain and the United States, were then at war.

While some may criticize the schematization of the muscular torso, or the rather heavy brown coloration of the painted *Hercules,* the picture and the sculpture are among the most powerful interpretations of the nude in American art before the late nineteenth century. Like Allston's *Dead Man Revived,* though without its refinement, they *are* "interpretations"; both artists expressively utilize the human form for the display of power, one figure called to life, one subsiding into death.

Both Morse's *Hercules* and Sully's *Musidora* are overshadowed in the annals of American art by John Vanderlyn's *Ariadne,* the most famous pre–Civil War treatment of the nude (*Frontispiece*). Of all the American painters of the early part of the nineteenth century, Vanderlyn (1775–1852) was best trained. Not only did he study in Europe, after having been apprenticed to the English-oriented Gilbert Stuart, but his training in Paris was under Francois-André Vincent, the noted French neoclassicist. He was a history painter, by inclination, talent, and reputation. But it is ironical that, although Vanderlyn is known today for his thematic works in the grand manner, they constitute a bare handful of pictures in an *oeuvre* composed primarily of portraits. Although these history paintings are his most significant achievement, they underscore the lack of receptivity to such pictures on the American shores. They bear witness to Vanderlyn's career of frustration, despair, neglect, and poverty.[13]

Vanderlyn in Paris, like Morse in London, found acceptance and success with such historical paintings as his *Death of Jane McCrea (see Ill. 1–4)* and *Marius on the Ruins of Carthage* of 1807, which he exhibited there in 1808. He resolved, therefore, to create a companion canvas to the *Marius*—the relationship being one of imagery rather than of size or shape. *Marius* was masculine and powerful; Vanderlyn made his *Ariadne Asleep on the Island of Naxos* the epitome of feminine loveliness. As he wrote to Allston in 1809, he was painting "something in the female to make it more engaging to the American spirit."[14]

The sources for the *Ariadne* are many. In Vanderlyn's own *oeuvre* one must consider the copies he made in Paris at the Louvre. The finest of these was the *Antiope* of 1809 (*Ill. 3–13*), after Correggio's famous painting, and it is a testi-

3–10. Washington Allston. Study for *Jason Returning to Demand the Father's Kingdom.* n.d. Pencil. Fogg Art Museum, Harvard University, Cambridge, Massachusetts. On loan from the Washington Allston Trust.

OPPOSITE
Colorplate 5. Rembrandt Peale. *The Roman Daughter.* 1811. Oil on canvas. Private collection. Photograph courtesy of The Peale Museum, Baltimore, Maryland.

monial to Vanderlyn's ability to copy the work of the European masters. Vanderlyn went on immediately to his own original conception, and the *Antiope* can be said to have inspired the *Ariadne* in more than general mood. The poses are extremely similar, and the heads of the two figures are almost duplicates, both in facial type and in pose. Furthermore, as Kenneth C. Lindsay has pointed out, both pictures depict innocent femininity betrayed by male perfidy, in a forest setting.

Art historians have noted similarities between the *Ariadne* and the great *Sleeping Venus* by Giorgione in Dresden. There is, of course, a strong similarity of pose and formal arrangement but, beyond the question of whether or not Vanderlyn might have known this work of Giorgione's, is the fact that the soft, luminescent Venetian lighting is worlds apart from the strongly studio-lit and solidly, though gracefully, modeled neoclassic form of Vanderlyn's *Ariadne*. One might make a far better comparison of the *Ariadne* with Anne-Louis Girodet-Trioson's famous *Endymion,* of 1797. From Vanderlyn's own correspondence we know that he had a high respect for Girodet, and the languid pose and dreamlike forest environment of the French picture are extremely similar to Vanderlyn's despite the difference in gender—a minor difference in this case, considering the soft and somewhat effeminate character of Girodet's figure. Strangely, Vanderlyn's work is even more neoclassic than Girodet's, for he has avoided the up-ended and foreshortened pose of *Antiope* and *Endymion* and chosen rather to place Ariadne in a shallow stage space parallel to the picture plane.

PAGE 54

Colorplate 6. Thomas Sully. *Musidora.* 1835. Oil on wood. The Metropolitan Museum of Art, New York. Gift of Louis Aliston Gillet, in memory of his uncles, Sulley Gillet and Lorenzo M. Gillet, 1921.

PAGE 55

3-11. Samuel F. B. Morse. *The Dying Hercules.* 1812–13. Oil on canvas. Yale University Art Gallery, New Haven, Connecticut. Gift of the artist.

3-12. Samuel F. B. Morse. *The Dying Hercules.* 1812. Terra-cotta cast of preparatory sculpture. Yale University Art Gallery, New Haven, Connecticut. Gift of Rev. E. Goodrich Smith.

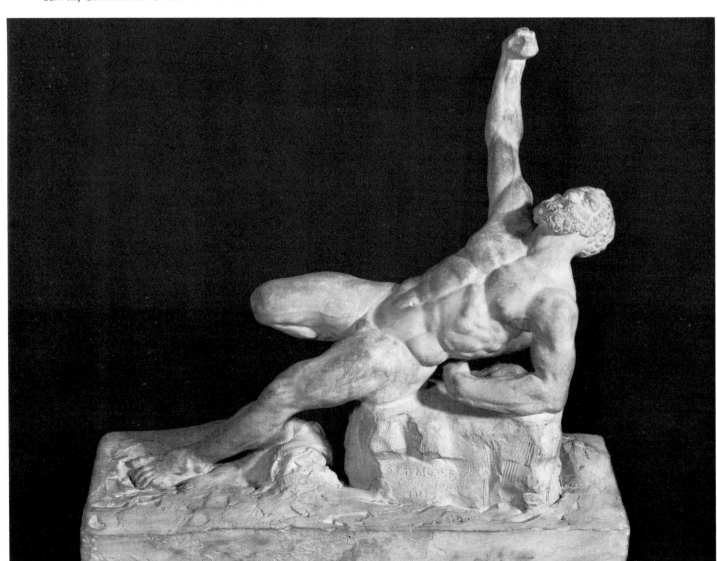

As such, *Ariadne* is part of contemporary European history painting. Another comparison can be made with the beautiful *Sleeping Nymph* by John Hoppner, exhibited at the Royal Academy in 1806 and first engraved in 1808 (*Ill. 3–14*). Again, Vanderlyn's *Ariadne* is more sculptural, in a French fashion, than the rather fluid English painting. Perhaps, too, considering his predilection for the French, Vanderlyn was inspired by the *Antiope* by Benigne Gagneraux, which he could easily have seen in Rome, in the vault of one of the upper rooms of the Palazzo Borghese. Vanderlyn also had recourse to the live model, however, as the several beautiful charcoal drawings of details of the figure attest (*Ill. 3–15*).

There has been a good deal of confusion about the date of the painting. The picture appears to bear the date of 1814, but it was exhibited at the Paris Salon in 1810 and 1812, and Vanderlyn's own correspondence states that he was finishing the work in 1811. With an accumulation of pictures, both original works and copies after the Old Masters, Vanderlyn returned to America in 1815 with eager expectations of critical and financial success. But in this he was doomed to disappointment. America was not receptive to the elevated taste of Europe, and French neoclassicism was condemned as both cold and vulgar, while the *Ariadne* particularly had to face the charge of immorality. Vanderlyn's return occurred at a singularly unpropitious time, since conservative ire had already been aroused by the wantonness of Wertmüller's *Danaë* and Peale's *Dream of Love*. Dunlap admired the *Ariadne,* excepting the work from his general proscription against nudes, and later such critics as Tuckerman recognized her virtues, but Vanderlyn's own contemporaries were often scandalized.

The *Ariadne,* along with the *Marius* and the other works, was exhibited in the New York City Rotunda, which was built in 1818 to house Vanderlyn's *Panorama of Versailles,* but the exhibition was ultimately a failure. The work was also shown on tour in such cities as Washington and Philadelphia, and even as far away as Havana, Cuba, in 1828, where, however, Vanderlyn ran into difficulty with the customs because of the nudity of Ariadne. In Charleston, the *Courier* described Ariadne's features as "subjects of eager attraction and awakening interest," to Southern connoisseurs, and in Baltimore, Rembrandt Peale removed his wax figure and *Dream of Love* to present Vanderlyn's *Ariadne* to the public.

There are a number of other versions of the *Ariadne* by Vanderlyn, including a newly discovered one, in Philadelphia. In 1825–26, Vanderlyn painted a version for Colonel James A. Stevens of Hoboken, for the salon of his steamboat, the *Albany,* which was decorated with works of art by a dozen major American painters (*Ill. 3–16*). It is noteworthy, however, that in this American version, Vanderlyn felt the necessity of clothing Ariadne with a semitransparent drapery. In a still later version of 1837, a half-length *Ariadne,* Vanderlyn moved the lady into a bedroom, covered her with sheets, though carefully still revealing her breasts, and added a coy and insipid Cupid, underlining the element of sensual love and at the same time pandering to a growing sentimental taste (*Ill. 3–18*).

In 1829–30, Vanderlyn was engaged in copying his original *Ariadne* on a smaller scale; a letter from Joseph Coolidge of January 8, 1830, mentions that Vanderlyn would not sell his large *Ariadne* for less than $1,000, but would part with the new one for $300. The smaller version may be the work ascribed to Asher B. Durand, and certainly it was completed by him. In 1831, Vanderlyn sold Durand the original *Ariadne* for $600, and the small replica, unfinished, for $50. The small version was the basis for Durand's engraving of *Ariadne* (*Ill. 3–17*)—the painting and the engraving are almost of identical size. It was Durand's final excursion into the graphics field, and not only is it his most beautiful and sensitive print, but it is also recognized by many as the finest example of American engraving of the period. John Durand, biographer

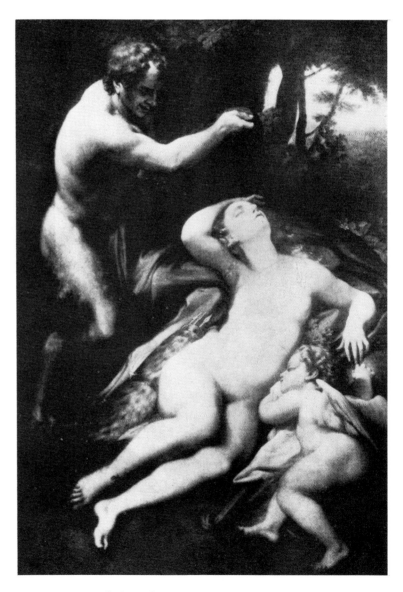

3–13. John Vanderlyn, after Correggio. *Antiope.* 1809. Oil on canvas. The Century Association, New York.

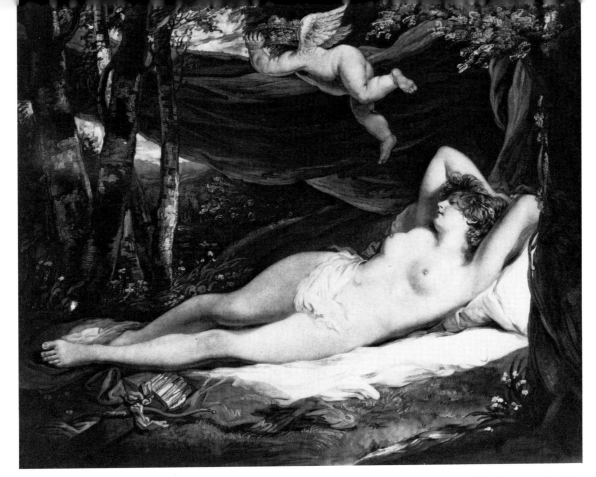

3-14. R. J. H. Doney, after John Hoppner. *Sleeping Nymph*. 1824 (original oil exhibited in 1806). Engraving. Photograph courtesy The British Museum, London.

3-15. John Vanderlyn. Study for *Ariadne*. Ca. 1809–12. Charcoal and chalk. IBM Corporation.

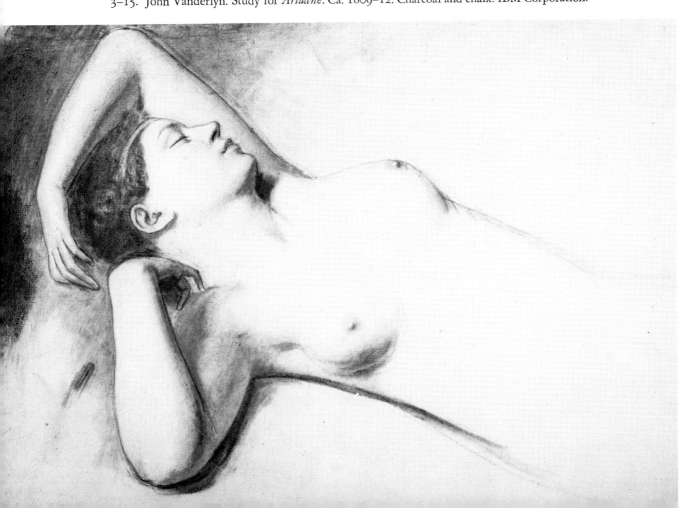

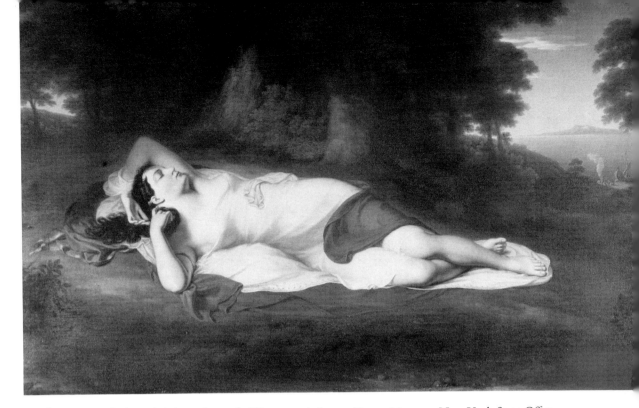

3-16. John Vanderlyn. *Ariadne.* 1825–26. Oil on panel. Senate House Museum, New York State Office of Parks and Recreation, Division for Historic Preservation, Kingston, New York.

3-17. Asher B. Durand, after Vanderlyn. *Ariadne.* Ca. 1835. Engraving. The Metropolitan Museum of Art, New York. Harris Brisbane Dick Fund, 1927.

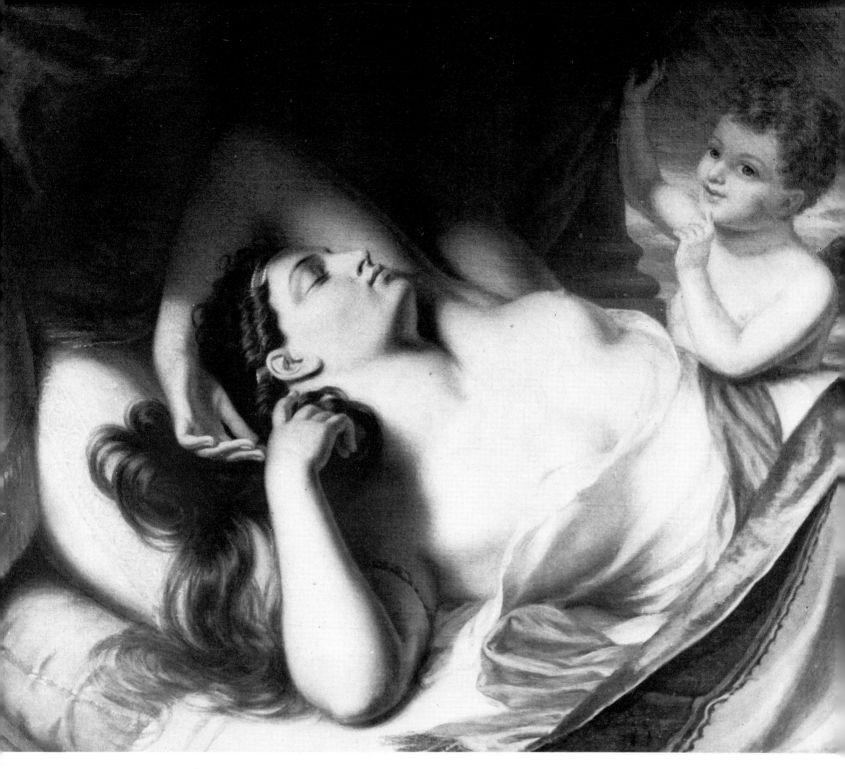

3-18. John Vanderlyn. *Ariadne*. 1837. Oil on canvas. Neville Public Museum, Green Bay, Wisconsin.

OPPOSITE

3-19. John Vanderlyn, after Raphael. *The Calumny of Apelles*. n.d. Monochrome in oil on canvas. The Metropolitan Museum of Art, New York. Gift of the family of General H. Sharpe, 1924.

of his father, maintained that the print was made for the love of art and that it was a commercial failure. The engraving was made in 1835 or 1836; John Durand stated that half of the impressions had to be destroyed because of imperfections, and that the rest remained, for the most part, unsold.[15]

Vanderlyn's Rotunda Gallery was such a failure that his unpaid lease on the property was taken back by the city of New York after ten years. The artist's attempt at gaining an important historical commission from the government was frustrated by rivalry with John Trumbull, and ill-feeling between the two artists further embittered Vanderlyn; it undoubtedly was detrimental to him in other ways, too, since Trumbull was a powerful and influential figure. Gradually, Vanderlyn's hopes of establishing himself as the great history painter of America vanished, and most of his major works remained unsold, or sold for very small sums. With the exception of the Capitol Rotunda picture *The Landing of Columbus* (1839–46), a commission that came too late to revive Vanderlyn's spirits or reputation, his later career was given over to increasingly pedestrian portraits, hack and sentimentalized replicas of his earlier works, and further copies from the Old Masters. In 1843–44 he painted another truncated copy of the Correggio *Antiope,* not dissimilar from the late, also truncated, *Ariadne.* He also painted, late in his career, an undated *Calumny of Apelles* (Ill. 3–19), an oil painting after a bister drawing by Raphael, based upon the ancient author Lucian, relating allegorically Antiphilus's slanderous remarks against the Greek painter Apelles. The figures include Slander, dragging the innocent, protesting and praying Apelles, along with figures of Ignorance, Suspicion, Envy, Treachery, and Deceit; at the left, in a bright glow, is the figure of Truth, naked, thus revealing that she had "nothing to hide." It has been suggested that Vanderlyn painted it at the same time he was working on his Rotunda commission, that it refers to accusations made at the time that his *Columbus* was actually being painted by French artists, and that Vanderlyn was likening himself in this allegory to the maligned Apelles of antiquity. Ironically, if consistently, the *Calumny of Apelles* also went unsold. The drawing and modeling of the figures, as well as the general spirit and expression of the work, are disheartening testimony to Vanderlyn's diminishing powers, and the figure of the nude Truth is a sorry descendant of his beautiful Ariadne.

After a drawing in bister by Raphael composed from the discription given by Lucien of a picture painted by Apelles, representing Calumny, on the occasion of a false accusation brought against the painter Apelles.

4

Painted Nudes at Mid-Century

THE SPIRIT OF AMERICAN ART from the 1840s until immediately after the Civil War is quite distinct from that of the preceding decades of the century. The differences are numerous and may be related to political developments—a shift toward a populism best expressed in the ascendancy of Andrew Jackson to the Presidency.

In the arts this populism took on several facets. The aristocratic idealization of the portraiture of Inman and Sully gave way to a hard-bitten realism as exemplified by the mature works of Charles Loring Elliott. The general artistic and cultural heritage from England was decried as outmoded; critics cautioned painters against the easy acceptance of European influences. In subject matter, too, artists were advised to seek their themes at home. Landscape painters were asked to appreciate the superior beauty of the American scene, and genre painters were eager to present their public with vignettes of everyday American life—of self-reliant newsboys and Yankee peddlers.

There was, in fact, a shift in emphasis from portraiture to subjects of more general interest as the arts became more popular—a trend greatly abetted by the success of the popular art unions, which brought both original paintings and engravings of them into tens of thousands of American homes. William Sidney Mount, whose work in the 1830s was admired for technique but condemned for its "vulgarity" and lack of idealism, became recognized in the 1840s as America's finest

artist for the same reasons—that his work was unalloyed "truth to nature" and totally American, untainted as it was by European training and representing the most native American virtues, which were to be found in rural America and not in the urban centers, where European corruption already had made inroads.

One would expect this nativism to have rendered difficult any presentation of the nude. Yet this was not the case. Certainly, the subject did not become widely popular at mid-century; yet it did find increasingly wide areas of popular expression.

One area of the arts on view to the general public was that of banknote and certificate engravings (*Ill. 4–1*). Such bills and documents were often decorated with virtuous allegories, and the ladies were often presented at least half-naked. They were, of course, small upon the printed sheet; they were also exceedingly generalized; their forms and poses were usually taken from Old Master sources. The use of an occasional nude figure within a grand-manner allegorical conception can be found in such ambitious works as the tinted drawing presently in the New York Public Library *Science Unveiling the Beauties of Nature to the Genius of America* by the Philadelphia-based artist John James Barralet (*ca.* 1747–1815). Barralet was trained in England and Ireland and brought an elaborate iconographic tradition to America, which he popularized through commemorative engravings. It was their appeal to American

nationalism that undoubtedly made acceptable his introduction of a multibreasted seminude personification of Nature into the 1814 drawing; still this tribute to the antique *Diana* of Ephesus seems to have been unique in early American art.

Another popular source that offered an occasional nude in the mid-century was the lithographs of Currier & Ives.[1] Nude subjects by this firm are rare, but they exist, though usually with some apologia in the form of an acceptable subject or title. These prints all seem to have been made at the time when Nathaniel Currier (1813–88) went into business on his own in New York City in 1835, before James M. Ives (1824–95), previously a bookkeeper with the firm, joined the partnership in 1857. Probably the most famous subject is the *Queen of the Amazons Attacked by a Lion* (*Ill. 4–2*), a strange translation of Delacroix and Rubens into the American graphic vernacular and bearing coincidental comparison with the early Le Moyne de Morgues Indian subject depicted here (*see Colorplate 1*). While the emphasis in the print is ostensibly on the savage attack of the lion upon the horse of the Amazon chieftain and the strenuous efforts to repel the beast by her legions, the subject allowed Currier to offer a partial display of the nude in a variety of poses. More idyllic and intimate, and more frankly emphasizing the sensual female charms, is *After the Bath,* which displays much of what Raphaelle Peale had earlier kept hidden (*Ill. 4–3*).

Still another area for the popular presentation of the nude, this time in oil painting, was the decoration of urban fire engines.[2] Each engine was distinguished by its painting, and sometimes even such well-known artists as John Quidor would undertake such decorative tasks. Here the nude would sometimes figure, more frankly sensual than similar presentations

on banknotes. The portrait painter George W. Hoffman (*ca.* 1823– after 1887) probably painted a rather voluptuous *Venus* for a fire engine about 1848, while a more dramatic and romantic subject was depicted by Albert P. Moriarty (w. 1847–56) in his *Mazeppa* for a hose carriage of about 1850 (*Ill. 4–4*). The nude Mazeppa was also the subject of a series of Currier lithographs.

Probably the finest painter of this popular art form was John Archibald Woodside (1781–1854), who also created easel paintings. He was a painter from Philadelphia, and his signs were much admired by William Dunlap. A good many ornamental panels decorating the sides of fire engines by him have survived, such as the *Birth of Venus* and particularly the *Translation of Psyche,* which features a relatively voluptuous nude beauty taken up to the immortals of Olympus. This was about as close as one could come in public art of the period to sensual figure painting. Both these panels, painted in 1849, decorated the Americus Company Engine Number 6, of New York City.

If prudish restrictions still held sway over the work of America's professional artists, it is small wonder that the folk, primitive, or naïve painter—the talented but usually self-taught artist working in small rural communities where religion was the mainstay of individual and community life—undertook the subject even less often. One of the most fascinating examples is *Hercules Between Vice and Virtue* (*Ill. 4–5*), where a near-nude Hercules bends toward a sad-faced Virtue, while a nude infant Cupid, conveniently wielding a branch that covers Hercules's mid-section, leads forth an eager but decorous Vice. Windswept drapery reveals a bit more of the figure of Vice than of Virtue, but it is the male figures, not

OPPOSITE

4-1. Rawdon, Wright, Hatch, and Edson. $100 American banknote. Ca. 1847–58. Engraving. Prints Division, The New York Public Library. Astor, Lenox, and Tilden Foundations.

ABOVE

4-2. Nathaniel Currier. *Queen of the Amazons Attacked by a Lion.* 1835. Lithograph. Photograph courtesy Paul Magriel.

the female ones, that are allowed to be nude, and these, of course, are so stiff, unmodeled, and generalized as to be devoid of any sensual implications. The theme itself is an attack upon all aspects of sin, including the sensual, rather than an excuse for it.

Probably the most famous folk artist to deal with the nude was Erastus Salisbury Field (1805–1900).[3] Field was a prolific portrait painter in the Connecticut Valley, entirely self-taught except for several months spent in the studio of Samuel F. B. Morse. With the advent of photography, Field's portrait trade declined, and the artist turned to allegorical and biblical compositions—including two versions of *The Garden of Eden,* which probably should be examined in the context of the evangelical religious revival of the late 1850s (*Ill. 4–6*).

Field here presents the spacious and fertile garden, filled with animals and with two nude figures of Adam and Eve, both discreetly obscured by lush vegetation. The sense of careful order derives from a happy welding of the pattern and symmetry often implicit in naïve art to the presentation of God's creation. Again, of course, nudity is necessary and emphasizes the state of man before sin, though Eve is picking off several apples and blissful innocence is soon to be lost. As if in anticipation of this, some later hand at one time covered up the figures of Eve and the serpent with overpaint.

Field's conception may be traced generally to a number of sources. His composition relates to a print after Thomas Cole's now lost *The Garden of Eden* and also to *The Temptation* by John Martin, an Englishman whose works, both original paintings and, particularly, the engravings of biblical subjects, were well known in America. Indeed, Martin's engravings were sources for Cole's biblical works. The paired animals in Field's picture are possibly derived from illustrations after the pictures of Jan Brueghel. The sense of "pairing" here, however, has taken on almost obsessive proportions. The animals are presented almost always in twos, reflecting the story of Noah and also emphasizing their sexual nature. The two rivers of Eden, the Tigris and Euphrates, and two mountain ranges appear to the right and left. The rivers feed the vegetation, and the trees, bushes, and plants grow two by two, while Eve, in the center of the painting, is carefully picking off two apples—apples of sin, presumably, one for each gender!

Sophisticated private collections in America, both those consciously conceived of as painting galleries and the more ordinary casual collections on walls in homes, increasingly included nudes by mid-century. Robert Gilmor of Baltimore was one of the first great American art collectors, and among the works he owned were *Nymphs Flagellating a Satyr, Roman Charity,* and *Nymphs Bathing.* Gilmor also owned Horatio Greenough's full-sized *Medora,* depicting the deceased heroine of Byron's poem "The Corsair" in the purity of white marble with the coverings turned down to expose her half-naked form. Even Nathaniel Hawthorne, who in theory did not approve of nudity in modern art, had two pictures of Psyche in his bathroom, one showing the lady about to bathe, the other, about to dress.

Yet, despite her increasing visibility, the nude still met with opposition. One mid-century critic noted the "repugnance every delicate and sensitive mind feels at any exposure of undraped manhood or womanhood." And this writer added a new argument to the condemnation of nudity, pointing out that not only did the ancient Greek have more opportunity to see the nude in his daily experience, but "he knew nothing of the soul—for us who do, there is more of beauty and worth in the face than in the whole man to the Greek." Thus, the expression of Christianity, the finest pictorial achievement possible, dispensed with any need to reveal physical beauty, which was, after all, only a pagan achievement.[4]

For the professional artist, it was increasingly necessary to have the opportunity to draw the nude, not only from casts but from life. Although the new popular theme of genre almost always presented the figure clothed, the variety of poses in which figures were shown was innumerable, and the function and movement of the body had to be understood.

James De Veaux, a Charleston artist who died in Italy tragically young, wrote from Rome on June 7, 1843:

> Drawing the human figure with accuracy is the most important step in our profession, and the rock, I am certain, upon which the English and American schools have split. . . . Beautiful color cannot disguise the misshapen limbs of the full length portraits in our country, and in historical compositions, where figures are varied from the plumb lines of a sober up-and-down portrait, the difficulties increase ten fold.[5]

Gradually, artists were given the opportunity to draw more and more from live models; in fact, the National Academy of Design in New York City opened up its life and antiques schools to ladies in December of 1845. But women who were willing to pose for artists were suspect, and American artists writing home from Europe were often at pains to insist that their models were "poor but honest" hard-working girls of good moral standing. In America, the strictures were even more severe, and the suspicions were also greater. Thomas Le Clear wrote to Asher B. Durand in August of 1849:

> I have known of the difficulty attending your efforts for the last few years in procuring good female figures for the life school. For the last few weeks I have been drawing and painting from a woman whose figure is almost faultless. She is of the loose order, but I judge from the condition in which I find her figure, that she has *trained* herself especially, for this purpose. I can procure her if you wish it, and can assure you she is a person in whom the school can depend.[6]

Seth Eyland, reminiscing about life in New York City in the early 1860s, mentions a woman who approached Thomas Seirs Cummings, the vice-president of the National Academy, stating that she believed art students were all gentlemen and

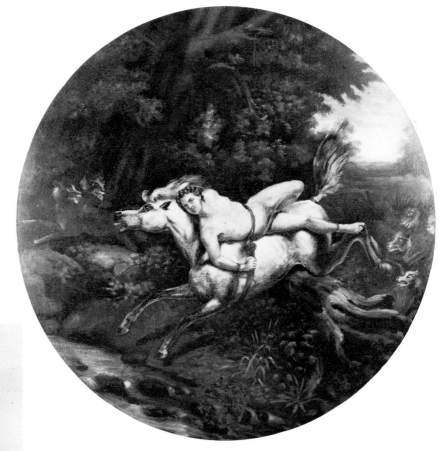

4-4. Albert P. Moriarty. *Mazeppa* panel from Hose Carriage No. 42. Ca. 1850. Oil on wood. Museum of the City of New York. Given in memory of Mrs. Sophie Kohler Eypper by her children.

4-3. Nathaniel Currier. *After the Bath*. 1835. Lithograph. Photograph courtesy Paul Magriel.

4–5. Anonymous artist. *Hercules Between Vice and Virtue*. n.d. Oil on canvas. Courtesy of The Newark Museum, Newark, New Jersey. Collection of Elizabeth Fitzel Riefstahl. Photograph courtesy Paul Magriel.

4–6. Erastus Salisbury Field. *The Garden of Eden*. Ca. 1860–70. Oil on canvas. Courtesy, Museum of Fine Arts, Boston. M. and M. Karolik Collection.

that she proposed to model naked for them, as her husband was an invalid and they needed the money. She set down certain conditions, however. She would appear masked; she would be spoken to by no one except the Vice-President; and she would be allowed to leave 15 minutes earlier than any of the students. However, one student *did* wait for her by a side door, and, the rules having been broken, the female branch of the life school of the Academy was suspended.[7]

A number of attractive representations of the nude by mid-century American painters, both major and forgotten figures, are known today. One still very much in the tradition of Sully and the English school is the *Venus and Cupid* by William Sanford Mason (1824–65).[8] Mason was a Philadelphian and a frequent exhibitor at the Pennsylvania Academy of pictures with classical, genre, and, particularly, literary themes. Many of these are classical and may have been inspired by the *Bacchantes* and *Psyches* by the neoclassic sculptors of the day, or by engravings and even original oil paintings of European origin. His *Venus and Cupid,* for instance, is not only similar to the work of the English romantic school in color and brushwork, but the soft and fluid generalization of the female form suggests a provincial imitation of the work of William Etty (*Ill. 4–7*).

Another painting of the nude that would be of interest but unfortunately has been lost is one by Miner Kilbourne Kellogg (1814–89). Kellogg is probably best known today as Hiram Powers's unhappy agent in the tour of *The Greek Slave* in America, a business venture that ended unsuccessfully financially and with bitter personal recriminations. Kellogg was raised in Cincinnati and lived in Florence. He was a painter both of portraits and of figure pieces, and one of the latter was decried by Tuckerman as "a picture remarkable for its flesh tints, and perhaps objectionable for its nude motive, representing an Eastern beauty reposing after her bath." Kellogg also painted a series of "portraits" of national types, including Circassian, Greek, Jewish, and Moorish—the interest in which might well have been derived from not only *The Greek Slave* but other French neoclassic representations of exotic ladies in distress. A quotation from James Jackson Jarves suggests that the earlier American prejudice against French art, not only for its cold neoclassicism but for its sensuality, was, if anything, reinforced at the mid-century.

It is plain to every observer that modern Art—to wit, the Art of the 19th century—is striving to do without the nude in its compositions; to rely less and less on pure human form as its basis of life and character, and to lay its stress chiefly on clothing and like tangible evidences of our complicated materialized civilization. I do not mean to assert that there is no nakedness in modern Art. On the contrary, a prolific branch of the chief school of Europe, the most advanced in technical power and fertile in invention, bases its popularity largely on prurient nudity, licentious meaning, and seductive corruption; it is as avowedly sensual and lascivious as its companion-art the French Drama. . . .

So long as civilization was mainly confined to the Latin and Greek races, Art had no moral obstacle in its way to using the nude as its supreme manifestation of its loftiest ideas, abstract or otherwise. Hence its most emphatic triumphs, whether under Catholic or classical inspiration, have been wise in the use of the human form as typical of divine attributes. But the tendency of Art in the northern people has been steadily in the opposite direction, relying less on human idealism and more on external nature in its every-day material aspects, until a sturdy, unpoetic realism and the *genre* type of motives have dominated, both in sculpture and painting. . . .

Two causes make him drift in this direction. Northern climates require plentiful clothing, so that the human figure is virtually a lost and unrecognized force and fact as regards its inherent beauty, both in popular knowledge and in Art.

Aesthetic movement and character are now associated with redundant costume. Any transient disclosure of muscle and outline, unless in the license of high life or the stage, is held to be an infringement of sound morals and offensive to the sight. But the most cogent opposition to the nude in Art is born of religious scruples. Since the Restoration everything of this nature has been put under ban because of its connection with an anathematized paganism or papal idolatry. Thus it has been brought about that the purest principles, loftiest ideas, and noblest types of Art, have become associated in the minds of the now dominant Protestant nations with impiety and indelicacy, to the absolute hindrance of the re-development of a pure and beneficial use of the nude in Art, which really has been subtly degraded into the service of the devil, by leaving it to pander to the cravings of disordered imaginations in shapes of absolute sensuality.[9]

Yet, more and more American artists were going to study in Paris by the 1850s, and American reflections of the French academic nude are known. One of the handsomest of these is a picture of 1870 by Dennis Malone Carter (1818/20–81). Carter was an Irish portrait and figure painter who came to America in 1839 and spent most of his life in New York City. His nude is a bathing figure; the heavy rounded form of her body contrasts with her piquant profile and the rugged rocks behind her (*Ill. 4–8*). The irregularity of the tumbling drapery and the sharp geometry of the rocks contrast tellingly with the smooth curvilinear surfaces of the figure. Here the idealism of Sully and Vanderlyn has given way to a more telling realism, for there is an emphasis upon the sag of the body and the heaviness of the buttocks. While the form is still simplified along neoclassical lines, there is something of Courbet in the treatment of the body. The figure is no longer a classical goddess but a directly and realistically portrayed figure. Again, as in

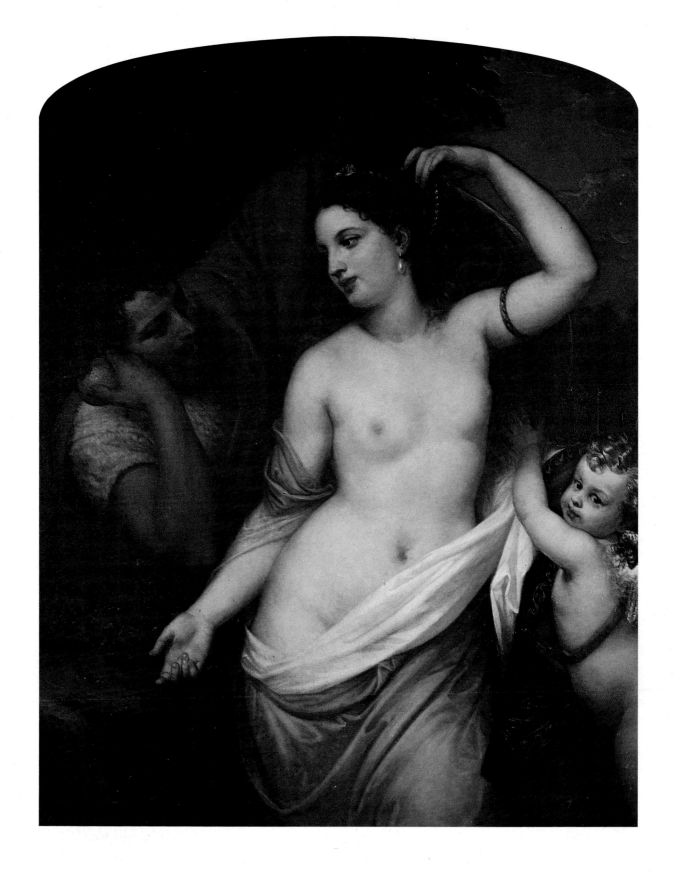

Colorplate 7. Henry Peters Gray. *Judgement of Paris*. 1861. Oil on canvas. In the collection of the Corcoran Gallery of Art, Washington, D.C.

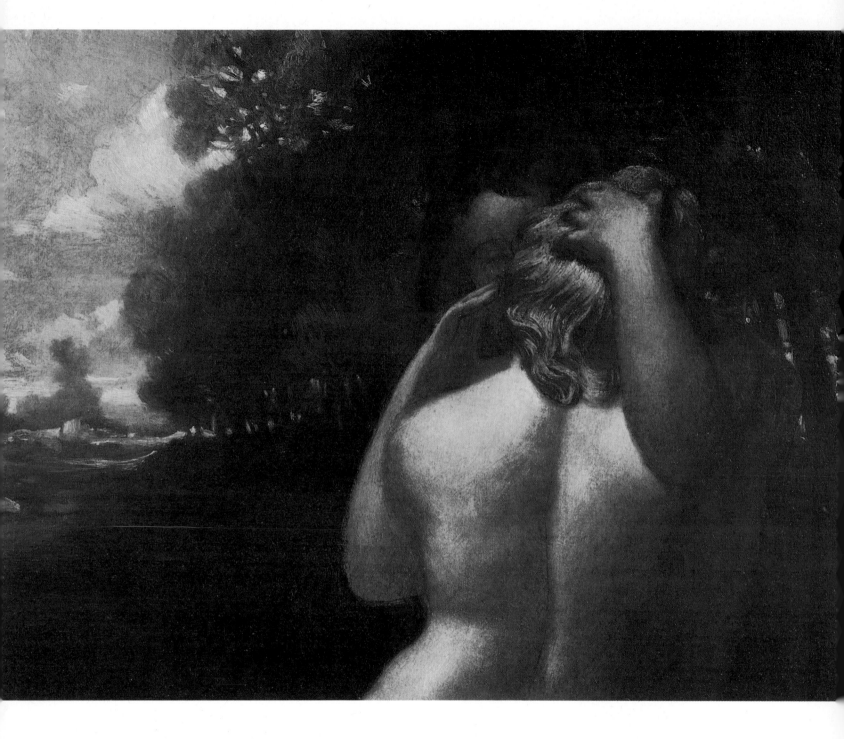

Colorplate 8. William Page. *Cupid and Psyche*. 1843. Oil on canvas. Collection of Mr. and Mrs. John D. Rockefeller, III, New York.

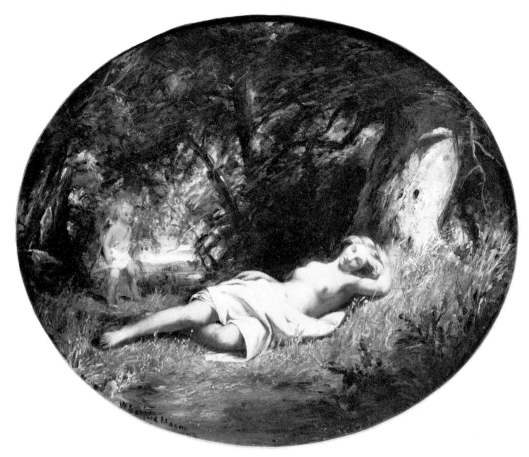

4–7. William Sanford Mason. *Venus and Cupid.* 1856. Oil on chipboard. Courtesy, Museum of Fine Arts, Boston. M. and M. Karolik Collection.

Courbet's work, there is a curious contrast between the academically posed model and the outdoor setting. Instead of choosing a motif taken from antiquity or the Bible, the painter of the nude figure was now turning in the direction of observable reality for his nudes. The bathing figure was an obvious choice—although nudity was not compatible with the voluminous bathing costumes of the times. Thus, the settings were not open beaches but secluded areas of nature, the intimacy of which was congenial to the private presentation of nudity.

Another pair of casually posed nude ladies was depicted by Jerome Thompson (1814–86), in 1867, in setting of high grasses and weeds that shielded them from observers but not from the picture's viewers (*Ill. 4–9*). Thompson studied in England in 1852, and the pre-Raphaelite nature of his picture, with its intense coloration, is attributable to this influence. The interest in outdoor light, too, is probably derived from English sources, and the picture is a study of bright sunlight and transparent shadows. The heads of both women are bent and shaded as the sunlight plays discreetly over their bodies.

The most amazing of all these pictures of bathing ladies by mid-century Americans is the *Bathing Beauties on the Hudson* of 1887 (*Ill. 4–10*), by John O'Brien Inman (1828–96), the son of the far better known portraitist Henry Inman. The younger Inman's years in Europe were spent primarily in Rome and Paris, and the latter city seems to have had a good deal of influence upon him; there are tightly painted, well-characterized costume pieces known by him *à la* Meissonier. Yet, even Paris cannot fully account for the amazing display of female forms upon a rocky coastline in this picture—Courbet-like in subject but academic in style—and we can forgive Inman the rather inane expressions of his figures and the strange proportions of some of his "sirens," considering the daring display of nudity. These cavorting ladies, in all manner of poses and all degree of dress and undress, sport with real abandon. The picture is almost an encyclopedia of the bathing nude. Inman's little picture has an uninhibitedness that really *is* pagan, and the picture must have been the delight of some collector for whom the work was possibly a hidden cabinet treasure.

America's most celebrated historical painter of the mid-century was Emanuel Leutze (1816–68), born in Schwabische Gmünd, Germany. He grew up in America and then went to Düsseldorf. The nude was not an end in itself in Düsseldorf art, probably because of the intense religious spirit derived from the German Nazarenes in Rome, which underlay the founding of the Düsseldorf artistic tradition and the strongly middle-class nature of the themes and the patronage of the painting produced there. Nevertheless, the study of the live

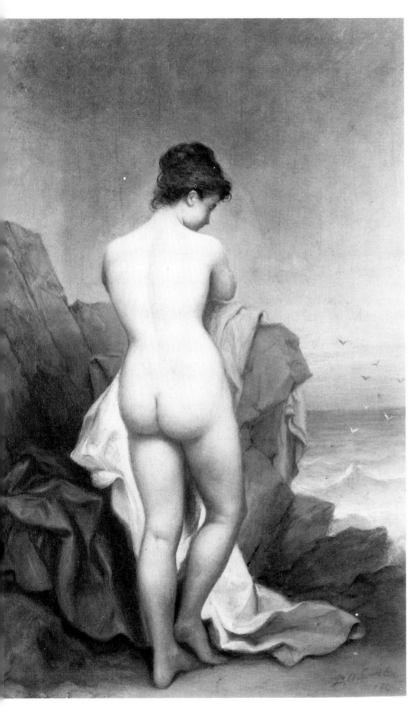

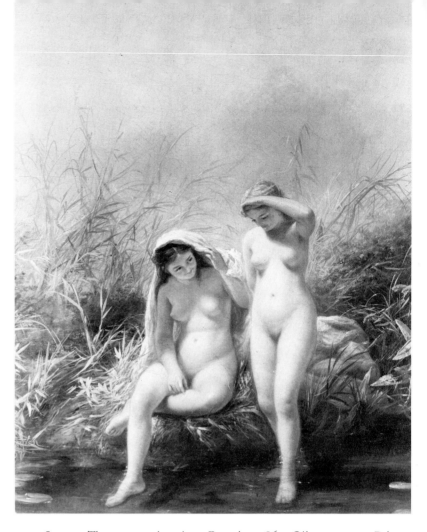

4-9. Jerome Thompson. *American Beauties*. 1867. Oil on canvas. Private collection. Photograph courtesy Paul Mariel.

4-8. Dennis Malone Carter. *Bathing Nude*. 1870. Oil on canvas. Whereabouts unknown. Photograph courtesy Paul Magriel.

BELOW

4–10. John O'Brien Inman. *Bathing Beauties on the Hudson.* 1887. Oil on canvas. Private collection.

FOLLOWING PAGE

4–11. Emanuel Leutze. *Seated Nude.* n.d. Oil on canvas. Whereabouts unknown. Photograph courtesy Paul Magriel.

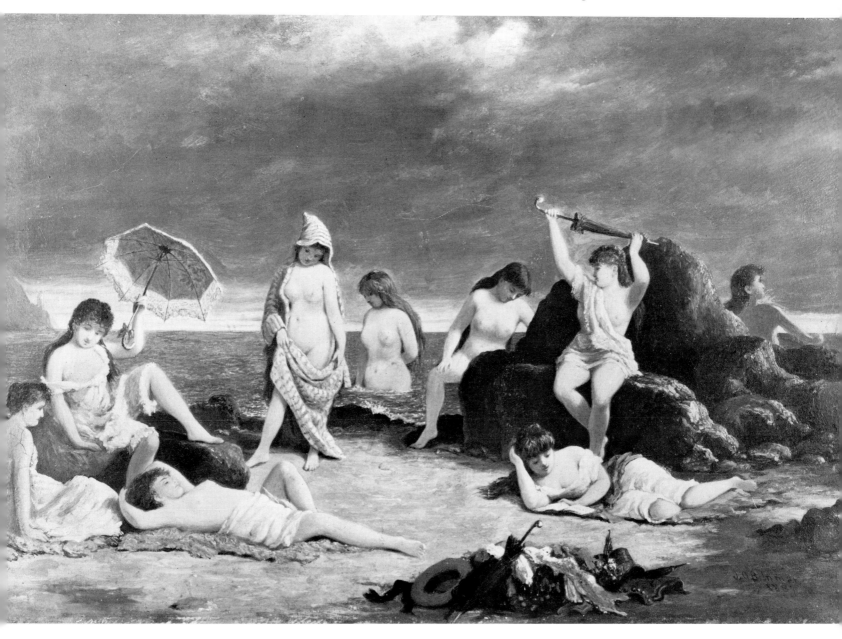

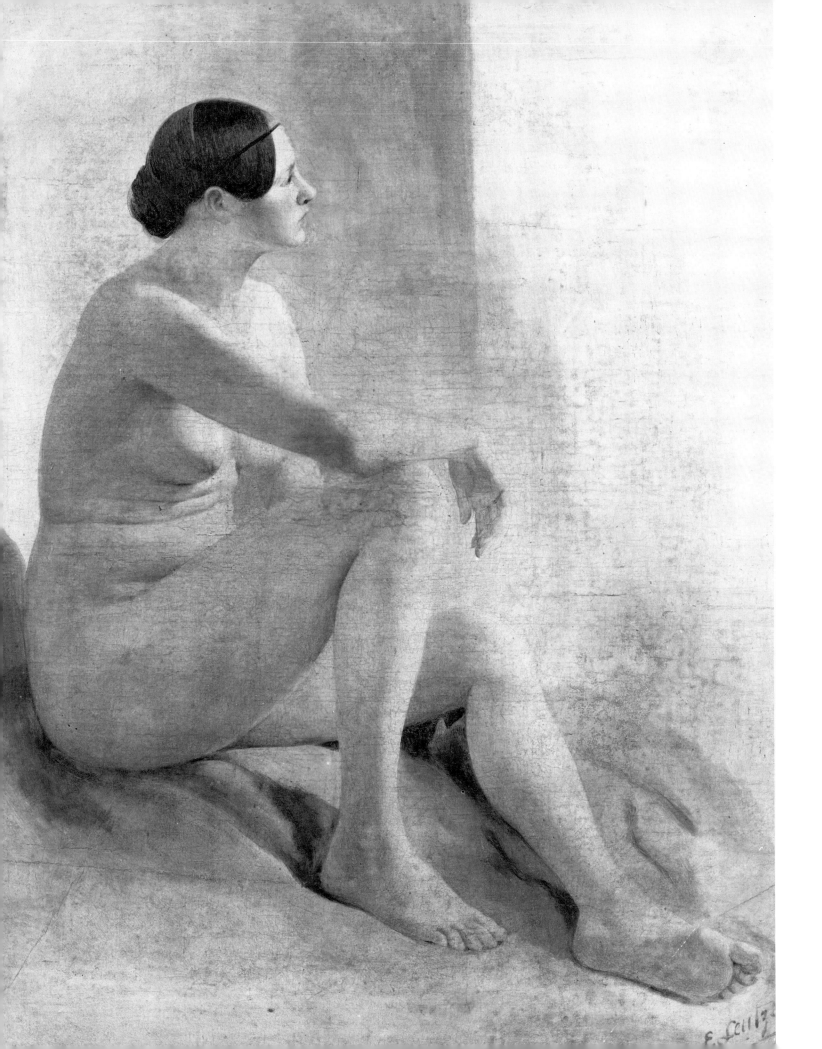

model and thorough anatomical preparation were essential for all the figure painters of the Düsseldorf school, and figure painting—earlier dealing chiefly with historical and religious subjects, later with increasingly popular genre themes—was the underlying interest of Düsseldorf art. It is not surprising, then, that such a study of the nude exists by Leutze, a solidly constructed, sculptural treatment of the figure, with a kind of academic naturalism characteristic of Düsseldorf (*Ill. 4–11*). Quite German, too, is the emphasis upon the weight of the figure, with its sagging breasts and midriff. Typical of both Düsseldorf in general and of Leutze in particular is the sensitive yet thoroughly objective treatment of the face. At his best, as in the great study of his father-in-law, Colonel Löttner, Leutze was one of the finest objective portraitists of the nineteenth century, part of a tradition going back to Hans Holbein, and the treatment of the model in this polished academic study is a reflection of this. Noteworthy, too, is the artist's sensitivity to light, and the transparency of the soft shadows of the figure raises the work above the general level of competent but uninspired academic art. In his finished history pictures, Leutze seems to have generally avoided the nude, although H. T. Tuckerman speaks of a *Godiva* in which Leutze's "coarse rendering of the rude medieval legend offends the delicate preconception of the bard's admirers, and hence makes the painter's illustration offensive."[10]

We have seen that, from the first, the American nude was closely associated with Titian and the Venetian school. Two mid-century American artists became particularly notable followers of the great Venetian. Henry Peters Gray (1819–77), one of the most popular and successful figure painters of his day, made many trips to Europe, and his emulation of Titian was widely acknowledged in his time. Titian's presence is evident in Gray's *Judgement of Paris* of 1861 (*Colorplate 7*). Samuel Benjamin acknowledged in 1880 that Gray's figure of Venus was "a fine piece of form and color."[11] A year later, Earl Shinn spoke of the picture at great length:

> Mr. Gray emulated the amber warmth of Titian, and was thought by his colleagues to have caught a great deal of the color of the Venetians; he lingers in the mind as a sort of William Etty, with excellent endowments of nature in the research for color, somewhat hampered by the difficulty experienced by all Americans of his period to get into the atmosphere of art. The languid roundness of his Venus, the soft adolescence of his Paris, about to bestow on her the prize, *pro pulchrior,* are voluptuously conceived in the sentiment of Titian, Palma and Giorgione. A little more evidence of anatomical knowledge would give them that look of constructive probability, lacking which our Ettys and Haydons died without their full meed of renown.[12]

Certainly, Gray's Venus, one of the fullest and ripest nudes of the mid-century, is clearly modeled on Titian. It is conceived with a soft Venetian veil of color and atmosphere, smoothly idealized to "pass the censors." A later confused but more original attempt, combining a Venetian treatment with a patriotic theme, is Gray's *The Birth of Our Flag,* which was painted in Florence in 1874 (*Ill. 4–12*). The nationalism is underlined by a derivation from a poem by Joseph Rodman Drake:

> When Freedom from her mountain height unfurled her banner in the air,
> She tore the azure robes of night, and set the stars of glory there.
> Then from his mansion in the sun, she called her eagle bearer down,
> And gave unto his mighty hand the chosen emblem of our land.

The allegorical personification of the Genius of Liberty, a partially nude female figure, is painted in Titianesque reminiscence, though it is slightly harder and drier than the Venus.

Yet the mid-century American painter who is most associated with the depiction of the nude was not Gray but William Page (1811–85).[13] Page is often grouped with Gray and with Gray's teacher Daniel Huntington, since the three were among the few American mid-century artists concerned with ideal themes; however, in both his career and his personality, Page was a far more complex artist than they. His painting was controversial, and he never achieved the popular success that they did. Yet Page appears more interesting to us today, the more so because his career involved him with such diverse persons on both sides of the Atlantic as James Russell Lowell, William Wetmore Story, Charlotte Cushman, and Elizabeth and Robert Browning. A concern with color, and with the emulation of Venetian effects of color and transparent tones and atmosphere, were dominant interest of Page's art. Page also shared with Washington Allston a strong religious bent and, like him, dealt often with religious themes and conceived his art as an expression of high morality. This would suggest that, like Allston, he shunned the subject of the nude, fraught as it was in nineteenth-century America with overtones of licentiousness. But such was not the case.

Page's earliest surviving treatment of the nude, and one of his finest and best known works, is the *Cupid and Psyche* (*Colorplate 8*). It is painted in the succession of thin, transparent glazes, in emulation of Venetian art, that became customary with Page, and it has a richness and depth unique in painting of the time. Against a dark, enveloping landscape, the intertwined figures of Cupid and Psyche appear—shadowy yet substantial—and their intense embrace reinforces the romantic mood of the painting.

In the National Academy exhibition of 1843, Page was represented by seven works, but his *Cupid and Psyche* was refused on the grounds of its nudity. When Page's close friend, the newspaper writer and editor Charles Frederick Briggs, defended the painting strongly in the *New World* (under the

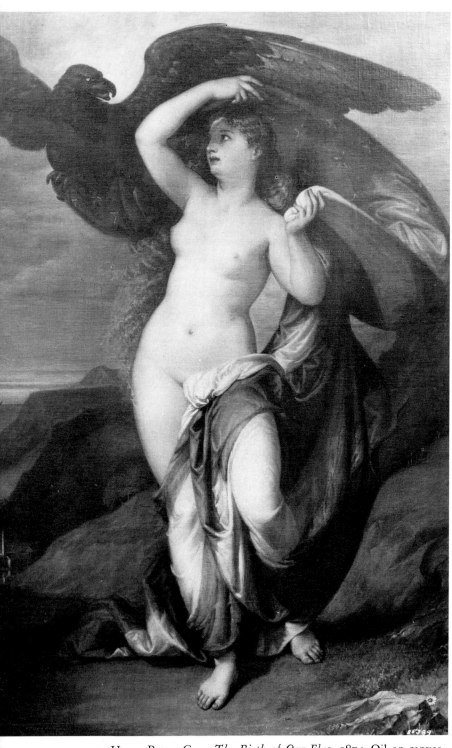

4-12. Henry Peters Gray. *The Birth of Our Flag.* 1874. Oil on canvas. The National Academy of Design, New York. Photograph courtesy Frick Art Reference Library.

pen name of Harry Franco), he aroused a violent response from the paper's readership. One anonymous writer, signing himself "N. T. M.," produced the time-worn criticisms of indecency and European vulgarity, adding:

> Long, indeed, may it be ere the walls of our popular Academy shall be disgraced with the Ledas, and the Cyprian Venuses of heathen mythology, or the Potiphar's wives, the Susanna and the Elders, and Lot and his Daughters of sacred history, or even the "moral pictures" of Adam and Eve, or any other hypocritical cover to a licentious conception.[14]

The memory of Dubufe, ten years earlier, was evidently still fresh!

In his defense of the picture, Briggs pointed out that it was not drawn from life but based on an antique sculptural group—thus, a painting derived from sculpture, and the reverse of Horatio Greenough's *Chanting Cherubs,* based on a detail of a Raphael painting, a sculpture that scandalized Boston and New York twelve years earlier. The derivation from sculpture points up the peculiar quality of the picture and of Page's aesthetic and moral philosophy. As the artist's modern biographer Joshua Taylor has noted, the picture is a combination of the constructed and the observed, a combination of a classical perfection of structure and form with the essential basics of painting—color, expression, light, and shadow. Strangely enough, what New York found morally unacceptable, Boston did not, and the work was shown that same year, 1843, at the Boston Athenaeum.

In Italy, from 1850 to 1860, Page began the first of a series of four paintings of Venus that were intended to express his highest ideal of the embodiment of physical and spiritual perfection.[15] Of the four examples only one is known today in the original, and we are not certain which it is (*Ill. 4-13*). Undoubtedly, it is not the first, which was described as "Venus Rising from the Sea" and painted in 1856. In this first rendition the figure of Venus was standing on the head of a dolphin. A now missing work, it was inspired by a small antique torso in the British Museum. Here Page was working —in the tradition of Allston and Morse—from sculpture to achieve an expressively painted figure, and like his own earlier *Cupid and Psyche* the work was an attempt to combine a classical form with his own inventive use of color and light, derived from the old Venetian masters.

Page's aim, however, was not to represent the goddess of love, or sensuality, but rather to embody his own recognition of the female figure as the highest ideal of beauty in the mind of the Creator, the personification of beauty, life, and love. Such a mystical concept was, however, far beyond the understanding of most Americans of the time. A group of the artist's friends in Italy, including Robert Lowell and Charles Eliot Norton, banded together in a plan to purchase the work and donate it to the Boston Athenaeum. Approximately $3,000

was raised for its purchase, and the work was offered to the Athenaeum for $500, which the Athenaeum refused to pay. To raise the additional sum, the purchasers placed the work on public exhibition in Boston, requiring an admission fee, only to be accused of licentiousness in the presentation of a painting of a nude female. Venus, after all, of all the pagan deities, was the one who embodied qualities most diametrically opposed to the accepted virtues of Victorian America. Even a fellow artist and close friend of Page, the sculptor Benjamin Paul Akers, remarked that Venus was the "voluptuous, the wanton. . . ."[16] Finally, in the spring of 1859, the Athenaeum trustees, after accepting the picture, put it in the annual exhibition; yet so great was the opposition that they soon voted to move the work from public view. It was put away in storage and ultimately disappeared some time after 1905.

In 1858 Page was busy on two representations of Venus guiding Aeneas and the Trojans to the Latin Shore, followed still later by a third. This time the main figure was shown on a shell, pulled by doves and guided by putti, with the vessels of the Trojans in the distance. In the spring of 1859 one of these was submitted to the Paris Salon and rejected; it was also rejected by London's Royal Academy but was shown privately in that city in the summer of 1859, and the *London Literary Gazette* of July 30 stated that "the thought of impurity would assuredly never cross the mind of anyone looking at this picture."

So obsessed had Page become with the series that he neglected the more lucrative and dependable business of portraiture. His distraught brother-in-law and creditor, Henry Stevens, wrote to him, "High art and naked human female figures are all well in their places, but the first and only thing for you both to do *now* is to go into a still *higher* art in getting out and keeping out of debt."[17]

Page brought his second *Venus* to America, and it was exhibited in the fall at the Düsseldorf Galleries in New York City. Charles Loring Elliott wrote to Page's friend Briggs:

> I was deeply impressed with the idea that as a work of *Art* it stands at the head of all the works that hitherto distinguished the subtil abilities of our friend,—in colour, it is *marvelous*—as I looked from it at the detestable Dusseldorf inanities around it, it shown like the *sun in the West* amid the sombre clouds of the East, and I felt proud of it, as the production of an *American.* In drawing to my comprehension it is perfect.[18]

The Crayon viciously attacked the painting in its December issue:

> If Page is glaringly incapable of producing a Venus of mere physical beauty—of attaining to a classical model in this respect, what moral derangement must have possessed him to artistically spawn upon modern days a Venus wholly abortive in the only material attribute

4-13. William Page. *Venus Guiding Aeneas and the Trojans to the Latin Shore.* Ca. 1857–62. Oil on canvas. Collection of Mrs. Leslie Stockton Howell.

79

which could save her from contempt. He has not only violated all modern delicacy of moral sentiment, but has burlesqued Grecian conception of form by the production of his Venus. We are uncharitable enough to think that if Page had genius enough to rise to the artist's conception of Grecian form, he would have had moral delicacy enough to refrain from casting out upon the modern world a naked Venus.[19]

Presumably, the writer in *The Crayon* spoke with righteous indignation; but, of course, such criticism brought for Page's *Venus* a curiosity and popularity that made it a great success. The picture was shown for four weeks at the Düsseldorf Gallery and two weeks at the National Academy; then it began a tour of Boston, Baltimore, and other cities all the way to New Orleans. The painting brought in substantial sums, and the greatest disappointment expressed by the general public seems to have been by those who expected the picture to be indecent. To offset real and potential criticism, an anonymous pamphlet was printed in 1860, perhaps written by Mrs. Page or possibly by one of the subscribers to the first *Venus*, describing the picture as follows:

> The museums of Europe abound in statues of Venus, of every period of Greek art; and additions are constantly made of them. . . . Page's *Venus*, the finest picture of its own, or probably of any other kind, ever seen in America, derives its origins in part from one of these. . . . Mr. Page has, as is well known, mastered the secrets and style of Titian, who perfected color, the life of painting; and he conceived the idea of setting forth the charms of this masterpiece of sculpture by his own art. In this combination of different influences, we have a perfection of beauty, an energy of design, a grace of execution, which indicated a new era in art. It is as far removed on the one hand from the conventional, affected, and unnatural, as it is on the other from anything like a vast number of modern works of art, which are either really corrupting, or, "endeavoring to be vicious, only succeed in becoming silly." A healthier, a purer, or a nobler work of art than this representation of the Queen of all Grace, and of the principles of loveliness, was never placed on canvas. The Pharisee and bigot who object to the design, and raise an outcry as to its influence, simply place themselves, in the view of the educated and refined of sound tastes and tendencies, as either grossly ignorant, or vulgarly and morbidly corrupt. At this day, that which is purely and perfectly beautiful and what is more, healthy and natural, is no longer excluded from well-regulated collec-

tions of art. . . . No person familiar with either art or literature, will hesitate to say that there is not a person in the community of any intelligence whatever, who is not every day exposed to a score of influences every way more demoralizing than any which any true work of art in existence can exert; and yet who ever dreams of exposing them? . . .

> The admiration which this *Venus* has elicited from the first artists and critics of Europe, the approbation manifested by the thousands who have visited it, and finally, the earnest discussion which it has awakened in the press, all prove that whatever scruples the squeamish, pharisaical, and ignorant may have, or affect to have, as regards its "unadorned beauty," there can be no question whatever as to its exquisite beauty and certainly none as to its wonderful merit as a painting.

Meanwhile, Page was at work on his third version of *Venus* in Rome. The sculptor William Henry Rinehart wrote to the painter Frank B. Mayer in Baltimore on December 9, 1859:

> Page is painting another Venus which promises to be wonderfully fine. His stile is peculiarly his own and consists in glazing one thin coat over another an indefinite number of times. He seems to be successful with it but no one else has as far as I can learn. The fact of the business is this—that Page is rather an extraordinary man and would be successful with almost any stile.[20]

The third *Venus* was exhibited in London at the great International Exposition of 1862.

In August, 1860, Page and his wife returned to New York City, and then retreated to a utopian socialistic art colony outside of Perth Amboy, New Jersey. There Page painted the last of his pictures of Venus, in 1862.

For some reason, the third and the fourth *Venus* seem not to have elicited the charges of lewdness and vulgarity that the first did; perhaps the tour of the second *Venus* had helped popularize Page's concept of Venus in the minds of the public and the critics. In his series of four paintings, Page admittedly sought an ever greater degree of spiritual and physical perfection through slight and subtle means. Undoubtedly, in all of them he attempted to re-create the plasticity of classical sculpture and apply to this the light and color of the Venetians. Yet, for all the classical and Old Master references, the picture that remains to us, at least, has a coyness both in pose and the subsidiary attributes that marks it as very much of the mid-nineteenth century.

Sculpted Nudes During the Neoclassic Period

THE DIFFERENCES BETWEEN painting and sculpture relate not only to the nude as a theme but also to its reception. Sculpture is concerned with three dimensionality and form, painting with color and illusionism. Furthermore, the thematic limitations of the sculptor are vastly greater than those of the painter. Until recent explorations by modern sculptors of still-life and even landscape themes, sculpture has been principally confined to the figure. With so all-inclusive a concentration, the sculptor was bound to be proportionately more concerned with the nude, partial or complete, than was the painter. Such an emphasis, furthermore, led naturally to a consideration of the ideal of perfection of the human form, which could best be presented unclothed. This was especially true in the neoclassic period, when the art of antiquity was glorified.

Actually, the nude in American sculpture predates the nude in American painting by some years; the best known of these early representations is the curious and primitive Indian weathervane that once stood atop the State House in Boston, by the colonial sculptor Shem Drowne (1683–1774). Drowne's Indian is partially nude in the tradition of Indian representation, but franker nudity can be found, of all places, in religious imagery—on eighteenth-century gravestones and even on late seventeenth-century ones.[1] Partial or full nudity

This chapter is a revision of an article by the author that appeared in the May–June, 1971, issue of *Art in America*.

is presented in the images on the slate-and-sandstone grave of Sarah Nisbett, who died in 1698 and was buried in Milford, Connecticut, and in those depicted on the gravestones of Sarah Swan, buried in Bristol, Rhode Island, in 1767 (*Ill. 5–1*) and Seth Pomeroy, who died in Northampton, Massachusetts, in 1777. The full-breasted nudity of the feminine images suggests that the sexual symbolism of the Puritan religion was far greater than we might have thought; Jonathan Edwards, the great eighteenth-century New England theologian, for instance, made reference to the words of God as divine milk from the breasts of the Church nourishing the soul. Colonial ministers were remarkably frank in picturing the love of God in distinctly anthropomorphic ways; the colonial clergyman-poet Edward Taylor, for example, wrote:

The Soul's the Womb Christ the Spermodote
And Saving Grace the seed cast there unto. . . .

Beyond this artisan tradition of gravestone carving, however, along with such allied areas of functional sculpture as weathervanes and ship figureheads, the art of sculpture found little reception in America until the second quarter of the nineteenth century.

Early American professional sculpture was much concerned with the portrait. Here, a perennial and at times fascinating but ultimately repetitive controversy that continued

throughout the nineteenth century raged around the question of proper dress for statues depicting historic Americans. The proponents of classical garb insisted that contemporary dress was unsuitable and unattractive, and they maintained that such statues would quickly appear outdated to the next generation; those who favored modern dress argued that togas had nothing to do with modern subjects. Almost all agreed, however, that either was preferable to *un*dress. The question of nudity in historic statues seldom came up. The example of Horatio Greenough[2] and his poorly received heroic and half-naked *George Washington* (Ill. 5–2) was enough to dissuade other sculptors from the temptations offered by such European examples as Antonio Canova's even more heroic and totally nude *Napoleon Bonaparte* (Ill. 5–3). Greenough (1809–52) was America's earliest neoclassic sculptor and the first to go to Europe—to Rome, and ultimately to Florence, which became his home. There he conceived and executed his major works, which at times involved the representation of nudity—for example, the partially nude but conveniently deceased *Medora*

5–1. Anonymous artist. *Adam and Eve* on the gravestone of Sarah Swan. 1767. Slate. Bristol, Rhode Island. Photograph courtesy of Dr. Allan I. Ludwig.

and his totally nude *Venus Victrix.* The *Washington* engendered a great deal of controversy, as did its exhibition in the Rotunda of the Capitol. Its derivation, acknowledged by Greenough and his admirers, was from the reconstruction of the Phidian *Zeus,* and its general symbolism and, particularly, its partial nudity were also. Hawthorne, in his Notebooks, asked belligerently, "Did anybody ever see Washington naked! It is inconceivable." And Philip Hone, the well-known New York diarist, wrote in his journal in 1841:

> It strikes me that the sculptor has failed in representing the character by its adjuncts. The Roman Toga would have done better—that grand resort for artists in search of the picturesque; a suit of ancient armour even, obsolete though it may be, or the ungraceful Continental uniform; either would have been more appropriate than a body naked from the waist upward. Washington was too prudent and careful of his health to expose himself thus in a climate so uncertain as ours, to say nothing of the indecency of such an exposure—a subject on which he was known to be exceedingly fastidious.[3]

But the French sculptor Houdon had already presented Washington in contemporary garments; the English sculptor Chantrey had depicted him in a long cloak resembling a toga; and the Italian Canova had shown him in a "suit of ancient armor." Undoubtedly, one of Greenough's motivations for his choice, though probably not the principal one, was to depict Washington in a fashion different from the already well-known versions by European neoclassicists. And partial nudity, along with colossal scale, invoked a classical, timeless tradition of representing figures who were spiritually "larger than life" and "of the ages."

Still, it was a mistake to have based the conception for *Washington* on a Canovan precedent, for Americans found almost everything wrong with Canova, and sensuousness was at the bottom of it all. Almost the only laudatory comments made by Americans in regard to Canova's art had to do with his tomb sculpture in Rome and Vienna, and what they really liked best about Canova was his *own* tomb in the Frari in Venice, presumably because it commemorated the end of his career. His ideal works were almost universally condemned, sometimes for lack of simplicity, sometimes for affectation. But what really bothered Americans was Canova's conscious sensuality —which was, as the authoress Grace Greenwood wrote, "worse than absolute voluptuousness." One American, on seeing Canova's *Venus Coming from the Bath,* found her "a trifle too bashful," another called her "a grisette," and all Americans condemned the artist for giving his work a "French air." One American, Matthias Bruen, traveling abroad, must have been thinking of Canova when he wrote that Italian sculpture combined "Italian effeminancy and French corruption."[4]

Canova's successor in the neoclassic pantheon was the Dane

5–2. Horatio Greenough. *George Washington.* 1840. Marble. National Collection of Fine Arts, Smithsonian Institution, Washington, D.C. Transfer from the U.S. Capitol.

Bertel Thorwaldsen, and he, by contrast, was much appreciated and approved of by Americans. His work was praised for naturalness and ease, and his bas-reliefs, particularly, were often referred to as the greatest work of the times. Canova and Thorwaldsen were invariably compared and always to the latter's favor. Canova's art was wanton and feminine; Thorwaldsen's, heroic and manly. But, then, Thorwaldsen was associated in the minds of American connoisseurs with religious sculpture, and it was felt that he cast the spirit of Christianity over the forms of classicism.

Surprisingly, the neoclassic statue in Europe most admired and revered by visiting Americans was a work by neither Canova nor Thorwaldsen, but rather the *Ariadne on a Panther*

(*Ill.* 5–4) by the German artist Johann Heinrich von Dannecker, which was housed in Frankfurt, in the private museum of Simon Moritz von Bethmann. The Bethmann Museum was an obligatory stop for just about every American making the Grand Tour. Harriet Beecher Stowe wrote glowingly about the sculpture, which she went to visit immediately on arriving in Frankfurt. On seeing the *Ariadne,* she felt she was "under a spell in the transfigured world of art where passion ceases, and bestial instincts are felt to be bowed to the law of mind, and of ideal truth." She went on to muse, "Could mere beauty and grace delight and fill the soul, one could not ask for more than the *Ariadne.* . . . But after all, what is it? No moral charm—mere physical beauty, cold as Greek mythology."[5]

A number of visitors spoke rapturously of the *Ariadne* because of the surface fleshiness, not often achieved in marble —the "effect of living surface." But this very quality bothered others, particularly because of the color. The marble itself was white, but the light that streamed in upon the sculpture, which rotated on its pedestal, filtered in through a window of tinted glass, casting upon the piece what was variously described as a pink, rose, or purple light. In any event, it was meant to enhance the suggestion of human flesh, and this disturbed some, such as Clara Crowninshield, touring in Europe with Longfellow in 1836; she insisted that the *Ariadne* was still marble, not flesh, and that pure white was preferable to pink light.[6]

The introduction of color, even vicariously as here, violated the concept of abstraction, which was one of the justifications for nudity in sculpture or, indeed, for the existence of sculpture itself—for Americans. Painting was color, sculpture was form, and as Margaret Fuller said, "Solid sculpture appeals to the positiveness of [the American] nature." As long as sculpture displayed the pure white of the Carrara or Serravezza marble, it could be justified, for the spectator could not mistake the statue for the real thing. Nudity was acceptable as long as the suggestion of sensuality was secondhand, filtered through the purity of the virginally white marble.

The artist most associated with—and most condemned for —his introduction of color to sculpture was the leading English neoclassicist in Rome, John Gibson, who colored his sculpture directly instead of using colored glass to light his work. Gibson tinted his gods and goddesses—with what was variously described as watercolor (by his admirers) or tobacco juice (by his detractors), but which was actually colored wax —in emulation of the ancients. The *Tinted Venus* (*Ill.* 5–5) is today the best known of these productions, but color was added to a good many of his sculptures. Occasionally, American visitors who saw his production in Rome admired the effects he wrought with color. Edward Everett Hale, for instance, commented that Gibson gave his sculpture an overall glow on the flesh areas, ruddy and warm, which made pure white marble statues appear blue and cold. He wondered thoughtfully why sculptors did not then work in green or black marble, concluding that white is closest to flesh color of all possible marble hues, but that marble with a slight yellow tint to it was preferable to chalky, dead white stone. William Dean Howells, too, admired Gibson's colored sculptures; he described them as suggesting flesh merely warmed, with hair a delicate yellow, the eyes, a lovely violet, and perhaps the hem of a robe traced in blue. Others did not. Harriet Trowbridge Allen echoed Howells's comments but concluded that Gibson's *Pandora* and *Venus* were false, though beautiful. The argument that classical sculpture was, indeed, colored was countered by the suggestion that *if* the ancients did color their sculpture, they did it in their decline. It was Nathaniel Hawthorne, writing in *The Marble Faun*, who summed up the prevailing opinion of Gibson and his work. Hawthorne admired Gibson, as man and artist, but he felt that he had

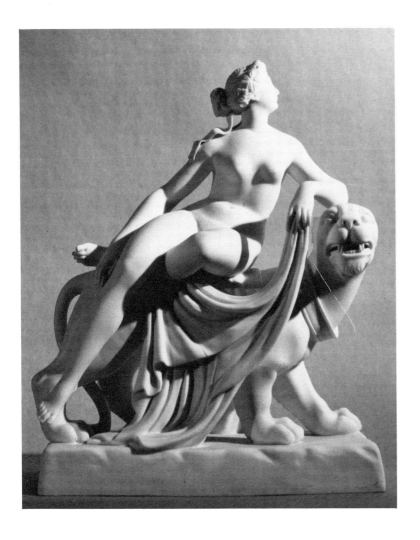

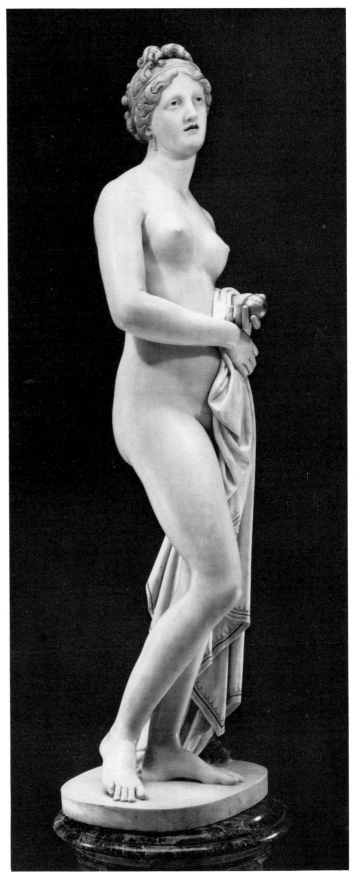

OPPOSITE

5-3. Antonio Canova. *Napoleon Bonaparte*. Ca. 1809. Marble. The Wellington Museum, Apsley House, London.

ABOVE

5-4. Johann Heinrich von Dannecker. *Ariadne on a Panther*. Ceramic copy of the original marble of 1803. Private collection.

RIGHT

5-5. John Gibson. *Tinted Venus*. Ca. 1850. Marble colored with wax. The Walker Art Gallery, Liverpool. Photograph courtesy of the Victoria and Albert Museum, London.

"robbed marble of its chastity by giving it an artificial warmth of hue. Thus, it became a sin and a shame to look upon his nude goddesses." They became only naked women.[7]

Few Americans followed Gibson in tinting statues, whether clothed or unclothed. One critic suggests that Gibson's pupil Harriet Hosmer (1830–1908) did endow her work with a creamy tint, but stated firmly that she did not use flesh tones.[8] Miss Hosmer was one of the most famous American women sculptors in Rome, referred to by Henry James as "The White Marmorean Flock." Her first full-length sculpture, done in Rome—under Gibson's tutelage—was the *Oenone,* a representation of the shepherd wife of Paris, grieving for her lost love and taken from a poem by Tennyson (*Ill. 5–6*). Oenone is partially nude, but the interpretation is poetic rather than sensual; the simplification of the body emphasizes the drooping curves, expressive of the subject's melancholy. The other major nudes by Harriet Hosmer were *The Sleeping Faun (Ill. 5–7)* and *The Waking Faun*—the latter possibly never put into marble. *The Sleeping Faun,* derived from the Barberini *Faun,* is a soft and effeminate figure, a point made critically at the time it was exhibited. The sculptor Thomas Crawford (1814–57) severely criticized Harriet Hosmer in a letter to his wife, stating that her

> . . . want of modesty is enough to disgust a dog. She has had casts for the entire *female model* made and exhibited in a shockingly indecent manner to all the young artists who called upon her. This is going it *rather strong.*[9]

Women sculptors, in general, were far more concerned with the representation of the female figure whether clothed or unclothed, though full-scale nudity was rare in any case. One of the loveliest of their depictions of partial nudity was the *Spirit of the Carnival* by Vinnie Ream Hoxie (1847–1914); another example of complete nudity was her *Indian Girl.* However, the presentation of the Indian woman as completely naked is

5–6. Harriet Hosmer. *Oenone.* 1854–55. Marble. Gallery of Art, Washington University, St. Louis, Missouri.

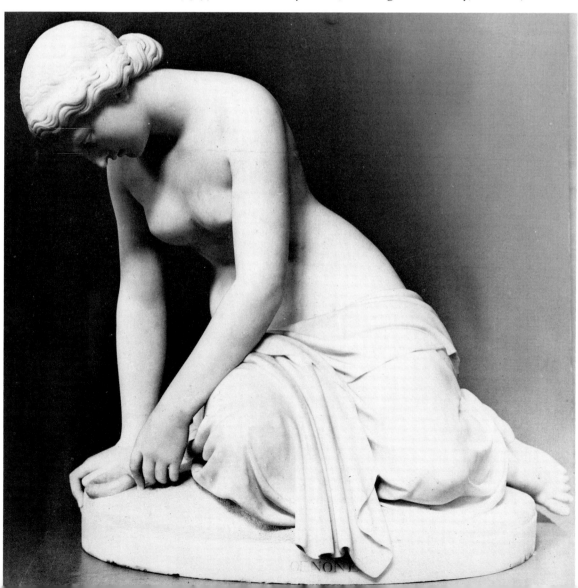

unusual; this one is doubly so since it is a portrait statue, not an idealization. Miss Ream's sister-in-law was the model, an American Indian girl married to her brother.

One American artist who avoided the stricture against color in sculpture was Joseph Mozier (1812–70), who is known to have tinted at least one replica of his most popular work, *The Wept of Wish-Ton-Wish,* and probably others as well. The examples of this piece known today are all in pristine white, however, and the tinted example or examples are still undiscovered—or else the coloring has worn off. It is strange but perhaps peculiarly American that Mozier applied the tinting to one of his most fully clothed statues in which relatively little flesh is visible anyway; he was not otherwise averse to nudity.

Once in Italy, American sculptors produced nude statues with abandon and in abundance, and travelers from America dutifully went to see them, though, as Clara Crowninshield remarked, it was "an awkward thing to contemplate naked statues with young gentlemen." Nathaniel Hawthorne in-

veighed against their creations in *The Marble Faun.* His heroine, Miriam, speaks out against nudity and "indecorous womanhood" and calling such works "Eve," "Venus," or a "Nymph" to apologize for their lack of clothing. Hawthorne goes on to suggest that "Today, people are as good as born in clothes. . . . [The] old Greeks found models in open sunshine and among pure and princely maidens; thus, they are as modest as violets draped in their own beauty."

Due to the nudity of the two babes, Horatio Greenough's *Chanting Cherubs,* completed in Italy in 1831, met vociferous opposition in America, which neither their infant innocence nor their derivation from a Raphael altarpiece could mollify; occasionally when they were shown, little aprons were tied around their waists. The exhibition of the sculpture in New York was fiercely attacked in the press by a critic significantly calling himself "Modistus." The *Cherubs* was Greenough's first major opus; it is lost today but it must have been very similar to the artist's *Angel and Child* of only a year or so

5–7. Harriet Hosmer. *The Sleeping Faun.* n.d. Marble. Collection of the Marquess of Northampton, D.S.O., Castle Ashby, Northampton, England.

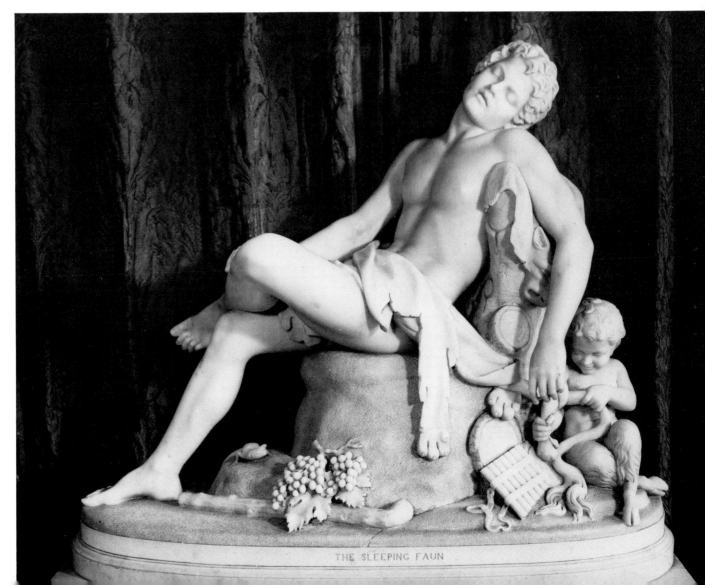

BELOW

5–8. Horatio Greenough. *Angel and Child.* 1832. Marble. Courtesy, Museum of Fine Arts, Boston. Gift of Laurence Curtis.

RIGHT

5–9. Hiram Powers. *Eve Tempted.* 1839–42. Marble. National Collection of Fine Arts, Smithsonian Institution, Washington, D.C.

OPPOSITE

5–10. Hiram Powers. *The Greek Slave.* 1847. Marble. Yale University Art Gallery, New Haven, Connecticut. Olive Louise Dann Fund.

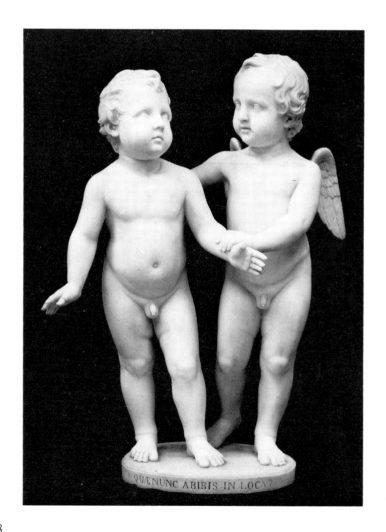

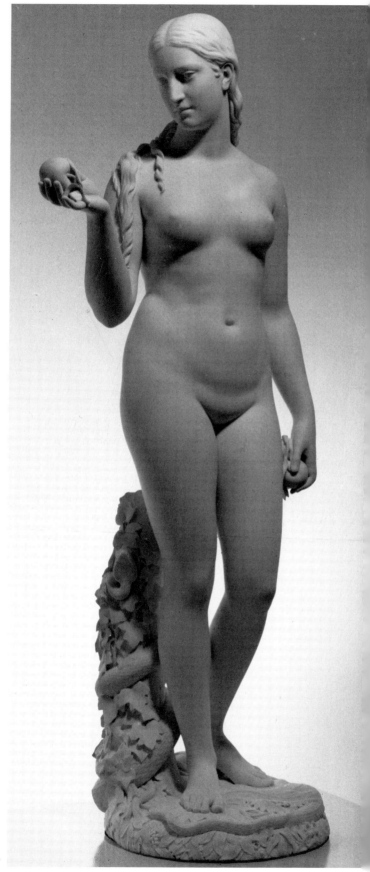

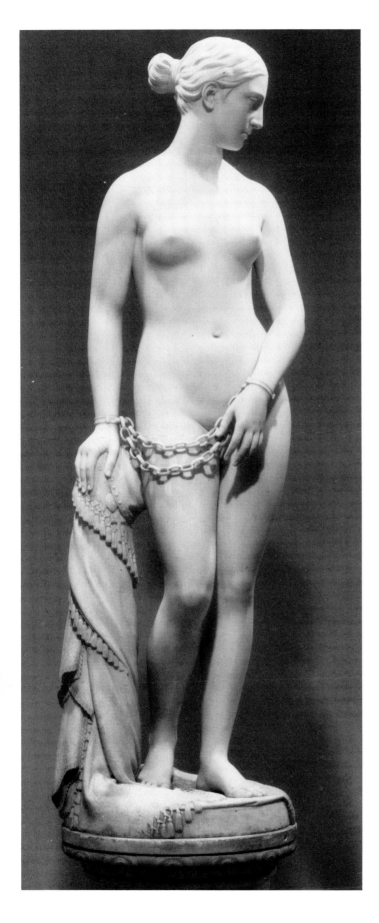

later (*Ill. 5–8*). About this group Greenough wrote to his patron and friend James Fenimore Cooper, from Florence, on January 29, 1833:

> Angels never wear clothes you remark—This comes strangely from you—I never saw one that was not dressed and very tastefully too—I make 'em both stark naked—The conversation that passed between me and the gentleman who ordered the group was a scene—I fought hard and carried the day—the little fellows are to be provided with alabaster fig leaves which shall fall at a tap! of the hammer when the discerning public shall have *digested* the fruit of the knowledge of good and evil.[10]

Hiram Powers (1805–73) went to Florence less than a decade after Greenough arrived, and one of his first sculptures was a full-length nude, *Eve Tempted,* perhaps the finest of all his figures and one much admired by the aging sculptor-patriarch Thorwaldsen (*Ill. 5–9*). But it was Powers's second full-length sculptured nude, *The Greek Slave,* that made his reputation (*Ill. 5–10*). It was shown in his studio in Florence, in the Crystal Palace International Exposition in London in 1851, and in galleries and on tour in America. Its popularity is further attested to by the number of replicas and copies produced: There were six full-length, full-size *Slaves;* three full-length, half-size ones; and about 77 busts. This does not include copies by other artists and reproductions by various ceramic manufacturers.

Greenough had expected public approval of the *Cherubs* and was bewildered when he did not receive it; Powers armed himself with powerful ammunition and found little opposition to his work. In part, this was due to the advance notices of his sculpture; Thorwaldsen was often quoted as saying of the *Eve,* "You say, sir, it is your *first* statue—any other man might be proud of it as his *last.*" The fact that the *Slave* was the hit of the London Exposition duly impressed Powers's audience in America. But the subject itself readily won the hearts of Americans—for at that time America identified itself with Greece, which was struggling for its independence against the Turks. Powers's sculpture depicts a captured Greek woman in the slave mart of Constantinople, naked and for sale, against her will. In other words, her nudity is a natural aspect of a sympathetic theme. White marble was also virginal: Powers won approval for his life-size marble statue, while John Vanderlyn, earlier, received only condemnation when he returned to America with his painted nude *Ariadne.*

The subject appealed to antislavery passions, too, and has been called the "American arts' first antislavery document in marble," a factor which was taken into account in Elizabeth Barrett Browning's sonnet on the piece. Also, when the *Slave* was exhibited in America, the pamphlets accompanying the exhibition contained words of approval by such eminent ministers as the Reverend Orville Dewey, who stated that the *Slave*

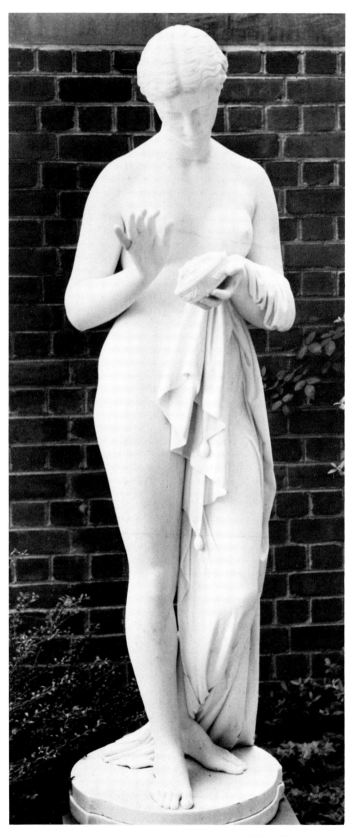

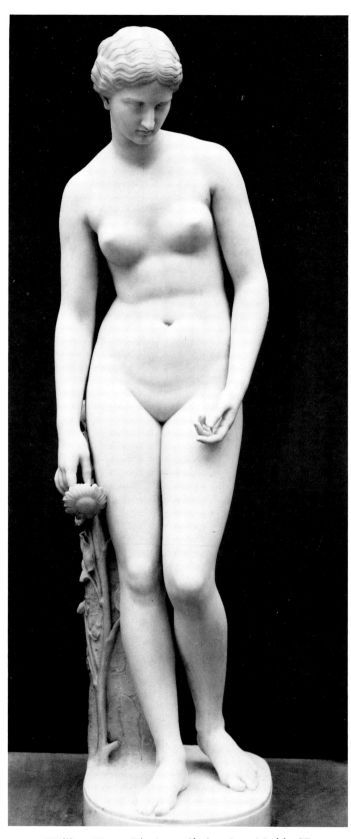

5-11. Chauncey B. Ives. *Pandora*. 1854. Marble. Virginia Museum of Fine Arts, Richmond, Virginia. Gift of Mrs. William A. Willingham.

5-12. William Henry Rinehart. *Clytie*. 1872. Marble. The Metropolitan Museum of Art, New York. Gift of Mr. and Mrs. William H. Herriman, 1911.

was "clothed all over with sentiment, sheltered, protected by it from every profane eye." There were Christian overtones to the sculpture, and to underline this Powers included, with the maiden's clothes piled up next to her, a conspicuous cross for all to see.[11]

Christianity was the key to understanding the popularity of the marmoreal figures produced by American sculptors in Florence and Rome in the second and third quarters of the nineteenth century. Ancient Greece and Rome were universally ackowledged to have provided the greatest, indeed, the only, acceptable aesthetic, but it troubled the American conscience that it was a heathen aesthetic, nevertheless. What made the neoclassic appear greater than the classic itself was the overlay of Christian idealism upon the forms of the ancients. We have little difficulty in distinguishing today between a classical marble statue and a Victorian one, although the Christian idealism may not, to some eyes, appear to be a desirable endowment.

In *The Greek Slave,* Powers has turned the head of his figure away from the gaze of her would-be purchasers, and her expression is downcast and mournful; descriptions and even poetry about her emphasized not only her disgust with her situation but also her yearning to return to home, family, country, and religion—all the approved Victorian institutions. Meanwhile, she is very, very naked. She wears nothing but her chains, and these, as they swing from wrist to wrist, carefully cover her so that the chains become not only a symbol of her captivity but also a barrier to her violation. Of course, they *are* chains, and the artist titillates his audience, who can see through and around them. Whereas Powers's first full-length nude, the *Eve Tempted,* is completely unprotected—presumably because she is Eve before sin—in later works partial, but only partial, barriers appear. The *Slave* has her chains—and it is interesting to note that the one change Powers was to make in the last replica of the *Slave* was to replace the ornamental link chains with stronger bar manacles. His *California* has a divining rod placed "just so"; and his late *Eve Disconsolate* has a downward plunging hand placed somewhat awkwardly but right in front of her genital region.

The Greek Slave was not only the most famous of Powers's sculptures, it was also the most famous marble statue created by any nineteenth-century American artist. It became the touch-stone by which others were judged. Probably its closest rival was *Pandora (Ill. 5–11)* by Chauncey B. Ives (1810–94), of which many versions were made in several sizes, with some changes wrought among the replicas by Ives himself. Ives's figure is completely nude, though shielded by a large amount of drapery, a big-hipped female figure, very classical and "Gibson-like" of face. The similarity to Gibson's work may not be coincidental, for one of Gibson's best-known and most admired sculptures was his *Pandora*. Pandora was, of course, a classical figure, but also the classical equivalent of Eve and thus easily identified with her Christian counterpart. Likewise, *Psyche,* a bust by Powers, was explained and excused as a

symbol of the immortal soul—she was carefully identified with her symbol, the butterfly, also the symbol of the soul. Powers's most popular bust of all, the *Persephone*—of which at least 133 copies were carved—is also, like the *Slave,* brought to carnal experience against her will.[12]

Perhaps the finest of all the later full-length nudes was *Clytie (Ill. 5–12)* by William Henry Rinehart (1825–74), his answer to Powers, so to speak; but the greater heaviness of figure and, particularly, the greater realism of the modeling of the anatomy and musculature of the figure are indicative of changes that occurred even within the mid-century aesthetic in the 1860s and 1870s. Among the later neoclassic nudes, *Clytie* stands alone in beauty and grace, equaled perhaps only by Ives's *Egeria.*

Whiteness of marble, severity of form, Christian virtues, acceptable context, all these went hand in hand with spectator titillation. Sometimes, too, the artists intrigued their audience by what was almost but not quite seen, rather than what was completely visible. See-through illusionism is usually identified with eighteenth-century virtuoso sculpture, particularly in Naples, but it was reborn in the rococo revival of the nineteenth century, notably at the hands of the Milanese artist Raffaelle Monti. Certain American artists investigated Monti's approach. The two most famous examples are Randolph Rogers's *Flight of the Spirit,* a bas-relief for the J. W. Waterman tomb in Detroit, and Joseph Mozier's rather spectacular *Undine,* in which drapery swathes and, at the same time, reveals the entire figure, and the lady's face seems to be emerging through the thin veiling. Undine's nature—she was a water-sylph—offered an acceptable rationale for the "wet drapery" technique; she was also in search of her soul and thus had the proper Christian connotations. Undine was the subject of numerous marble representations, including several by Chauncey B. Ives. In Ives's statue the watery lady is rising to receive her soul, and while her face is not covered with transparent drapery her body is; the folds of the wet cloth reveal more than does the truly naked *Pandora,* not only of Ives's sculptural virtuosity but of the anatomy of the lady herself.

A similar peek-a-boo quality characterizes some statues of ladies on dry land. As long as it was consistent with the literary allusions, it was often customary for the sculptured ladies to reveal a breast in their usual state of both spiritual and physical disarray. Sometimes, however, there seems less justification for such exposure. Powers's *Faith* and *Hope* each reveal one breast; *Charity* is fully covered. Still, Powers received more orders for *Faith* and *Hope* than he did for *Charity.* (He was only able to sell two complete sets of all three.) And there may, too, have been a chronological progression here. Randolph Rogers (1825–92), in the first two of his three most popular ideal figures, the *Ruth Gleaning in the Fields of Boaz* and the *Nydia, the Blind Girl of Pompeii,* revealed one breast; this was justified because of the toil of Ruth and the terror and blindness of Nydia. In his later *Lost Pleiad,* the allegorical astral figure has not only lost her way but lost her covering. This may be due

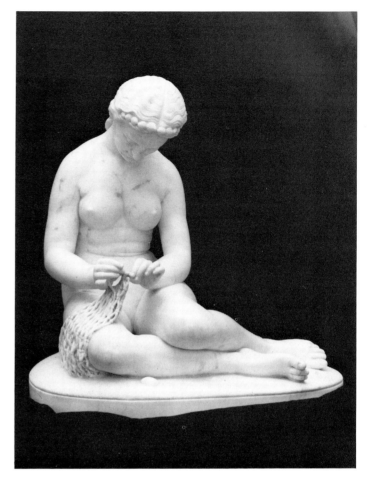

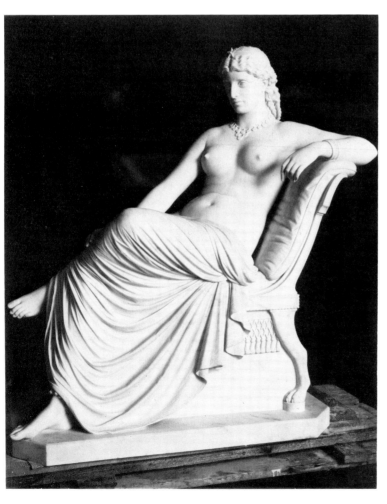

5-13. William Wetmore Story. *Salomé.* 1871. Marble. The Metropolitan Museum of Art, New York. Gift of William Nelson, 1896.

ABOVE
5-14. William Randolph Barbee. *Fisher Girl.* Ca. 1858. Marble. National Collection of Fine Arts, Smithsonian Institution, Washington, D.C.

to the artist's greater confidence in the display of the naked figure, or it may relate to a greater anatomical freedom in general after 1860. Breasts became larger and larger—from Powers's work in the 1840s to the larger forms of Ives in the 1850s and the full roundedness of Rinehart's treatment in the 1860s. The culmination is surely to be found in the work of William Wetmore Story (1819–95), whose *Salomé* (*Ill. 5–13*) and *Delilah* are very well endowed. It is worth noting, though, that Story started out with a modest, fully clothed *Marguerite* and moved on to the famous *Cleopatra,* with one breast exposed, before doing his triumphant ladies of the 1860s and 1870s.

As we have seen, full nakedness was acceptable and even desirable, when appropriate. One story that rivaled that of Undine in popularity was Thomas Moore's "Paradise and the Peri," a poem from his *Lalla Rookha*. The Peri was an angel expelled from Heaven who tried vainly to bring to God the gift He most desired, but only got through the gates of Paradise by offering the tears of a repentant old man. In an early version of this subject, Thomas Crawford presented a downcast, modestly clothed angel; Joseph Mozier's later winged figure looks determinedly upward, and there is no doubt in the spectator's mind about the gender of the angel; She is a plump and Rubensian female.

While Victorian America was certainly intrigued by the nude, she was fascinated by death. A morbid streak runs through both the literature and the art of the time. It is not surprising that Harriet Hosmer created her most popular—and touching—monument in her *Beatrice Cenci* (*Ill. 5–16*). The story of the beautiful, young Cenci who was condemned to death for slaying her wicked father had a romantic appeal unsurpassed in the nineteenth century, and Guido Reni's portrait *Beatrice Cenci* was just about the only work of art to avoid the general Victorian proscription of things baroque. But, of course, if death *and* nudity could go hand in hand, so much the better; and if, in turn, these could be joined to the much favored watery themes—then one would have the acme of American neoclassic sculpture. And one could. In the most admired and certainly most spectacular sculpture by Edward A. Brackett (1818–1908), *Shipwrecked Mother and Child* (*Ill.*

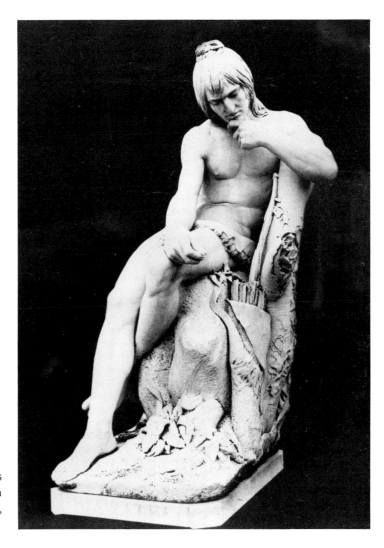

5–15. Augustus Saint-Gaudens. *Hiawatha.* 1872. Marble. Whereabouts unknown. Formerly, Saratoga Springs, New York. Photograph courtesy of the Saint-Gaudens National Historical Site, Cornish, New Hampshire.

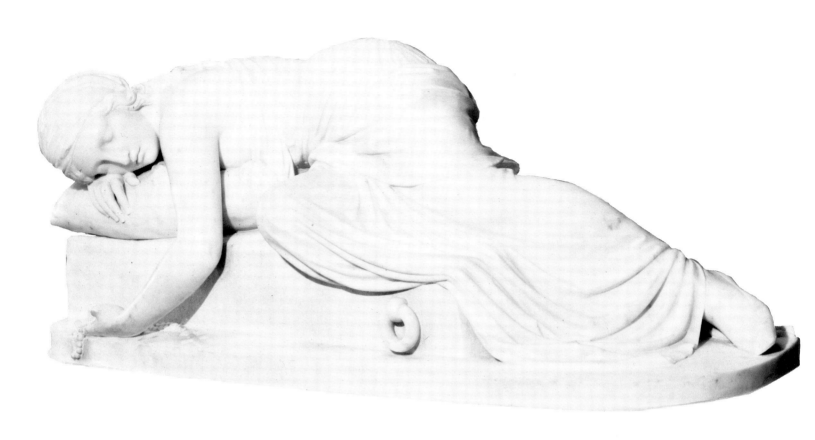

5–16. Harriet Hosmer. *Beatrice Cenci.* 1857. Marble. Art Gallery of New South Wales, Sydney, Australia.

5–17), nudity, death by drowning, and maternal devotion are united in imperishable marble. It stirred both the heart-strings and the libidos of Victorian viewers. The impact of this sculpture in 1851 was particularly great since America had just learned of the demise by drowning of a favorite author, Margaret Fuller, and her child, and, indeed, Brackett's sculpture may be considered a memorial to her.

Benjamin Paul Akers (1825–61), who died tragically young, is best remembered for *The Dead Pearl Diver (Ill. 5–18)*. This pathetic sculpture features a handsome young man struck down in his youth, and the artist adds to the appeal of the piece with a garment of see-through fishnet, a variation of the transparent veil. Water themes—that is, fisherboy and fishergirl subjects—in sculpture as in painting allowed for the presentation of the nude without the encumbrance of allegorical justification, and therefore they abound in neoclassic sculpture. The best-known work by William Randolph Barbee (1818–68) is *Fisher Girl (Ill. 5–14)*.

Nearly all the American neoclassic sculptors created one or two male nudes, mostly youths or young men, some alive and some dead. As is true of William Henry Rinehart's *Leander,* the genital region was almost never uncovered. The male nudes

were not, of course, as popular as the female. *Leander,* for instance, was one of a matched set of *Hero* and *Leander,* which could be ordered and purchased separately or together *(Ills. 5–19 and 5–20)*. Only one collector owned both, and Rinehart had at least eight orders for the female figure *Hero* (loosely based, by the way, on Dannecker's *Ariadne*) and only two orders for the *Leander,* despite the fact that the *Leander* is probably the finest male nude by any of the American sculptors of the period. Among similar figures are one by the Vermont artist Larkin Mead (1865–1910), Powers's *Fisher Boy,* and John Adams Jackson's (1825–79) *The Culprit Fay (Ill. 5–25)*, based on the popular poem by the American Joseph Rodman Drake. Again, both figures are young and softly defined, so that characteristics suggesting power, virility, or sensuality are almost completely absent.

If the white male figure was usually a youth and, with rare exceptions, either clothed or with a rather poorly defined physique, the Indian male figure was powerful and heroic. (The only major exception is the figure of the Indian in *The Rescue* by Horatio Greenough on the portico of the Capitol, which is also the one neoclassic representation of the Indian as a savage and ferocious creature, here restrained by the colossal

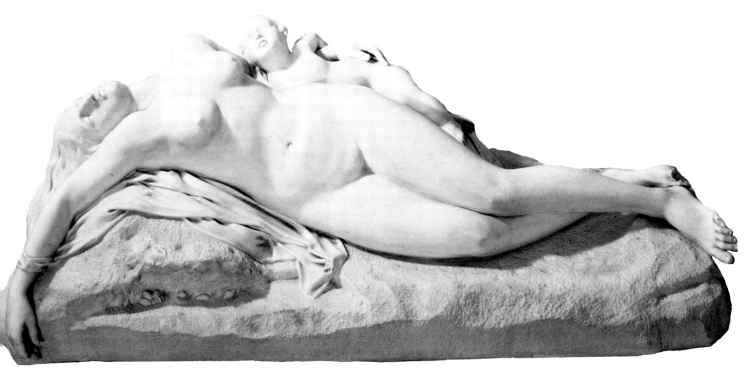

5-17. Edward A. Brackett. *Shipwrecked Mother and Child.* 1850–51. Stone. Worcester Art Museum, Worcester, Massachusetts. Gift of Edward A. Brackett.

5-18. Benjamin Paul Akers. *The Dead Pearl Diver.* 1858. Marble. Portland Museum of Art, Portland, Maine. Gift of Mrs. Elizabeth Akers Allen *et al.,* 1888.

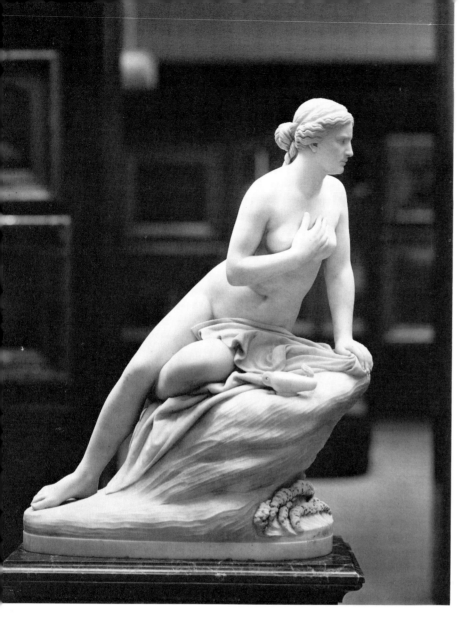

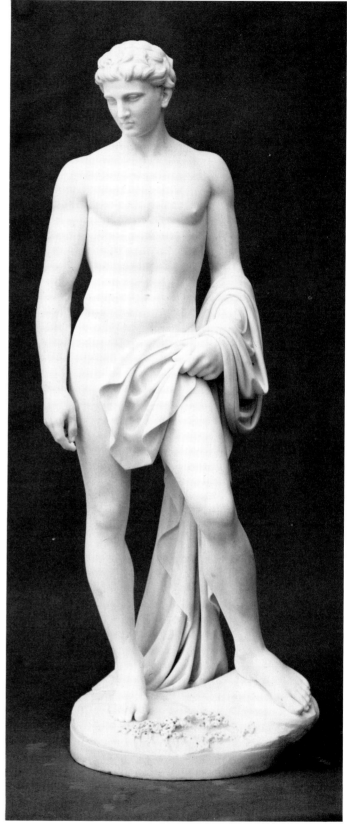

ABOVE
5-19. William Henry Rinehart. *Hero*. 1869. Marble. Courtesy of the Pennsylvania Academy of the Fine Arts, Philadelphia.

RIGHT
5-20. William Henry Rinehart. *Leander*. Ca. 1858. Marble. Collection of The Newark Museum, Newark, New Jersey.

figure of the frontiersman, who is, however, clothed). The neoclassic Indian remains naked and a symbol of a lost or departing world, the primitive innocent pushed out by the oncoming Europeans. In Thomas Crawford's *Dying Chief Contemplating the Progress of Civilization,* part of his conception for the Senate pediment of the Capitol, the figure is Indian only in costume and attributes—his physique and his features are classical (*Ill. 5–21*). On the other hand, probably the finest sculptured savage, the *Wounded Indian* of the Boston artist Peter Stephenson (1823–60), the first teacher of Harriet Hosmer, is a tragic figure with Indian features, and the verisimilitude extends even to a careful contrast of the arrows—those of the Indian and the one that has gravely wounded him (*Ill. 5–22*). Yet, despite the more accurate treatment of the Indian here, the magnificent expressive power of the body remains classical in inspiration, and the pose is taken from the *Dying Gaul* of antiquity.

The tradition of nakedness in the depiction of Indian warriors remained constant, from the earliest freestanding single figure of an Indian by Shobal Vail Clevenger (1812–43; though never put into marble, his *Indian Chief* of 1842 is known from an early line engraving) to *Hiawatha* by the young Augustus Saint-Gaudens (1848–1907), one of his few neoclassic works done in Rome (*Ill. 5–15*). One of the finest Indian sculptures of all, a portrait or "semiportrait," is the beautiful *Dying Tecumseh* of 1856 by the German sculptor Ferdinand Pettrich (1798–1872), who worked in America from 1835 to 1842 and later created the *Tecumseh* in Brazil. It is, again, the dying Indian theme, and at the same time the nudity is expressive of strength and virility even in death.

Except for Edward Brackett and Peter Stephenson, all the American sculptors dealt with here spent much of their careers in Florence and Rome. The one major American sculptor who made a name for himself equal to that of Powers and Story while in America was Erastus Dow Palmer (1817–1904) of Albany. His most famous, and most naked, sculpture was *The White Captive (Ill. 5–24)*, an obvious paraphrase of and challenge to Powers's *Greek Slave*. Slavery themes had a special fascination in the 1840s and 1850s, in the form of white, rather than Negro, slavery. In this case, the captive maiden bound and totally nude—is an American girl captured by the Indians, a subject closer to home and engendering greater patriotic feelings than Powers's Greek lady. She is also more nubile; Palmer seems to have preferred a somewhat more Lolita-like image than his transatlantic peers. Bondage and attendant chains, manacles, ropes, and such were an important aspect of American neoclassic sculpture. In those pre-Freudian days, the mixture of sex and sadism was fully displayed, if never discussed.

Many critics of the period, and some afterwards, too, emphasized the greater naturalness of Palmer's work as compared

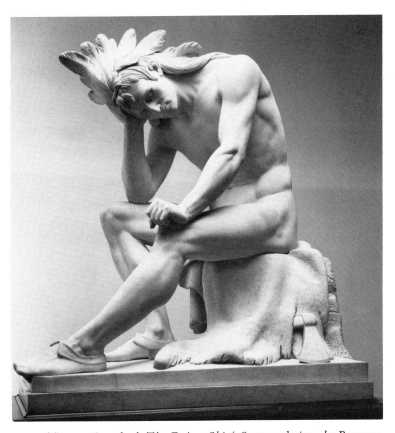

5–21. Thomas Crawford. *The Dying Chief Contemplating the Progress of Civilization.* 1856. Marble. Courtesy, New-York Historical Society, New York City.

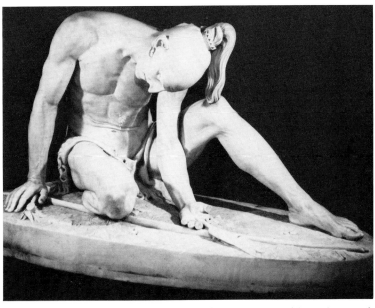

5–22. Peter Stephenson. *Wounded Indian.* 1850. Marble. Private collection.

5-23. Erastus Dow Palmer. *Indian Girl,* or *The Dawn of Christianity.* 1856. Marble. The Metropolitan Museum of Art. Gift of the Honorable Hamilton Fish.

to that of Powers, and Palmer and Powers were inevitably compared, representing as they did the highest American sculptural achievement. Despite the aversion to suggestions of sensuality, the critics could not help but emphasize the ability of their respective favorites in achieving verisimilitude of flesh, skin porosity, and the like. Powers was said to have been able to duplicate the actual texture of flesh through certain instruments with which he worked his marble; Palmer was commended for using live American models, rather than depending upon the borrowed inspirations of the antique.

Nudity was as important an aspect of Palmer's art as it was in the work of the artists working in Italy. His second best-known figure in the round was the *Indian Girl,* also significantly called *The Dawn of Christianity* (*Ill. 5–23*). More modest than the warrior brave, the Indian girl was usually shown fully clothed or half-naked, as in Palmer's statue or Powers's *The Last of the Tribe* (his last work and the female counterpart of the dying Indian warriors representing the end of the Indian civilization). She is also shown as more receptive to the great gifts of white civilization—the reason, generally proffered as acceptable, for the end of the primitive way of life. In Palmer's work Christianity again enters the picture, for the Indian girl has found a cross in the woods and stares with wonder and fascination at it; she has just become spiritually enlightened. This is not an isolated instance: Mozier's *Pocahontas,* more fully covered, though with one breast exposed, likewise holds a newly found cross, while at her feet is a beautifully carved deer, symbolic of the wilderness and the freedom of life in America before the coming of the white man.

A final variant should be mentioned: the white woman, who, having been captured by the Indians, refuses repatriation when the opportunity presents itself. This is the fictional subject of Mozier's *Wept of Wish-Ton-Wish* and the basis of Ives's most ambitious sculpture of all, *The Willing Captive,* which he created in marble in 1868 and is known today from the bronze version of 1886, in Lincoln Park, Newark, New Jersey. Ives's sculpture is based on an actual historical incident. It depicts the young white woman clinging to her warrior husband, blind to the entreaties of her aged mother to return to white civilization. The Indian brave is, again, half-naked and, like Crawford's *Dying Chief,* quite classical in the idealization of his heroic muscularity. He is, thus again, the embodiment of physicality and sensuality, believed to be inherent qualities of primitive man.

Another acceptable subject for the presentation of the nude was Adam and Eve. Statues of Adam alone are not known; Eve is the dominant figure in her role as the origin of sin (implicit in her nudity) and the first mother. We have already seen two examples, early and late, by Powers, who carefully distinguished between Eve-before and Eve-after the Fall. In contrast to Powers's standing *Eves* was Edward Sheffield Bartholomew's (1822–58) seated one, a despondent and totally nude *Eve Repentant* (*Ill. 5–26*). Adam and Eve together made a meaningful theme for ambitious two-figure

5–24. Erastus Dow Palmer. *The White Captive.* 1859. Marble. The Metropolitan Museum of Art, New York. Gift of the Honorable Hamilton Fish, 1894.

5–25. John Adams Jackson. *The Culprit Fay.* n.d. Marble. The Art Museum, Princeton University, Princeton, New Jersey.

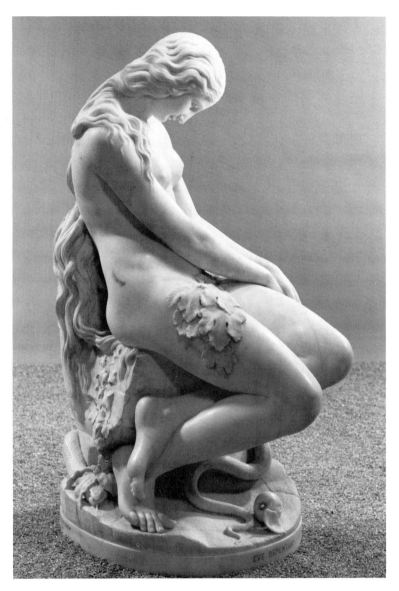

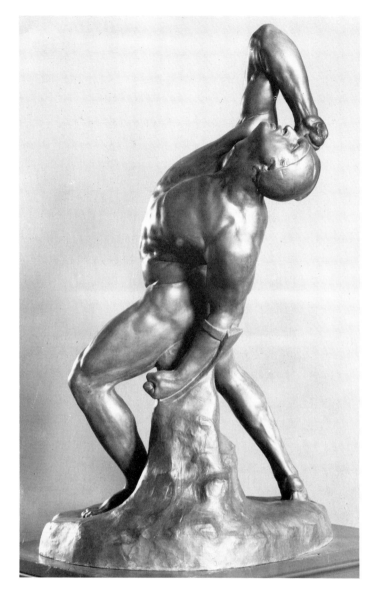

5-26. Edward Sheffield Bartholomew. *Eve Repentant*. 1858-59. Marble. Courtesy, Wadsworth Atheneum, Hartford, Connecticut.

5-27. William Rimmer. *The Falling Gladiator*. 1861. Bronze. Courtesy, Museum of Fine Arts, Boston. Gift of Miss Caroline Hunt Rimmer, Mrs. Adelaide R. Durham, and various subscribers.

groups, such as one of 1855 by Thomas Crawford and one by Joseph Alexis Bailly (1825-83), a Parisian artist who came to America in 1848 and ultimately became the most significant sculptor residing in Philadelphia. Both Crawford's and Bailly's groups depict Adam and Eve after the Fall, in despondency and frailty, which is emphasized by their nakedness. The theme, of course, was unusual in permitting the conjunction of male and female nudity in a situation acceptable to Victorian America.

An unusual neoclassic treatment of nudity is the *Woman Triumphant,* or *Triumph of Chastity,* of 1865-77 by Joel Tanner Hart (1810-77). His subject was praiseworthy indeed in Victorian America—the glorification of womanhood and of

chastity—and it is presented in a manner similar to that of *Love Captive* by Horatio Greenough and *Poor Cupid* by Edmonia Lewis (1843-after 1893). Yet the triumphant woman who has snatched away Cupid's dangerous arrow is a completely naked figure. Admittedly, she is quite simplified and abstracted and resembles quite closely Powers's *Greek Slave* (not surprisingly, since the two artists were good friends). But, like the *Slave,* Hart's figure is a curious combination of the condemnation of sensuality with its presentation in a manner as strong as could be acceptable in mid-nineteenth-century terms.

A contemporary of the neoclassicists was William Rimmer (1816-79), the most individual and perhaps the finest of all

the nineteenth-century sculptors in America.[13] Rimmer was born in England and was brought to Nova Scotia at the age of two and to Boston at the age of ten. He began his artistic career as a painter but soon turned to sculpture, first as an amateur but later as a professional. He also studied and practiced medicine, and the combination of artistic skill and anatomical knowledge was one of the factors that make his work so outstanding. However, Rimmer's career was one of much frustration. His style was uncongenial to the more sentimental tastes of Victorian America. Yet his reputation grew in the last two decades of his life, and he became a well-known lecturer on art anatomy and a teacher of drawing and modeling.

It was not only his anatomical knowledge that separated Rimmer from his contemporaries but also idealism and personal emotionalism, which had been in part inspired by Washington Allston. The most complete expression of Rimmer's sculpture is to be found in *The Falling Gladiator* of 1861, created for his most important patron, Stephen Perkins (*Ill. 5–27*). Although it is classical in theme, the sense of bodily strain and struggle in this nude was unique. Shown in the Paris Salon of 1863, it appeared so lifelike that the artist was accused of having cast the work from a living model, an accusation that had been hurled earlier at the Italian sculptor Giovanni Dupré and later at Auguste Rodin. Indeed, in the sensuous, undulating surfaces of the work and its alternating patterns of light and dark, Rimmer's sculpture presages the impressionism of Rodin.

Equally impressive is Rimmer's sculpture of ten years later, *The Dying Centaur* of 1871 (*Ill. 5–28*). The subject, half-human and half-animal, has often been interpreted as a symbol of the artist himself; the amputated arm reaches toward the heavens while the animal nature crouches close to the earth. Again, the sense of strain and stress, the expression of agony, and the powerful anatomical display make this unlike the work of any other artist of the day.

Despite the classical subject of these two works, they are obviously not neoclassic in style. In his lectures, Rimmer spoke of some of the major monuments of neoclassicism: He referred to Canova's statue *Hercules and Lychas* as confusing and meaningless and to Thomas Crawford's *Orpheus,* so famous in Boston, as one of the worst examples of modern art. Yet, though not a neoclassicist, Rimmer believed that sculpture should strive for idealization and generalization, and he condemned the work of the naturalist sculptors such as John Quincy Adams Ward.[14] But if Rimmer's theories seem to coincide with those of neoclassicism, they differ profoundly in their expressionism.

Rimmer made three other nude statues in the early 1860s, the *Chaldean Shepherd, Endymion,* and *Osiris*—all subjects from antiquity. All have been destroyed, but the *Osiris* lasted longer than the other two. It was shown in Boston and later exhibited at the Cooper Institute, and photographs of the work exist. Although it was Rimmer's personal favorite among his sculptures, it appears to have been more closely related to

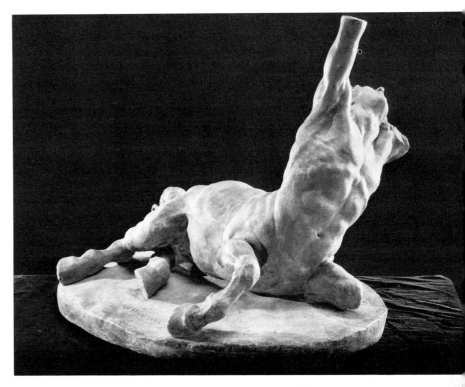

5–28. William Rimmer. *The Dying Centaur.* 1871. Plaster. Courtesy, Museum of Fine Arts, Boston. Bequest of Miss Caroline Hunt Rimmer.

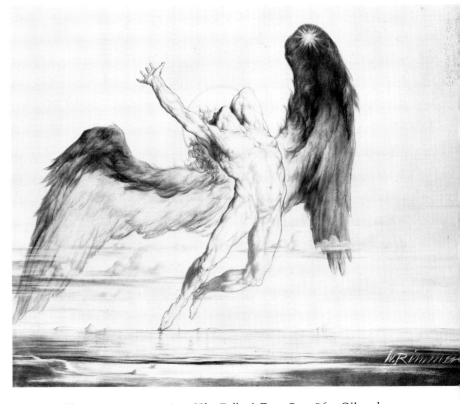

5–29. William Rimmer. *Evening: The Fall of Day.* Ca. 1869. Oil and sanguine on canvas. Courtesy, Museum of Fine Arts, Boston.

contemporary neoclassic work than any of his other, more individualized statues; it is, in fact, directly based on classical models. The artist, however, did employ a living model as reference. The figure, being in repose, was meant to contrast strongly with the *Gladiator.* Its most remarkable feature was that it had interchangeable heads—one of a man, one of a hawk—which could be alternated at will. Rimmer himself preferred the hawk head, but the photograph of the work that has been reproduced shows the human one.

In the twentieth century, Rimmer's achievements as a sculptor have been accorded far more attention than his paintings. Though anatomical considerations are strong in his oils, the nude does not figure as largely as it does in his sculpture. Rimmer's expressiveness is to be found at its most magnificent in his treatment of male figures. When he treated the female form, whether in oil or in drawings, it was with a sense of generalization and a lack of any sensual expression, which renders the work rather pedestrian. As a draftsman, however, Rimmer was an exciting artist, generally, and his drawings of the male nude are probably the finest by any nineteenth-

century American.[15] In these drawings, the very real influence of Michelangelo is apparent in the musculature, the vigorous, even violent, contrapposto, and the glorification of the heroic. These drawings are often allegorical in theme, and their martial spirit is in keeping with the powerful treatment of the nude. The *Secessia and Columbia* of 1862, is a melodramatic but powerful reference to the civil conflict of the time. Probably Rimmer's finest drawing, or oil sketch, of the nude is his *Evening: The Fall of Day,* the largest of all his drawings (*Ill. 5–29*). It is very much like his sculpture of *The Dying Centaur* in the combination of beast and human being, a theme obviously of great interest to him. The Evening, too, like the Centaur, is a tragic figure, striving to rise but falling toward the ground, bent back almost double in its vain but heroic aspirations. The Evening figure throws up one powerful arm toward the heavens in a double gesture of reaching out and of despair; the other arm is bent back behind the figure, and the stumplike elbow is similar to the Centaur's amputated arm. The two works are fitting memorials in their respective media to the genius, the isolation, the striving, and the failure of America's greatest nineteenth-century sculptor.

The Academic Nude: Realism and Thomas Eakins

. BECAUSE OF ITS TRADITION and its medium, neoclassic sculpture presented nudity to a generally approving American public, but the nude in American painting remained an exceptional item until the 1870s and later. Even at the end of the century, Americans continued to be shocked at the spectacle of nudity on the walls of art galleries, but the situation had noticeably changed from earlier decades.

The reasons for the change are complex, but one certainly was the increasing number of European paintings of the nude that were being seen by Americans—no longer only "approved" Old Masters but also contemporary works. The majority of these were undoubtedly French, and, though the age-old proscription against things Gallic did not disappear, new factors tended to mitigate the condemnation. Another reason was the heightened artistic activity in the major cities in America on a public institutional and commercial level, which tended to make contemporary European art more familiar. Moreover, the new generation of wealthy Americans that appeared after the Civil War brought with it a need for culture and a lack of any tradition for it. Having acquired new economic and social position, these wealthy individuals quickly acquired cultural status by buying Old Master paintings and antiques; indeed, this generation was responsible both for the great collections of European art that eventually found their way to American museums and for the heightened interest in the accumulation of antiques and bric-a-brac.

The taste of these collectors, especially those in New York City, may at times have been vulgar, but it was also often candid, and in contemporary European art they liked the Salon nude, the nymphs of Adolphe William Bouguereau, and the September Morns of Paul Chabas. They looked at such "forbidden" works in European exhibitions and more occasionally brought them back to America. It was, in fact, the day of the barroom nude, but the qualitative range of the category was a wider one than is usually supposed; it encompassed crudely pornographic paintings of reclining ladies, with dimming lights behind the canvas to simulate the swelling and subsiding of the subject's breath, and such grandly opulent works as *Nymphs and Satyr* by Bouguereau

The Bouguereau is probably the most famous of all barroom nudes (*Ill. 6–1*). From the early 1880s to 1901 it hung beneath a fringed canopy in the bar of the famous old Hoffman House on Broadway between 24th and 25th streets in New York City. The picture was seen by the wealthy and influential, since the Hoffman House was the social center for the rich and famous of business, politics, and show business—from Buffalo Bill to Ulysses S. Grant. It was purchased by Edward S. Stokes for the Hoffman House after his release from Sing Sing, where he had been sent for the murder of Jim Fisk in 1872. The success of the Bouguereau started a vogue in America, and the Palmer House in Chicago and the Palace Hotel in San Francisco soon purchased paintings of nudes. Another

6–1. Adolphe William Boùguereau. *Nymphs and Satyr.* 1873. Oil on canvas. Sterling and Francine Clark Art Institute, Williamstown, Massachusetts.

version of the picture hung in the Barberry Room of the Berkshire Hotel in New York City—a work carried off by Salvador Dali after a dispute with the management![1]

Of course, nudity in art had not become totally accepted; it was simply far more common. As Samuel Isham, painter and art historian, wrote at the turn of the century:

> Against the paintings there was no such protest from outraged modesty. They were not bought, but they were admired and praised with few dissenting voices; but nevertheless, the nude had become imperfectly acclimated among us. We are a northern nation and a decorous nation, unlearned in artistic traditions and unacquainted with the artistic view-point. Interest in a picture is apt

to depend on the object represented and not on the manner of its representation, and before a painting of the nude the average beholder experiences some-thing of the same embarrassment that he would feel before reality. This is not so strange nor so derogatory to the national intelligence as it at first seems to artists and their friends. There were honest burghers in the Greece of Pericles who were horrified at an undraped Aphrodite, and equally excellent people of the Renaissance insisted that costumes should be painted over the figures in Michael Angelo's *Last Judgement.*

In those favored periods, as today, purely aesthetic delight in the human figure and comprehension of its beauty and expressiveness was limited to a comparatively small number of cultured people, but among them were some so powerful in the state as to be able to defend the artists and impose their taste upon the public. Even to-day the British Philistine and the French Bourgeois are hostile, and only the long list of acknowledged masterpieces and the authority of the cultured classes keep them from protest. In America, culture is democratic, the leisure class is small, its opinions carry little weight, and it is not very sure of its opinions. The very wealthy have much the same views on art as the rest of the people, and, being founded on social habits and moral considerations, they are not likely to be changed by ampler artistic knowledge. The suggestion may seem grotesque, but it is possible that public toleration of the nude is more advanced by certain widely circulated advertisements of soaps and porous plasters than by all the efforts of culture. Whether these considerations are sound, or not, the fact remains that in the annual exhibitions paintings of the nude are not numerous, are usually small in scale, and are treated decoratively rather than realistically. The carefully finished life-size study such as crowds the walls of the French and German salons is practically unknown.[2]

Isham's reference to the "decorative" nude perhaps especially evokes the work of Frederick S. Church (1842–1924), an artist who often related pearly pink nudes to equally pink flamingoes and other birds and beasts, thus not only going Chabas one better but also underlining the sense of simple innocence implicit in the "oneness" of man (or rather woman), beast, and nature—somewhat salacious *Peaceable Kingdoms.*

It is noteworthy that Isham relates the presentation of nudity to France and Germany, and the majority of American reflections of the Salon nude—such as those by Church, Julius L. Stewart (1855–1919), who, indeed, not only lived but died in France, Alexander Harrison (1853–1930), and George Willoughby Maynard (1843–1923)—are related to Continental art. Their ladies are usually presented in a natural setting, as, for example, in Stewart's *Wood Nymphs (Ill. 6–2)* and Harrison's *In Arcadia (Ill. 6–3;* a sensation in the Paris

Salon), and often in water; indeed, mermaids were themselves particularly popular, underlining the "animal" aspect of nudity, as well as adding a touch of exoticism, mystery, and myth. Maynard, who had a studio in Paris in 1878, is remembered by such works as *In Strange Seas* (*Ill. 6–4*), *The Mermaid,* and *The Sea Witch,* the last an inhabitant of the deep enveloped in the pale blue and green water rolling over her.

Wyatt Eaton (1849–96) was another American—actually born in Canada—who received his training in Paris before settling in a New York studio and producing homegrown interpretations of the Parisian Salon nude, in addition to grave, quiet portraits and reflections of Barbizon art. Probably Eaton's best-known nude was *Ariadne* of 1888, a recumbent figure set in a forest landscape (*Ill. 6–6*). Its acceptability depended —in addition to the general lessening of the proscription against nudity—on the sense of poetic feeling that contemporary critics discerned in the figure. Clarence Cook wrote in 1888, "Of late, [Eaton] has produced several poetic subjects in which the nude is treated in connection with landscape. . . . The pictures, mostly of small size, have been eagerly welcomed by amateurs and have excited the liveliest interest among the artists."[3]

Eaton had been a pupil of Daniel Huntington, but in 1872 he went abroad and studied in the atelier of Jean-Léon Gérôme; later he became a protégé of Millet, a combination of influences perhaps more curious than that received by the many earlier Americans who moved from Thomas Couture to Millet. Yet, for all the picture's pseudo-classicism, the success of Eaton's *Ariadne* may have been due in part to the successful integration of the nude figure and the gentle, enveloping landscape in which she lies—a melding not unlike that found in Millet's very different canvases.

In 1919 Frederic Fairchild Sherman wrote of Eaton's interest in the nude:

> Mrs. Eaton in her brief sketch of her husband's life says that, "one of his most cherished desires was to become a painter of the nude," and it may be added that his later years were pretty much devoted to the effort to realize this ambition. His works of this kind are few, but for purity and grace they are hardly to be excelled in American painting. The "Ariadne" in the Evans collection at the National Gallery is to my mind one of our three greatest paintings of the nude. Felicitous and natural in pose, rich and harmonious in color, sweet and pure in feeling it intrigues one with all sorts of happy suggestions of the idyllic charm, the tender and exquisite poetry of youth dreaming, as it were, in the safety of a paradise on earth. The "Ariadne" of John Vanderlyn is more famous because it is better known, but it is hardly so fine. Perhaps those who are partial to the painting of the period think it a finer work, but their reason for so doing can have nothing to do with any attribute of perfection save that which finds expression in the work of Bouguereau.

The Vanderlyn-Bouguereau type of nude has relatively little of the suggestion of life to recommend it, however perfect it may be in drawing and modelling. In color it tends to sugariness and in line approaches the fixity of a "cast." The fleeting flushes of color that give charm to Eaton's nudes, the suppleness of line that imbues them with the semblance of life, the earlier artists neither understood nor attempted.[4]

In his later years, Eaton seems to have tried to adapt the vigorous technique and a feeling for nature derived from his Barbizon studies to other traditional classical and religious subjects. A critic in 1917, years after the artist's death, summed up his career as follows:

> It was Eaton's lifetime ambition to become a great painter of the nude, and in his drawing "The Judgement of Paris" which he completed in 1886, some ten or twelve years after his weeks with Millet, we get striking evi-

6–2. Julius L. Stewart. *Wood Nymphs.* 1900. Oil on canvas. The Detroit Institute of Arts, Detroit, Michigan.

6–3. Alexander Harrison. *In Arcadia.* n.d. Oil on canvas. Whereabouts unknown. Photograph courtesy of Paul Magriel.

6–4. George Willoughby Maynard. *In Strange Seas.* 1889. Oil on canvas. The Metropolitan Museum of Art, New York. Gift of William F. Havemeyer, 1901.

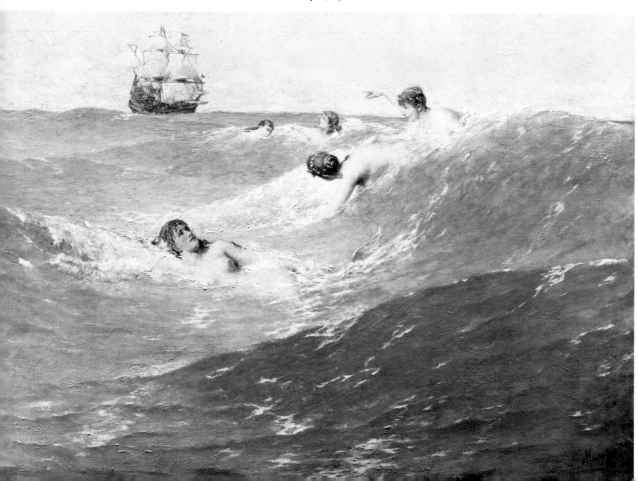

6–5. Will H. Low. *Ariadne on Naxos*. 1920. Oil on canvas. From the collection of the American Academy of Arts and Letters, New York. Gift of Mrs. Will H. Low, 1934.

6–6. Wyatt Eaton. *Ariadne*. 1888. Oil on canvas. National Collection of Fine Arts, Smithsonian Institution, Washington, D.C. Gift of William T. Evans.

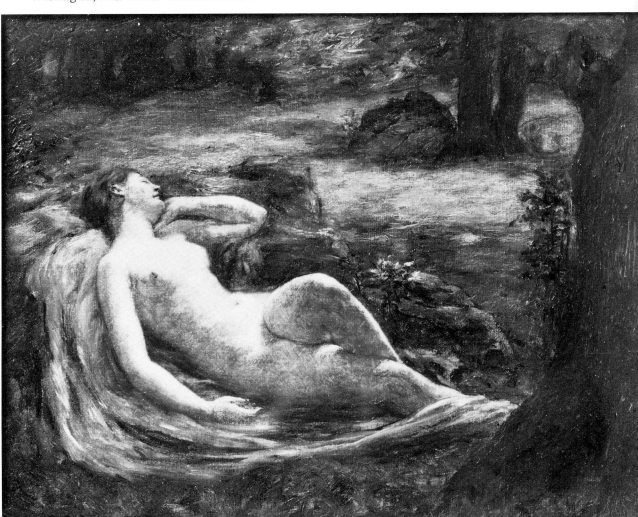

dence of his talent in that direction. This is Eaton's most consummate drawing, revealing that delicacy so characteristic of him and showing to a marked degree his poetical temperament, one that did not however, allow itself any poetical licence as regards structural accuracy. The figures of the shepherd and the three goddesses have all the refinement of a silver point, and yet bespeak that knowledge which comes with academic training; so we need not wonder that before even setting to work on this large drawing he had made numerous studies for its component parts. . . . Apart from two studies of nude men there are, I think, only six recorded canvases in which his brush has interpreted with loving refinement the unclothed human form. The "Magdalene," the "Ariadne," and a delightful painting in the Angus collection at Montreal are probably the finest three.[5]

This late nineteenth-century classicizing strain can be seen in the works of Will H. Low (1853–1932) as well.[6] It is indicated not only in his titles, *Chloe, Daphne,* and *Ariadne on Naxos* (*Ill. 6–5*), but in his introduction of classical attributes and draperies and, more important, in a dependence upon French classical traditions that manifested itself in balanced compositions and graceful lines. Low, too, placed his lovely ladies in outdoor settings, showing a concern with the *plein-air* traditions of Barbizon. Low's work, however, is considerably more fluid and broad than that of a number of the painters previously discussed, and this can be attributed to his study with Charles Emile Auguste Carolus-Duran in Paris—along with John Singer Sargent, Irving Wiles, J. Carroll Beckwith, and others. Carolus-Duran was considered something of a modernist among the teachers in Paris, for his instruction was based much more upon direct, unctuous painting than was that of Gérôme or the teachers at the Académie Julian, who favored labored drawing as the basis for their instruction, and this richer and more vivacious technique can be seen in the work of his pupils.

Women artists of the late nineteenth century were little involved with the depiction of the nude, but Lillian Genth (1876–1953) is notable for her singular devotion to the subject. While Miss Genth painted other subjects—portraits and figure pictures—the great bulk of her art fitted firmly within the category of the American Salon nude, and she alone received the tribute of an article acknowledging her as "our American Painter of the nude."[7] Confirmation of her acceptance as such is to be found in the large numbers of her nudes in major American museums (albeit now in the basements!)—the *Springtime* at the Metropolitan Museum or the *Adagio* (*Ill. 6–7*) in the National Collection of Fine Arts, which is referred to as her masterpiece and, logically enough, critically equated with Eaton's *Arcadia* and Benjamin Fitz's *Reflection* (see *Ill. 6–8*). She seems to have remained faithful to the formula of a standing nude young woman—references were made to "healthy young beauties"—under bending branches of trees in a secluded natural setting, about to step

into the waters of a pool or river. Poetic titles were always affixed—*The Fountain of Life, The Sun Maiden, Sunlit Dell,* or *The Mountain Stream*—which suggest an interest in light and flickering shadow patterns, and Miss Genth's art was not untouched by impressionism; *The Sun Maiden,* in particular, was treated impressionistically. Yet her admirers acknowledged that her figures were symbols of life rather than living; neither accident, tragedy, nor drama ever entered into her conceptions. Her nudes are lovely and generalized, beautiful of form, happy of face. Their conventions seemed even to such of her admirers as Frederic Fairchild Sherman artificial, springing from a poetic retreat from contemporary reality.

A somewhat more vigorous and dramatic presentation of the nude emanated from Germany, particularly Munich, which was, with Paris, one of the two major centers for progressive artistic activity in Europe and for American study. One Munich-trained artist who is totally forgotten today is Benjamin Rutherford Fitz (1855–91). In his own time, however, Fitz was especially noted for one work entitled *The Reflection* of 1884, representing a young nude girl standing at the edge of a pool looking down into the water (*Ill. 6–8*). Fitz is quoted as having said at one time, "I do not see why a nude cannot be painted without suggestion of sensuality, with refinement and nobility of feeling. Some day I may attempt it."[8] Many contemporary critics felt he had succeeded: Charles Caffin wrote that the figure in *The Reflection,* "in its purity of drawing and feeling comes near to being the loveliest nude yet painted in America."[9] On the other hand, Caffin was conscious of the academic origins of the work, which are betrayed by the absence of any attempt to render the effects of light and atmosphere in an open-air setting. Fitz's painting was at one time owned by William T. Evans, the great collector of American art in the late nineteenth century and the first major donor of such art to the National Gallery (now the National Collection of Fine Arts); judging by the number of pictures of the period depicting the nude once in the Evans collection, his interest in the theme was not inconsiderable.

The history of painting in Munich in the late nineteenth century and American participation in developments there are more complicated than is acknowledged in most histories. For one thing, most Munich painting was traditional rather than progressive; even in the 1870s and 1880s the teaching there was just as academic as that at the Ecole des Beaux-Arts, in Paris. Most of the Americans who came to study in Munich were attracted to that city because of its fame as a center for monumental painting and thorough academic training, a tradition that originated under Ludwig I, who brought to Munich the Nazarenes Peter von Cornelius and Ludwig Schnorr von Carolsfeld, and which in the late nineteenth century was represented by Karl von Piloty, Hans Mackart, and others. It is true and significant that such American artists as Frank Duveneck, William Merritt Chase, Walter Shirlaw, J. Frank Currier, and others were impressed by the powerful imagery, the dramatic chiaroscuro, and the vigorous handling of paint of the Leibl-

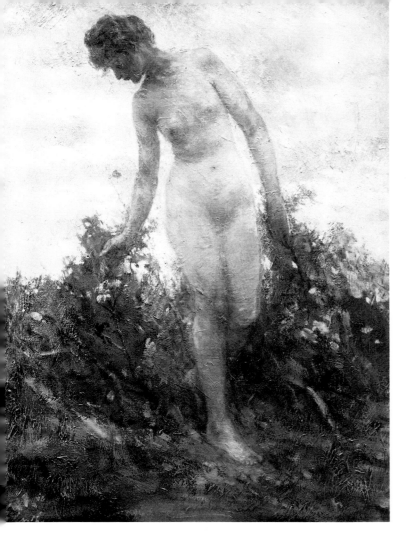

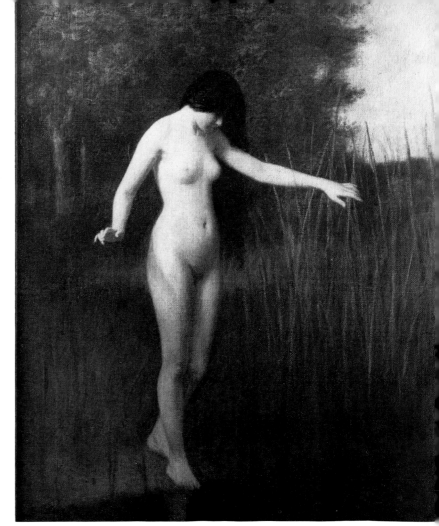

6–7. Lillian Genth. *Adagio.* n.d. Oil on canvas. National Collection of Fine Arts, Smithsonian Institution, Washington, D.C.

6–8. Benjamin Rutherford Fitz. *The Reflection.* 1884. Oil on canvas. Collection of Nelson Holbrook White.

Kreis, a group of radical realist artists influenced by Gustave Courbet and headed by Wilhelm Leibl, and turned away from their original academic pursuits; however, the artists who went to Munich earlier than Duveneck—David Neal, Toby Rosenthal, and others—worked entirely in the approved Munich tradition.

In joining the Leibl-Kreis, American artists were not necessarily improving their opportunities to depict the nude, for Courbet's vigorously realistic nudes were one aspect of the French master's art that his German followers do not appear to have adopted. But Courbet did inspire his German admirers with a new, more energetic approach to figure painting, in terms of a greater sense of reality and a rich and sensuous handling of paint that was radical insofar as it meant a new consideration of the picture plane, as opposed to an attempt at total illusionism. The reality came through in several ways. It led to a representation of the figure as seen, rather than as imagined or idealized—a recognition of the artistic virtue of presenting a truth, neither perfected nor romanticized. It also led to a dramatic, immediate response on the part of the spectator, erotic or sentimental, perhaps, but not "phoney." Leibl's peasants are dramatic, monumental, and truly moving,

betraying sentiment that is not cloying. Similarly, the urchins and street boys painted by Duveneck, Chase, and Currier are fresh, vigorous, and alive, with a vitality matched by the dramatic technique that is also implicit in the subject; they are a far cry from sentimental contemporary equivalents by such popular American artists as John George Brown and Karl Witkowski. It is to be regretted, therefore, that these artists seldom undertook the depiction of the nude.

Duveneck (1848–1919) did paint a number of nude figures in oils and pastels; his earliest etching was a reclining nude. His standing nudes have a sense of weightiness, a corporeality that is reminiscent of Courbet (*Ill. 6–9*). The best known of all his nudes is probably the *Reclining Nude* done in 1892. To say that it is "barroom" in its pose is a reversal of values. While the typical barroom nude concentrates on but one aspect, the erotic, Duveneck's work even in its unfinished state offers this along with a dramatic vigor and a sense of living surface in which painterliness exists in harmony with a tactile reality of flesh. The series of swelling surfaces is extremely real and alive, rather than abstracted in an Ingres-like manner.

While Duveneck turned his attention to the nude at various times throughout his career, he occupied himself with the sub-

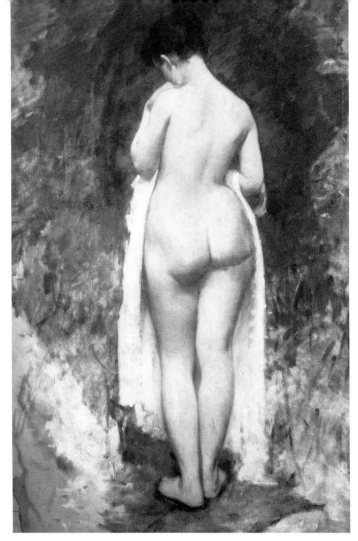

6–9. Frank Duveneck. *Standing Nude.* 1892. Oil on canvas.
The Cincinnati Art Museum, Cincinnati, Ohio.

ject particularly in the 1890s, the period when he taught at
the Art Academy in Cincinnati, which was attached to the Art
Museum. While his concentration upon the subject may have
begun as part of his teaching, the 15 or 20 paintings of the
period that investigate the nude in a variety of poses—sitting,
standing, reclining, front and back views—testify to his ab-
sorption in the subject.[10] Probably the most famous of these
is one entitled *Siesta,* a large, almost life-size pastel of a model
asleep on a bed (*Ill. 6–10*). This really *was* a barroom nude,
hanging in the saloon attached to the restaurant of Theodore
Foucar in Cincinnati. While women were not admitted to the
bar, the reports of the picture that filtered down to the ladies
of the town convinced them that the picture must be indecent,
and they demanded its removal. Foucar complied, not by with-
drawing the picture from view but by presenting it to the Art
Museum! He said at the time, "That girl was too naked for a
saloon, but she was not too naked for high society." Saloon art
is an aspect of American painting that deserves more attention;
some of America's finest artists of the late nineteenth century,
figure painters such as Duveneck, still-life artists such as Wil-
liam Harnett and others, had their works hung in bars, which
provided patronage and brought their work to the attention

of a large public. Such exhibition also undoubtedly helped to
encourage the choice of themes and directions, including a cer-
tain specifically masculine appeal noticeable in painting of the
time.

For William Merritt Chase (1849–1916), academic train-
ing and exposure to the Leibl-Kreis in Munich comprise only
two of many aspects of his extremely complex art, manifested
particularly in his early figure pieces and in still lifes through-
out his career.[11] Other influences and parallels in the art of
Manet, Whistler, Sargent, and Antoine Vollon can be sub-
stantiated. In any case, the nude appears rarely in his art, but
when it does the renderings are beautiful, and particularly
when the medium is pastel (*Colorplate 9*). After its popularity
in the rococo art of the eighteenth century, pastel fell into
disrepute in the neoclassic era, perhaps because it was too
closely associated with the aristocratic, the feminine, and the
sensual for the stalwart taste of Jacques-Louis David and his
school. Gradually, the medium was revived in the latter half
of the nineteenth century to find glorious expression in the art
of Manet, Monet, and particularly Degas, Odilon Redon, and
Gustave Moreau, as well as in the work of the American ex-
patriates Mary Cassatt and James A. M. Whistler. In 1882, the
Society of American Painters in Pastel was formed, with Chase
as one of the founding members. Several of his softly, sensu-
ously formed nudes, their backs to the spectator, are marvel-
ously delicate, glowing in the light tonalities only achievable in
this medium and manifesting the influence of Whistler and of
impressionism rather than the dramatics of Chase's Munich
years.

All of Chase's nudes in pastel appear to be drawn from the
same model, probably his wife. They include such accessories
of Japanese exotica as screens and kimonos and testify to the
Japanese influences in Western art at the time, and perhaps
here even more specifically to the influence of Chase's good
friend Whistler. It is noteworthy, too, that a Japanese sensitiv-
ity pervades these most delicate and refined of Chase's works.
At the same time, one cannot help but wonder if Chase had
become familiar with some of the Japanese prints of the nude,
in which he might have found not only shallow space and
broad areas of color, as well, of course, as native accessories,
but even the poses which he adopted for his own nudes.

There exist, as well as the pastels, a number of oils of the
female nude, including one well-known one, the *Reclining
Nude,* or *A Study in Curves,* which was shown at the Paris
Salon in 1900. The abstraction of the figure—as the subtitle
suggests—is reminiscent of Ingres, but the work has far greater
dynamism than do the French master's canvases and suggests
close parallels with Duveneck's art. The other oils include
several *Standing Nudes* at the Pennsylvania Academy and sev-
eral paintings somewhat disguised by descriptive titles, such
as the *Red Shawl.*

One of the better known American artists trained in Munich,
the one most devoted to the nude, and so known in his own
time, was Walter Shirlaw (1838–1909). Samuel Isham noted

that the decorative aspect of Shirlaw's art was more successful than the realistic,[12] and Shirlaw's nudes are decorative renderings in landscape settings; however, he retained a vigorous painterly technique while lightening his palette in a departure from the dark dramatics of Munich. These paintings are thus rather more full-blooded, German-inspired equivalents of the Gallic works of Church and Eaton. As in the latter, however, Shirlaw's ladies are always in outdoor settings, by pools or rivers, as in *The Bathers* or in *Water Lilies* (*Ill. 6–11*). Sometimes they were given such high-sounding allegorical titles as the *Spirit of the Lily* or the *Spirit of Autumn Leaves,* but they were no less nude for all that! Caffin has pointed out, too, that Shirlaw and Eaton both preferred a "riper type of beauty" than did Fitz.[13]

Shirlaw had a significant influence upon younger artists at the end of the century, for when he returned to America in 1877 he became one of the first painting instructors at the Art Students League. The following year, Chase replaced Shirlaw with his famous classes in painting, but Shirlaw in turn took Frederick S. Church's place as composition teacher. When in 1877 the Society of American Artists, a new and temporarily more vigorous organization than the moribund National Academy of Design, was founded Shirlaw became its first president. The society represented a new, more modern force in American art, since most of its members had only recently passed from the rank of student, and with Shirlaw as president, Wyatt Eaton as vice-president, and such members as Low and Chase, the Society of American Artists may be reckoned as one more

—albeit temporary—force in liberalizing American art, including its attitude toward the nude.

The type of nude depicted in most of the canvases of such artists as Church, Eaton, Maynard, Fitz, and even Shirlaw may be termed, because of both its aesthetic and its primary derivation from French academic art, the academic nude. It—she, usually—was popular enough in American exhibitions and marked a breakthrough for the subject matter. Her studied artificiality was diametrically opposed, as we shall see, to the powerful realism of artists like Thomas Eakins in America or Gustave Courbet in France, however much both these artists were influenced by their training in the art of the figure in French academies.

Charles Caffin summed up the nature of the academic approach to the nude rather succinctly:

> And here a word may be said upon the subject of what many arbitrarily call the "ideal" picture. It involves the use of the nude or of figures wrapped in draperies, for the most part, supposed to be "classical." This class of motive is based upon the assumption that the painter's duty and privilege is to improve upon the imperfections of the human form and to give the figure an ideal perfection. Therefore the world of real men and women will not do; the painter must invent some fancy of his own. As a rule, he does not so much invent as follow along some well-worn ruts that have led for centuries to the same goal. Here some nymph of antiquity for the thousandth time

6–10. Frank Duveneck. *Siesta.* n.d. Oil on canvas. The Cincinnati Art Museum, Cincinnati, Ohio. Gift of Theodore M. Foucar.

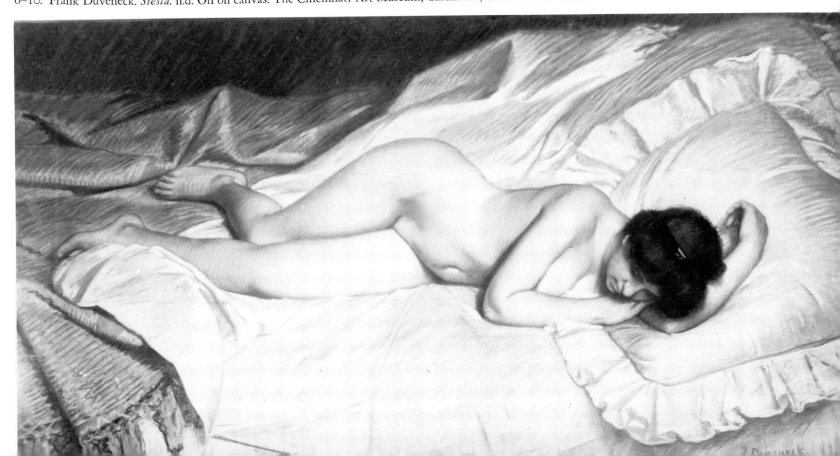

disposes of her maiden beauty to invite the approach of her divine or human lover; or steps into her bath or merges therefrom; or beautiful youths and maidens pose themselves in self-admiring groups, or weave their bare limbs and nicely calculated draperies into a rhythmic maze. The innumerable changes rung on these and such like themes have produced some of the most beautiful pictures in the world, but by artists who were nearer to the sources of Classic culture than we are to-day, especially in America. Regarded as a product of ourselves, such modern pictures are at best a graceful affectation; and, as a consequence, reach only a pretty mediocrity.[14]

Only rarely did American artists undertake more dramatic or melodramatic themes derived from classical antiquity and involving the nude, as in *The Bacidae* of Sarah Paxton Ball Dodson (1847–1906), an important woman artist of the period who exhibited at the Paris Salon (*Ill. 6–13*).

The slow liberalization of Victorian bourgeois attitudes was neither unimpeded nor uniquely American. Indeed, as one writer has noted, there was a "triumph of nudity" at the end of Queen Victoria's reign in England.[15] There, however, it came about as much because of a renewed enthusiasm for classical antiquity as because of a greater regard for the beauty of the human form. The nude also appeared more frequently in England because of the increasing number of art schools in London where the undraped model could be studied, drawn, and painted, not only at the Life School of the Royal Academy but at such schools as Sass's, Heatherly's, and the Langham Sketching Club. The days when John Gibson, the great neoclassic sculptor, had to resort to body snatching in order to study human anatomy were becoming increasingly distant.

Even in England, however, opposition to both the study and the depiction of the nude figure still made itself felt from time to time. Probably the most celebrated incident was the presentation of a paper against nudity in art by the academician J. C. Horsley to the Church Congress of 1885, which provoked Whistler's well-known witticism, "Horsley soi qui mal y pense." Horsley became known as "Clothes" Horsley because of his strong stand against the representation of the naked form.

In America, too, art schools were gradually permitting the study of the nude more and more frequently, not without hesitancy and opposition, but, then, even in the Berlin Academy the study of the nude model was not permitted until 1875. Indeed, it should be reckoned that the growing liberalization in America's attitude toward the study and presentation of the nude had much to do with the increasing cosmopolitanism of both art and life in America. One of the by-products of the loss of the American dream of a purer civilization after the Civil War was a greater identification on the part of Americans with Europe. The belief in the superiority of American moral culture and in her divine mission had been shattered in the knowledge that strife, destruction, and rapaciousness equal to anything in European history could occur in America. And the moral feeling that had held nudity in art to be a European corruption was necessarily reduced in intensity in the increasing identification of Americans with European culture.

Not that the puritanical voice disappeared; in fact, it could still be heard issuing from even the more perceptive critics and artists. James Jackson Jarves, calling Manet the "painter-in-chief of ugliness," wrote that *Olympia* "was naked, but as her flesh was as of the hue of green meat, there was nothing corrupting to the public morals in the gross display of her flaccid charms."[16]

One of the most detailed documentations of late nineteenth-century prejudice against the presentation of the nude is an interview in 1879 with George Inness by the editor of *The Art Journal*. Inness himself was, of course, not primarily a figure painter, and his aversion to some of the newer directions of contemporary painting such as impressionism is well known, but it is still a surprise to find him filling the role of the J. C. Horsley of American art!

> "Considerable interest seems to be taken at present," said Mr. George Inness, "in the subject of the nude in Art. It is a subject on which many artists hold views much more conservative than they are given credit for. . . ."
>
> "What, then," I asked, "is the test for pictorial impurity?"
>
> "The point I start from," he replied, "is the motive of the artist. If his motive is pure, his work will convey pure ideas. This rule is simple, and can be verified. It is of universal application. Test it for yourself."
>
> "Yet, doubtless, it would commend itself to every moral philosopher."
>
> "Specialists in morals are not authorities on Art. Art is above any ideas that moralists possess—just as religion is above any such ideas. . . . The artist must never forget that in nude figure-painting, when the ideal is ignored, the tendency is inevitably lustful. The nude human form should never be painted for its own individualities— there is no use in so doing—but from a desire to represent beauty in form. Otherwise the result is invariably shocking to modesty. We don't need to contemplate individualities and peculiarities of the male or female figure, unless we are anatomists or surgeons. . . ."[17]

Victorian prohibitions sometimes took a long time in dying and, of course, still exist. The *New York Herald* found it fitting to report on a distressing event at the Carnegie Institute in Pittsburgh late in April, 1907, when a group of plaster casts after famous European masterworks were put on exhibition.[18] Despite the enthusiasm of the director, John W. Beatty, the trustees were shocked and declared that the people of Pittsburgh could not but be offended by such nakedness. As the newspaper observed, a solution was found, but it involved what amounted to the cornering of the fig-leaf market! An

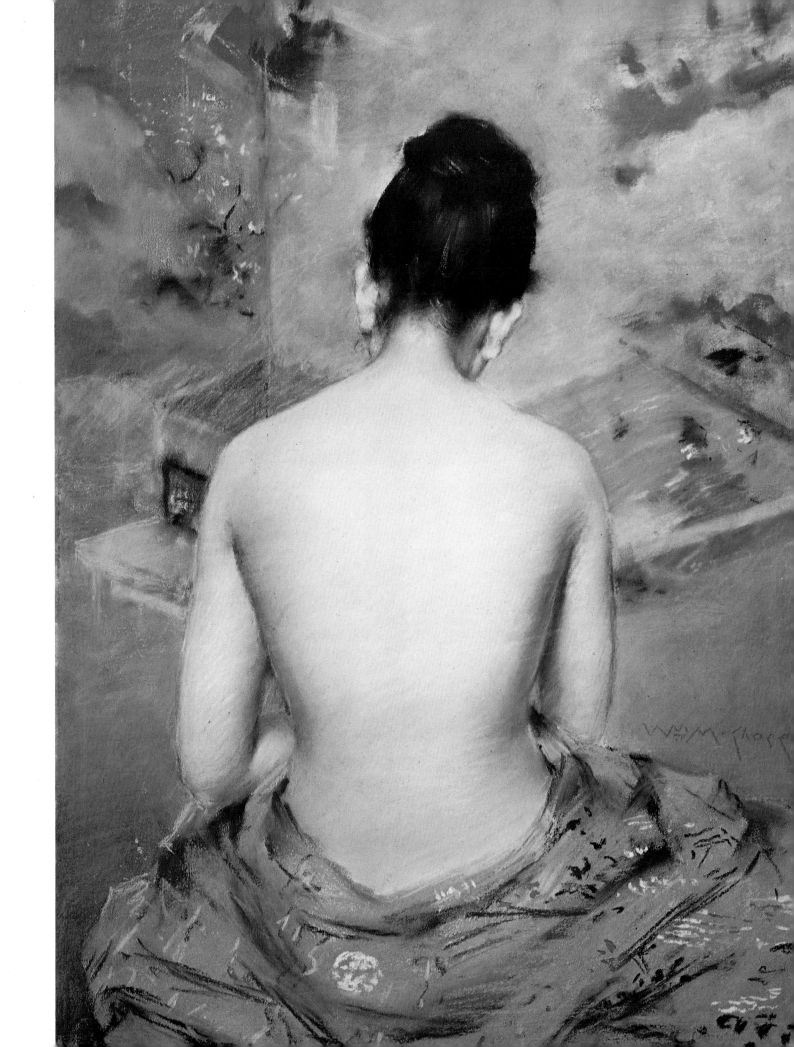

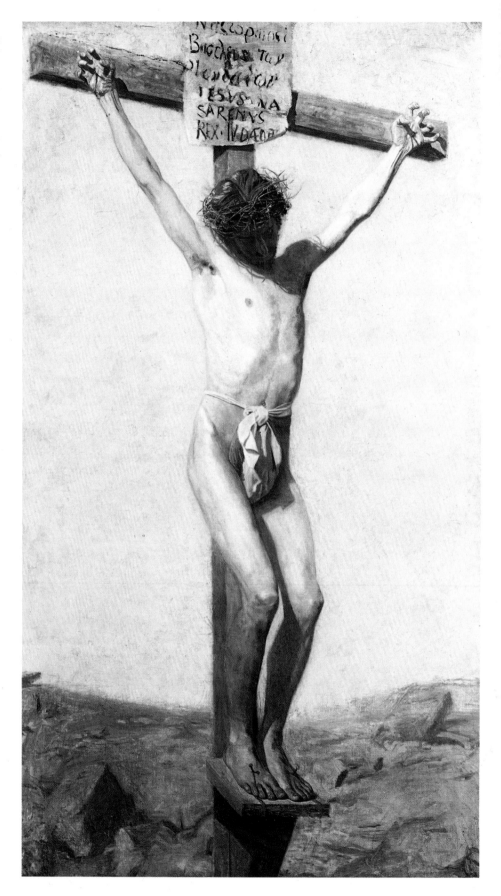

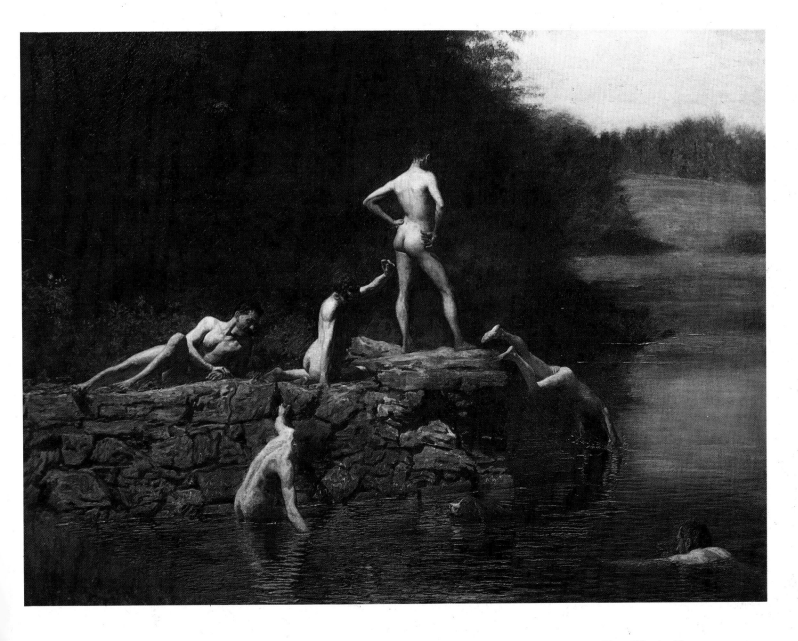

Colorplate 11. Thomas Eakins. *The Swimming Hole.* 1883. Oil on canvas. Fort Worth Art Center-Museum, Fort Worth, Texas.

FOLLOWING PAGE
Colorplate 12. William Morris Hunt. *The Bathers.* 1877. Oil on canvas. Worcester Art Museum, Worcester, Massachusetts.

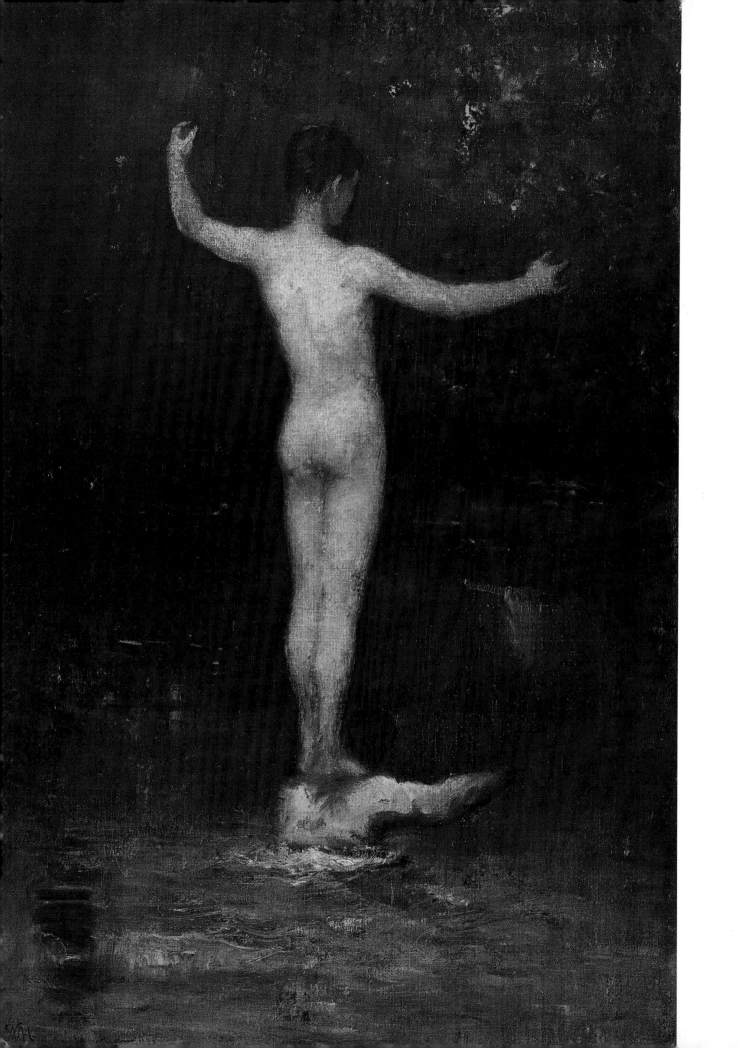

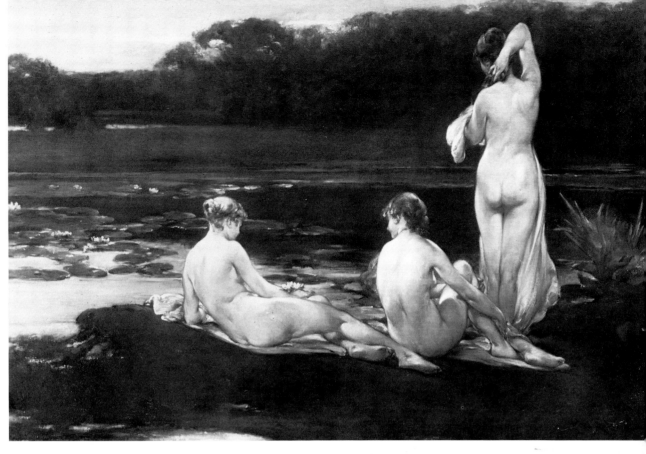

6–11. Walter Shirlaw. *Water Lilies*. n.d. Oil on canvas. National Collection of Fine Arts, Smithsonian Institution, Washington, D.C. Gift of William T. Evans.

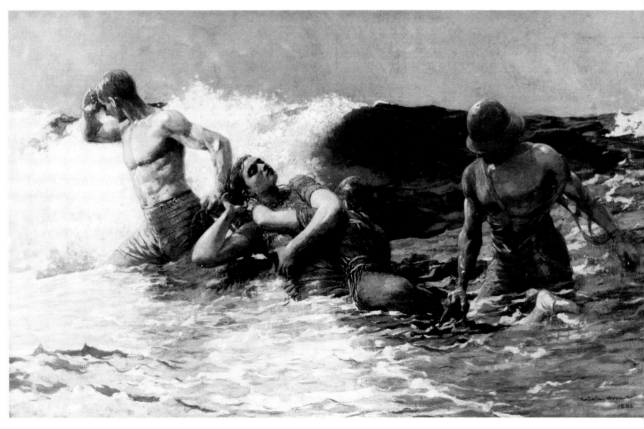

6–12. Winslow Homer. *Undertow*. 1886. Oil on canvas. Sterling and Francine Clark Art Institute, Williamstown, Massachusetts.

irony lies in the superior attitude of the New York newspaper, for one could find parallels enough in New York and elsewhere in America.

Of America's greatest realists of the late nineteenth century, one, Winslow Homer (1836–1910), was not interested in the nude to any degree. The closest Homer came to a serious study of the undraped figure is in a number of late Bahamian watercolors, where the glistening bodies of native blacks brilliantly contrast with the vivid light enveloping the scene and the white of the paper itself. The emphasis in the interpretation of these figures is upon the manly and the heroic, the sense of raw physical power that is communicated in all of Homer's art after his stay in Tynemouth in England in 1881–82. Homer utilized the partial nude in two of his most famous oils, *The Gulf Stream* of 1899, in which the small, half-naked figure of a black is pitifully contrasted with the merciless elements—the wild sea, the savage sharks, and a typhoon—and one of his most complex figural compositions, *Undertow* of 1886 (*Ill. 6–12*), in which four figures—two near-drowned women and two male rescuers—are linked in a human chain in and against the rushing power of the water. Based upon an actual incident Homer had witnessed at Atlantic City in 1883, the scene was painted in a New York studio, where two models in bathing suits were wetted down while the artist observed the effects of the sunlight upon their bodies. The female figures are partially revealed beneath their drapery, but it is in the males that an almost Michelangelesque power and dynamism are achieved—as one might well expect from an artist whose painting is so ruggedly masculine as is Homer's later work. This partial nudity did not go unappreciated in the 1887 exhibition at the National Academy; a critic for the *New York Tribune* noted, "The superb figures are like sculpture in their modeling, and they have one of the prime qualities of sculpture in their physical grandeur and comparative repose. In his Bermuda sketches the artist suggested such figure work, but he has hardly equalled in his serious pictures these bronze heroes of the sea."[19] And another critic wrote:

> They seem more bloodless than ever here after the superb virility of Mr. Winslow Homer's *Undertow*. Two women . . . are being rescued by two stalwart coast-guardsmen. . . . One . . . is towing them by ropes . . . the second rescuer stoops to lift the heavy folds of a dress which retards progress. The first is half nude, his muscles as distinct and tense after the strain as those of an oarsman "well trained down" at the end of a hard-pulled race. His figure is modelled as cleanly and solidly as sculpture in the round, and his companion with clothing torn off and cut in strips by the struggle with the waves is another finely plastic figure.[20]

The male figure at the left is, indeed, solid and sculptural, as both early and contemporary critics have noted; while he is undoubtedly based upon posed models, the artist would seem to have been indebted to actual works of antiquity and/or of the nineteenth century (the little statuette of Poseidon of the second century B.C. in the Louvre comes to mind as a prototype, though not as a specific model). This is suggested not only because of the timeless, "frozen" pose of the figure, but also because its contrapposto seems somewhat ill suited to the activity in which it is engaged.

Homer's interest in the nude was minimal; the ruggedness and drama of his man-and-nature, or natural forces, confrontations precluded the investigation of the female nude, and he seldom chose to deal with male nudity. Homer's contemporary and peer Thomas Eakins (1844–1916) was far more concerned with the theme of the nude and dealt with it more strongly and forcibly than any American artist until comparatively recent times. Indeed, the problems that confronted the American painter desirous of studying the nude are strikingly exemplified in Eakins's career as student, artist, and teacher; they were made more complex by the nature of his own instruction, which led to his dismissal from his teaching post at the Pennsylvania Academy after his free use of the nude model, and by his own personality as well.

Eakins was born in Philadelphia, a city whose Quaker strain reinforced, perhaps even more than in most centers, a puritanical proscription against the nude. He began his artistic studies about 1861 at the school of the Pennsylvania Academy of the Fine Arts. There the course of instruction began, and continued for months and even years, with drawings from casts after the antique, rather than from the living model; the life classes to which Eakins finally gained admittance were held irregularly, and the female models wore masks to hide their identity. A number of drawings from the nude by Eakins exist from this period, which, though academic in their precise naturalism and sculptural form, already testify to a sense of monumentality and a feeling for corporeality (*Ill. 6–14*).

In spite of his attendance at the academy and at the anatomy classes of the Jefferson Medical College in Philadelphia, after five years Eakins still had little experience at painting. In the fall of 1866, finding that the academy had no more to offer him, Eakins departed for Europe, sailing for France and enrolling himself in the classes of Jean-Léon Gérôme at the Ecole des Beaux-Arts in Paris. Increasingly, Paris, even more than Munich, was becoming the center for study for American students, superseding London and, more recently, Düsseldorf. While ultimately Eakins was to react against Gérôme's emphasis upon drawing, and his own American experience was not to allow him the wide range of interpretation of the nude that was the basis of much of his teacher's art, Eakins nevertheless remained devoted to his master, and recent studies have shown striking parallels between Eakins's and Gérôme's art, both in subject and in style. It should be emphasized that it was Gérôme's pupils, rather than those of the other French academicians, who were led to an investigation of the nude, a group that includes such painters already considered as Julius L. Stewart, Alexander Harrison, and Wyatt Eaton.

Eakins's career as a painter of the nude is often discussed as a tragic example of the crippling effect of American puritanism, but that puritanism extended to him as well. In regard to the nudes crowding the annual Salon exhibitions in Paris he wrote:

> About twenty pictures in the whole lot interest me. The rest of the pictures are of naked women, standing, sitting, lying down, flying, dancing, doing nothing, which they call Phrynes, Venuses, nymphs, hermaphrodites, houris, and Greek proper names. The French court has become very decent since Eugenie had figleaves put on all the statues in the Garden of the Tuilleries. When a man paints a naked woman he gives her less than poor Nature did. I can conceive of few circumstances wherein I would have to paint a woman naked, but if I did I would not mutilate her for double the money. She is the most beautiful thing there is—except a naked man, but I never yet saw a study of one exhibited. It would be a godsend to see a fine man painted in a studio with bare walls, alongside of the smiling, smirking goddesses of many complexions, amidst the delicious arsenic green trees and gentle wax flowers and purling streams a-running up and down the hills, especially up. I hate affectation.[21]

After four years abroad, primarily in France, Eakins came home to Philadelphia in July, 1870. He returned with a combination of superb academic training, at the hands of Gérôme and Léon Bonnat, and a natural talent unique among American artists of the period. His training had only reinforced the realistic strain of his own aesthetic predilections, and his tendency to shun the "Phrynes and Venuses" certainly corresponded to that of the majority of his fellow Americans. Yet he was a figure painter. The figure, of course, had been a primary focus of American painting from its inception, first in the portrait, and, by the 1840s, as the mainstay of anecdotal genre, and, much more rarely, in paintings of grand-manner subjects. But artists devoted to an exploration of the expressive force of the human figure *for its own sake* simply had not existed, with the exception of a few such as Allston and Page, and even they dealt with historic themes. About the later nineteenth-century American figure painters, like Eakins newly trained in Parisian studios, Caffin wrote:

> Abroad the figure-painters devoted themselves primarily to the representation of the nude; then to classic and historic subjects, or to costume or peasant genre. But in

6–13. Sarah Paxton Ball Dodson. *The Bacidae,* n.d. Oil on canvas. Indianapolis Museum of Art. Gift of Richard B. Dodson.

6–14. Thomas Eakins. *Nude Woman Seated, Wearing a Mask.* Ca. 1866. Charcoal. Philadelphia Museum of Art. Given by Mrs. Thomas Eakins and Miss Mary A. Williams.

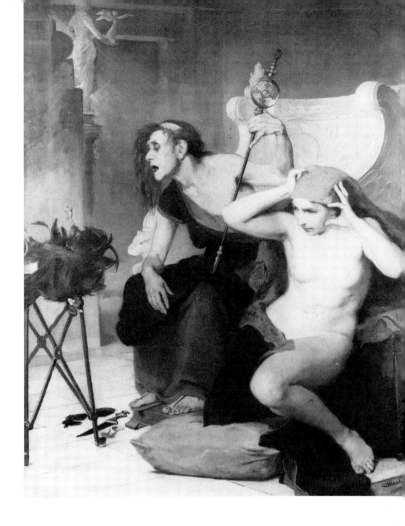

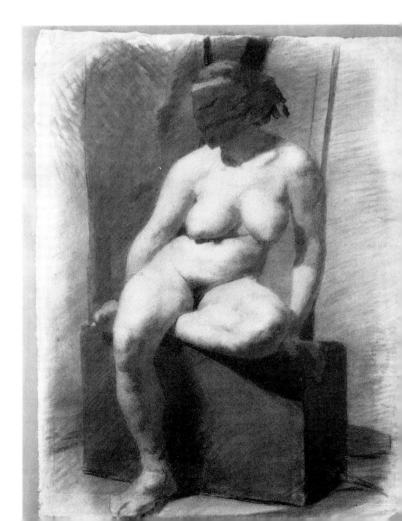

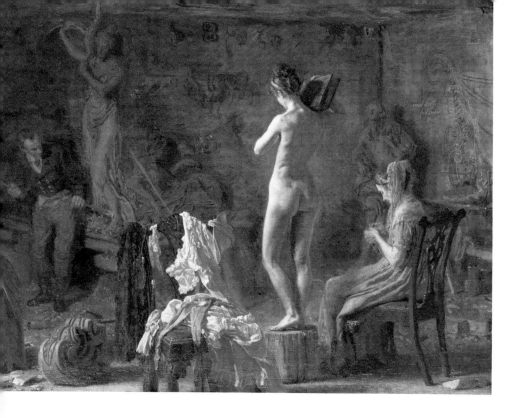

6-15. Thomas Eakins. *William Rush Carving His Allegorical Figure of the Schuylkill River.* 1877. Oil on canvas. Philadelphia Museum of Art. Given by Mrs. Thomas Eakins and Miss Mary A. Williams. '29-184-27.

none of these directions was there much opening for the painter in America.

To the American public the nude was scarcely distinguishable from the naked. It had not the familiarity with culture that discovers in the human form the highest symbol of abstract beauty; and two centuries of Puritanical tradition and prejudice had engendered a prudishness that even to-day, while not quite so virulent, is still prevalent and hidebound.[22]

It was not until 1877 that Eakins undertook his first painting of the nude; its subject is almost the only one he was to choose that utilizes the naked female form. The subject Eakins chose to depict was *William Rush Carving His Allegorical Figure of the Schuylkill River* (Ill. 6–15). It is a complex work, not only in its formal elements but in its psychological overtones. The theme must have had special meaning for Eakins. As a Philadelphia artist, he certainly remembered Rush as one of the major figures in Philadelphia art circles at the beginning of the century. He may have held Rush in special esteem as a kind of father of American sculpture, for his own sculptural interests were blossoming with the studies for this picture. Moreover, Rush had also defied convention in his use of the nude model. Yet for all its newness in Eakins's work and in American art of the period, the painting remains very much a part of nineteenth-century Western art. Artists had honored other artists by depicting significant scenes from their lives from the late eighteenth century on, and the practice reached an apogee first in the paintings by Ingres of the life of Raphael and later in Frederick, Lord Leighton's great depiction of *Cimabue's Madonna Carried Through the Streets of Florence in Triumph.* They both updated the past and established their own connection with it. American examples of this genre are few—Eakins also planned a scene from the career of Phidias—but European ones are innumerable, including several by Gérôme, his *Bramante Showing Raphael the Sistine Ceiling* and *Rembrandt Etching.*

Neither Rush nor Eakins actually utilized a professional model for his works. Rush's was a Miss Vanuxem, the daughter of a successful merchant, and Eakins's was a young teacher, a friend of his sister. Both works provoked a puritanical reaction in Philadelphia—Eakins's canvas, like Manet's *Olympia* and *Le Déjeuner sur l'Herbe,* probably more for the manner of the presentation of the subject than for nudity. Both Manet and Eakins contrasted rather unconcerned clothed figures with the dramatically illuminated nude and refused to idealize the figure. Eakins's picture is devoid of the symbols of innocence one finds in the "poetic" nudes of many of his contemporaries, and at the same time offered nothing of the smooth abstraction associated with traditional nudes, from Titian to Ingres. With her scrawny arms and heavy buttocks, his image is, as Lloyd Goodrich has called her, "a realistic figure, pictured not in an imaginary setting but in a studio."[23]

Interestingly, there is a sketch of 1876 for the picture in which the nude figure is heavier and Courbet-like. Eakins made some concessions to public taste in his final version of 1877. In the study both the chaperone and Rush are in modern dress; in the finished picture their costumes not only are historically accurate but, of course, help to remove the subject in time and, therefore, make it less likely to give offense.

Even so, however, when the picture was first put on display in 1878, critical reaction was unfavorable. While some disliked Eakins's color, or rather his lack of it, it was really the issue of nudity that bothered the viewers. The model was considered by many as ungraceful—these included the critics of the *Herald,* the *Tribune,* and the *Brooklyn Union Argus.* However, behind their seeming disapproval of the lack of poetic beauty, one senses another issue, which was at least acknowledged by the critic of the *New York Times*—that is, impropriety. That critic particularly condemned the pile of clothing doffed by the model, which he felt made the viewer aware of her nudity—and this, after all, was really the cardinal sin.[24]

Eakins returned to the subject of William Rush and his model at the end of his career in 1908. The composition is somewhat changed, and the overall warm, brownish tone is more striking; the touches of crisp color that animated the 1877 version are absent. In this much later version Eakins's identification with Rush is more complete, for he has given the sculptor his own features, while the chaperone, still knitting, is no longer an elegant matron of earlier days but a contemporary black woman—a contrast between the nude white woman and the clothed black woman to be found also in Manet's *Olympia,* but with very different intent. In both versions the model is seen from the back, but in another late picture Eakins depicted Rush assisting the model down from her platform, a frontal nude, with a realistic depiction of pendulous breasts, rather thick legs—totally unidealized (*Ill. 6–16*).

Eakins's next treatment of the nude—now masculine—also explored an unusual (for America) theme, but a very different one, *The Crucifixion* of 1880 (*Colorplate 10*). The work, much as the religious pictures of such European realists as Velázquez and Manet, has often been criticized for its lack of ideal sentiment; it appears to represent an attempt by Eakins to paint the nude male form in both an acceptable and a natural context. For this work, Eakins posed J. Laurie Wallace, a painter and his chief demonstrator of anatomy in his classes at the academy, uncomfortably strapped to a cross. Studies first near Pennsauken Creek, New Jersey, and then on the roof of his studio were made out of doors, though the final picture was painted inside the studio. It is not unlikely that Eakins had in mind the *Crucifixion* of his second French master, Léon Bonnat, which had been painted from a cadaver nailed to a cross. The emotional atmosphere is diametrically opposed, however; Bonnat's figure looks up to heaven, thus guiding the spectator's salvation; though emaciated, his Christ is still muscular. Eakins's, on the other hand, is a tragic figure—thin, bony, and unidealized. The head is totally in shadow and, slumping downwards, speaks only of despair and death.[25]

There exist a number of studies of both the individual male and female nude done by Eakins in 1882 and 1883, in both oil and watercolor, which are, in turn, based upon photographs. Eakins was, in fact, one of the first major American artists to base much of his work upon photography, and he was, indeed, a photographer of ability himself. Some of the photographs of

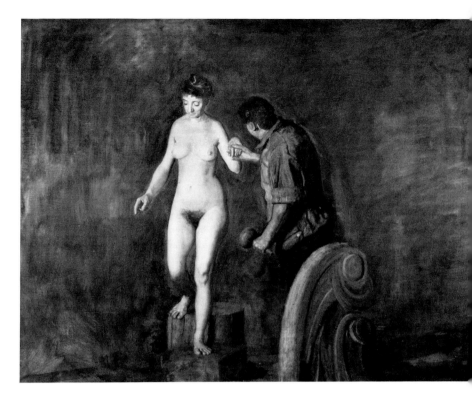

6–16. Thomas Eakins. *William Rush and His Model.* 1907–8. Oil on canvas. Honolulu Academy of Arts, Honolulu, Hawaii. Gift of Friends of the Academy.

6–17. Thomas Eakins. *Arcadia.* 1883. Oil on canvas. The Metropolitan Museum of Art, New York. Bequest of Miss Adelaide Milton de Groot, 1967.

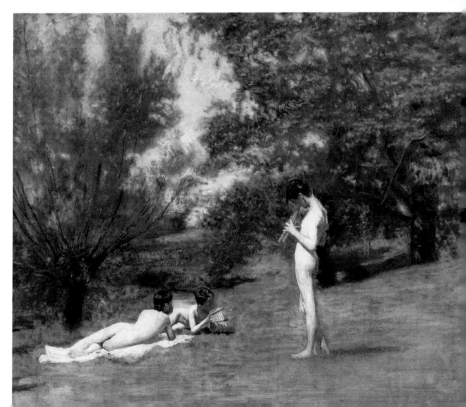

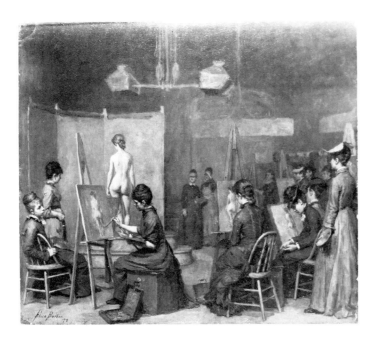

6–18. Alice Barber. *Female Life Class.* 1879. Oil on cardboard. Courtesy of the Pennsylvania Academy of the Fine Arts, Philadelphia.

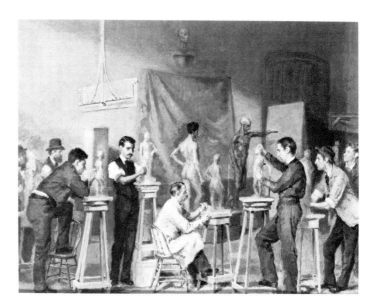

6–19. James P. Kelly. *The Modeling Class.* 1879. Oil on cardboard. Courtesy of the Pennsylvania Academy of the Fine Arts, Philadelphia.

male nudes and the oils based upon them show J. Laurie Wallace again, playing panpipes. These studies served Eakins both for his painting *Arcadia* of 1883, which depicts a nude girl and a nude youth lying on the ground, listening to another young man playing the pipes (*Ill. 6–17*), and for a bronze relief of the same subject, though the figures in both are younger than those in the preliminary oils and watercolors. *Arcadia* depicts his sister's children on their farm in Avondale, Pennsylvania.

These works have also been criticized for the peculiar dichotomy between the sharply realistic and unidealized figures and the classically pastoral setting and the arcadian tradition they reflect. Undoubtedly, the contrast was partly intentional, Eakins thus presenting his own answer to the coy idylls of Shirlaw and others. In part, too, it must have been intended to reflect an ideal, more pagan world in which the social and moral restraints under which Eakins labored did not exist, and this quality is underlined by the dreamlike yearning that is the picture's essential mood. Then, too, the subject was one that permitted Eakins the representation of the nude, even under his own strict standards of realism.

Between Eakins's early picture of *William Rush* and the later ones—a period of over 30 years—the nude or even the partially nude female hardly appears in his art; when Eakins treated the nude at all, it was almost invariably the male nude. It is noteworthy, for instance, that in his other arcadian picture, entitled *An Arcadian,* of about 1883, a female figure is resting on the ground, garbed in classical robes. (This was, of course, in correct classical tradition: nude children and youths but draped females.) A more pagan spirit burst forth in a picture

of 1883, *The Swimming Hole* (*Colorplate 11*), a display of lithe and strong muscular manhood in a pastoral setting, supple young men in a variety of positions—reclining, rising, standing, diving, and swimming. Wallace appears again, as does Eakins himself swimming in the lower right corner, looking at the others. The work is a kind of frieze of the male nude. The figures rise like pedimental sculpture in a triangular design with classical analogies; indeed, the reclining figure and the *Dying Gaul* are specifically related. Yet it is a very contemporary scene—one of the few in which the nude figure could actually be seen and studied without artifice; at the same time, the figures are amazingly like the photographs Eakins was undertaking at the time in order to study the movement of the nude form. It is almost as though the artist had excerpted a series of stills of a figure moving from "recline" to "dive," and chose the key poses and postures to illustrate the action.

This, while he himself looked on. Critics have spoken at great length about the naturalness of the scene and of Eakins's much-acknowledged love of athletics and physical prowess. But there is also something very sexual about this work, as, indeed, there is about Eakins's other depictions of male nudity. The love of youth expressed, the nobility and detailed muscularity of the figures, the caressing light, all suggest the sexual attraction on the part of that older man introduced into the composition as observer, or voyeur, at right angles to the general axial direction of the triangle of nude figures. Such sexuality is lacking in Eakins's few treatments of the female figure. Whether conscious or not, homosexuality may have contributed to a sympathy with Walt Whitman, whose great portrait

Eakins painted and whose poem "Twenty-Eight Young Men Bathe by the Shore" bears literary analogy to Eakins's *Swimming Hole*.[26]

Eakins's involvement with the nude was twofold. Not only was he concerned with it in his art, but it was the basis of his own teaching. (He took over the life classes at his own alma mater, the Pennsylvania Academy, when it opened its new building in 1876; in 1882 he was appointed director.) William C. Brownell, in an article in *Scribner's* in 1879, spoke of Eakins as a "radical" and a "revolutionary" and summed up his innovations as follows: first, his insistence upon painting immediately, rather than emphasizing the long ritual of months and years of drawing; second, his disregard for antique models and casts; third, his emphasis upon the study of anatomy, both human and animal (a course of training that Eakins had made himself undergo in his own student days); and, fourth, an emphasis upon the nude. Brownell obviously admired Eakins as an innovator but felt that there were dangers to his methodology—a love of anatomy and nudity for its own sake and an admiration for the ugly and the unpoetic.[27] There exist a number of paintings of about 1879 commemorating Eakins's teaching and his emphasis upon the nude model—most notable are Alice Barber's (1858–1932) *Female Life Class* (*Ill. 6–18*) and James P. Kelly's (1854–93) *The Modeling Class* (*Ill. 6–19*). Interestingly enough, she painted the women's class, he the men's—no integration there!

But as a teacher Eakins confronted not only aesthetic issues but practical and moral ones as well. To study the nude, nude models were necessary. Eakins changed these frequently, so that the students would have a variety of types and a variety of poses to deal with. In addition to professional models, he introduced athletes and circus performers. At times, Eakins asked some of his own students to model, and at one point one of his women students burst into tears and complained to her father. Eakins also posed both male and female models together. In 1882, one of his women students wrote an emotional letter to the president of the Pennsylvania Academy, J. L. Claghorn, hysterically condemning Eakins's classes as endangering womanly refinement and delicacy and insisting that the study of women's nudity was a promotion of licentiousness—and even attributing a furthering of immorality to the heat of the rooms in which the classes were held![28] Matters came to a head when Eakins removed a loincloth from the waist of a male model. This led to a protest on the part of the directors of the academy. Eakins refused to curb his practices and resigned; many of his students, including most of the men, sided with him, and they founded the Art Students League of Philadelphia with a plan of study based on the nude human figure.[29] Despite the high hopes for the organization, it lasted only six years.

The controversy over the teaching of the nude reached the press, and the typical reaction was on the side of propriety. The *Philadelphia Evening Bulletin* mentioned the matter on February 16, 1886, and reported:

Mr. Eakins has for a long time entertained and strongly inculcated the most "advanced" views. . . . Teaching large classes of women as well as men, he holds that both as to the living model in the drawing room, and the dead subject in the anatomical lecture and dissecting room, Art knows no sex. He has pressed this always disputed doctrine with much zeal and with much success, until he has impressed it so strongly upon a majority of the young men that they have sided with him when he has pushed his views to their last logical illustration by compelling or seeking to compel the women entrusted

6–20. Thomas Eakins. *Salutat*. 1898. Oil on canvas. Addison Gallery of American Art, Phillips Academy, Andover, Massachusetts.

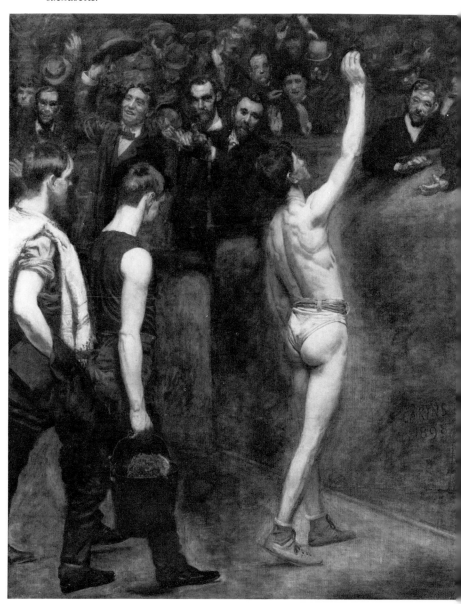

to his direction to face the absolute nude. That the women of the life school should have revolted at the tests forced upon them was inevitable.

It should be pointed out in all fairness that there were other reasons for friction between the directors and Eakins. One was financial: The school was not totally self-sustaining, and the directors had hoped it would be under Eakins. Another involved complaints concerning the limitations of Eakins's course of instruction—that is, his emphasis solely upon the figure. Eakins attributed the friction primarily to his brother-in-law, Frank Stephens, who wanted him out of the academy and who had suggested that Eakins was having illicit relationships with his students and models.

Eakins's later paintings of the male nude continued his investigation of athletic themes developed earlier in his rowing and sculling paintings of the 1870s. These include his *Wrestlers* of 1889—by the very nature of the theme, a combination of powerful anatomical forms and a complex interlocking of two struggling figures—and several other subsidiary studies of the male partial nude in the gymnasium. Eakins based his picture upon photographic studies he had made of wrestlers brought from the Quaker City Athletic Club to his studio.[30] The finest of his athletic pictures, though, are his three late boxing paintings: *Taking the Count* and *Salutat* (*Ill. 6–20*), both of 1898, and *Between Rounds* of the following year, all large, major works. The first two present the boxers close up in extremely powerful, monumental images; the boxer relaxing in *Between Rounds* is more removed from the spectator, and the emphasis is spatial and compositional rather than anatomical. In all three, the fighters as well as the other figures are actual individuals whom Eakins knew; the standing fighter in *Taking the Count* is reputed to be Charlie McKeever, the kneeling one Jack Bennett, "the Pittsburgh Boy." The contrast between the weary, crouching figure at the right and the more self-assured, upright McKeever is beautifully rendered, and the powerful anatomy is all the more striking as it is contrasted to the elegantly clothed figure of the referee. Even more monumental and heroic is the figure of

Billy Smith in *Salutat,* a scene in the Philadelphia Coliseum. His form is erect, its movement ascending, in contrast to the downward-looking attendants and the more earthbound, raucously applauding spectators. Dark, clothed, frantically active and all frontally viewed, they contrast in every way with the light and glistening nearly nude fighter, beautifully, even lovingly rendered. That Eakins has returned to a really pagan theme is evident not only in the physical nature of the picture but in its presentation as an almost gladiatorial rite—with a Roman title and a subject analogous to the famous gladiatorial scenes, also with Latin titles, painted by his revered teacher Gérôme. Eakins's boxing pictures have been criticized for their lack of motion and activity, but the painter's interest was in form, not dynamics; if he did not idealize the body, he found it glorious: "A naked woman . . . is the most beautiful thing there is—except a naked man."

One factor that must be considered in order to understand and appreciate Eakins's depiction of the nude is "realism." Not only are his nudes painted realistically, but the figures themselves are individualized and corporeal. The nude whom Rush-Eakins helps down from her pedestal in one later version of the Rush theme is no idealized or semiabstract creature, and it is the recognition of a personage from our own world that must have made Eakins's nudes more difficult to accept in their day than, for instance, those of Harrison or Fitz. Titian's nudes were acceptable not only because of their place in a grand tradition but because of their simplifications and abstractions of form; Eakins's various depictions of William Rush's model were too close to reality to be acceptable. His male nudes have the "real" heroism of the fighting ring, rather than the ideal heroism of the *Apollo Belvedere* or the Farnese *Hercules.*

These are all very masculine paintings by an artist who combined tremendous sensitivity with a love of rugged beauty and factualness. If the female nude had been more openly available to him and to contemporary society, perhaps she would have figured more strongly in Eakins's art. Even his treatments of the male nude are sadly few, but the series constitutes the apogee of the American depiction of the nude in the nineteenth century.

The American Nude at Home and Abroad

IN 1886, a large, expensively produced volume of reproductions of American paintings appeared under the title of *Book of American Figure Painters*. Among the works dealing with the nude illustrated in it were Wyatt Eaton's *Judgement of Paris*, a typical Frederick S. Church, *Friends in Council*, this time featuring a nude with bear, and paintings by H. Siddons Mowbray, S. W. Van Schaick, Walter Shirlaw, Childe Hassam, Francis Jones, Kenyon Cox, and George de Forest Brush. Paintings by other artists concerned with the theme, including Carl Marr, Alexander Harrison, Thomas Eakins, George Maynard, Thomas Dewing, John La Farge, J. Alden Weir, Abbott Thayer, J. Carroll Beckwith, Edwin Blashfield, and Elihu Vedder, were reproduced.

The book reflects the rise of figure painting as a primary area of creative expression among American artists of the time, as Mariana van Rensselaer noted in her introduction; we have discussed this and its origins in French traditions transmitted to America especially by students in the Parisian ateliers, and particularly by those of Gérôme. Figure painting, of course, did not necessarily involve nudity, but it could and often did. The approach to the nude, naturally, varied widely in both subject and style; in the *Book of American Figure Painters,* the range extended from the coy part-*animalier* of Church, to Eaton's classical studies, to American Indian themes in Brush's *Before the Battle,* and to the lugubrious allegory of Van Schaick's *The Dance of Death.*

126

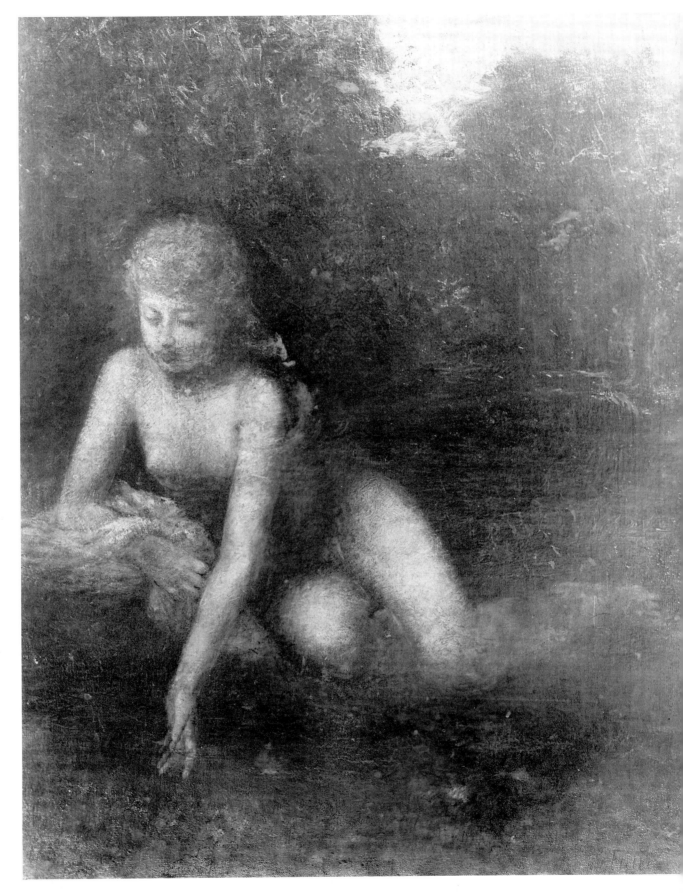

The variations in the approach to the nude were the result of many factors; these included the artist's own thematic predilection, training, specific purpose, and, not the least of these, aesthetic philosophy. The realism of Eakins, for instance, was only one tradition in late nineteenth-century American painting. Although in the exploration of that old chestnut, the "Americanism" of American art, realism has often been called the dominant approach, the truth is it was only one such strain —sometimes, as the mid-nineteenth century, a really significant one, sometimes much less so. At the end of the century, a resurgence of poetic romanticism existed side by side with realism; indeed, it is arguable that romanticism, from the paintings of Allston, Cole, Stuart, and Sully to the work of Ryder and La Farge, was fully as characteristic of the American aesthetic experience as was realism, if not more so.

For instance, it is interesting to note the variety of painters who chose to depict the "swimming hole" subject, one situation where the nude was available and observable in the ordinary round of experience. Eakins's treatment of this theme resulted in a frieze of strong, muscular nudes ranged against a clear landscape. Thomas Worthington Whittredge (1820–1910) was a landscapist, and his several versions of *The Bathers* show a limpid secluded brook, with a group of young men in the distance bathing naked. Whittredge's landscape has Barbizon overtones; Willard Metcalf (1858–1925) was an American impressionist, and in his rare figure picture *The Swimming Hole* a bright pattern of sunlight and shadows flickers over a group of nude youths, as in the work of the English Sir Henry Tuke (*Ill. 7–1*). More poetic and idealized are the treatments of the same theme by William Morris Hunt and George Fuller (*Ill. 7–2*). Even the portrait-painting Episcopal minister Henry Darby (1829–97) painted nude youths at the water's edge.

All of these artists brought a personal approach and personal experience to the same subject. At the same time, their paintings achieved a perfect mating of an informal and natural presentation of the nude with the unclassicized, informal natural setting that was a heritage of the Barbizon tradition. Nature, like the nude contained within it, was studied and presented naturally and shown to be in harmony with her human occupants. There is a quality more fresh and more wholesome about these pictures of bathing male nudes than one finds in their rather arch and coy feminine counterparts, which, like their French equivalents in the Salon exhibitions, seem stagey and artificial.

George Fuller (1822–84) seldom dealt with the nude. His career was a bizarre one, for, after involving himself in the art life of New York and Boston, he retired to his family farm in Deerfield, Massachusetts, in 1860. The failure of the tobacco crop of 1875, however, impelled him to return to the art world, and during his last years he gained great success in Boston, encouraged by William Morris Hunt. These years were given over to exploring rustic and imaginative themes painted in a poetic vein.

A number of Fuller's figure pictures have classical and poetic titles, such as *Nydia* and *Psyche,* though nothing could be further from classical tradition than the interpretations of these subjects. His only major female nude is the *Arethusa* of 1883, one of his last pictures (*Ill. 7–3*). In his "Homage to Fuller," Whittier captured some of its charm:

> By mystic lights soft blending into one
> Womanly grace and child-like innocence.

Frank Millet remarked that in this picture Fuller had "extended to the female figure the same sense of perfection of form and refinement of color which he has striven for in his heads. No more chaste and poetical rendering of the figure has been seen in modern times."[1] Americans, of course, looked for purity and chasteness in paintings of the nude and found it in this Greek nymph lying beside the fountain in which she dips her fingers. The figure merges into her surroundings, and, despite the classical derivation of its theme, the picture, as one critic wrote, "almost savours of the ploughed fields in which Fuller had spent his youth as a farmer."[2] The work was also much appreciated for its poetic spirituality, and the effect of the nymph's pearly nakedness shimmering through a soft, golden hue was likened to musical experiences. To Fuller, photographic precision was an abomination, though he was occasionally criticized for not drawing directly from the model.

Fuller is often grouped with Ralph Albert Blakelock, Robert Loftin Newman, and Albert Pinkham Ryder, the most poetic of late nineteenth-century American artists. Rare examples of the nude by all of them are known. A tiny untitled picture by Newman (1827–1912), in a private collection, is a shimmering evocation of Delacroix's painterliness, and a half-dozen other small, limpid nude-figure paintings are known, one of them surprisingly echoing Bourguereau's *Nymphs and Satyr* in composition, although opposite in scale and in tenderness to the erotic consciousness of the French masterwork. Several works by Blakelock (1847–1919) are better known. His *Hiawatha,* or *Shooting the Arrow,* is a glowing Indian figure with none of the emphasis upon heroic anatomy so often found in interpretations of the American Indian. Though visually the work seems devoid of literary allusion, it is supposed to represent Hiawatha; if this is indeed the case, it is one of a large number of contemporary representations of the hero of Longfellow's poem, including a number of sculptures by Edmonia Lewis and one by Augustus Saint-Gaudens.

A somewhat larger canvas is Blakelock's *At Nature's Mirror,* which shows a nude young woman within a typically Blakelockian forest interior, sharply defined against a dark and dramatic landscape configuration executed in thick impasto (*Ill. 7–4*). Though small within enveloping Nature, the girl sits absorbed in reverie, at one with her surroundings. The painting expresses the retreat from reality that is the essence of Blakelock's mature expression. A similar work is Blakelock's *Wood Nymph* in the Worcester Art Museum.

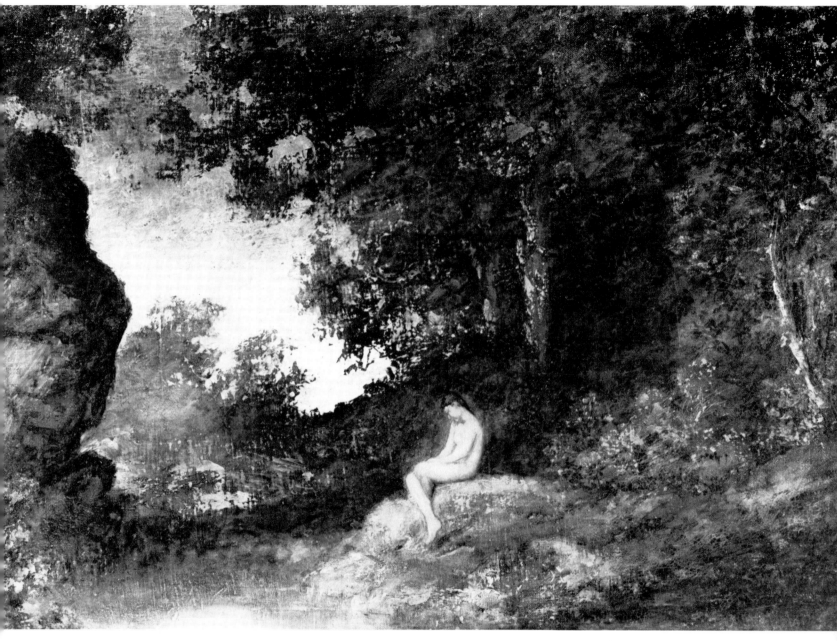

7–4. Ralph Albert Blakelock. *At Nature's Mirror*. n.d. Oil on canvas. National Collection of Fine Arts, Smithsonian Institution, Washington, D.C. Gift of William T. Evans.

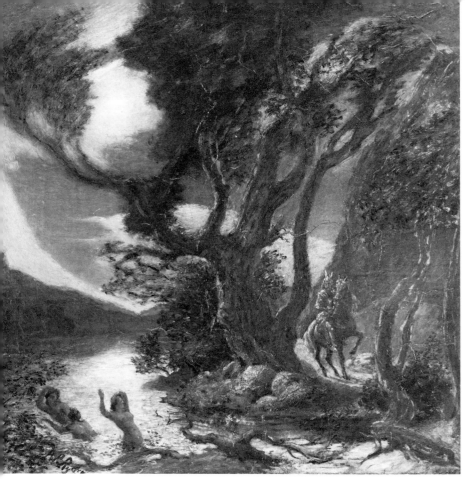

7–5. Albert Pinkham Ryder. *Siegfried and the Rhine Maidens.* n.d. Oil on canvas. National Gallery of Art, Washington, D.C. Andrew Mellon Collection.

Elliott Daingerfield (1859–1932), a collector and writer who championed the group of artists of whom Blakelock was one, was also a painter of repute in his time, and his work is a slightly more academic version of Blakelock's. His *Arcadian Huntress,* in the City Art Museum of St. Louis, displays a figure equally poetic but more specifically defined than the nude in *At Nature's Mirror* within a richly painted forest setting.

There also exist a few treatments of the nude by Albert Pinkham Ryder (1847–1917), including a *Diana* painted on gilded leather and the more famous *Siegfried and the Rhine Maidens (Ill. 7–5).* The latter is in every way typical of the artist's unique expressionism: The gestures of the three naked river maidens are echoed in the wildly swaying and pulsating branches of the trees and in the sweep of the sky behind, as Siegfried gallops into view at the right. Here, again, musical parallels have been evoked—Frederic Fairchild Sherman has spoken of this picture, together with Ryder's *Dancing Dryads,* as "the most rhythmical and musical of his works," the *Siegfried* being dramatic and the *Dryads* lyric.[3] Elliott Daingerfield wrote at length about the picture:

> I spoke to him once about [it], alluding to the beautiful musical quality in its coloring and rhythm. He said: "I had been to hear the opera and went home about twelve o'clock and began this picture. I worked for forty-eight

hours without sleep or food, and the picture was the result." This tells us of the birth of the picture—born out of the womb of a great emotion, born of a musical mood lying deep in the spiritual nature of the man—quick with the balance, the rhythm of complete harmony—but it does not tell us of the picture itself, nor is it likely that every one can discern its magic—indeed, it is not accounted as a chief work of Ryder's by many of his admirers. For me, I am disposed to consider it one of his perfect works—and the reason lies in its completeness of pure beauty, in its assured arrival at the goal the master sought, upon its power to arouse in any sensitive observer just the quality he desired to quicken—and the means are very simple. The picture is not a large one, and it is nearly square in form; there are a few strange trees sloping against a moonlight sky, the moon hung low; beneath the trees the young Siegfried rides; in the edge of the stream in the immediate foreground the Rhine maidens sing.[4]

Nudity here, of course, is presented neither for sensual reasons nor as a study of human anatomy. The exaggeration of the gestures underlines the dramatic mood of the whole opera —and of the moment when the tragic hero appears, summoned almost as a vision. It is, indeed, a pictorial visualization of musical drama. In this and other features the painting further confirms the supposition that Ryder should not be looked upon as an isolated phenomenon in the world of late nineteenth-century art. By no means a recluse, Ryder was friendly with such convivial artists as the painters J. Alden Weir and the sculptor Olin Warner. His association with the English art dealers Cottier and Company led to a trip to London and Paris in 1882 and most probably an introduction to some aspects of contemporary art in Europe. He was friendly with the Dutchman Matthew Maris, who also worked for Cottier. In a larger sense, however, Ryder's art bears multiple similarities with European symbolist painting of the late nineteenth century. More specifically, Wagner's operas were one of the major sources of inspiration for the symbolists, as they were for Ryder. Ryder's means and his visions were his own, but they do bear particular comparison with the figural work of the contemporary Frenchman Henri Fantin-Latour; one may speculate, in fact, on the possibility of some familiarity on Ryder's part with at least the graphic art of Fantin.

Less visionary, more naturalistic, but still a poet in paint was William Morris Hunt (1824–79). Hunt's painting today is often given short shrift, and emphasis is instead placed upon his influence in Boston as an arbiter of taste as well as his enthusiastic advancement of the art and principles of the Barbizon School there. Hunt's earliest artistic studies, in sculpture, were pursued in Düsseldorf, which he forsook to study painting under Thomas Couture in Paris. Subsequently, he deserted Couture for the humbler truths of Millet. Yet that combination of sensuous paint handling with firm formal construction was

Couture's legacy in his own art and in that of his many pupils, both French and American.

Although Hunt dealt with the nude in his earliest studies of anatomy at Düsseldorf—William H. Powell when visiting Hunt there saw some impressive nude studies—his only well-known treatments are two pictures of 1877 entitled *The Bathers,* his contributions to that popular theme of the 1870s and 1880s which we have previously encountered in the *oeuvre* of Eakins, Fuller, Whittredge, and others. The smaller and earlier, at the Worcester Art Museum (*Colorplate 12*), is fresher and more vibrant than the second version at the Metropolitan Museum of Art, but both were the result of Hunt's actual observation of two youths in a cove of the Charles River. He himself wrote:

> I don't pretend that the anatomy of the figures is correct. In fact, I know it is not. It's a little feminine but I did it from memory, without a model, and was chiefly occupied with the pose. . . . I knew that I could correct that anatomy, but if the pose were once lost I might never be able to get it again.[5]

Thus, Hunt is here specifically a figure painter—concerned with the sense of perfect balance and ease, with color, and with surface. He has caught the instant when one youth stood perched precariously but triumphantly upon the shoulders of another. At the same time, he has rendered the sunlit color of flesh at the expense of an anatomical definition as we find it, for instance, in Eakins's treatment of the theme. The two *Bathers* are Hunt's major easel expression of the nude, although there are other examples: *The Boy and the Butterfly* is a rather heroic treatment of an active nude infant form.

The major undertaking of Hunt's last years, one of the earliest mural projects to be undertaken in America, was the series of allegorical paintings in the assembly room of the State Capitol in Albany. As early as 1846 his brother sent Hunt a copy of a Persian poem about Anahita, the Goddess of the Night, and he paired an interpretation of this legend (*Ill. 7–6*) with *The Discoverer,* a mural of Columbus (who is shown bringing light into darkness). The works were completed in 1878, but because they were hastily executed the decorations, painted directly upon the walls, have deteriorated badly and are best known today from the drawn, painted, and sculptured studies for them. In both of the murals, Hunt introduced the partial female nude. Naked to the waist, riding through the heavens, Anahita is shown as she is being driven

7–6. William Morris Hunt. *The Flight of Night.* 1878. Oil and chalk on canvas. Courtesy of the Pennsylvania Academy of the Fine Arts, Philadelphia.

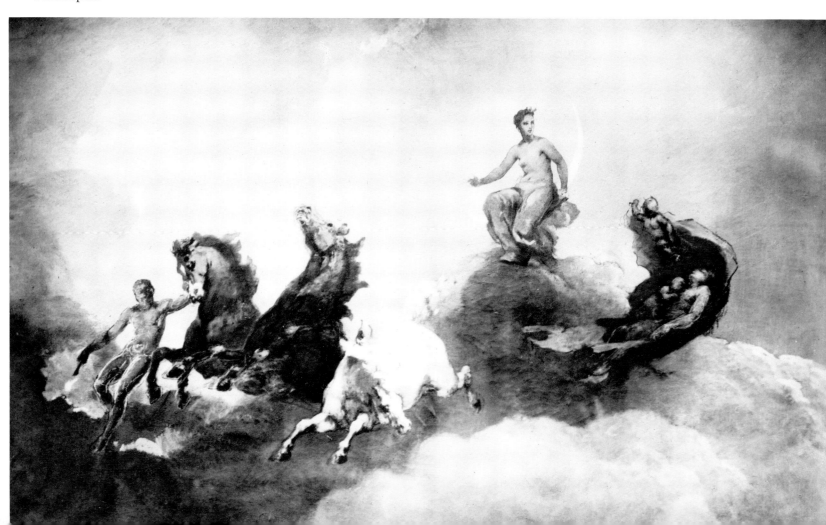

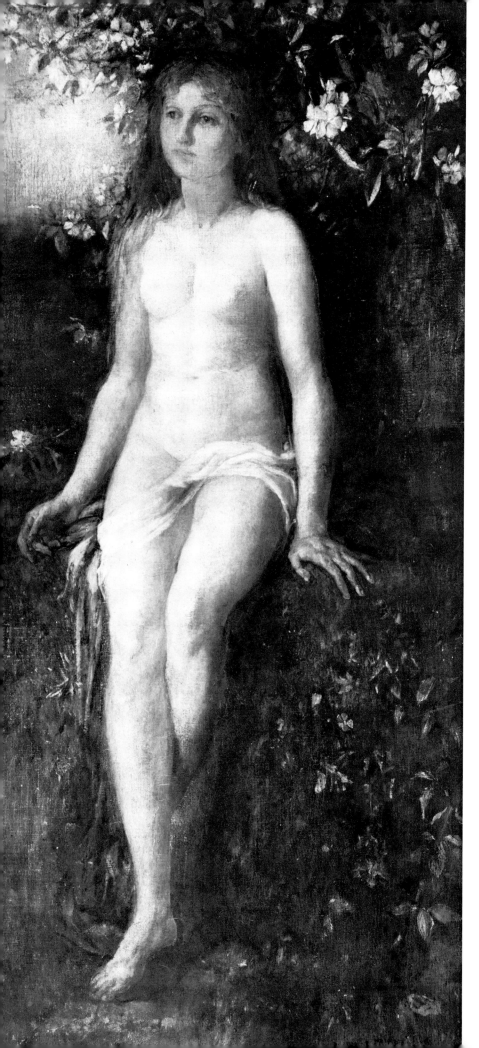

from her realm of fantasy by the illumination of civilization—a female and negative principle. Columbus, representing the male and positive principle, is surrounded by Science, Hope, Faith, and a half-nude Fortune; she is winged, and with one hand grasps the helm of Columbus's bark while holding the sail in the other.

Both nude figures are conceived in the broad, generalizing style of Couture, with the emphasis on massive volumes created first in outline. The faces are detailed, but the bodies are strongly simplified, an approach that removes the figures from the specific and raises them to a more universal, allegorical sphere. Fortune is upright and firm; in contrast, Anahita is seated and twists about, expressing doubt and uncertainty. Her broad and heroic form and her contrapposto suggest a debt to Michelangelo.

Hunt's influence as a teacher was felt particularly by John La Farge (1835–1910), who worked with him in 1859 after a period of study with Couture in Paris. The two artists had much in common—artistic experience in France, concern with the figure, and involvement in the rise of mural painting in the mid-1870s. In their treatment of the figure, including the nude, they both disdained photographic naturalism. Concerning La Farge Charles Caffin wrote:

> It was significant that this dreamer should be attracted especially by the nature students among the living painters. . . . Another point of great significance, as affecting his subsequent career, is that, although he afterward made a close study of anatomy, in his apprentice days he seems to have drawn from drawings rather than from living models, studying, in fact, the abstracts made by others instead of the concrete directly studied by himself. Thus the habit of his mind was directed toward the generalization and significance of the figure rather than its anatomical facts.[6]

Certainly La Farge's early *Anadyomene* of 1862 is all poetry, a small and delicate young woman rising from the sea, frontal as in the great painting by Botticelli, but soft and lyrical, prefiguring such similar works as Fuller's *Arethusa.* She is a private interpretation of classical myth. Likewise, the *Idyll—Shepherd and Mermaid* takes a popular theme of the time and turns it into a private vision, as does the poetic *Golden Age* (*Ill.* 7–7).

But La Farge's exploration of the theme of the nude found its fullest expression in the watercolors and oils painted later in his life on his travels to the South Seas, in 1890–91 (*Ill.* 7–9). Here, curiously like Gauguin in his personal reaction, if not in his paintings, La Farge saw the survival of a heroic age in the primitive simplicity of the islands. Cecilia Waern recounted La Farge's reactions thus:

7–7. John La Farge. *The Golden Age.* 1870. Oil on canvas. National Collection of Fine Arts, Smithsonian Institution, Washington, D.C. Gift of John Gellatly.

Young men went by, with wreaths on their heads, undraped to the waist, like the statues of the gods of the family of Jove, their wide shoulders, and strong, smooth arms, and long back-muscles or great pectorals shining like red bronze. All this strength was soft; the muscles of the younger men softened and passed into one another as in the modelling of a Greek statue. . . . If all this does not tell you that there was no nakedness—that we only had the *nude* before us—I shall not have given you these details properly. Evidently all was according to order and custom; the proportion of covering, the manner of catching the drapery and the arrangement of folds according to some meaning, well defined by ancient usage.[7]

Miss Waern quotes La Farge further:

[In Samoan culture] the whole body has had an external meaning, has been used, as ours is no longer, to express a feeling or maintain a reserve which we only look for in a face. . . . I am lingering here, as I see for the first time, and probably for the last, a rustic—a Boeotian antiquity, and if I like to paint subjects of the "nude" and "drapery," I shall know how they look in reality.

La Farge, then, found his own Golden Age among the Pacific natives, whom he equated with the Greeks of yore, and the essence of the aesthetic philosophy of the figure painter through the expressiveness of the South Sea natives. If he had experienced this enlightenment earlier, his many church murals would perhaps have been stronger works, though his delicate and aesthetic vision, for all the refined poetry of expression that it contained, was not truly suited to the execution of grand and heroic compositions.

Another pupil of Couture, an artist of considerable significance who has fallen into undeserved neglect in the twentieth century, was William P. Babcock (1826–99). A Boston artist, Babcock moved on to friendship with Jean François Millet, like Hunt and La Farge. Indeed, it was Babcock who introduced Hunt to Millet. Babcock spent much of his life at Barbizon and died in France, but he actively maintained American and Boston ties. He was primarily a figure painter and indulged in the representation of traditional classical, and biblical scenes. Several small oils of this nature, such as *Susannah and the Elders,* survive in the large collection of his work at the Museum of Fine Arts in Boston (*Ill. 7–8*). They have a strong poetic strain and a Venetian feeling for form, color, light, and atmosphere, and in manner reflect Couture and Titian.

The poetic figural strain in American art of the period reached a peak in the works of Thomas Wilmer Dewing (1851–1938). Dewing was a member of the group called The Ten American Painters. These artists exhibited together in 1895, and the group has been called an academy of American impressionism. Dewing's art is concerned with light and color,

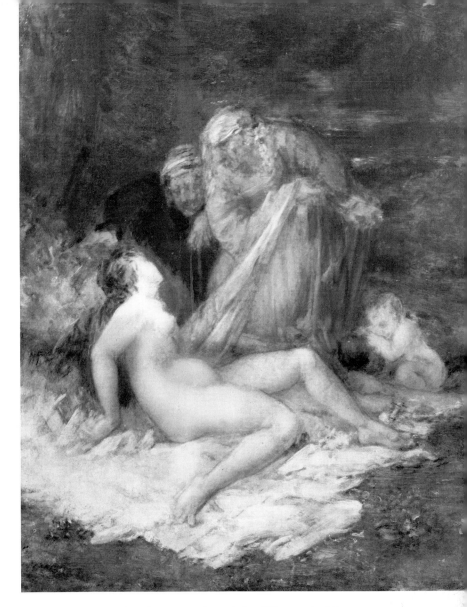

7–8. William P. Babcock. *Susannah and the Elders.* n.d. Oil on panel. Courtesy, Museum of Fine Arts, Boston. Bequest of the artist.

and like that of some of the impressionists—both French and American—it is also an art of poetry and reverie. Its mood is created, not through a retreat into the classical past or a remote primitive world, but through the highly sensitive depiction of delicate women, sometimes in groups, sometimes singly, either in hazy outdoor settings or in empty interior ones. These women—detached, their gaze always directed away from the viewer—are divorced from reality, immersed in their own dream world. The pictures have a soft, feminine charm, one of beauty and grace, and yet remarkably lacking in sensuality. The romantic haze through which we see them as well as the soft gauzes in which they are dressed—not classical gowns and yet reminiscent of these—effectively seal them off, both into their hermetic pictorial world and from the spectator's yearning. Yet they *are* the quintessence of the feminine ideal of the period, these fragile goddesses, so feminine that nudity would seem irrelevant. A few are nude, however, and the Whistlerian

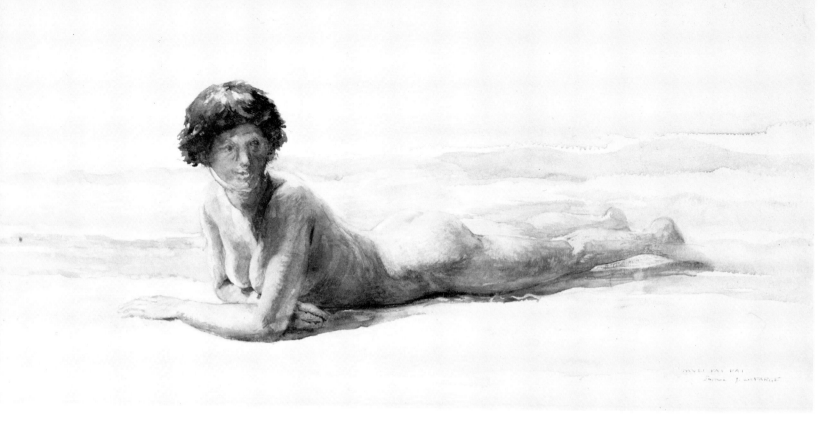

7–9. John La Farge. *Mali Pai Pai, Samoa.* 1890. Watercolor. Graham Galleries, New York.

7–10. Thomas Wilmer Dewing. *Reclining Nude Figure of a Girl.* n.d. Pastel. National Collection of Fine Arts, Smithsonian Institution, Washington, D.C. Gift of John Gellatly.

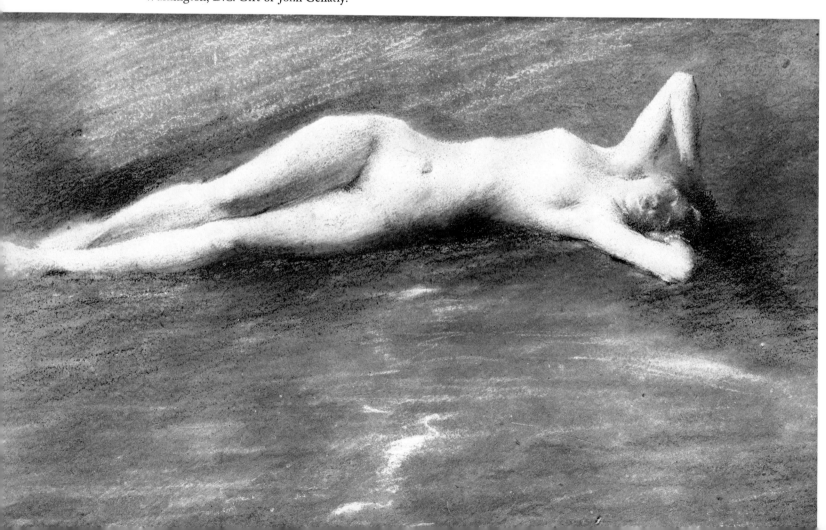

evanescence of, particularly, the pastels makes Chase's contemporary pastel nudes appear almost "tough" (*Ill. 7–10*).

The remote, untouchable goddesses of late nineteenth-century America had another interpreter in the "white Virgins" of Abbott Thayer (1849–1921).[8] Idealized though contemporary creations, these creatures' angelic purity was often given literal wings. Thayer worked under Gérôme, however, and studies of the nude from this period affirm the solid basis of his training as a figure painter (*Ill. 7–11*). Thayer's work, too, has evoked comparisons with poetry and music. His one major nude, the *Figure Half-Draped* of about 1885, is one of the finest paintings of the theme in late nineteenth-century America (*Ill. 7–13*). Remote, not enticing, the young woman reveals both her bare torso and the artist's superb understanding of anatomical construction. The work also displays a richness in the handling of paint for which Thayer too often is not given credit. Isham said of his work, "The draftsmanship is large and ample, the color pure and strong and held in large, simple masses...." In the *Figure Half-Draped* Thayer has spiritualized the nude figure. Isham remarked, "It is a noble ideal, a sort of revivifying of the figures of Phidias with modern spirituality...."[9]

George de Forest Brush (1855–1941) was a close friend of Thayer's, also a painter of the ideal and, like his friend, master of a thorough academic technique of drawing and construction learned from Gérôme.[10] Brush is most noteworthy for his paintings of maternal themes, an updating of the Quattrocento Madonna. Brush's women are mothers and more mature than the young virgins of Thayer.

Brush's other major area of interest was the Indian theme. Some of his subjects, which include members of native tribes of the United States and of the Aztec people of Mexico, date from early in his career (for example, *Aztec Sculptor* of 1869). But he returned to these themes from time to time, even as late as the first several decades of the twentieth century. It is the nearly nude male Indian who dominates these pictures: a powerful, muscular figure, anatomically superb and rendered with anthropological correctness. Brush's academic training stood him in good stead. In many of these Indian canvases, Brush juxtaposes the Indian brave and large birds—swans, geese, and spoonbills, as in *The Silence Broken, The Indian Hunter,* and others. He makes the most out of the contrast between the solid human figure and the fragile bird; the one broad and monumental, the other a mass of intricate, soft feathers. Sometimes the Indian is hunting; sometimes the birds have already been killed, and their pathetic lifelessness stands in opposition to the awesome splendor of the living red man. Similar contrasts appear in other works. In *Indian and the Lily,* the majestic figure bends over a small and fragile flower; in *The Weaver,* the contrast is made between the massive anatomy of the figure and the intricate pattern of the cloth. These are, in a sense, genre paintings in which the nude is featured. Here there is a return to earlier treatments of the Indian, though now with a layer of superficial historicism. Far more

"correctly" rendered than most of those we have seen, they are again noble primitives; not savages, but dignified, sensitive, and heroic. In his investigation of the nude in terms of exotic genre, Brush created subjects that are American equivalents of Gérôme's Near Eastern Moslems in their mosques and slave markets.

Occasionally, Brush painted the nude in other contexts, as in the curious *Orpheus,* again beautifully drawn and firmly constructed, though the figure is decidedly unclassical in feature (*Ill. 7–12*). As is true of Brush's Indian pictures, the *Orpheus* has a reportorial, "you-are-there" immediacy.

In general, Brush's nudes are male; his one major female nude is *Leda and the Swan* of 1883 (*Ill. 7–14*). It is a small painting, much admired in its own time, and has been in such famous collections as that of William T. Evans and that of Stanford White. The figure is a graceful one, conceived poetically enough so as not to offend, and, as in many of the artist's

7–11. Abbott H. Thayer. *Male Nude.* Ca. 1878. Oil on canvas. Collection of Nelson Holbrook White.

7–12. George de Forest Brush. *Orpheus*. 1890. Oil on canvas. Private collection. Photograph courtesy Vose Galleries of Boston.

7–13. Abbot H. Thayer. *Figure Half-Draped*. Ca. 1885. Oil on canvas. National Collection of Fine Arts, Smithsonian Institution, Washington, D.C.

7–14. George de Forest Brush. *Leda and the Swan*. 1883. Oil on canvas. Amherst College, Amherst, Massachusetts.

Indian pictures, the monumental figure contrasts with an arching, curving bird.

Many of the artists concerned with figure painting turned their hand to murals—not only Hunt but La Farge, Thayer, and Elihu Vedder (1836–1923).[11] Vedder was more concerned with the undraped figure than most American painters of the period, not surprisingly since he was more cosmopolitan than most of his contemporaries, an expatriate in the tradition of Allston and Page. Like the latter, Vedder spent much of his creative life in Rome, where he worked before the Civil War and where he returned in 1865.

Vedder, like Ryder and Fuller, was a mystic, a painter of fantasy—but in a more traditional mold. Indeed, even more than Ryder, Vedder deserves to be considered and evaluated in terms of late nineteenth-century European symbolism. Important compositions by him, both easel and mural, involved the nude, all of them dating after about 1872. They are painted in a style that is peculiarly Vedder's, and they are very different from the early works for which he first achieved acclaim—haunting, brooding visions, such as *Lair of the Sea Serpent, The Lost Mind,* and *The Questioning of the Sphinx.* The later works present bold and powerful figures, often rather swarthy, simplified forms darkly outlined, garbed in thick, ropelike drapery. The monumentality of the images may derive from Michelangelo, but the paintings are even more clearly influenced by Vedder's close friend in Rome, Frederick, Lord Leighton, the president of the Royal Academy. Indeed, Leighton's *Clytemnestra,* in the Leighton Museum in London, could pass for a Vedder.

Some of Vedder's most appealing nudes are frank studies of the model for itself, for example, the early, seated *Nude* of 1867, *Model Posing, Nude—Young Woman Hanging Curtains,* and particularly well-known and much acclaimed and engraved *Venetian Model* of 1878.[12] While painting the nude could be freely indulged in in Italy, its reception back home was something else again: During this period Mark Twain could comment in *A Tramp Abroad* that Titian's *Venus* in the Uffizi Gallery was utterly depraved. Vedder noted that a Miss McGraw of Ithaca wanted the *Venetian Model* but finally declined to buy it for fear of public recrimination, not before first asking the artist if he could paint drapery over her! A Dr. Ruppaner of New York also wanted the picture but decided against the purchase after remembering that ladies visiting his professional offices had turned away from a bronze statuette of a nude gladiator in embarrassment.[13]

In the late 1870s Vedder found a way to present the nude and yet placate the public through the introduction of symbolism into the work. Partial or complete nudity can be found in such major works as *The Phorcydes* of 1877–79, made up of restless, strange, seminude creatures wound together by a light scarf—solid and substantial figures, as Walter Montgomery commented.[14] Other allegorical nude compositions of this period are Vedder's *Fortune* of 1877, *The Soul in Bondage* of 1891, *The Morning Glory* of 1892, and *Love Ever Present* of 1887, a youthful male nude (*Ill. 7–15*).

Despite his residence abroad, Vedder was called upon to design the cover of *The Century* magazine, but here he ran afoul of American delicacy, and his nude design had to be draped. Again, in 1883, when he was involved with his best-known illustration project, the designs for the *Rubaiyat of Omar Khayyam,* he was told that nudity was not permissible, but this time he insisted, and when the book appeared in November, 1884, his nude figures remained as he had originally designed them.

Vedder was one of the artists most actively involved in the development of mural art in America. Among such projects executed by him were the ceiling decorations for Collis P. Huntington's New York home at 57th Street and Fifth Avenue in 1893, those at the Walker Art Building at Bowdoin College in Maine executed in 1894, and ceiling decorations at the Library of Congress painted two years later. Hunt and La Farge had both executed murals in the 1870s, but it was only after the World's Columbian Exposition in Chicago in 1893 that mural painting evoked the enthusiasm of private and public patrons.[15] These great mural projects proliferated in America at the end of the century, and through them the depiction of the nude found increasing exposure.

One of the panels of Vedder's project for the Huntington mansion, for instance, was an allegory of Fortune, with the central figure presented undraped except for a long flowing scarf winding behind her; in contrast to the two youths who flank her, her nakedness marks her as a member of a higher order.

While the Library of Congress murals (by Vedder and others) are better known than any other similar project of the period in terms of public visitation, the most exquisite series of murals is perhaps the four lunettes of 1894 at Bowdoin College.[16] For this four major American muralists were chosen, each to represent a time-honored European city of cultural heritage—La Farge for Athens, Thayer for Venice, Kenyon Cox for Florence, and Vedder for Rome, the city where he lived so long (*Ill. 7–16*). In Vedder's mural, the central figure of Natura is again flanked by a series of clothed and unclothed forms representing Wisdom and Thought, and she herself is an idealized nude posed in classical contrapposte. Both her long hair and a swirling scarf are in Vedder's characteristic style. La Farge's mural of Athens features a half-length nude, a rarity in his mural decoration.

Kenyon Cox (1856–1919), a student first of Emile Carolus-Duran and then of Gérôme, was another once-famous American painter, particularly involved with mural decoration. Today he is considered as perhaps the most formal and academic of all American artists of the period.[17] Cox was greatly interested in the depiction of the nude, and Isham speaks of him as "almost the only man to paint the nude as it is understood in Europe. . . ."[18] In his nudes, Isham saw those qualities truly, not invidiously, termed academic: "rhythm of line and mass, rendering of form in accord with the old traditions, and

7-15. Elihu Vedder. *Love Ever Present* (*"Super Est Invictus Amor"*). 1887. Oil on canvas. Private collection. Photograph courtesy The Brooklyn Museum.

sometimes the expression of a symbolic idea." Yet, despite a style that gained contemporary appreciation, his nudes—such as *Nude on a Yellow Couch* of 1889 at the National Academy and *The Hunting Nymph* at the Lotos Club—received small appreciation. Isham felt that this was one factor in Cox's abandonment of such easel paintings for the more lucrative mural decorations, such as those at the Iowa State Capitol and New York's Appellate Court Building. Nude allegories occasionally figure in these works; one of the most monumental is to be found in the grandiose *Under the Rule of Law Inspired by Justice, Peace and Prosperity Abide* in the Essex County Courthouse in Newark, New Jersey, where the figure of Prosperity is a beautifully rendered, academic half-length nude.

In terms of the development of American art, the position of three major American expatriate artists of the late nineteenth century—James Abbott McNeill Whistler, John Singer Sargent, and Mary Cassatt—has always been somewhat perplexing. Should they be considered as Americans or Europeans? Of course, as the study of American art has widened in recent years to include international considerations, this question has become less significant.

On this point, at least, Whistler (1834–1903) is probably the most problematical of the three, never returning to America once he had settled abroad in 1855. Influences from the art of both France and England are strong in his painting, and, in turn, his own contributions to English painting are immense. Yet his significance for American art is strong also and has been too often overlooked; such American artists as William Merritt Chase looked upon him as American and related to him accordingly, and others, like Leon Dabo, were his frank imitators.

Whistler was not greatly concerned with the subject of the nude, and, indeed, some critics have looked upon this as the result of residual puritanism, particularly since so many contemporary English aesthetes glorified the human form as the highest ideal of beauty. Yet the relatively few nudes by Whistler—all female figures—are extremely beautiful and sensitively done. They belong to two specific periods in his art.[19] The first occurred in the late 1860s when he was involved in the decorative scheme known as the Six Projects, a reaction against the realist trends with which he himself had been concerned in Paris. The paintings that resulted from this are an attempt to weld the classicism of the Aesthetic movement with the orientalism that figures so strongly in his art, in terms of simplification, flatness, and linear emphasis. These paintings are thinly executed group compositions of women done in pale tones, and they are close to the art of Whistler's close friend Albert Moore. The *Venus Rising from the Sea* in the Freer Gallery of Art is the only single-figure picture of the group, although Whistler did an etched *Venus* at the same time. It is an extremely delicate painting, pale and chromatically limited, with the nude form off center to the left, balanced by a flowering branch. Her definition is indistinct, and she

SAPIENZA · PENSIERO · ANIMA · VITA · NATVRA · ARMONIA · AMORE · COLORE · FORMA

7–16. Elihu Vedder. *Rome*. 1894. Oil on canvas. Bowdoin College Museum of Art, Walker Art Building, Brunswick, Maine. Gift of the Misses Walker.

seems to be a memory image rather than a creature of flesh and blood.

For a good many years, Whistler abandoned this approach to figure painting, but he returned to it 30 years later, in the late 1890s. At that time he did a group of nudes, in both oil and pastel, that are, again, wistful and suggestive creatures. The best known is his *Phryne the Superb: Builder of Temples* of 1898, a tribute to the great courtesan-model of antiquity, but a very personal and very *un*-archaeological treatment. Whistler was very fond of the work. He wrote, "Would she be more superb—more truly the Builder of Temples—had I painted her what is called life-size by the foolish critics who always bring out their foot-rule?"[20]—thus referring to the typical Salon nude to be seen in annual academy and Salon exhibitions. For all her lack of full definition, there is something mysteriously erotic about *Phryne*.

Many of Whistler's other nudes of the period, such as *Rose et Vert—une Etude* (*Ill. 7–17*), are more adolescent images, yet they, too, have a decidedly sexual quality; late in life Whistler appears to have found real passion in the depiction of young girls and women. While the Eves, Odalisques, Bathshebas, and Danaës he intended to paint were never executed, a suggestion of them may perhaps be found in his many pastels of the nude of the period, delicate studies on brown paper of a favorite model in a variety of poses. These interpretations are a recurrence of that interest in feminine beauty he had first expressed in the Six Projects so many years earlier.

Whistler considered himself an artist of the world, not bound by nationality. This attitude also characterized the art and career of John Singer Sargent (1856–1925), who was known in his own lifetime primarily as a great society portraitist. Yet Sargent's connections with his native country were strongly maintained, and he participated in the mural projects of the late nineteenth and early twentieth centuries, executing works for the Public Library and the Museum of Fine Arts in Boston and for the Widener Library at Harvard University. As a figure artist, Sargent was necessarily involved with studies of the nude, and the nude appears in some of his completed mural projects, including the rather stilted *Orestes* of the early 1920s in the murals for the Museum of Fine Arts.

Sargent also did several sculptures of the nude, but the subject rarely appears in his easel work. There do exist such watercolors as the reclining nude in a landscape once in the estate of Sir Roderick Cameron, but Sargent's one great exploration of this theme is his famous *Nude Egyptian Girl* in oil, painted in 1891 (*Ill. 7–18*).[21] It was executed in Egypt where Sargent had gone to study ancient religions and sites in preparation for painting the Boston Public Library murals. He rented a studio in Cairo and painted this finished study of a nude there. It is a very beautiful, very sensual image, tall and striking with great animation in pose, the head and torso turned to the left as the figure walks away braiding her hair. In this elegant twist it is reminiscent of Sargent's famous and controversial *Portrait of Mme. Gautreau* of the previous decade, and in its spirited

elegance the figure is similar to many of his portraits. The painting was much appreciated in its own day; Kenyon Cox wrote that Sargent was "a draughtsman of the nude figure as well as of the head, as his *Egyptian Girl* should remind us if it were necessary. It is his profound knowledge of form that renders his virtuosity possible."[22] The picture was shown in a group of outstanding works by Sargent at the World's Columbian Exposition at Chicago in 1893. Though in her smooth and sensual outlines and sleek flesh tones the *Egyptian Girl* is far apart from Manet's *Olympia,* she shares with that French work both seductiveness and realistic immediacy; it is not surprising that Sargent believed that Manet had never surpassed this masterpiece and that he was active in the attempt to acquire the *Olympia* for the Louvre.

Both Whistler and Sargent related to the art of France and England and increasingly to the latter. In her experience as an expatriate, Mary Cassatt (1845–1926) was exclusively connected with France—in her training, her artistic influences and colleagues, and her general aesthetic. Although she made only one trip back home after settling in France, her influence in the United States was great, both through her own paintings, which were exhibited and collected in America, and through her friendship with wealthy American collectors who patronized the French impressionists under her guidance.

Though a figure painter, she was not an artist of the nude, and the single example of the depiction of this theme in her oils is the wistful *Red-Haired Nude, Seated* of about 1875. It was probably painted in the studio of the academician Charles Chaplin; Cassatt was not really attuned to the painting of studio nudes, and here the very light, very colorful, and very painterly approach she took prefigures her superb merging of a strong figural art with the light and color of impressionism.

The nude does appear in other works by Mary Cassatt, the fully nude infants and very young children that one finds particularly often in her works that date after 1900—the fine adolescent *Jules Standing in His Bath* of about 1901 is an example. Despite her reaction against academic procedures, Cassatt's study of the nude model stood her in good stead when she worked with the nude in her mother and child themes, which she painted in oil and watercolor and incorporated in drawings and prints. Her very free, painterly, and simplified approach is diametrically opposed to the academic, but it was her sound structural training that made possible the sure and succinct Japanese linearism we find in the nude baby in the color print *Maternal Caress.* The half-length female nudes seen from the back (and in reflection from the front) in Cassatt's color prints of *Woman Bathing* and *The Coiffure,* and the drawings preparatory to them—all these prints were made in 1891—are highly successful in their abstract design precisely because of her training. Sure in her knowledge of the human body, Cassatt could jettison those extraneous details of form that did not suit her purpose.

The American impressionists who learned abroad but practiced at home—men such as Childe Hassam, John Twachtman,

7-17. James Abbott McNeill Whistler. *Rose et Vert—une Etude.* Late 1890s. Oil on canvas. Hunterian Museum, University of Glasgow, Glasgow, Scotland. Gift of Birnie Philip.

Julian Alder Weir, Theodore Robinson—were almost exclusively landscape painters, seldom interested in the figure and the nude. The art of Julian Alden Weir (1852–1919) is rather complex.[23] The son of a famous American historical, figural, and portrait artist, he studied first at the National Academy of Design and then under Gérôme in Paris. The nude studies he did at this time are academically brilliant (*Ill.* 7-19). Weir's study of a naked male model, illustrated here, is among the most bold and successful done by an American artist of the period and speaks volumes in regard to the respective experience and training involving the nude in the academies of France and the United States at the time. Yet, at the same time, Weir was influenced by the *plein-airisme* of

Colorplate 13. Edmund Charles Tarbell. *Grief*. n.d. Oil on canvas. Collection of Mr. and Mrs. Edward E. White.

FOLLOWING PAGE
Colorplate 14. Robert Henri. *Figure in Motion*. 1913. Oil on canvas. Collection of Mr. and Mrs. John C. Le Clair.

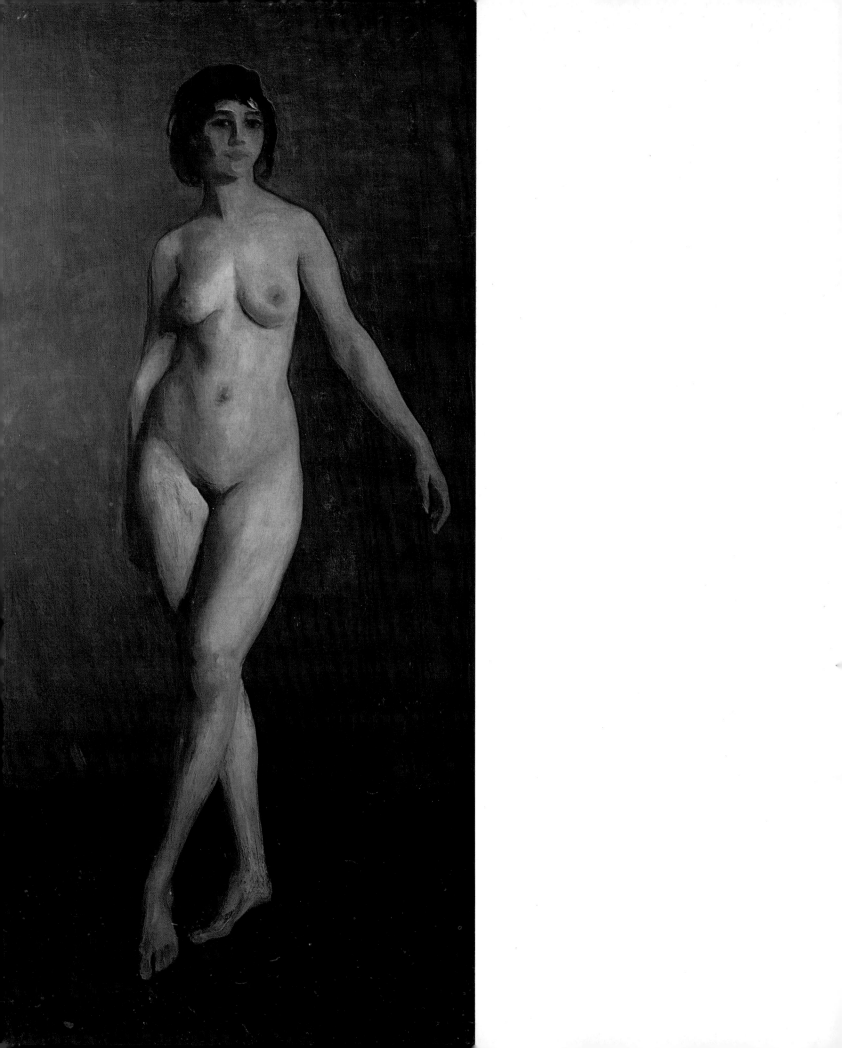

Jules Bastien-Lepage, and enjoyed the friendship and guidance of Whistler. Weir's art went increasingly in the direction of an impressionist exploration of the light and atmosphere, although this did not take a direct or uninterrupted course. Even his impressionism was tonal rather than colorist; that is, it depended primarily upon a manipulation of varieties of a single hue, rather than the total spectral range. Furthermore, he was more concerned than were most of his American colleagues in the movement with figure and still-life painting, and in the treatment of both themes his concern with form and with poetic mood found expression.

Thus, in Weir's mature work—that is, the painting in which luminous atmosphere is a dominant element—there is one nude, or partial nude, of size and significance, *The Open Book* of 1891. This haunting painting depicts a young woman seated in a generalized landscape, with an open book resting upon her draped lower limbs; she looks up from the book and away from the spectator dreamingly into the sky. Like her setting, she is poetically rendered, in the manner of La Farge and Hunt.

The picture is a rarity for Weir, not only because it is of a nude but because of its imaginative qualities. Indeed, its uniqueness was recognized in its own time. About ten years after the picture was painted, Weir's friend Colonel Charles Erskine Scott Wood attempted to help him sell it to an elderly patron, a Mrs. Corbett, who, he pointed out, would not want a "common or disagreeable subject."[24] Mrs. Corbett was evidently pleased with *The Open Book* and purchased it for $2,000; Wood was then prompted to urge Weir to paint more ideal paintings and concern himself less with prosaic reality. He said:

> I appreciate, I hope, as much as anyone, the beauty of nature and, in one sense, all representations of nature are ideal—all art is ideal, but the very inmost soul keeps coming back to a picture like *The Open Book* with that same delight the old Greeks must have felt in their tales of dryads, nymphs and the whole attendant train of the god Pan. It is something higher and sweeter and better than we ever do actually see in this world.[25]

However, what "we actually see in this world" was the primary concern of the impressionists, and *The Open Book* remained an exceptional work in Weir's *oeuvre,* however much that was modified by a personal poetic response.

The nude appears in a good many paintings by one of the American impressionists, however, Childe Hassam (1859–1935).[26] Hassam, too, was trained in an academic atelier in Paris, but French impressionism struck him far more immediately and directly than it did Weir in the later 1880s. Hassam's treatments of the nude date mostly from the later years of his life; *The Lorelei* of 1907 is among the earliest of the best known ones. It is now the fashion to decry these pictures on two grounds. First, Hassam's later works, with

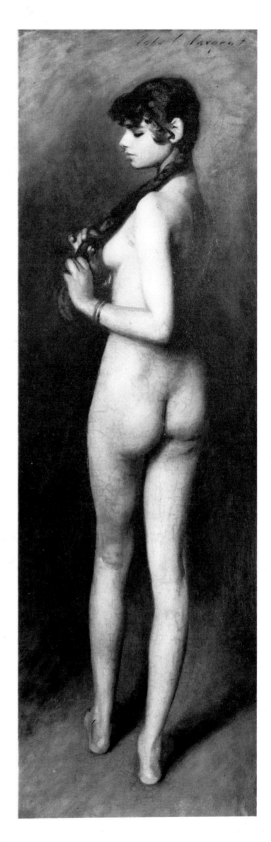

7–18. John Singer Sargent. *Nude Egyptian Girl.* 1891. Oil on canvas. A private collection.

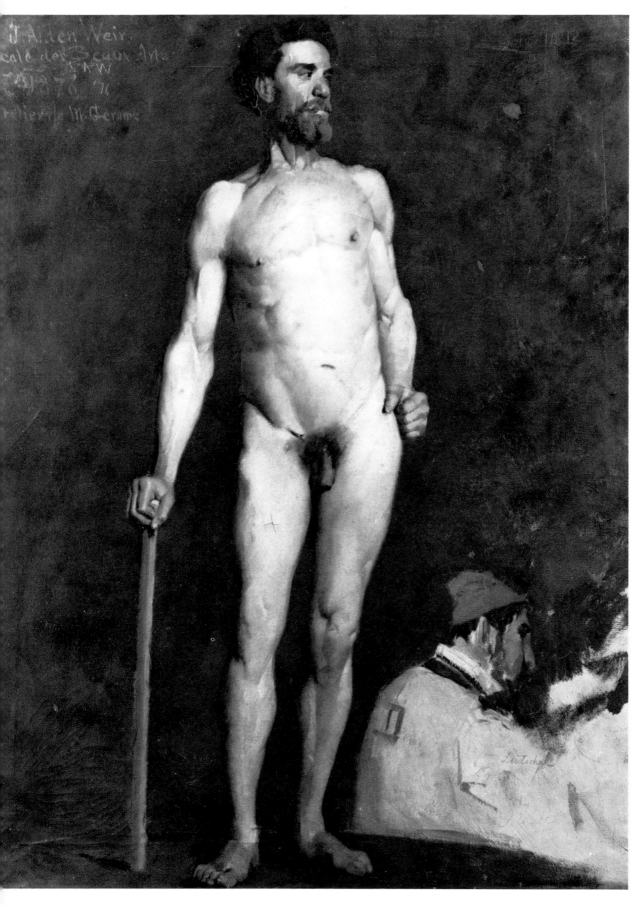

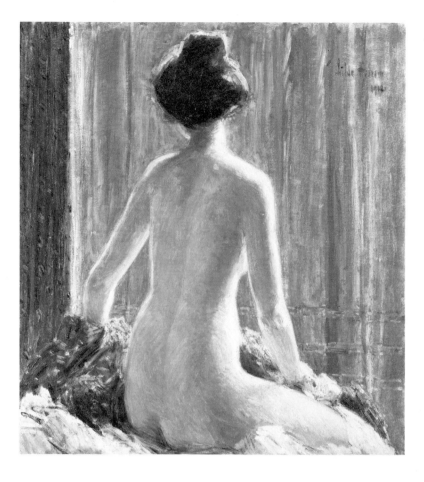

OPPOSITE

7–19. Julian Alden Weir. *Study of a Male Nude Leaning on a Staff*. 1876. Oil on canvas. Yale University Art Gallery, New Haven, Connecticut. Gift of the artist.

LEFT

7–20. Childe Hassam. *Nude Seated*. 1912. Oil on canvas. National Gallery of Art, Washington, D.C. Chester Dale Collection.

BELOW

7–21. Philip Leslie Hale. *Moonlit Pool*. n.d. Oil on canvas. Collection of Franklin Folts.

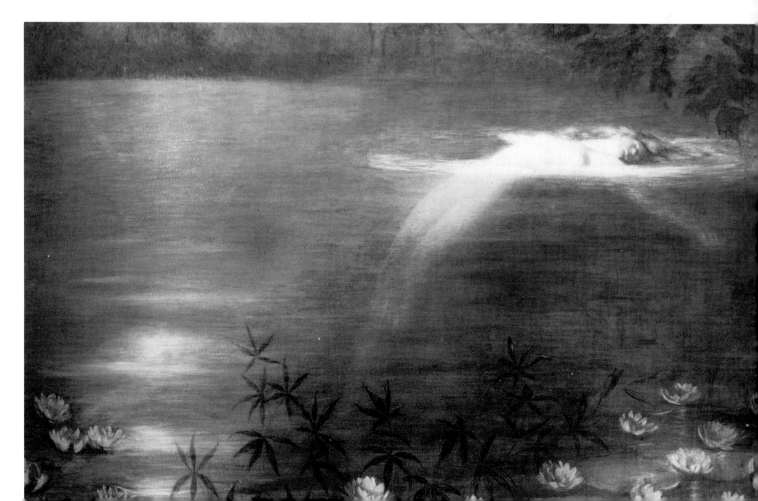

perhaps the exception of the Flag series, tend to be schematic and repetitious. Second, his treatment of the human figure, draped or undraped, at *any* time in his career, is stiff and crude. These criticisms are not unjustified, but they fail, like most generalizations, to take into account some fine and even exciting works buried among a mass of mediocre painting.

Hassam painted a good many pictures of naked young women in brightly sunlit arcadian settings, figures posed classically, friezelike and sometimes, as in the *Pomona in the Rose Bower* of 1919, with classical titles. As is true of *Pomona*, Hassam's figures are usually drawn in profile, with the resultant sharp outline separating them from their settings, although a concern with color and light and broken brushwork reunite the figures with their environment. The *Pomona* is a close-up nude; more often such figures are seen from farther away and are thus correspondingly more completely integrated into the landscape, as in *June* in the collection of the Carnegie Institute, Pittsburgh, and in several paintings in the Phillips Gallery in Washington, D.C. These works acknowledge Hassam's entrance into what Kenyon Cox referred to as "the artist's immemorial dream of Arcady."[27] Hassam found his Arcady on Appledore in the Isles of Shoals, where he painted *Lorelei, Golden Rod, Rock Pool,* and other nudes.

As a series, perhaps the most underestimated of Hassam's works are the Window pictures done in the second decade of this century, paintings of figures in interiors, often with many accessories—furniture, flowers, and the like—often involving both reflecting mirrors and windows open to let the sunlight into a darkened room. In these works, the figures are particularly monumental, and Hassam's experiments with both indoor and outdoor light and atmosphere, and reflections of the open and solid forms and colors they play upon, are often striking. These pictures are not usually studies of the nude, but there are a few examples such as the *Nude Seated* of 1912 (*Ill.* 7–20). This figure is "haloed in light," as one writer on Hassam has described such works.[28] They represent the most intense and mature attempt by Hassam as a figure painter to come to terms with impressionism.

Of the many lesser known American impressionists, mention should be made particularly of Philip Leslie Hale (1865–1931), an artist who frequently painted the nude. Some of these pictures such as his *Girl and Gulls* are really monumental in scale—and here the figure and bird combination suggests a parallel with the works of Frederick S. Church, though the pose of the figure is derived from Botticelli! Hale's nudes are rather bold and "sexy" for the period, as one can see in his *Moonlit Pool* (*Ill.* 7–21), in which a nude figure floats in the water, her arched back thrusting her breasts above the surface. In the quiet and secluded natural setting with the drooping branches echoing the figure's curves, Hale presents a sort of nude and sensual Ophelia. But, beautifully painted though such works are, they emphasize the problems confronting the impressionist figure painter, and particularly one whose aim it was to give emphasis to the more sensual qualities of the nude.

The majority of Hale's works are extremely light and bright in color; his brushwork is more broken and flecked than that of most of the American painters of the period; and the veil of light and atmosphere in his painting is particularly rich. Yet in the depictions of the nude his style is, necessarily, tighter and more linear than in either his pure landscapes or in those pictures wherein he wished to merge the figure completely with her environment. Thus, Hale's nudes are a good deal like those of Church, Harrison, Maynard, Fitz, and others in pose, setting, and general artistic purpose, for all their greater refinement and control of light and atmosphere.

Nearly all the Boston impressionists seem to have painted an occasional nude. The Museum of Fine Arts owns a beautiful nude by William McGregor Paxton (1869–1941), one of the Boston School who studied first with Dennis Bunker and then with Gérôme (*Ill.* 7–22). The works of these artists have been disparaged as reworkings of the aesthetic of Vermeer. This is true, but the modernization of the subtle tonalities and luminosities of Vermeer and the presentation of beautiful renditions of the female nude within such an ambience are real achievements. Edmund Charles Tarbell (1862–1938), another Boston artist and a member of The Ten American Painters, created a painting of a partially nude young woman in an interior setting entitled *The Venetian Blind* (which, curiously enough, prefigures Hassam's Window series by several years) that Philip Hale described as being, in his opinion, the "best picture that has been done in America."[29] However, Tarbell's finest nude is probably his superb *Grief,* a reclining female figure, characteristically American, with only her back revealed to the spectator (*Colorplate 13*). It is painted with subtle nuances of color and light that display a sensitivity quite unequaled in other American treatments of the theme at this time.

The nude flourished in late nineteenth-century American sculpture although, as we have seen, it had been far less a stranger in the glyptic than in the pictorial realm. The theme now took on greater diversity of expression than it had had at mid-century. Close equivalents to the painted Salon nude—without, however, the arboreal surroundings and the limpid pools—were created, and, in reaction against academic traditions, nudes that reflected other sources appeared.

By and large, however, the one basis for agreement among all the sculptors of this period was a rejection of neoclassicism. The sculptors of the late nineteenth century studied in France, not Italy, as did their fellow painters also, and they came back to America with a beaux-arts tradition unrelated to the neoclassicism of Canova. Usually, too, they returned as sculptors in bronze rather than in marble.

The *premier* sculptor of the period was Augustus Saint-Gaudens, whom we have seen working in a neoclassic mode early in his career. This he soon abandoned, however, on his return to the United States in 1875, and his later monuments, beginning with that to Admiral Farragut in New York's Union Square, which established his reputation, are in a tradition of

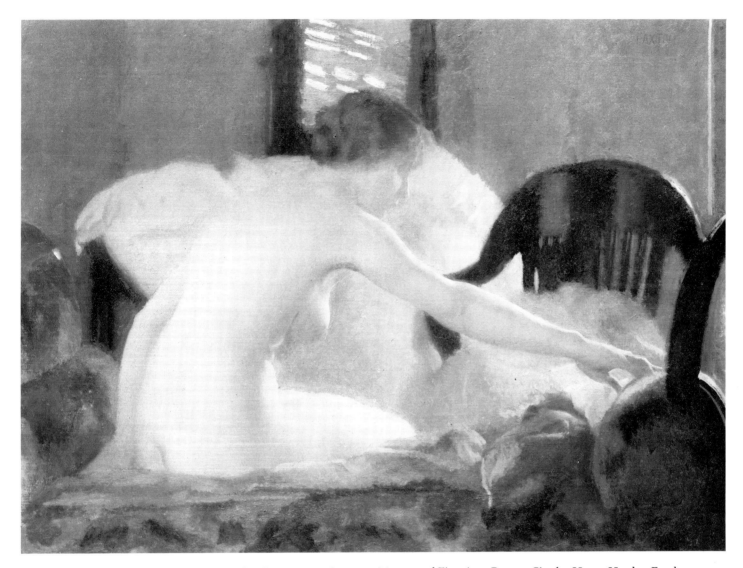

7–22. William McGregor Paxton. *Nude*. n.d. Oil on canvas. Courtesy, Museum of Fine Arts, Boston. Charles Henry Hayden Fund.

bronze heroic portrait monuments. They maintain a nobility which is, however, not classicizing and not generalized; if anything, it is more in the tradition of the Italian Renaissance than of antiquity. The nude had little place in Saint-Gaudens's work. His one mature treatment of the theme is the great statue of Diana, designed in 1892 as a weathervane for Stanford White's Madison Square Garden (*Ill.* 7–23). The original figure was 18 feet high; it proved to be out of scale with the building and was replaced by one 13 feet high, which was presented to the Philadelphia Museum of Art when the Garden was demolished in 1926. The work was a labor of love, and Saint-Gaudens and White shared the expenses of making the hammered sheet-copper lady.

The original statue was nude except for some flying drapery balancing her bow and arrow, not found in the later replica. She is heroic in pose as well as size, and the original was certainly the largest image of the nude created in American art at the time. A female minister, the Reverend Mary Hubbert Ellis, attempted to block the entrance of *Diana* into Philadelphia as part of her leadership of the Youth Protection Committee and the "Crusade Against Pornography," but by then proscriptions against nudity had lost much force, and she was unsuccessful.[30]

Saint-Gaudens was unique among the major sculptors of his day in preferring the draped figure. Daniel Chester French (1850–1931), Saint-Gaudens's peer after French's success

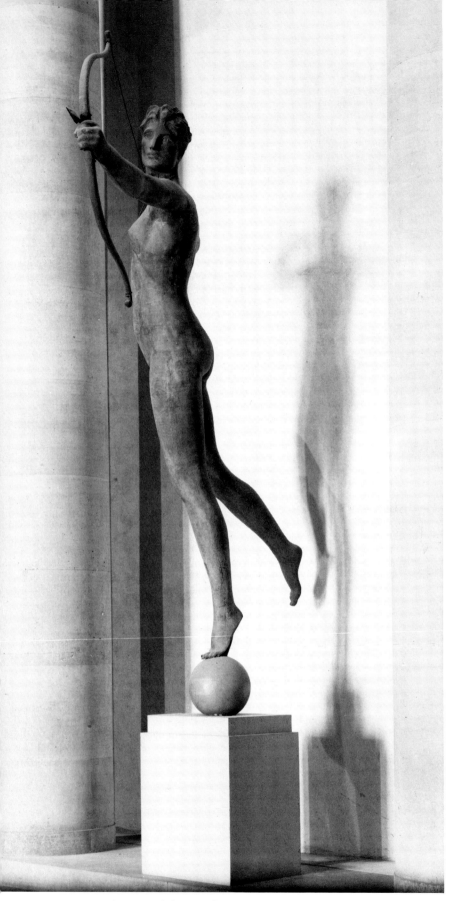

7-23. Augustus Saint-Gaudens. *Diana.* 1892. Sheet copper. Philadelphia Museum of Art. Given by The New York Life Insurance Company. '32-30-1.

with *The Minute Man* for Concord, Massachusetts, created a good many nude figures, particularly in the first two decades of the twentieth century. Probably the best known are *Africa* of 1907, one of the Four Continent representations for the United States Customs House in New York; *Genius of Creation* for the San Francisco Exposition of 1915 and *Sculpture* for the St. Louis Exposition of the same year; and *Memory* of 1919 (*Ill. 7–24*).[31] *Africa, Sculpture,* and *Memory* are seated nudes, heavy and powerful images, with rolling flesh far different from the smooth outlines of the neoclassic nude. There is a power and a restlessness to French's forms—real triumphant nudity. It is not surprising that Chandler Post in his great survey of Western sculpture should have suggested that French would have done well to concentrate upon the theme of the nude. French was a master of allegorical representation, and his heavy-hooded figures were famous to the point of insipidity. But he strove for a monumentality in figural art that had been seldom achieved in America until his time.

A far different aesthetic characterized the art of French's contemporary Frederick William MacMonnies (1863–1937). Before gaining fame for his fountain at the Columbian Exposition of 1893, MacMonnies studied with Alexandre Falguière and Antonin Mercié in Paris in the mid-1880s, and much of his work resembles theirs. But his most famous nude, the *Bacchante and Infant Faun,* is perhaps the most complete expression in American sculpture of the rococo liveliness and vitality of Carpeaux (*Ill. 7–25*). She is all animation, both in her pose—standing on one foot with the other raised and bent, balancing her upraised arm—and in her gay and smiling expression. The surface, too, is rippling, sparkling as it catches the light. The statue was the focus of a storm of controversy when the architect Charles Follen McKim offered it as a gift to the newly built Boston Public Library in 1896. The *Bacchante* shocked, not so much because of her nudity as because of the suggestion of drunkenness, particularly in relation to the theme of woman and child—thus, an affront to motherhood—and the Women's Christian Temperance Union succeeded in having the work rejected. As one writer stated:

> Had MacMonnies planted both feet firmly on the pedestal, stroked off some of the rotundity of form so as to give a suggestion of consumption or piety, substituted a rattle for the grapes, taken the laugh out of the eyes and given them an upward pensive cast, and compressed the joyous mouth into sedate seriousness, the merits of the work might have been better appreciated.[32]

When the sculpture was subsequently offered to the Metropolitan Museum of Art, both the American Purity League and the Social Reform League petitioned against her, but this time without success. This was the most famous but only one of a good many controversies in which MacMonnies's sculpture found itself, but they only succeeded in enhancing his notoriety.

French offered powerful allegories; MacMonnies, sparkling

BELOW

7–24. Daniel Chester French. *Memory.* 1919. Marble. The Metropolitan Museum of Art, New York. Gift of Henry Walters, 1919.

RIGHT

7–25. Frederick William MacMonnies. *Bacchante and Infant Faun.* 1893. Bronze. The Metropolitan Museum of Art, New York. Gift of C. F. McKinn, 1897.

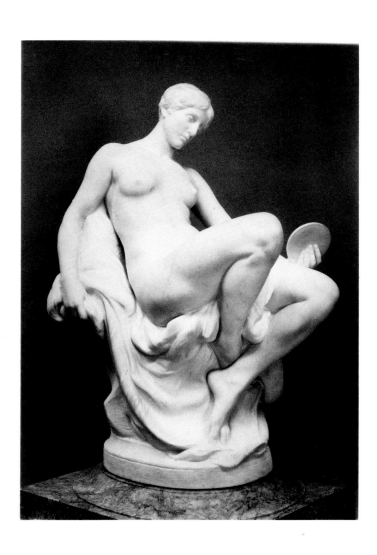

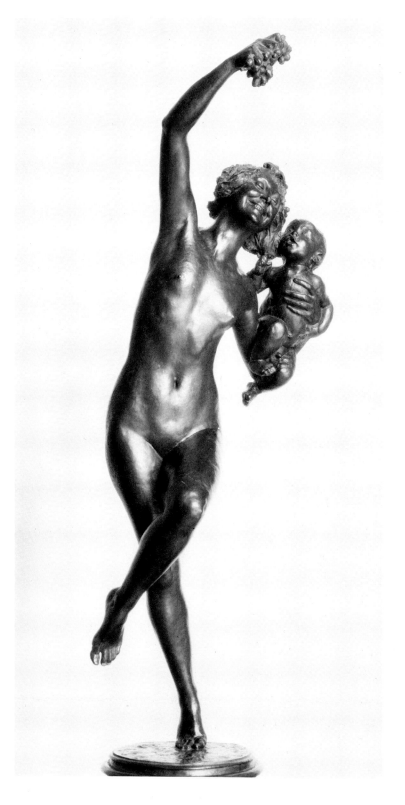

7–26. George Grey Barnard. *I Feel Two Natures Within Me*. 1894. Marble. The Metropolitan Museum of Art, New York. Gift of Alfred Corning Clark, 1896.

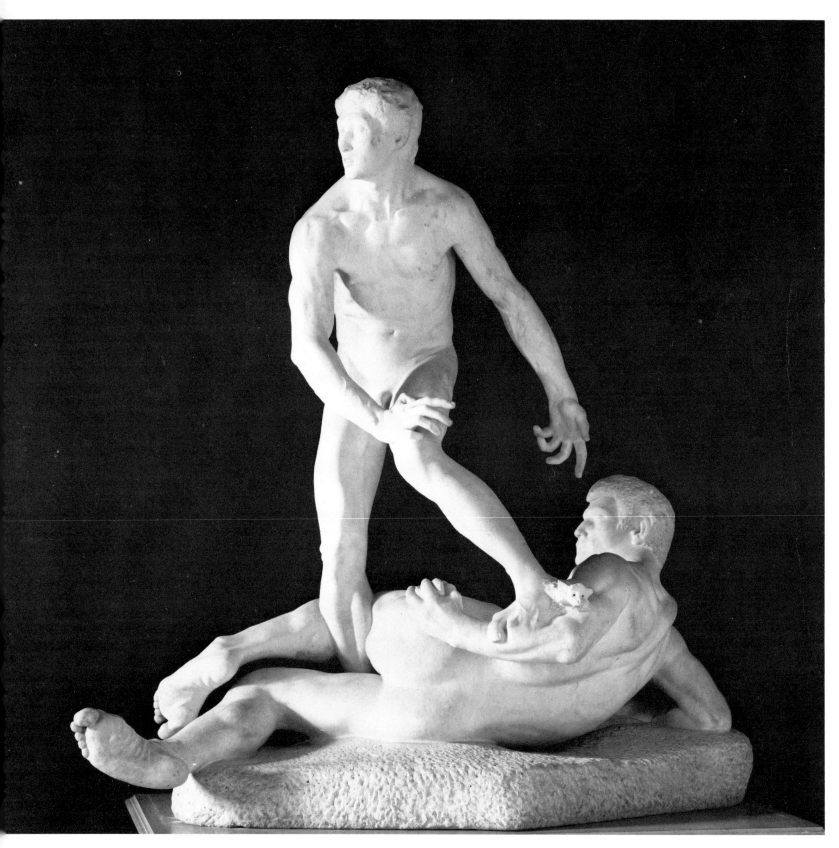

Bacchantes. John Donoghue (1853–1903), in such works as the bronze *Young Sophocles* of 1885, continued a neoclassic vein but with greater animation. In other works, such as his reclining *Venus* in which the full-figured subject becomes all the more voluptuous in contrast to the skimpy but exotic jewelry she wears, there are strong similarities to the little-known sculpture of the great academic painter, Gérôme. For all his conservative tendencies, or perhaps because of them, Donoghue remains one of the most interesting and underrated sculptors of his day.

A more vigorous realism can be found in the sculpture of some other artists of the period. This is particularly true of the work of the specialists in Indian subjects. In these, of course, the nude was an integral part of the conception. Aesthetic naturalism is combined with ethnological accuracy in such works by Alexander Phimister Proctor (1862–1950), Cyrus Dallin (1861–1944), and Herman Atkins MacNeil (1866–1947) as *Indian Warrior, Medicine Man,* and *The Sun Vow.* But while the figures in these works often follow time-honored tradition through the introduction of heroic poses and expressions that have their counterparts as far back as classical antiquity, there are occasional Indian sculptures that very consciously avoid such connections. One of these is MacNeil's *The Moqui Runner,* which Lorado Taft speaks of as "void of ideality."[33] But the most famous of such Indian sculptures is *The Ghost Dancer* of Paul Wayland Bartlett (1865–1925), who studied under Emmanuel Frémiet and is as much a French as an American sculptor. The figure is naked and wiry, posed extremely ungracefully on one leg and exhibiting an ungainly awkwardness rather than heroism. He hops in a loose-jointed way, and the overall anticlassic spirit suggests parallels with the work of Vincenzo Gemito and other contemporary Neapolitan sculptors who were also reacting against neoclassicism. Even Bartlett's best-known nude, *Bohemian Bear Tamer* of 1887, while far more powerful, is posed naturalistically, without reference to ideal form or past traditions.

If William Rimmer was "The American Michelangelo" of the mid-century, George Grey Barnard (1863–1938) can be said to have deserved the title around the turn of the century. He went to Paris to study in 1883, and some of his work done there such as *Two Friends* bears witness to a closer relationship to the art of Rodin than that of any other American. In Paris Barnard produced what remains his most famous work, *I Feel Two Natures Within Me,* a theme suggested by a poem of Victor Hugo (*Ill.* 7–26). In this majestic composition of two figures, or, rather, two expressions of the same figure, one reclining and one standing, Barnard has left far behind academic work and beaux-arts surface fussiness. The debt here is to Michelangelo—in the tremendously muscular forms, in the violent contrapposto of the turning figures, in the intertwining, but above all in the utilization of the nude, and particularly the male nude, as the most expressive of all forms for emotional communication. Furthermore, like Michelangelo and unlike other sculptors in marble of the period and even earlier,

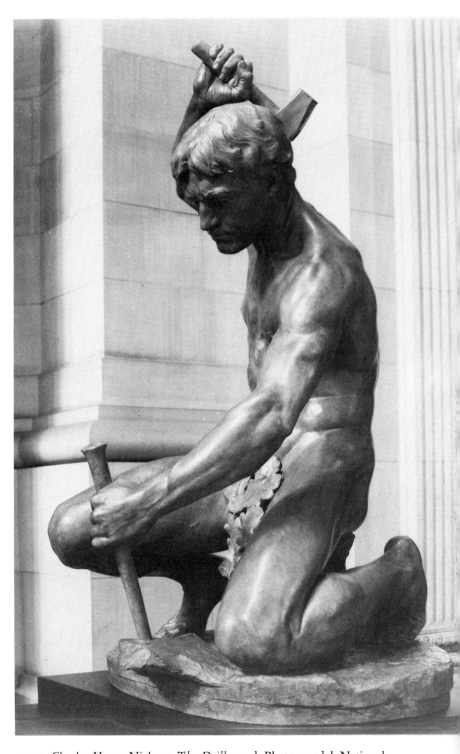

7–27. Charles Henry Niehaus. *The Driller.* n.d. Plaster model. National Collection of Fine Arts, Smithsonian Institution, Washington, D.C. Gift of the sculptor's daughter, Miss Marie J. Niehaus.

Barnard carved his own statues rather than relying upon assistants, and perhaps because of this, the degree of understanding of the relationship of solid forms to voids manifested here is unequaled in the period.

Naturally, so original a work, defying the conventions of ideal beauty, with its lack of grace, charm, or repose, brought forth bitter attacks by uncomprehending critics. Back in America, Barnard continued to work in Michelangelesque terms, producing such works as the dynamic single figure of *The Hewer* of 1902. Lorado Taft was obviously puzzled by its awesome physicality; after admiring the sense of sculptural "bigness," despite the absence of conventional appeal, Taft concluded, "No other figure of the strength of *The Hewer* has up to this time been done or even considered in America."[34]

In the early years of the new century, however, Barnard's style gradually, and not completely consistently changed; this change is most evident in *Maidenhood* and *Woman*. Of course, femininity partially accounts for the sleek gracefulness of these works. Although they are still monumental, they lack expressiveness, whether of face or body. Their generalized form relates them more to the post–art-nouveau work of Paul Manship than to the noble tradition of Michelangelo.

Much of Barnard's later life was devoted to one of the largest projects ever undertaken that involved the sculptural rendition of the nude—the decoration of the Pennsylvania State Capitol in Harrisburg, on which he worked from 1903. Masses of nude allegorical figures appear in four groups to symbolize Man's sufferings or prosperity in, respectively, disregarding or fulfilling the laws of God. The groups depict *Agriculture—The Rewards of Labor; The Lost Paradise: Adam and Eve; Love and Labor: The Unbroken Law;* and *The Burden of Life: The Broken Law.* The complex massing of figures reminds one somewhat of the great project in Frogner Park in Oslo by the twentieth-century Norwegian sculptor Gustav Vigeland, though Barnard eschews both the sexual symbolism and the superheroic idealism of his European contemporary.

Barnard was as individual a figure as Rimmer before him and had no immediate followers. Mention should be made, however, of Charles Henry Niehaus (1855–1935), of Cincinnati, who furthered his study at the Royal Academy in Munich. Many of Niehaus's works were public monuments and architectural sculptures—but there are several sculptures which in their sense of power and strength and intensity of expression are the closest parallels to Barnard's heroic work that the period offers. They include *Caestus* of 1883 and the *Athlete Scraping Himself with a Strigil.* Taft, in his consideration of Niehaus, speaks of *The Scraper* as morally and emotionally without appeal and says that in it ideality is subordinated to literal truth, conveyed in a large and masterful way. He concludes by stating that *The Scraper* is "one of the few good nude figures in American sculpture."[35] Quite different in subject, though otherwise not unlike *The Scraper,* is *The Driller,* which was created for the Drake Monument in Titusville, Pennsylvania, to commemorate the discovery of oil there (*Ill. 7–27*). The nude youth, symbolizing the energy of labor, is over life-size, and in the combination of Michelangelesque muscularity and Rodin-like surfaces is a slightly heavy-handed Germanic companion to Barnard's *Hewer.*

8

The Nude Leaves the Salon

THE LATE NINETEENTH CENTURY saw the first real flowering of the nude as a theme in American painting and sculpture. Yet the artists who explored the subject in the early twentieth century found themselves, ironically, beset by opposition on two fronts. On the one hand, puritanical opposition to the theme remained never far from sight, and charges of vulgarity, coarseness, and immorality were continually thrust at painters of the undraped figure. On the other hand, no sooner did the artists trained in Munich and Paris exert their right to portray the nude than charges of artificiality were brought against them.

It has often been said that American art at the turn of the century reached its lowest ebb, with exhibitions full of either sentimental, anecdotal painting or idealized nudes, neither of which had an even remote connection with the realities of the time. The art of The Eight, or the Ashcan School, came about as an antidote. Of course, the vigorous urban realism of Robert Henri and his circle, which did, indeed, have a marked impact upon the public, was looked upon at the time as novel and revolutionary. Conservative critics of the period certainly preferred the Salon equivalents of Frederick S. Church and Lillian Genth to the freewheeling city scenes of Robert Henri, William Glackens, John Sloan, and the other members of the school, and it should be remembered that many of the nineteenth-century Salon-style painters continued to work and exhibit well into the twentieth century, though their art came to

look increasingly outmoded. In fact, younger men continued to emulate them; for example, Henry Brown Fuller (1867–1934), the son of George Fuller, in his *Illusions* (*Ill. 8–1*) continues to call forth a poetic never-never land, a dim memory of the twilight world of the pre-Raphaelites—but paler than that of Burne-Jones—and of the reveries of Fitz and Eaton. Maxfield Parrish (1870–1966) also continued to popularize the contemplative, idyllic nude, as in his *Stars* of 1926.

The American artist no longer had to go to Europe to study the nude. Life classes back home were increasingly free and open. The last major opposition to the presentation of the nude to serious art students may be found in the raid upon the New York offices of *The American Student of Art,* the Art Students League's publication. This was conducted by the most famous of American moral supervisors, Anthony Comstock, for over 40 years the secretary of the New York Society for the Suppression of Vice and the author of such books as *Morals Versus Art.* It is significant that Comstock's raid was made, not in protest against the life classes or works of art depicting the nude, but rather against drawings of undraped nudes in publications sent through the mails. Comstock, acting thus in his capacity as Postal Inspector, arrived at the League offices with two policemen and arrested the bookkeeper, Miss Robinson, on the charge of distributing such studies. The reaction was predictable: The League students hung Comstock in effigy. Officially, the case was withdrawn at the end of the year, as the District Attorney found no evidence of turpitude in the publication. Indeed, in the League's 1907–1908 catalogue, as though in defiance of Comstockian prudery, there were illustrated not only undraped studies made by League students but photographs of the men's and women's life classes.[1]

The figure is the key to the art of the new urban realists of the twentieth century—the figure, that is, incorporated into dramatic scenes from everyday, and everynight, life. Though they are not anecdotal, the paintings are works in which the gusto of life is captured by and reflected in a bravura technique that was, ultimately, a heritage from the Munich School and William Merritt Chase. The Ashcan School artists were not the first to paint urban scenes, but their concentration upon them, and their conscious defiance of academic practice in both subject and technique, placed them in the forefront of American art. And the nude—as part of the academic repertory—played only a minor role in their work.

Robert Henri (1865–1929) was the leader of the group in a number of ways—as friend and mentor and also as a major teacher of his generation.[2] His early art, excepting a brief and extremely beautiful foray into impressionism, was devoted to dark, almost Whistlerian city views of Paris and New York. He is today associated more with the later portraits and single-figure studies in which brilliant colorism and vigorous brushwork enliven a search for individualism of expression in both form and face. Henri can be faulted, in fact, for relying on the vivacity of his brush to convey emotional intensity at the expense of psychological insight.

There exists, though, a fairly significant group of nudes by Henri from the second decade of the century; of these, the *Figure in Motion* of 1913 (*Colorplate 14*) is one of the most famous and certainly one of his largest and most brilliant renderings of the figure—here, as the title suggests, in motion. Legs, arms, and breasts counter and balance each other in this lively, if carefully posed, study.

The *Figure in Motion* was exhibited by Henri in the Armory Show of 1913, and it may have been painted for inclusion there—thus, as a manifesto of his aesthetic creed. It must certainly have been the most dramatic nude by the American representation in the show, bearing comparison with that sensational product of European modernism, Marcel Duchamp's great *Nude Descending a Staircase.* The earliest specialists in the Salon type of nude were conspicuously absent from the Armory Show; several of the impressionists previously mentioned were represented in the exhibition, however—Hassam with a *Nude Woman with Mirror.*

Henri's other paintings of the nude seem to follow the *Figure in Motion,* demonstrating his investigation of the full- and half-length figure—standing, seated, reclining, turning, twisting—of foreshortening, and of light and shadow. They were drawn from professional models, and neither in pose nor in facial expression does Henri attempt to evoke a personal, emotional response on the part of the spectator.

Those members of The Eight whose predilection was for scenes of urban realism were not drawn as often as Henri to the nude. There are occasional nudes by John Sloan (1871–1951), done early in his career—such paintings as *Blond Nude, Rose Scarf* of 1918.[3] It should be noted, too, that Sloan's first sale, in 1913, was a painting of a nude; it was sold to Albert Barnes, the great collector, who had been a high-school classmate of the artist. At the end of the 1920s, however, Sloan devoted increasing attention to the large-scale single figure and often to the nude. Unfortunately, in substituting an intellectual for an emotional approach to art, Sloan broke radically with his own early vigorous work in newspaper illustration, and critics tend to agree that his late canvases are empty of life. In these works, and in his later etchings, Sloan's concentration centered about a new sense of form and design as embodied in the naked female figure. All his nudes were female, although the type he chose was strong and muscular, never "pretty." Energy was often embodied in his concepts, but never sex. Sloan once said, "I don't like a nude that looks too much like human flesh," and he disliked "nasty, lascivious nudes," *à la* Bouguereau.[4] Sloan's late nudes do *not* look like human flesh, not only because of their tough, leathery texture, but also because of the cross-hatching in which they are swathed. This technique, while undeniably reinforcing the modeling of the nude form—giving it a solidity lacking in much of his early painting—became obsessive with Sloan, and the web of lines that seems to surround his figures tends to render them inert and unreal. More satisfactory are Sloan's etchings, of which 38 are nudes, almost all made in the 1930s.

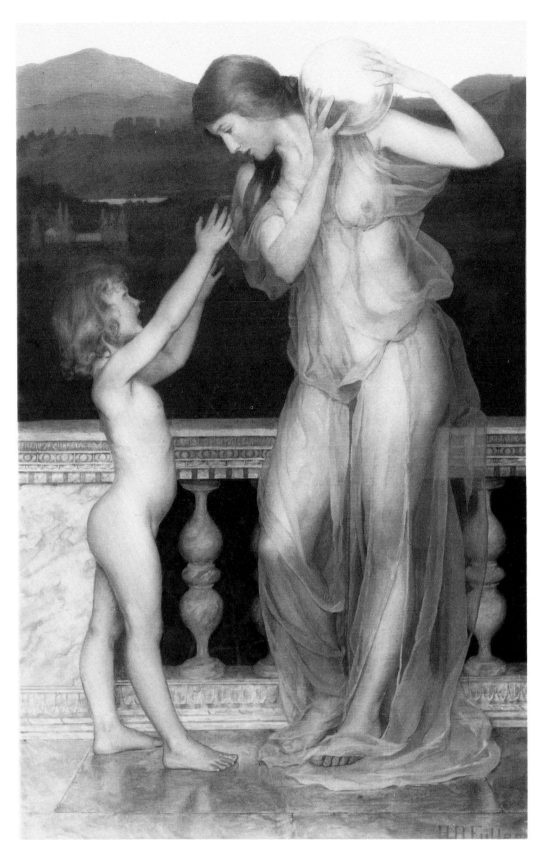

8–1. Henry Brown Fuller. *Illusions.* n.d. Oil on canvas. National Collection of Fine Arts, Smithsonian Institution, Washington, D.C.

The other member of The Eight whose technique and outlook were close to Henri's was George B. Luks (1867–1933). Luks's art was often spoiled by sentimentality, on the one hand, and a careless, unstructural slashing technique that carried Henri's vitality to the point of formlessness, on the other. Luks made several monumental forays into the depiction of the nude. *The Wrestlers* of 1905 is a triumph in its expression of energy and its representation of large and powerful forms (*Ill. 8–2*). Luks himself realized the dramatic power of his picture, and he wrote to Sloan: I'll keep it 'til I'm invited to send to some big exhibition. Then this will show Kenyon Cox and the other pink and white painters that we know what anatomy is.[5]

Luks's other major treatment of the nude was a late work, his large *Morning Light* of 1928. Flatter in tone and much more simplified than his amply rounded *Wrestlers,* it is much a part of his later painting. It is a vivid picture: The subject, with a casual expression, stands arm on hip, her nakedness completely revealed in the full-length mirror, which emphasizes her brilliant skin and rounded buttocks. She is an erect, saucy, and modern *Olympia.* Structurally, this is one of the finest of Luks's later figure paintings, carefully composed within a series of parallel verticals provided by the paneling, wall mirror, picture frame, and stool, which all contrast with the nude's curvilinear figure.

The early work of William Glackens (1870–1938) shares with that of Sloan, Henri, and Luks a dramatic approach to the urban scene; about 1910, however, he veered away in the direction of French impressionism, particularly the art of Renoir. Glackens adopted that master's feathery brushwork and colorful tones, while still retaining an interest in the contemporary scene. Glackens's *Nude with Apple* of 1910 (*Colorplate 15*) may be considered a monument to this break with his own past, though the slim and elegant nude lacks the full, rich Rubensian quality of the Renoir nudes which Glackens is otherwise emulating. One of the artist's largest pictures, *Nude with Apple* presents a rather bold, rather consciously inviting figure with a slight suggestion of derision in her expression as she holds an apple in her hand—a contemporary American Eve or Venus. In these features she is also the daughter of *Olympia.* Yet she is still very much in a realist tradition: The apple cannot be merely symbolic; it has been picked from the bowl at her elbow. She is almost nude, but the clothes which she has shed lie upon the couch next to her. There are other nudes, both in oil and pastel, in Glackens's art, dating chiefly from the second decade of the twentieth century, and although the theme never became a major one with him his nudes have the same joyousness and radiance that may be found in his street, park, and beach scenes as well as in his lush fruit and floral still lifes.[6]

In the paintings of Maurice Prendergast (1859–1924) the nude rarely figures, though there are some beautiful exceptions, such as the *Eight Bathers* of 1916–18. Prendergast also painted several single nude figures, greatly simplified, broad, flat forms with sharp, dark outlines. They suggest a primal female

8–2. George B. Luks. *The Wrestlers.* 1905. Oil on canvas. Courtesy, Museum of Fine Arts, Boston. Charles Henry Hayden Fund.

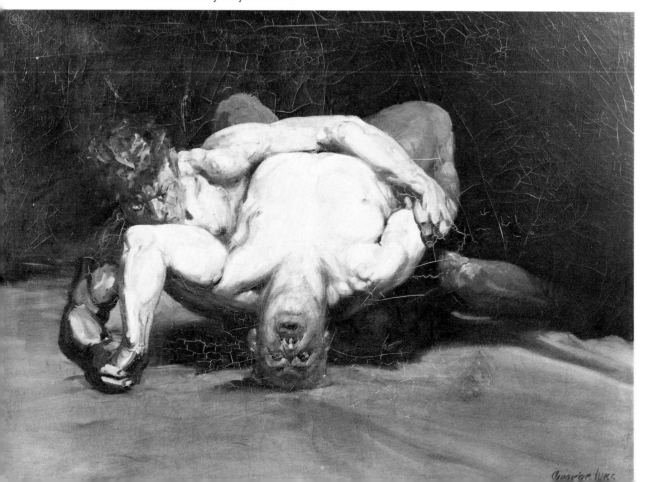

Jules Bastien-Lepage, and enjoyed the friendship and guidance of Whistler. Weir's art went increasingly in the direction of an impressionist exploration of the light and atmosphere, although this did not take a direct or uninterrupted course. Even his impressionism was tonal rather than colorist; that is, it depended primarily upon a manipulation of varieties of a single hue, rather than the total spectral range. Furthermore, he was more concerned than were most of his American colleagues in the movement with figure and still-life painting, and in the treatment of both themes his concern with form and with poetic mood found expression.

Thus, in Weir's mature work—that is, the painting in which luminous atmosphere is a dominant element—there is one nude, or partial nude, of size and significance, *The Open Book* of 1891. This haunting painting depicts a young woman seated in a generalized landscape, with an open book resting upon her draped lower limbs; she looks up from the book and away from the spectator dreamingly into the sky. Like her setting, she is poetically rendered, in the manner of La Farge and Hunt.

The picture is a rarity for Weir, not only because it is of a nude but because of its imaginative qualities. Indeed, its uniqueness was recognized in its own time. About ten years after the picture was painted, Weir's friend Colonel Charles Erskine Scott Wood attempted to help him sell it to an elderly patron, a Mrs. Corbett, who, he pointed out, would not want a "common or disagreeable subject."[24] Mrs. Corbett was evidently pleased with *The Open Book* and purchased it for $2,000; Wood was then prompted to urge Weir to paint more ideal paintings and concern himself less with prosaic reality. He said:

> I appreciate, I hope, as much as anyone, the beauty of nature and, in one sense, all representations of nature are ideal—all art is ideal, but the very inmost soul keeps coming back to a picture like *The Open Book* with that same delight the old Greeks must have felt in their tales of dryads, nymphs and the whole attendant train of the god Pan. It is something higher and sweeter and better than we ever do actually see in this world.[25]

However, what "we actually see in this world" was the primary concern of the impressionists, and *The Open Book* remained an exceptional work in Weir's *oeuvre*, however much that was modified by a personal poetic response.

The nude appears in a good many paintings by one of the American impressionists, however, Childe Hassam (1859–1935).[26] Hassam, too, was trained in an academic atelier in Paris, but French impressionism struck him far more immediately and directly than it did Weir in the later 1880s. Hassam's treatments of the nude date mostly from the later years of his life; *The Lorelei* of 1907 is among the earliest of the best known ones. It is now the fashion to decry these pictures on two grounds. First, Hassam's later works, with

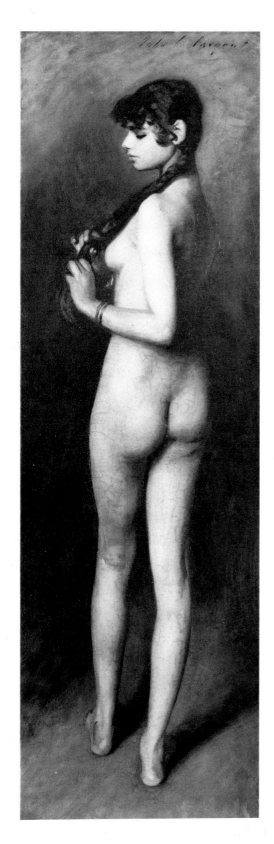

7-18. John Singer Sargent. *Nude Egyptian Girl*. 1891. Oil on canvas. A private collection.

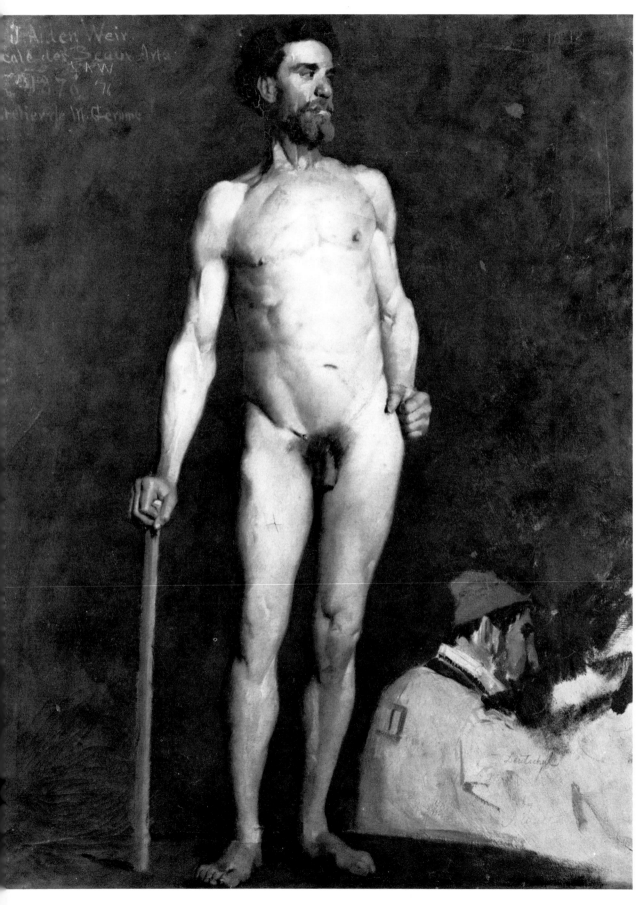

144

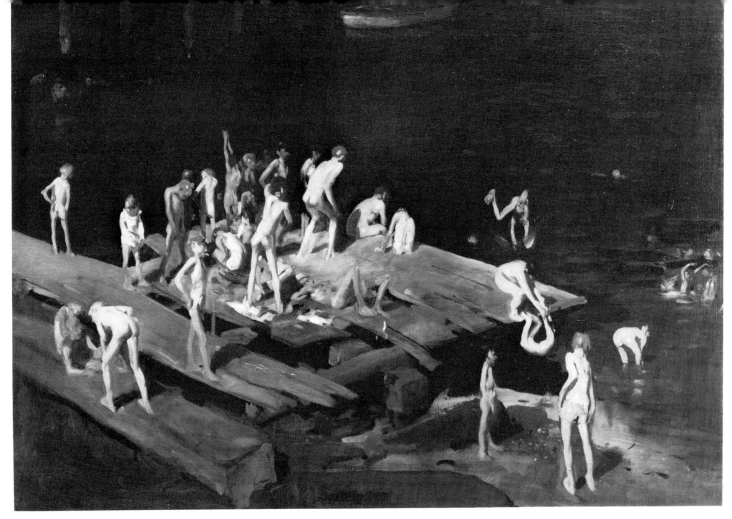

8–3. George Wesley Bellows. *Forty-two Kids*. 1907. Oil on canvas. In the collection of the Corcoran Gallery of Art, Washington, D.C.

imagery owing something of a debt to Gauguin, though without the lush exoticism of the French artist.

Of all the painters associated with the Ashcan School, however, Arthur B. Davies (1862–1928) was most devoted to the theme of the nude. Davies's art was farthest removed from that of Henri and Sloan. His early idylls reached back into time as he drew upon sources as diverse as Botticelli and the pre-Raphaelites to create a visionary world, part classical and part medieval. It is a world populated with sexless, pale nudes, figures without corporeality; it was a new pre-Raphaelitism, without modeling, without illusionism (*Ill. 8–4*). Davies's art can be allied with that of the European symbolists, but the sexual preoccupations and fantasies of that group are completely and deliberately absent from his painting, and it is not surprising that such critics as the straitlaced conservative Royal Cortissoz would champion Davies.

A great many of Davies's compositions include a frieze of nudes displayed across a tranquil landscape. Thin, poetic, somewhat anemic, his figures seem more suited to dreamlike allegory than to the evocation of classical mythology. They are the most elegant nudes in American art, but they are also those most lacking in vitality. As Jerome Mellquist described them: They are always "safe." They droop, they languish, they draw back, they are always preparing for flight. This is not the fullness of life, but its attenuation.[7]

Davies, the most timid of The Eight, was the one involved with helping to organize the great triumph of modernism in America—the Armory Show of 1913. This contact with European avant-garde art had a profound effect upon Davies's painting, and for a number of years he experimented with semi-abstract canvases in which still nude figures were broken up into myriad color blocks (they look almost like Harlequins), their forms and outlines subjected to swinging, curving linear rhythms that "energize" them.

Particularly close to Davies's art are a number of the early oils and watercolors by Louis Michel Eilshemius (1864–1941). Pictures of floating nudes in clear and verdant landscapes have a freshness that Eilshemius was to lose in his more dramatic and rather crudely voluptuous later visions, done after his travels to New Zealand and Samoa. In these late works, Eilshemius deliberately attempted to throw off the traces of his earlier training with the Barbizon-inspired landscapist Robert Minor and at the Art Students League and the Académie Julian. The nudes that emerged are vampiric, despite their idyllic settings.[8] They are conceived broadly and are securely located in the canvas, as opposed to the almost

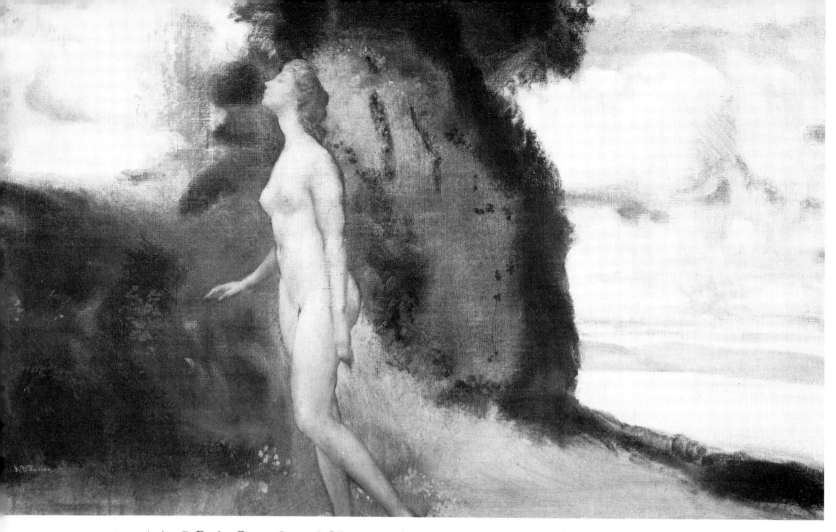

8–4. Arthur B. Davies. *Dream.* Ca. 1908. Oil on canvas. The Metropolitan Museum of Art, New York. Gift of George A. Hearn, 1909.

collagelike nudes in the earlier, more pastoral pictures. Even closer to the fantasy world of Davies was the art of Edward Middleton Manigault (1887–1922), who created oriental visions populated by mannered nudes more subtly erotic than Davies's wan nymphs. They are women with large hips and busts, enigmatic in their unreal world.

Ironically, the painter who best understood and imparted to his canvases the dynamism of modern life that was the primary interest of The Eight was an artist who was not a member, although he studied with Henri and was sympathetic to their aims. George Wesley Bellows (1882–1925) achieved meteoric success as a figure painter, as a teacher, and also as an academician, which the members of The Eight were not.[9] Bellows's aesthetic was more exciting and more complex, and his ability to manipulate myriads of figures in a vital natural setting was unequaled in his time, as can be seen in his well-known *Forty-two Kids* of 1907 (*Ill. 8–3*).

The *Forty-two Kids* bears comparison with Eakins's *Swim-ming Hole.* Both artists—the most brilliant realists of their time in America—have chosen to show a group of nude young men informally bathing. But, whereas Eakins's canvas is all anatomy, Bellows eschews this in favor of a kind of shorthand notation, in order to suggest a cumulative energy as they glint in the sunlight against the pier and water. A noteworthy parallel to the *Forty-two Kids* may be found in *Men and Mountains* of 1909 by Rockwell Kent (1882–1971), which shows similarly sketchy nude figures disporting in a sunlit setting. Kent, however, preferred an elysian landscape to Bellows's urban environment; a deliberate denial of modern civilization is part of Kent's role as a twentieth-century romantic.

Similarly, Bellows's most famous works of these early years, *Club Night* of 1907 and *Stag at Sharkey's* and *Both Members of This Club* of 1909 (*Ill. 8–5*), invite comparison with Eakins's late trio of boxing pictures. Ferocious vigor replaces careful muscular construction; Eakins's quiet and meticulous technique is exchanged for brushwork so slashing as to seem

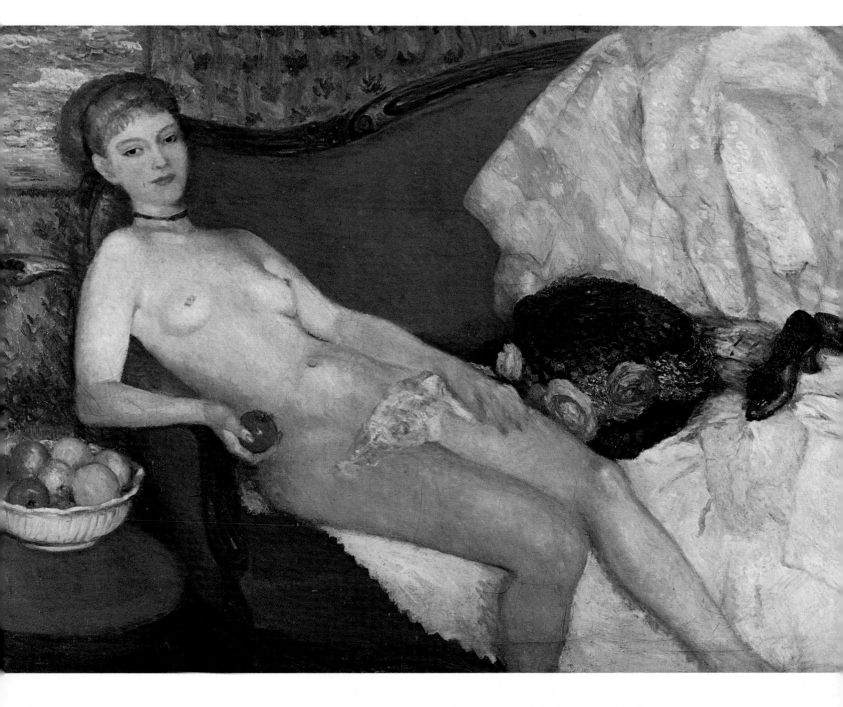

Colorplate 15. William Glackens. *Nude with Apple.* 1910. Oil on canvas. The Brooklyn Museum. Dick S. Ramsay Fund.

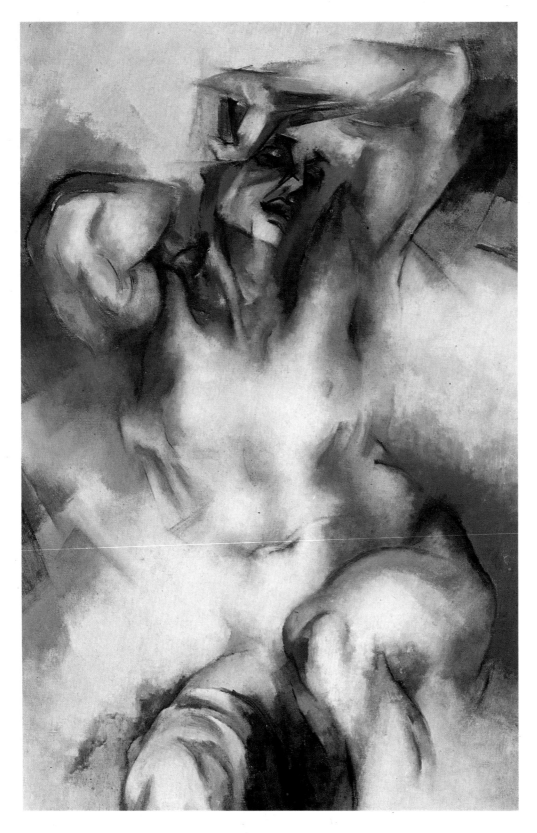

Colorplate. 16. Stanton Macdonald-Wright. *American Synchromy Number 1, Green*. Ca. 1919.
Oil on canvas. Courtesy, Wadsworth Atheneum, Hartford, Connecticut. The Ella
Gallup Sumner and Mary Catlin Sumner Collection.

8–5. George Wesley Bellows. *Both Members of This Club*. 1909. Oil on canvas. National Gallery of Art, Washington, D.C. Gift of Chester Dale, 1944.

8–6. George Wesley Bellows. *Nude with Parrot.* 1915. Oil on canvas. Love Estate, New York. Photograph courtesy of Hirschl and Adler Galleries, New York.

to propel the action of the fight. Bellows's drama is one of contrasting lights and darks, with no gradations of modeling or shadows. Dynamism involves the spectator immediately (of Eakins's pictures we remain observers). It is not surprising that Bellows once thought seriously of becoming a baseball player. Tom Sharkey's private club—professional boxing was illegal then—was both a haven for Bellows the sportsman and a life class for Bellows the artist.

Once, when Bellows was asked his attitude to the painting of the nude, he acknowledged that its study in the art schools was the basis for sound draftsmanship, but when it came to painting pictures for the public he preferred to include the nude figure only when it fit logically into public scenes of real life—bathers at the seashore, prizefighters in the ring. Yet Bellows later came to paint female nudes—about the same time as Henri. They include the *Nude with Parrot* of 1915 (*Ill. 8–6*), *Nude with Blue Ostrich Fan* and *Nude with Red Hair,* both of 1920, and his best-known *Nude on an Hexagonal Quilt* of 1924. Bellows wanted to call the last painting *Venus,*

but his wife Emma objected. The work has been compared to Henri's *Figure in Motion.* Concerning the *Nude with Parrot,* Bellows's mother once complained, "It's bad enough, George, to paint a girl with both of her breasts bare, but to show only one is nasty."[10]

One other realist painter of the period should be mentioned here, Charles Webster Hawthorne (1872–1930), who studied with George Brush at the Art Students League and with William Merritt Chase. Although not so dramatic as The Eight, he shared with them an interest in the world about him—in this case, the world of the New England and Portuguese fishermen of Cape Cod—and a regard for the quality of paint itself. He was later, in his Cape Cod School of Art in Provincetown, to become one of the most influential American art teachers of his time. Hawthorne painted the nude occasionally, particularly as demonstration work for his many students, but in his one major treatment of the theme, the monumental *Elijah* of about 1905, Hawthorne created what is perhaps the finest nude portrait of an elderly person in the history of American art (*Ill. 8–7*). Totally unidealized, tremendously realistic and nonsentimental, yet executed with feeling and sensitivity, the *Elijah* is expressive figure painting at its finest. The powerful, heavy form appears downward-drawn, expressing the cares and weariness of the world as the majestic, sorrowful figure gazes humbly at the ravens at his feet. In this, as in the *Calling of Peter* and other pictures with biblical themes, Hawthorne has drawn upon the rugged inhabitants of his world for inspiration by which to illuminate the humanity of the Bible. The *Elijah* has been likened with justice to the paintings of old men by the great Spanish realist José Ribera, but there is a delicacy in Hawthorne's figure that one does not find in Ribera's work.

Urban realism was one of the major progressive directions American painting took in the early years of the twentieth century; the other direction, which ultimately assumed many diverse forms, was an investigation of European modernism by those artists who went to Europe, especially to Paris, and whose interest was reinforced by the Armory Show in New York in 1913. Though the influence of cubism, futurism, orphism, and other modern movements upon American artists makes one of the most interesting chapters in American art of the period, these investigations have almost no significance in the history of the study and depiction of the nude. Even more emphatically than the members of the Ashcan School, these painters turned their backs upon the Salon tradition. Whatever the direction their art took, it tended toward abstraction and the study of formal elements of painting and away from the representation and glorification of that traditionally most beautiful and perfect of forms, the human figure. What may appear surprising—though perhaps characteristically American—is that, unlike the contemporary works of Picasso and Braque, in these paintings the human figure was almost never the subject of dissection and fragmentation in cubist terms. One of the few major exceptions is the group of synchromist works done by Stanton Macdonald-Wright (1890–1973), in some of which heroic,

almost Michelangelesque figures are constructed from light-filled kinetic color fragments—an approach to the figure that Macdonald-Wright retained in his later, more representational work (*Colorplate 16*). But even synchromism, that Paris-based modern movement originated by Macdonald-Wright and Morgan Russell, showed only occasional interest in the figure,

8–7. Charles Webster Hawthorne. *Elijah*. Ca. 1905. Oil on canvas. The Massachusetts General Hospital, Boston. Photograph courtesy Vose Galleries of Boston.

often producing pure color abstractions, though Macdonald-Wright, more than Russell, tended to create abstract natural forms in which vestigial representation remained. In such works, Macdonald-Wright combined his interest in the muscular coordination of the human body with the rhythms and velocity of intersecting color planes. This approach to the human figure was chosen only occasionally by other Americans during the decade 1910–20, notably by Arthur B. Davies in some of his experimental semiabstractions such as the *Day of Good Fortune* of 1916 (*Ill. 8–8*).

Joseph Stella (1877–1946) produced a group of compositions featuring the nude in 1922 after a trip to Italy, especially to Pompeii, Herculaneum, and Paestum, in which he renewed contact with classical antiquity. *Undine* and particularly *The Birth of Venus,* a major work 85 inches high, were both painted in that year; otherwise, the nude figures extremely seldom in Stella's *oeuvre*.[11] In these works, and perhaps even more so in such drawings done in relation to them as a pencil study for *The Birth of Venus* (*Ill. 8–9*), Stella invested the classical nude with a religious mysticism in which there appears to be a total sublimation of sexual elements. These works seem to hark back to Giotto and late medieval Italian art in their abstraction of form, in their solemnity, in what has been termed by Irma B. Jaffe their "trancelike suspension of reality." There is real "primitivizing" in their sharp outlines and additive forms. A curious puritanical streak seems to run through Stella's art, and it was noted by the critic in the *New Yorker* concerning these figural works: "An interesting analytical study could be made of Stella and his interpretation of the female form. There is a spot of fear there that to us mars an otherwise perfect execution."[12]

It was in the work of those artists most drawn to the fauve aesthetic, rather than those involved with the more intellectual and geometric approach of cubism, that figure painting and, occasionally, the nude still found vivid expression. This was true of Arthur B. Carles, Samuel Halpert, and also of Alfred H. Maurer (1868–1932), the earliest of the American modernists to go to Paris. Maurer arrived there in 1897 and remained until 1914.[13] His painting was first done in a Whistlerian manner, perhaps the most sensitive and accomplished of the American adaptations of that style. But under the influence of more progressive art in Europe, Maurer abandoned his earlier style and investigated first fauvism and then cubism. Maurer took a very active part in the modern art scene in Paris and was a frequent visitor of Gertrude Stein; on his return to America, however, his feeling that his work lacked artistic identity and his increasing professional obscurity led him to doubt his own aesthetic, and this doubt may have contributed to his decision to commit suicide.

Of the series of nudes Maurer painted in 1927–28, there still exist a few on gesso panels (*Ill. 8–10*). In them, simplified, twisting figures enclosed in rather sharply defined lines are flattened out, along with the upturned planes of their surroundings—a rather unique combination of fauve formal

8–8. Arthur B. Davies. *Day of Good Fortune.* 1916. Oil on canvas. Collection of the Whitney Museum of American Art, New York. Gift of Mr. and Mrs. Arthur G. Altschul.

representation and cubist spatial distortion. The spectator seems to be looking simultaneously down, across, and up at the figure. These imposing nudes appear to represent Maurer's only investigation of the theme. They were painted between the fall of 1927 and the spring of 1928, at which time he exhibited them at Weyhe's in New York City. It was this exhibition that first brought to Maurer what success he was to enjoy in his unhappy lifetime, but it did not prevent him from overpainting some of his nudes, traces of which can be seen through some of his later Heads series. Breasts have been turned into eyes, limbs into necks, and so forth.

The one important American modernist who never turned his back upon the figure was Max Weber (1881–1961).[14] Weber's art, from his arrival in Paris in 1905, reflected more aspects of the European aesthetic, running the gamut of fauvism, expressionism, cubism, and futurism, than that of any other American. Sometimes Weber's personal contributions are compromises, at others they are brilliant solutions to the expression of his own insights.

Weber varied his approach to the subject of the nude widely in these years. His *La Parisienne,* was painted in 1907. Radical simplification of the form of the reclining female nude attests to Weber's repudiation of his own early training, first in America and then in the academic traditions of the Académie Julian. The swelling curves and flowing patterns of form are not unlike those adopted by Modigliani, but the parallel can only be coincidental, since Modigliani was not to evolve his aesthetic of the nude until later. Weber's painting of this date suggests exposure to and perceptions gained from Gauguin and the post-impressionists, and perhaps the influence of Matisse.

In the latter part of 1907, Weber organized an art class un-

8–9. Joseph Stella. *Nude,* study for *The Birth of Venus.* 1922. Pencil and crayon. Courtesy of Rabin and Krueger Gallery, Newark, New Jersey.

8–10. Alfred H. Maurer. *Standing Female Nude.* 1927–28. Casein on gesso on composition board. University Gallery, University of Minnesota, Minneapolis. Gift of Ione and Hudson Walker.

der Matisse's guidance, which included a number of young Americans, among them Patrick Henry Bruce. The class emphasized the study of the nude, and the considerable group of oil sketches made by Weber show him far more involved with construction through color than previously. The color is bold, the forms tremendously simplified and constructed by areas, or blocks of color. This approach derives not only from Matisse's teaching but from Weber's previous exposure to the art of Cézanne, first at the Salon d'Automne in 1906 and then at the Memorial Exhibition of Cézanne's work in 1907.

Weber returned from Paris and arrived in New York City in 1909. In Paris he had been part of the avant-garde art world of the Steins, Picasso, Matisse, and his close friend Henri Rousseau, and such Americans as Samuel Halpert and Bernard Karfiol. In New York he was alone, and his art was misunderstood and condemned, when it was seen at all. Fortunately, Weber was able to find some exposure—in such exhibitions as his first one-man show in 1909, at Haas's frame shop on Madison Avenue and in those organized by such champions as Alfred Stieglitz in his gallery at 291 Fifth Avenue and John Cotton Dana, who gave Weber his first museum show at the Newark Museum in 1913.

Weber's art during his early years in New York City explored two rather divergent directions. As though in reaction against the strong, bold colorism of Matisse, such a work as the *Figure Study* of 1911 exhibits a powerful formalism, a cubist fragmentation of anatomical structure, and a figural and facial distortion deriving from primitive art and bearing comparison with Picasso's earlier *Demoiselles d'Avignon* (*Ill. 8–11*). It was about this work that the uncomprehending critic of the *Globe,* Arthur Hoeber, the impressionist landscape painter, wrote in 1911:

> Here are travesties of the human form, here are forms that have no justification in nature, but that seem for all the world like the emanations of someone not in his right mind, such as one might expect from the inmate of a lunatic asylum.[15]

Two years later, Weber created a body of work, equally modern, equally investigative of distortion, and yet different from the cubist concentrations of *Figure Study.* These include his well-known *Fleeing Mother and Child* and *Decoration with Cloud,* both of 1913 (*Colorplate 17*). There is here a reversion to Matisse. The figures and space are both flattened, and the bold, raw colors are laid on in flat areas. The distortions and simplifications of the nudes are reminiscent of the works of Matisse of just a few years earlier. The feeling for paint, too, and the broken edges of the flat areas of color bespeak fauve influence.

In both his cubist and his fauve approaches to the nude, Weber reveals a preference for expressive emphasis. In his cubist work, his interest is in formal coherence; but he has also evoked the emotional power of primitive art, adapting its

8–11. Max Weber. *Figure Study*. 1911. Oil on canvas. Albright-Knox Art Gallery, Buffalo, New York.

formal distortions. In his fauve pictures, it is not only the decorative brilliance of Matisse that finds expression but also a primitive emotionalism. The white figures are jarring against their brightly colored backgrounds; the exaggerations of form underline their activity; their soft outlines heighten the impression of an unstable environment. In *Decoration with Cloud,* the nudity of the central figure is purposely hidden behind the large, upright tree.

These fauve pictures by Weber are among the most surprising of his career, but it was the cubist direction that was to take primary place in his work for the remainder of the decade, to be joined with futurism, particularly in his brilliant investigation of the dynamics of the modern city. At the same time, the nude was relegated to a minor place in Weber's work, only to appear prominently again after 1920, another period of diverse exploration of this theme in American art.

OPPOSITE
Colorplate 17. Max Weber. *Fleeing Mother and Child.* 1913. Oil on canvas. Bernard Danenberg Galleries, New York.

Colorplate 18. Guy Pène du Bois. *Reclining Nude*. 1936. Oil on canvas. The Art Gallery of Hamilton, Hamilton, Ontario, Canada. Gift of the Women's Committee, 1964.

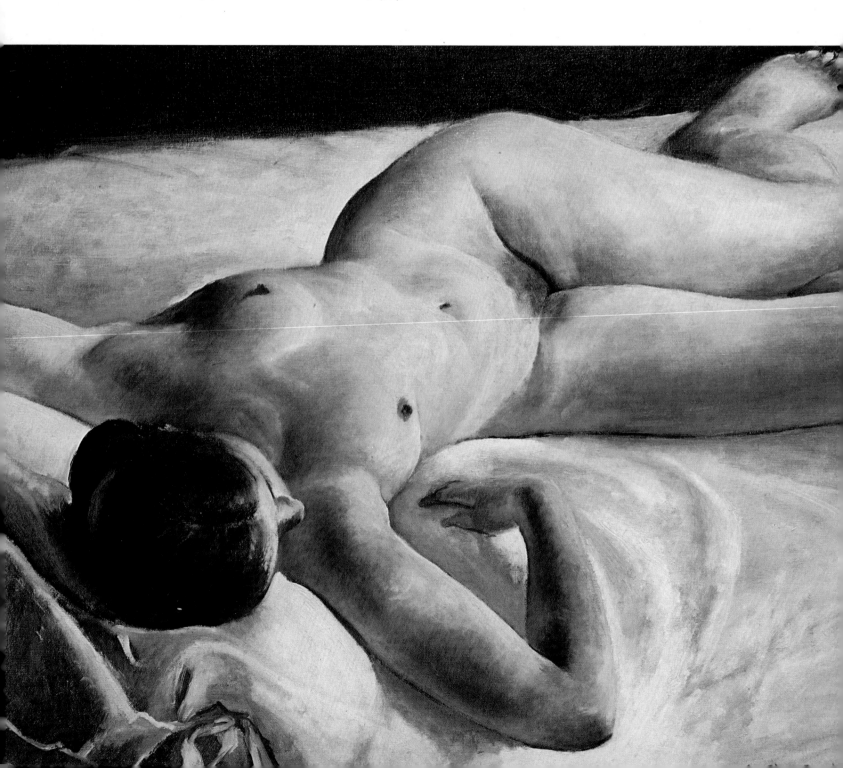

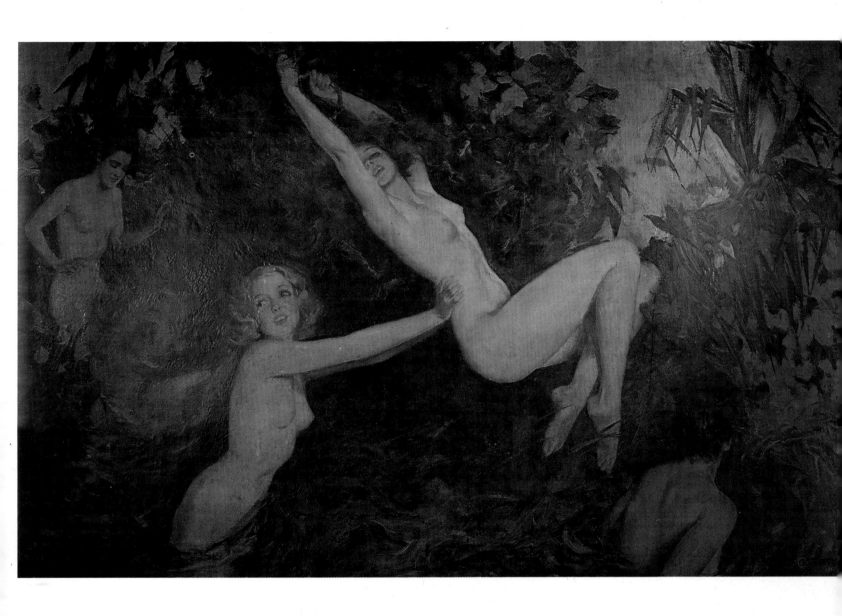

Colorplate 19. Howard Chandler Christy. Detail from the murals painted in 1941–43 at the Café des Artistes, New York.

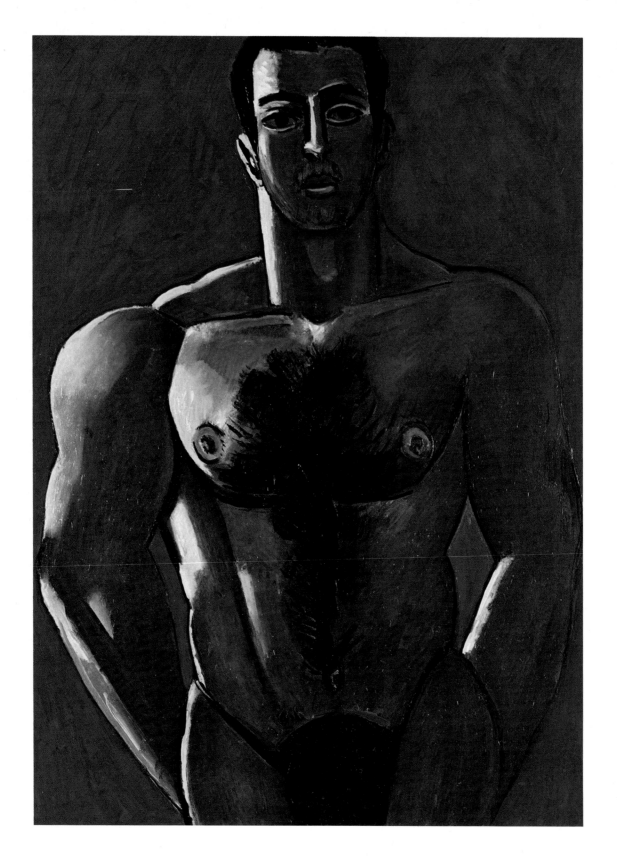

Colorplate 20. Marsden Hartley. *Madawacka, The Greek Boxer.* 1941. Oil on canvas. Collection of James Speyer.

Between the Wars:
A Second Golden Age

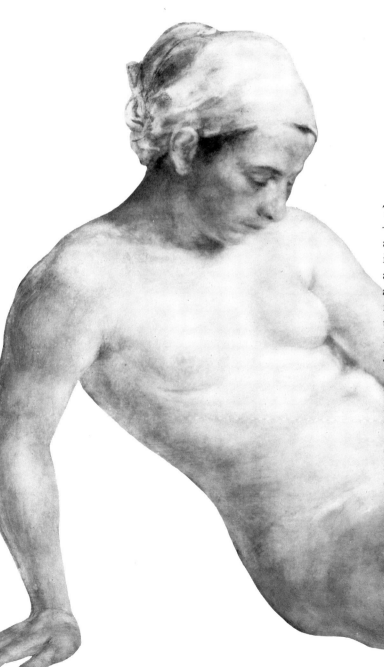

THE ART CREATED between the world wars has been described —and for good reason—as being conservative, even reactionary, mirroring the return to isolationism that can also be found in American politics during the period. The art of the 1920s and 1930s has also been found wanting because of its ill-achieved attempt at establishing a compromise between the inheritance of European modernism and the native American tradition. This is one way to view the more progressive and inventive American artists, such as the precisionists. The regionalists, on the other hand, deliberately turned their backs upon Europe, renouncing the more abstract tendencies of French modernism, and produced imagery either of an urban nature derived from the Ashcan School or of untainted rural America.

It was a period given over to retrenchment and rethinking of traditional forms, not a radical one. Many artists who, in the second decade of the twentieth century, had investigated modernist aesthetics retreated from abstraction and returned to more naturalistic methods of depiction—including Georgia O'Keeffe, Samuel Halpert, Joseph Stella, and others. Some of the paintings of the nude by Alfred Maurer and John Sloan that we considered in the previous chapter were produced in the 1920s and later, though they sometimes reflect investigations made previously.

About 1921 Max Weber returned to a far more traditional approach to subject matter. Throughout the 1920s, whether in

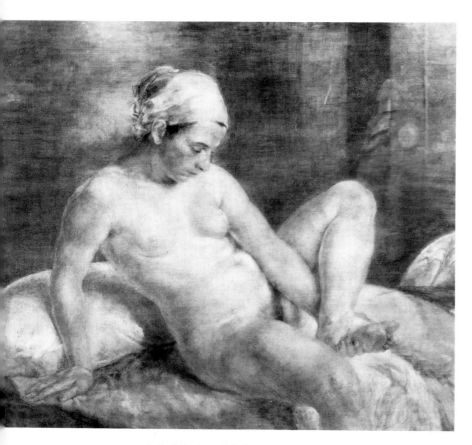

9–1. Isabel Bishop. *Nude*. 1934. Oil on composition board. Collection of the Whitney Museum of American Art, New York.

still life or in figurative works, which often involved the nude, his approach was far less "shocking" than had been the case earlier. Of course, the European artists Weber's earlier work had reflected were themselves taking more traditional lines—Picasso and Matisse included. Much of Weber's painting of the 1920s is directly reflective of Cézanne, in its concern with solid and powerful formal structure and with the building up of color volumes. In other words, far from renouncing the European position, Weber was returning to the basis of it all.

For all the ground apparently lost in the 1920s, it may well be argued that a permanent legacy was established through the concern of American artists with structural expression and their determination to understand that expression abstractly, even though many of them, like Weber, felt impelled to search out more selectively and perhaps hesitantly the underlying basis of modernism.

This proved a kind of second golden age for the depiction of the nude, not a surprising development. Certainly, the nude by its very nature, whatever its sensual overtones, offered a traditional theme that necessarily involved structural concerns. But the host of paintings of the nude made in the 1920s and 1930s differs markedly from those of the nineteenth century,

even though charges of conservativism have been leveled at the artists who painted them most frequently—for example, Yasuo Kuniyoshi (1893–1953), Bernard Karfiol (1886–1952), Leon Kroll (1884–), Louis Kronberg (1872–1965), Eugene Speicher (1883–1962), Alexander Brook (1898–), and Isabel Bishop (1902–). For one thing, the poetic trappings of the earlier American reflections of the French Salon nude are usually absent. The ladies—and, again, the nudes are generally, though not always, female figures—are more often than not indoors and are not stepping into limpid pools under shading tree boughs in intimate glades. The change in setting is significant. No longer was there any need to avoid charges of indecency. No longer did the outdoor setting, with its flickering lights, glowing reflections, and haziness and indistinction, serve the needs of the painters. Because of their structural and formal concerns, they preferred a setting wherein the figure could be observed and depicted under constant and controlled lighting, where clarity of form and structure could become uppermost. The figures were observed naturally, often in everyday interiors.

This is not to suggest, however, that all of the artists of the period treated the nude alike. Karfiol's treatment, for instance, is usually a good deal simpler and more primitive than that of Speicher or Kroll. The latter, for all his academic technique, combines a powerful structural sense with a real feeling for the warmth and beauty of the female form in a group of nudes of the 1930s. Isabel Bishop brings forth the poetry of everyday living in her figures both clothed and undraped, but it is a natural poetry descended from Degas through her teacher Kenneth Hayes Miller and the Fourteenth Street School, rather than the more artificial conventions of the Salon painters (*Ill. 9–1*).

Although the representational nature of the work of these artists may ally them with the Ashcan School, their techniques were more conservative and traditional. Isabel Bishop, for instance, revived a painstaking Renaissance tempera technique far removed from the slashing brushwork of Sloan and Henri; even this difference in technique is the result of an increase in concern for structure. There were variations, too, in the degree to which the different painters retreated from the extreme modernism of the previous decade. Karfiol, for instance, was one of the first Americans to go to Paris at the beginning of the century, and his work, perhaps because of this, remained more indebted to the radical aesthetic than that of many of his contemporaries.[1] Guy Pène du Bois (1884–1958), who studied with Chase and Kenneth Hayes Miller before going to Paris in 1905, painted a number of nudes, particularly in the 1930s, which are modernist in the structural concerns they evince and in their formal distortions and simplifications; yet they have both drama and sensual energy (*Colorplate 18*).

The work of this second generation of urban realists differs a good deal from that of Henri and his followers. One of the painters of this group is Edward Hopper (1882–1967),[2] who studied with Henri and Miller but like du Bois substituted a

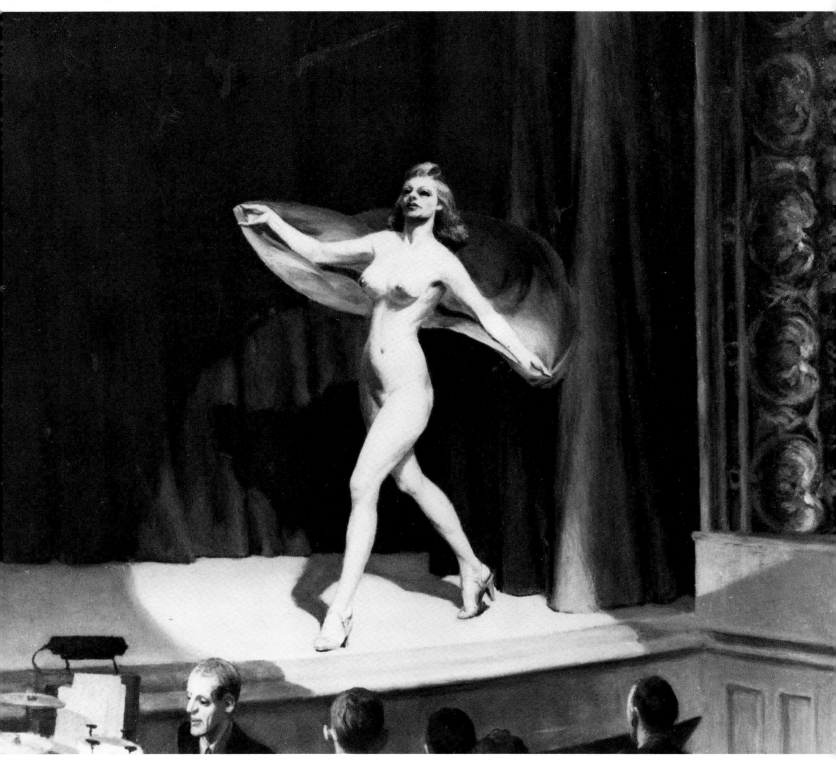

9–2. Edward Hopper. *Girlie Show*. 1941. Oil on canvas. Private collection.

structural organization for the slashing brushwork of his teacher Henri and replaced the latter's vibrant buoyancy with an often twilight melancholy. Hopper's figures are often as awkward and as graceless as the urban environments that were his main concern, and his relatively rare nudes are no exception. They include a number of monumental works painted at different times during his career—*Eleven A.M.* of 1926, *Morning in the City* of 1944, and *A Woman in the Sun* of 1961. In these paintings loneliness and melancholy are manifest in the contrast between the isolated, single figures and the spare and graceless interiors. The figures are presented before a window, looking out, a presentation that offers poignant contrast between the intimate nakedness of the women and the impersonal expanse of the city beyond. There is an underlying sensuality in these figures, though they are still as austere as the environment in which they are placed. The figures are solid and physical; they are also very honest, and there is no suggestion about them of academic idealism. These interior views bear some similarity to the Window series by Childe Hassam; they also suggest a kinship with the many paintings of single figures before an open window to be found in the work of Caspar David Friedrich and the German romantic painters, though without the somewhat surrealistic overtones that these European works occasionally have.

A somewhat different type of depiction of the nude may be found in Hopper's *Girlie Show* of 1941, one in a series of theater pictures he painted (*Ill. 9–2*). The work bears obvious

9–3. Edward Hopper. *Evening Wind.* 1921. Etching. Collection of the Whitney Museum of American Art, New York. Bequest of Josephine N. Hopper.

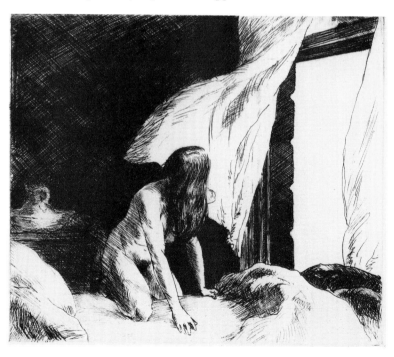

comparison with the many burlesque scenes painted by Hopper's contemporary Reginald Marsh, but Hopper avoids the wild, jazzy rhythms of Marsh, and his stripper is far more solid and structured with greater corporeality than the women in Marsh's work. Hopper's finest treatment of the theme, however, is probably his well-known etching of 1921 *Evening Wind* a highlight of the period when Hopper temporarily abandoned painting for etching and illustration (*Ill. 9–3*). His concern with this medium suggests a debt to Sloan, with whom Hopper's deepest aesthetic sympathies lay, though, as Sam Hunter has written, Hopper replaced energy with enervation to convey the romantic mood of the urban environment.[3] At the same time, the deliberate awkwardness of the figure's pose, its anonymity, and its appearance as a lump of flesh among lumps of furnishings suggests the other spiritual debt that Hopper's art owes to Edgar Degas.

A more vivacious and optimistic point of view infuses the urban scenes of Reginald Marsh (1898–1954), another student of Kenneth Hayes Miller, who alone of his generation seems most to have remained faithful to the great vitality of the Ashcan School.[4] Among Marsh's most successful and most often depicted subjects were the burlesque houses in and around New York City and the beach at Coney Island, natural settings for the nude or near-nude (*Ill. 9–4*). The human figure was of paramount importance to Marsh, and in his paintings it is never subservient to its environment, as it is in Hopper's work. Though Marsh painted a number of pathetic Depression scenes, it was the exuberant Rubensian, swelling figures that interested him most. Sex is a vital element in Marsh's pictorial repertory. He gloried in the human body, but it was necessary for him to find it in the real world, not in the studio. Marsh was acutely concerned with anatomy. This was a lifelong interest of his and led to the publication of his *Anatomy for Artists* in 1945. But, again, his interest was not in the subject for its own sake but rather for it as the manifestation of movement and sexual attraction.

The period between the world wars was also a second golden age of mural painting, principally because of the impetus given the medium by the Works Progress Administration's Federal Art Project of the 1930s. The murals at the Café des Artistes and the Park Lane Hotel in New York City were *not* part of the government's venture into the arts, however, which is not surprising since they represent a kind of apotheosis of the nude (*Colorplate 19*). These were undertaken by the noted illustrator of the period Howard Chandler Christy (1873–1952), who lived for many years at the Hotel des Artistes on West 67th Street.[5] While the 50 girls disporting in the Café paintings are stereotyped images (the Christy Girl, successor to the Gibson Girl and predecessor of the Petty Girl), rendered in a completely representational manner as befitted the talents of their creator, they are nevertheless unabashedly naked, frank, and smiling pagan creatures in glorious Technicolor. They inhabit a landscape setting, as did their predecessors of Salon days, but they are no longer wistful ladies lost in solitary

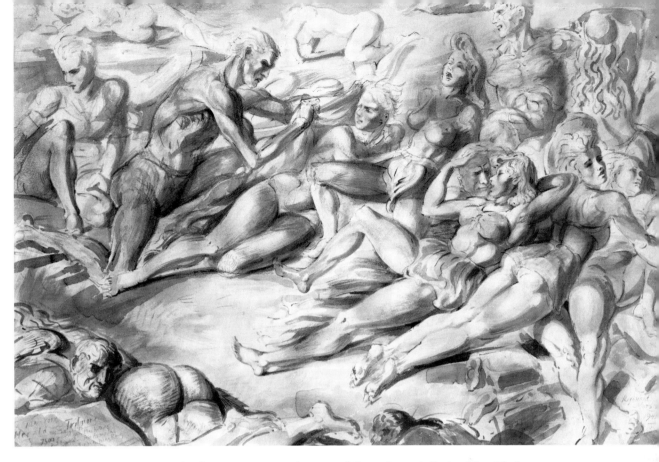

9–4. Reginald Marsh. *Coney Island*. 1945. Chinese ink. Bernard Danenberg Galleries, New York.

reverie, accompanied only by the beasts of the forests or the birds of the sky. Hordes of healthy, lively girls appear and romp about the walls of the Café.

The Christy murals at the Café des Artistes were born of the Depression and its aftermath—specifically, they were painted in several rooms which, after the repeal of Prohibition, were to be more robustly decorated. The first proposal was to have a number of the artists who lived in the hotel or who came there and to the restaurant each paint a single panel, but disagreement among the painters prompted Christy to offer to paint them all. And he did: one series in 1934 and a second between 1941 and 1943. Actually, though they are called "murals," like so much similar work in the later nineteenth and twentieth centuries they are painted on canvas. A number of models posed for them—Elise Ford, Claire McQuill, and others. Several domestic animals were also introduced, along with a male child and one single mature male figure, to join the approximately 50 joyous ladies. Several panels from the series were later sold to a club in Texas, while another triumphant Christy nude was acquired in the 1950s by the Sherry-Netherland Hotel in New York City and installed in the Christy Room. In the spring of 1974, a gigantic mural, *Homage to Terpsichore,* was designed by Enrique Senis-Oliver (1935–) for the proscenium of the Harkness Theater a few blocks away from the Café. This major display of the nude outstrips the former champion, Christie's 50 girls, with the significant difference that here the accent is upon the male nude.

If the Christy murals represent one culmination of the slow and sometimes painful triumph of the nude in American art, the exhibition in April, 1939, of *Classics of the Nude* at M. Knoedler and Company represents another. This appears to have been the first exhibition in America to celebrate the nude; it is noteworthy that Alfred Frankfurter in his introduction to the catalogue of the show pointed out that "one is not allowed to forget the fantastic assortment of tabus, prejudices and perversions—born of bigotry, stupidity, and pathology—with which dozens of generations have clouded its truth." And at even this late date one faced such incredible gestures as a postal interdict on an international art magazine reproducing a few nudes by great contemporary painters. Even the Knoedler show limited itself to "classics"; the latest artists represented were Cézanne and Picasso, with no American artists included.

Indeed, the 1930s were wracked with controversy over the publication of depictions of the nude and once again over the appearance of nude models in art classes. The magazine *Art Digest* appears to have been a particularly vital source of enlightened criticism against such prejudice, regularly reporting such controversies and attacking the narrow-minded who removed depictions of the nude from art shows in Hartford, Connecticut, Orlando, Florida, and Trenton, New Jersey. The magazine was especially annoyed by the removal of nude sculptural allegories from the 1939 Golden Gate Exposition in San Francisco by its director, Harris Connick, though the latter claimed only to be concerned with the appearance of "graceful, beautiful, and anatomically correct figures," qualities

177

9-5. Thomas Hart Benton. *Persephone*. 1939. Oil and tempera on canvas. Collection of Rita Benton.

which he claimed these sculptures did not possess.

Despite the abundance of depictions of the nude, the 1930s did witness a reaction in American art; the trend is manifest not only in the attempts to renew censorship of the nude but also in the struggle of native Americanism against European influences. For the 1930s saw the appearance of Thomas Craven's *Modern Art,* championing native American realism against European modernism and attaching the influx not only of European ideas and aesthetics but of European immigrant artists to American shores. It was the art of the Regionalist painters—Grant Wood, John Steuart Curry, and Thomas Hart Benton—that was upheld by Craven as the ideal of untainted Americanism in art.

For the most part, these artists represented not only the traditional American aesthetic virtues but the moral ones, too,

and the nude found almost as little place in their work as it did in the cubist-realist canvases of the precisionists and in the contemporary social-realist paintings of William Gropper and others. Ironically, it was the most virulent of these artists who did concern himself with nude figure painting—Thomas Hart Benton (1889–).[6] Benton had earlier been one of the most advanced modernists, joining Macdonald-Wright in applying synchromist fragmentation to the rhythms of the human body in free-flowing but almost Léger-like interpretations of volumetric Michelangelesque figures. Benton subsequently renounced this kind of work and destroyed much of what he had done, preaching the gospel of regionalism. As he told his champion Craven, he had previously "wallowed in every cockeyed 'ism' that came along . . . it took me ten years to get all that modernism dirt out of my system." Yet, for all his repudiation of modernism, Benton's later paintings of American urban and rural life still contain some of the pulsating movement and heroic energy of his earlier work. Occasionally, too, these qualities were wedded to the anecdotal depiction of the nude, though, unlike Christy's frank paganism, Benton's approach was purposely prurient.

In the late 1930s Benton painted two monumental nudes, *Susannah and the Elders* of 1938 and *Persephone* of 1939 (*Ill. 9–5*). In both of these, biblical themes have been transposed into agrarian, midwestern settings. In the *Persephone,* for instance, Pluto has become a leering old farmhand. *Susannah* was so popular that the St. Louis Art Museum had to rope off the picture to hold back the crowds when it was exhibited there; *Persephone* was brought by Billy Rose to his Diamond Horseshoe, after he had read that Benton said he would prefer "exhibiting my pictures in whorehouses and saloons where normal people would see them."[7] Anticlimactically, however, it was not a success there. Craven wrote that the *Persephone* "is unsurpassed by anything thus far produced in America," but less than ten years later a perceptive critic dismissed this painting of a model in which the sexual theme is crassly thrown at the spectator.[8] A good many years later, in 1950, Benton followed these two works up with a similar *Apple of Discord.*

Regionalism and the renunciation of extreme modernism were not confined to the American side of the Atlantic, and relatively few of the early American modernists continued to pursue their art in the direction of abstraction in the 1920s and later. Regionalism, however, took on a variety of forms and meanings; the midwestern ideology of Benton and the others was only one (though the most extreme and propagandistic) aspect of it.

Marsden Hartley (1877–1943) had been one of the most distinguished and distinctive of American abstractionists, first working in colorful abstractions based upon flags, emblems, and the insignia of the German military and upon American Indian symbols and later in a series of more austere cubist studies in the manner of Henri Laurens. But Hartley, too, later renounced abstraction for more monumentally structural interpretations of the southwest American landscape and then of

Maine. Perhaps the least studied aspect of Hartley's art is a series of male nudes done in the early 1940s, shortly before his death, including *Madawacka, the Greek Boxer* of 1941 (*Color-plate 20*), *Lifeguard* of 1942, and *Adelard Ascending* of 1941–43. These are awkward but tremendously powerful figures who dominate the minuscule forms around them. The imagery is supermasculine and of heroic scope.[9]

Masculine imagery was the primary concern of a number of artists who began in the 1930s to work in a style of extreme, even microscopic, realism, creating images of conscious erotic fascination. Probably the best known of these is Paul Cadmus (1904–). Cadmus's earlier work, including *To the Lynching* and *Gilding the Acrobats* (*Ill. 9–6*), both of 1935, sprang from regionalist sources. The latter combines a native circus theme with a twisting fluidity of form that is recognizably out of Benton. But this painting is devoted to the male nude, a theme to which Cadmus came to give more and more explicit sexual connotations—in such satirical fantasies as *Fantasia on a Theme by Dr. S.* of 1946, or in very beautiful idealizations of the youthful male in the many crayon drawings that show Cadmus at his finest.

Jared French (1905–), often associated with Cadmus because of his superprecisionist approach to the male figure, like Cadmus worked with an egg tempera technique. His well-known *The Rope* of 1954, is more symbolic than explicit, and in its hieratic simplification, which is related to archaic Greek art, one finds an hallucinatory dream state invoked within a surrealistic aesthetic.

A more subtle and evocative rendering of homosexual imagery had earlier, and very differently, been made by Romaine Brooks (1874–1970) in a series of nudes painted in and after 1910 (*Ill. 9–7*). Miss Brooks's paintings are primarily portraits, but they are also figure studies of the partial or complete nude, particularly *Azalées Blanches* of 1910, *Le Trajet* of about 1911, and the *Weeping Venus* of 1916–18. These works were painted about the time of Miss Brooks's first public appearance in successful exhibitions in the Durand-Ruel Galleries in Paris and Goupil's in London, when she had become part of an international cultural community that included her good friends Gabriele d'Annunzio and Natalie Barney. Romaine Brooks's art, and particularly these figure paintings and her later bizarre, surreal pencil drawings of the 1930s, reveal her as a late artist of the symbolist movement. Her nudes are thin and listless, wan and melancholic, and yet they project a dark sexuality—as Joshua Taylor has described it, "a nagging consciousness of disturbed harmony." Speaking specifically of *Le Trajet,* Taylor wrote:

> It is a quietly grim image formulated in the poetical twilight language of the end of the century. Each line is extended like a prolonged humming sound, and the fleshless nude belongs to the stylized artistic haven first defined by the Rossettian cult and later consecrated as the haunt of soul-seeking artists from everywhere. It is not a statement of innocence but of sensuality purged.[10]

9–6. Paul Cadmus. *Gilding the Acrobats.* 1935. Tempera and oil on composition board. The Metropolitan Museum of Art, New York. Arthur H. Hearn Fund, 1950.

9–7. Romaine Brooks. *Azalées Blanches.* 1910. Oil on canvas. National Collection of Fine Arts, Smithsonian Institution, Washington, D.C.

On the opposite side of the coin from the superheroic or idealized interpretation of the nude is the fixation upon its decay and decomposition. In the work of Ivan Albright (1897–), man is the center of a world, but it is a transient, rotting world of horror and decay. When Albright's figures are partially unclothed, as in the lithograph of about 1941 of *Three Love Birds* (*Ill. 9–8*) and the oil painting *And Man Created God in His Own Image* of 1931, the blotched and sagging flesh accents the decrepitude of the wrinkled faces of his worn-out subjects. As with Cadmus's and French's figures, minute precisionism lends surreal overtones to Albright's mournful interpretations.

Albright's figures appear diseased and on their way to death. Some of those by Hyman Bloom (1913–) have already arrived there. Bloom was one of the most individual of American expressionists to emerge in the 1940s; his work follows in the tradition of the bejeweled color and thickly impastoed distortions of Chaim Soutine. Many of Bloom's best-known canvases evince his concern with his Jewish heritage. But there is another, fascinating side to Bloom's art, the depiction of bloated, putrefied corpses, flesh that glows with brilliant color while it decomposes.[11] Bloom began this series in 1942 with his *Skeleton* and continued it in 1945 with depictions of amputated limbs, such as *The Leg*—a form ulcerous yet coloristically bejeweled, so that it is carbuncular in both senses. The same

year he began the series of paintings of life-size corpses of elderly persons, both front and back views, that deliberately emphasize the indecency of the autopsy. The corpse theme, per se, is a rare one. Of course, naked and half-naked figures have been shown many times dead on the battlefield and on the cross. But the dead nude, divorced from biblical, classical, and historic themes, is exceedingly rare in the history of art. In Bloom's canvases death in anonymity is presented; this mundane quality is offset by the chromatic brilliance of putrefaction. Cadmus and French, Albright and Bloom point the way to the diversity of new interpretations of the nude in contemporary American paintings.

Twentieth-century American sculpture before World War II appears even more conservative and less exploratory than American painting of the same period, offering almost nothing to match either the strong, vigorous realism of the Ashcan School or the experimental abstraction of those painters influenced by Europe. Nevertheless, American sculptors of the period did produce more varied interpretations of the figure and the nude than one finds in contemporary painting. Even in the work of one of the most conservative sculptors, there are outstanding examples of the nude figure. Arthur Lee (1881–1961) was Norwegian-born.[12] His academic inclinations were early brought out during his period of study under Kenyon Cox and at the Ecole des Beaux-Arts in Paris. He himself

ABOVE

9–8. Ivan Albright. *Three Love Birds*. Ca. 1941. Lithograph. Collection of Peter Pollack.

RIGHT

9–9. Arthur Lee. *Volupté*. 1915. Marble. The Metropolitan Museum of Art, New York. Anonymous gift, 1924.

9-10. Paul Manship. *Diana*. 1925. Bronze. Ball State University Art Gallery, Muncie, Indiana.

later became an instructor at the Art Students League. In *Volupté* and other similar works (*Ill. 9-9*), Lee's belief in ideal beauty is manifest, but it is successfully wedded to a sense of actual humanity and of idiosyncratic form. Lee often deliberately "fragmented" his work, not only to reinforce a classical sense of timeless loveliness but also for the sake of balancing and enhancing the remaining parts of the body—here the sloping, curving, arching rhythms of shoulders, thighs, buttocks, and breasts. The surfaces of Lee's works have the same general grace and beauty as the figure itself, a debt the artist would appear to owe to Rodin.

The dominant progressive tendency in the sculpture of the early years of the century was to be found in the direction of extreme stylization of form—an emphasis upon simplification and linearism, best embodied in the work of Paul Manship (1885–1966), particularly in his *Diana*, which was done several times in several sizes between 1921 and 1925 (*Ill. 9-10*). Manship was one sculptor who ignored Paris—both the beaux-arts tradition and that of Rodin—and found his inspiration, rather, in archaic Greek art, heretofore much ignored. Manship produced an interpretation of the figure emphasizing sleek rhythms, linear arabesque, and airy movement—a sculptural derivation from the aesthetic of art nouveau. He had emphasized the decorative value of line in an early paper read before the American Academy in Rome in 1912, "The Decorative Value of Greek Sculpture." No artist in American art had previously so emphasized linearism. When Manship was at the height of his career, his work had great appeal, for it tended toward abstraction and extreme sophistication and yet remained intelligible. In later years, however, his achievement has tended to be downgraded: in part because of superficiality, particularly in such later commissions as the *Prometheus* for Rockefeller Plaza in New York City; in part because his compromise with modernism seemed so extremely tame to more radical younger sculptors after 1940.

Yet, in the second and third decades of the twentieth century, Manship's style represented a breakthrough in terms of figure sculpture. Not, of course, that he alone brought it about. Extreme stylization of the human figure far more radical than Manship's can be found in the work of Alexander Archipenko (1887–1964), who, like Manship, rejected both beaux-arts and Rodin when he left Russia for Paris and who also was inspired by the archaic Greek world. But for Archipenko, unlike Manship, archaic sculpture was only one phase of a growing appreciation of primitive art generally, which was already affecting Picasso and other young modernist painters. At the same time, Archipenko evolved a sculptural style related to cubist and futurist aesthetics. His *Woman Combing Her Hair* of 1915 is one of the most complete sculptural statements in cubist terms; subsequently (in Berlin in 1921 and from 1923 on in America), Archipenko continued to experiment both with form and with materials, but much of his finest work represents a simplification and streamlining of the standing and floating female figure. This streamlining resulted primarily

from the exercise of a unique understanding of, and feeling for, the nature of the materials with which he dealt. This is particularly evident in his metallic *Torso in Space* (*Ill. 9–11*).

Another East European to come to America was the Polish Elie Nadelman (1882–1946), who had a stronger impact upon American art than his Russian contemporary.[13] He arrived in Paris in 1903 and became friendly with Picasso and Matisse, though he was closest of all to the Steins. Nadelman's work of about 1909 shows an analysis and dissection of the human figure in semicubist terms, but his primary interest lay in the exploration of the "line of beauty," a balance of curve and countercurve, though without that sacrifice of sculptural mass found in Manship's sculpture. Nadelman found a great patron in Helena Rubinstein, who bought out his entire show at the Patterson Gallery in London in 1911, and it was she who brought him to America in 1914. However, his work had been shown previously in the United States—by Alfred Stieglitz in 1910 and again in the Armory Show three years later. Much of the work of these years and after were interpretations of the nude; others were witty renderings of elegant society types.

After the Wall Street crash of 1929, in which Nadelman and his wife lost their fortune, the sculptor withdrew more and more from both the art world and society. He occupied much of his time with almost doll-like terra-cotta figurines, loosely inspired by antique Tanagra figures. He was also at work on a series of gargantuan figures, such as those designed in 1931 as overdoors for the Fuller Building in New York City. Today the most famous of these is the enlarged double pair of female figures installed in the New York State Theater at Lincoln Center early in 1964. These were based on two sculptures about five feet in height done by Nadelman about 1930–31; like much of his work of that period, these were executed in fragile papier-mâché. One is of two circus women, the other two female nudes. The latter (*Ill. 9–12*), about 19 feet high and weighing about 12 tons, must be the most heroic public American statue of the nude, though even these figures would be dwarfed by the huge beaux-arts female who once reigned above the entrance to "Dreamland" at Coney Island. But Nadelman's women are extremely sophisticated, humorous, and witty. The robust femininity of these doll queens, ballooning out in soft, curving undulations, suggests they were formed under the influence of the dynamic images of Gaston Lachaise.

Lachaise (1882–1935) was one of the major sculptors of the first half of the twentieth century, certainly the greatest interpreter of the nude in American sculpture of this century.[14]

9–11. Alexander Archipenko. *Torso in Space.* 1946. Chrome-plated bronze. Addison Gallery of American Art, Phillips Academy, Andover, Massachusetts.

Yet his art did not develop unaided, and his seven-year period as an assistant to Manship was vital for his own artistic development. Lachaise was born in Paris, and, after studying at the Ecole des Beaux-Arts, he came to America in 1906, thus reversing the pattern of such painters as Weber and Stella. During the second decade of the century, while working with and for Manship, Lachaise was evolving the imagery for which he is best known. These figures, primarily though not always female, show a debt to Manship in their simplified, curving contours, but Lachaise endowed them with a swelling roundedness at once monumental and tremendously sexual. These twentieth-century fertility images include *Standing Woman,* or *Elevation,* conceived in 1912 but completed in bronze only in 1927 (*Ill. 9–13*), and *Standing Woman* of 1932. These great figures have tremendous amplitude in their full-breasted, wide-hipped anatomy, which tapers down to slender feet

9–12. Elie Nadelman. *Female Nudes.* Enlarged from papier-mâché figures of 1930–31. Marble. New York State Theater, Lincoln Center for the Performing Arts, New York.

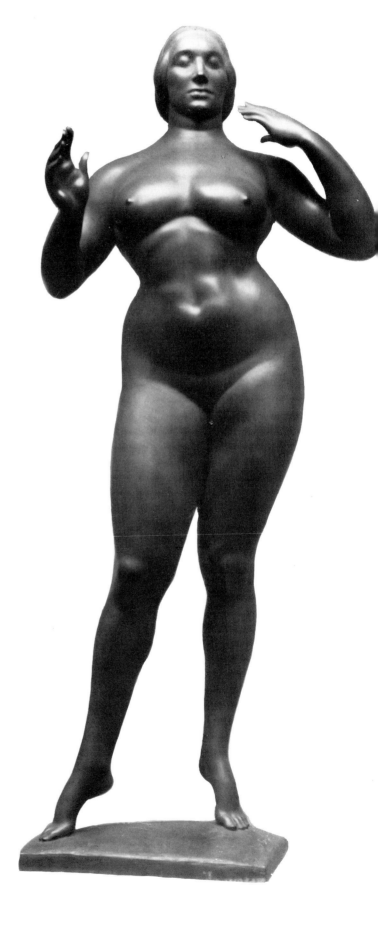

barely able to support them. In the 1930s, Lachaise revived, in modern terms, the nude portrait, the most successful of which is probably that of Lincoln Kirstein, the bronze *Man Walking* of 1933. Also in the 1930s Lachaise experimented more and more with "fragments"—parts of the human form. Knees, but particularly the female sexual organs, appear: *Breasts with Female Organ Between* of 1930–32 has an explicitness never attempted before in American art; here there is no suggestion of a ruin in the partial figure. Lachaise's later figures are more and more distorted toward an explosive sexuality, as is his *Dynamo Mother* of 1933; with tremendously erect nipples and enlarged sexual organs, it is a powerful statement of birth and love (*Ill. 9–14*).

Similarities to Lachaise's sculptures and particularly to his drawings can be found in the incised terra-cotta reliefs produced by Reuben Nakian (1897–) in the 1940s depicting lusty nude females, their outlines slashed into the clay. This is not surprising, for decades earlier Nakian had joined Lachaise in 1916 as an assistant to Manship.

Along with a new concern with form and a tendency toward abstraction came a new respect for the materials in which sculptors worked, but, rather than encouraging a new neglect of the human body, this interest furthered a proliferation of sculptures of the nude. Above all, the period between the wars witnessed a resurgence of interest in stone sculpture. Although there were a few examples of direct carving in the nineteenth century, by such artists as William Rimmer, it was only about 1920 that a new, vigorous tradition of stone-carving arose.[15] One of the first and oldest of the artists to express himself in this fashion was the Madrid-born José de Creeft (1884–). His interest in direct carving was probably influenced by his work in Paris repairing broken statuary.

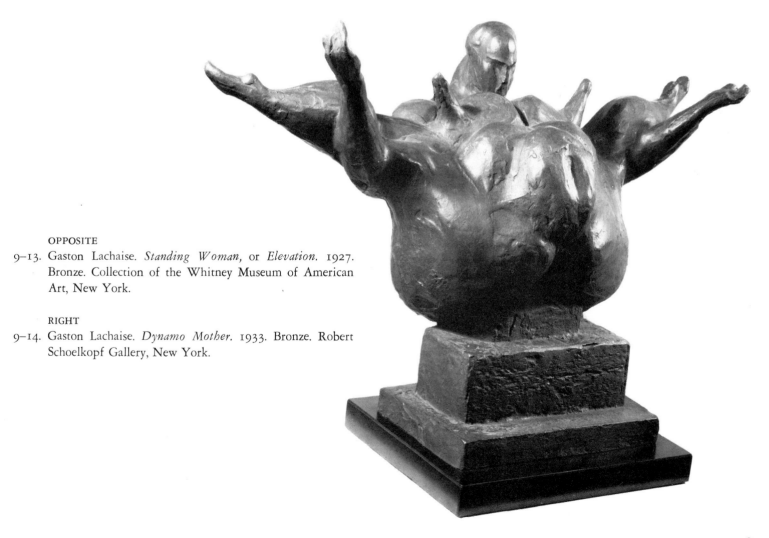

OPPOSITE

9–13. Gaston Lachaise. *Standing Woman,* or *Elevation.* 1927. Bronze. Collection of the Whitney Museum of American Art, New York.

RIGHT

9–14. Gaston Lachaise. *Dynamo Mother.* 1933. Bronze. Robert Schoelkopf Gallery, New York.

Artists such as de Creeft embodied in their sculpture a respect for the basic shape, texture, color, and weight of their materials in the tradition of Michelangelo and Rodin, who were the progenitors of this kind of sculpture.

The best known of all of these practitioners of direct stone-carving was William Zorach (1887–1966), who as a painter had been greatly influenced by cubism and fauvism before he turned exclusively to sculpture in 1923, after tentative experiments with the medium as early as 1917.[16] Zorach created a body of massive and monumental figures in which the influence of cubism is never completely lost. They are simplified and retain a geometric "blockiness." Planes were smoothed and right angles emphasized, as Zorach felt the influence of examples of primitive African art and derivations from that art by early twentieth-century modernists. Zorach's figures are far more massive and earthbound than those of de Creeft. Lacking the curves and diagonals of de Creeft, Zorach's figures fit a grid of horizontals and verticals; instead of depicting floating forms moving out into space, he places his figures solidly on the ground, and they maintain a strong parallelism with the viewing planes. Zorach particularly favored the beauty of the nude female form, and his figures acknowledged as dominant the theme of love; they lack the rampant sexuality of Lachaise, fitting comfortably into cherished beliefs about family and maternity, which added, as did Zorach's increasing sentimentality, to their wide acceptability and appeal. Yet, in the farther reaches of 1930s America, even the work of such a reputable sculptor as Zorach could come under fire. In 1936 a work by him honoring the pioneer women of Texas was rejected on account of the nudity of the subject because the woman depicted was not wearing a wedding ring!

Robert Laurent (1890–) was another of the first twentieth-century masters of direct carving; in addition, he was one of the most versatile sculptors of the period, equally at home with stone, alabaster, wood, and bronze. In the 1930s, Laurent, together with Zorach and Gwen Lux, was commissioned to produce sculpture for the Radio City Music Hall in New York City. Laurent's work was to be cast in aluminum. When Laurent's *Goose Girl* and Zorach's *Spirit of the Dance* were completed in 1932, the manager of the theater refused to accept them because they were nude, but critical opinion forced a reversal of this decision; the sculptures, however, were placed inconspicuously.

Beautiful and sensitive renderings of the human form were made in materials other than stone: for example, the hammered copper reliefs of Saul Baizerman (1889–1957) and the hammered lead reliefs of Dorothea Greenbaum (1893–) —a medium also investigated by de Creeft. These *are* reliefs, but the figures do not so much seem to emerge from a neutral background as to swell out the whole sheet that contains them. Baizerman's figures have a great sense of largeness and mass, while still openly acknowledging the nubbly texture of the copper. Miss Greenbaum's figures are dreamy, exquisite forms, and the dull, flat gray material adds to the sense of evanescence.

Stripped Bare of Pretense: The Past Thirty Years

THE 1940S WITNESSED the development and dominance of abstract expressionism, a movement which, for the most part, was antipathetic to the presentation and exploration of the formal or expressive possibilities of the nude. On the other hand, abstraction was only one aesthetic of the period, albeit the most significant one. While pure expressionism, the distortion of still recognizable form for emotional power, never took hold of the American artistic consciousness to the extent that it did in Germany, for instance, there have been isolated artists for whom and masterworks in which such expressive content has been primary.

In sculpture, the dominant figure was Jacques Lipchitz (1891–1973), who came to the United States in 1941 as a refugee from France; his influence had been strongly felt, however, in the previous decade, when his work was seen on a large scale at a show at the Brummer Gallery in New York City in 1935. Though Lipchitz had always been concerned with the human form, the exploration of the nude, as such, was not primary to his aesthetic, but mention should be made of the magnificent *Mother and Child II* of 1941–45. It presents a traditional theme doubling at a bovine head, thereby underlining the conception of an iconic Mother Earth image, as the figure's breasts become eyes, her child's legs become cow's ears, and her arms, raised in supplication, become horns. The power of the work, however, lies not only in the clever double imagery but also, and most essentially, in the swelling

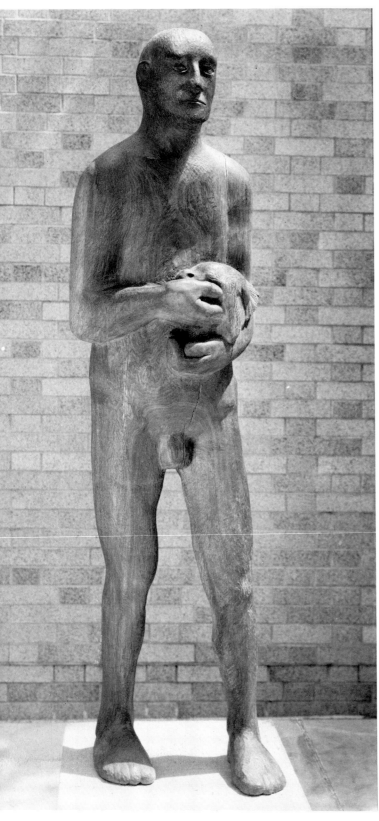

10-1. Leonard Baskin. *Man with Dead Bird*. 1951–56. Walnut. Collection, The Museum of Modern Art, New York. A. Conger Goodyear Fund.

massiveness of form, consistent with both aspects of the maternal equation.

The expressive possibilities of the nude are manifold, and never before the last several decades have American artists investigated such a variety of interpretations of the theme. Previously, the American artist, for all his apparent daring, was, after all, following traditional paths, and often quite timidly at that: The turn-of-the-century nude was presented in imitation of her French Salon counterparts, and Vanderlyn's *Ariadne* was related to European contemporary manifestations and could also be justified by comparison with hallowed Venetian Renaissance examples. But the contemporary artist seems deliberately, even flagrantly, to avoid every connection with the tradition, except occasionally in deliberate parody. As in almost all aspects of contemporary art, the American artist seems to have set about to open up new avenues in the interpretation of the nude. Considerations of formal beauty and of eroticism are two of the most obvious and frequent. Both are, of course, implicit in *all* interpretations of the nude in all periods, even when artists have—only very occasionally—consciously negated these qualities by depicting the naked body as ugly, as did Ivan Albright. Even in his work repugnance is imposed upon the spectator in obvious denial of the traditional treatment of the nude as a thing of beauty.

Leonard Baskin (1922–) has used nakedness to describe man's fears and isolation—the human being stripped bare (*Ill. 10–1*). His figures seem to have emerged from the grave or to be marching resolutely toward it. The fineness of bronze modeling or the beauty of wood graining and color seems only to point up the terror of death, as do Hyman Bloom's bejeweled corpses.

In painting, Bloom's fellow social realist Jack Levine (1915–) has in recent years taken to the study of the expressive possibilities of the nude.[1] These exist in two areas. Better known are his satiric reinterpretations of religious and classical history—the *Adam and Eve* of 1959, *Cain and Abel* of 1961, *Three Graces* of 1959, and the many versions of *The Judgement of Paris* of the 1960s. In *Adam and Eve,* man's weaknesses are expressed in blemishes and flaws, while consciousness of sin is translated into the distortions of the nude form. In the classical *Judgement of Paris,* the three goddesses, judged by a beatnik Paris, are presented as jokes upon female vanity.

More powerful, really, are those treatments of the nude closer to Levine's actual experience. Here he followed the iconography of Reginald Marsh. In his pictures of burlesque queens, the *Thirty-five Minutes from Times Square* of 1956 (*Ill. 10–2*) or *Girls from Fleugel Street* of 1958, Levine was mocking by exaggeration the offerings of the flesh. The painting of the ripe forms is lush, but their vulgarity, together with the vacancy of mind, produced sex without appeal, lust cheated by boredom. As such, Levine uses nudity as a satiric moralist, a modern-day Hogarth.

In the 1940s and 1950s, however, Levine and other expres-

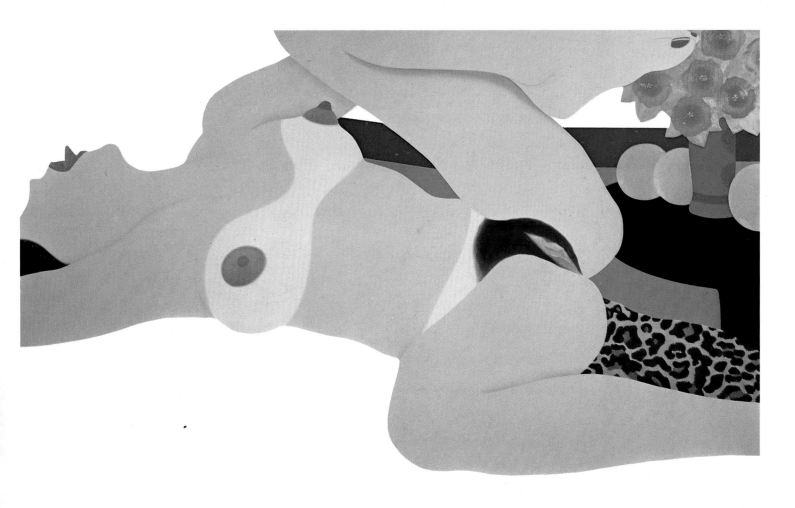

Colorplate 23. Tom Wesselmann. *Great American Nude Number 91*. 1967. Oil on canvas. Private collection. Photograph courtesy Sidney Janis Gallery, New York.

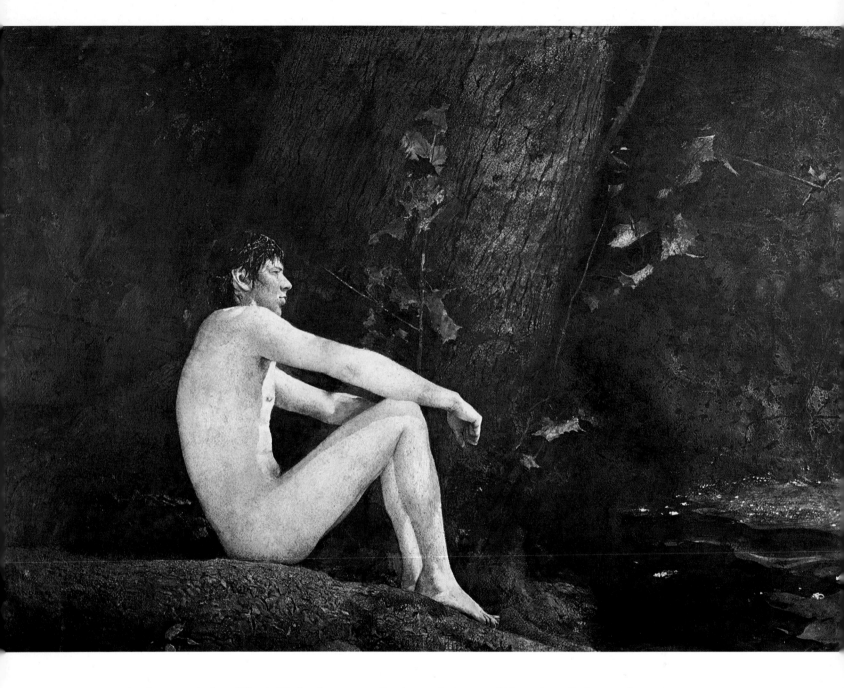

Colorplate 24. Andrew Wyeth. *Under Cover*. 1970. Dry brush. Collection of Katherine, Elizabeth, and James Ryan.

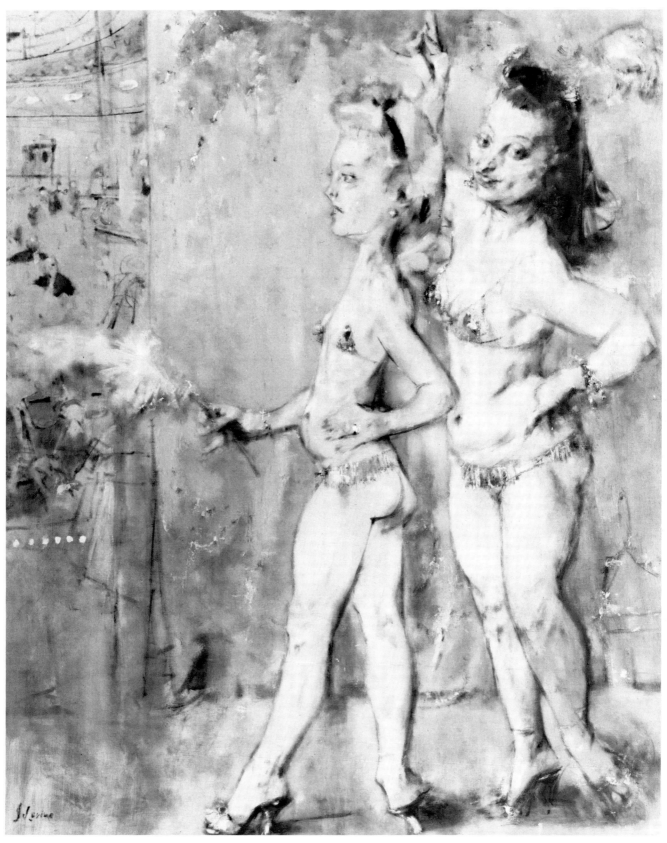

10–2. Jack Levine. *Thirty-five Minutes from Times Square*. 1956. Oil on canvas. The Hirshhorn Museum and Sculpture Garden, Smithsonian Institution, Washington, D.C.

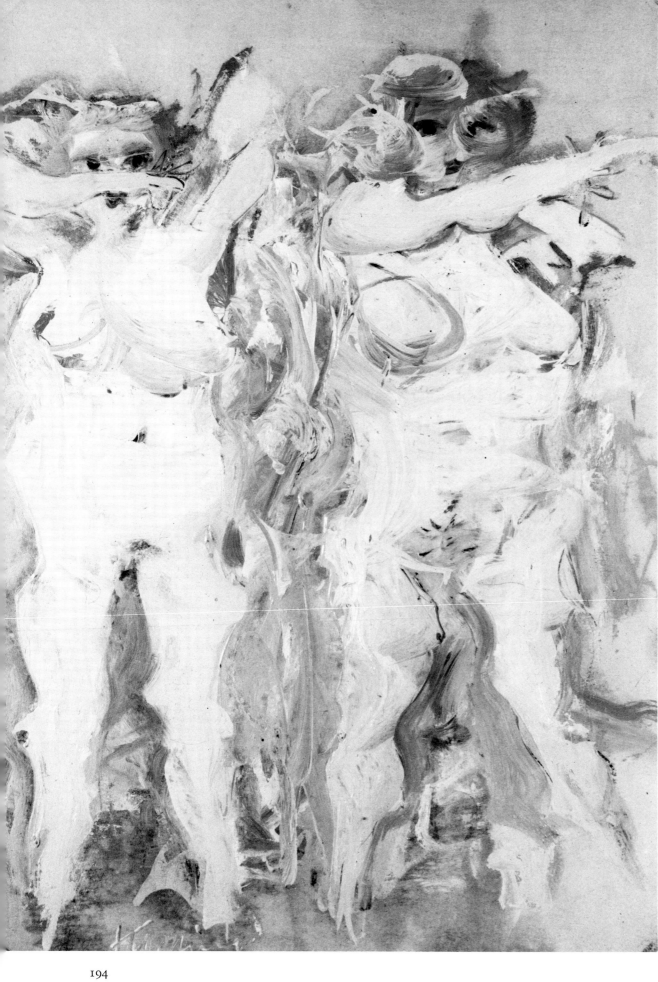

sionists were working against the dominant tendency toward abstraction in America. Almost all of the leading abstract expressionists had their artistic foundation in the presentation of the human figure but renounced this in favor of the greater freedom and expressiveness of abstraction. Yet Willem de Kooning (1904–) at no time in his brilliant career totally abandoned the figure and the nude.[2] Among his great figure paintings of the late 1930s (chiefly male images) and of the early 1940s (female images) are a number of partial and complete nudes, of which the *Seated Figure: Classic Male* of 1939 is one of the finest (*Colorplate 21*). The forms of the body are twisted, simplified, and distorted for rhythmic and coloristic interplay, but these figures have also an intensity of expression related to their imagery; they are powerful automatons vacantly staring out into an undetermined world. The swelling forms and shrieking, perfumed, and acid colors enhance the suggestion of "flesh" and underline a sexuality ever present in de Kooning's figures. Yet these early semiautomatons seem fundamentally tragic.

The abstractions that followed, in color and then in black and white, seem composed of vestigial parts of the human body, which are interrelated in abstract shapes. When de Kooning returned in the early 1950s to the presentation of the whole figure once again, in the famous Woman series, the dynamics of abstract expressionism were wed to the presentation of woman at the same time sexually powerful and appalling. These are figures of violence, presented violently. The artist returned once more to the figure in the early 1960s; the brushwork and the distortion of form became at times even more fluid than in the earlier pictures, but the cream and pink tones, the undulating surfaces and the outlines are far less menacing, far more titillating. These are, often, truly sexual images of woman (*Ill. 10–3*).

It would probably not be too much to say, then, that in his nude figure studies de Kooning has described the several dominant approaches of his time: first, the formal analysis and reconstitution of the figure—reflecting the heritage of cubism yet prefiguring the manikin-isolation developed by Baskin and George Segal; a violent expressiveness rising from abstract expressionism; and, most recently, the overt eroticism that is so much a part of the interpretation of the nude today.

The attempt to reconcile the aesthetic of abstract expressionism with the expressiveness of the nude has occupied the attention of a good many of the painters and sculptors of the 1950s and 1960s. One of the most successful has been Nicholas Marsicano (1914–), whose recent work is stylistically very close to de Kooning's late figures (*Ill. 10–4*). Marsicano has utilized bright, brilliant colors, almost fauve in the intensity of vivid reds and milky yellows. He maintains the loose, slash-

ing brushwork and the thick painterliness of abstract expressionism, which impart to his very recognizable figures a palpable vitality. Robert de Niro (1922–) has produced nudes severely outlined in thick, dark strokes but presented somewhat like a Matisse Odalisque; Balcombe Greene (1904–) has fragmented heroic figures in light-filled planes with a dramatically restricted palette of glowing whites against deep blues, browns, and purples.

The short-lived Jan Muller (1922–58) returned to the human figure as a radically simplified, white apparition against a tapestrylike field of softly outlined color areas, ghostly figures in a forest of contrasting tones. The demonic aspects of Muller's art were interpreted further in the frankly fantastic world of Robert Beauchamp (1923–), in which the erotic content of satanism is expressed through aggressive female demons.

In the wake of abstract expressionism in the late 1950s many artists began to explore a return to representational subject matter. This new realism took many directions. Some of it, like the painting of Muller and Marsicano, was compatible with abstract expressionism; other artists expressed in their work a reaction against the art of the preceding decades, though almost none of it was immune to its influence. Official recognition of this new representationalism was bestowed in several exhibitions at New York's Museum of Modern Art—the 1959 *New Images of Man* exhibition and the 1962 *Recent Painting U.S.A.—the Figure*. But, while the nude appeared in both these shows, it was not, as such, a serious consideration, and few of the artists represented were concerned with those

10–4. Nicholas Marsicano. *Arabian Red*. 1970. Oil on canvas. A. M. Sachs Gallery, New York.

areas of expression that are particularly the domain of the nude.

On the other hand, though the contemporary nude was almost totally absent from the exhibition of *The Nude in Art* in 1946 at the Wadsworth Atheneum in Hartford (Louis Kronberg was the only living American artist there represented), in the 1964 exhibition of the same title at the Vancouver Art Gallery the nude from all periods and cultures was considered. Indeed, one of the most fascinating aspects of the Canadian show was the comparison between the treatment of the figure in primitive cultures and the treatment in works of present-day artists, the latter including sculptures by Lachaise, Archipenko, and Baskin and paintings by de Kooning, Wayne Thiebaud, Larry Rivers, and Ben Johnson. Previous to this, however, in 1961 The Brooklyn Museum had presented an exhibit of *The Nude in American Painting,* the only such survey of the subject to have been mounted so far. Of commercial gallery exhibitions, one of the most unusual was that held at New York's Banfer Gallery in December, 1963. It consisted of paintings and drawings of the nude and was divided into two periods, the first dealing solely with the male nude, the second with the female. The show not only reflected the increased attention being paid to the nude as such but also recognized the fact that recent artists have been interested equally in the male and the female nude.[3] Considerations of the nude have usually centered primarily around the female nude, even though the genre made its appearance in Greek art with the male nude. Certainly, the American tradition presents far more female nudes than male ones, and, while the male bathers of Eakins, Hunt, and others may be considered in one sense merely the counterparts of the "lovely ladies of shady lane" by Lillian Genth, Benjamin Fitz, and others, the difference in treatment is significant—the male bathers were offered as naturalistic reportage; the American "September Morns" were consciously artful, presented as part of a tradition going back to the Renaissance. Not only did the Banfer two-part show give equal time to the two sexes, but many of the same artists were involved in both sections, and the interpretations of the nudes, whether from the point of view of expressiveness, of pure beauty, or of eroticism (and all these were reflected), did not differ between the female and male images.

Art Voices magazine, in the summer of 1966, also recognized the attention that many of the finest American painters were giving to the nude in an article entitled "Nudes Now," in which the work of about ten artists was illustrated and contrasted, including that of Richard Diebenkorn and Alfred Leslie, who had previously been associated with abstract expressionism.[4]

Diebenkorn (1922–) had deserted abstract art around 1957 for representational painting, though never abjuring the broad areas of color, the painterly mode, and the conception of flat areas of color and form simultaneously acting as space and flatness that had marked his abstract pictures. Yet the nude was relatively incidental for Diebenkorn. It was similarly so for Paul Wonner (1920–), another of the new figure paint-

ers of the 1960s from the West Coast. Others, however, such as Elmer Bischoff (1916–) and David Park (1911–60), were very occupied with the theme. Park's painting often dealt with somewhat anonymous yet assertive bathers, dramatically painted as repetitions with variations; Bischoff is a more sensual and lyrical artist. Strangely and probably coincidentally, one can almost find antecedents for the paintings of both—for Park, in the swimming-hole pictures of Eakins, Fuller, and others; for Bischoff, in the late nineteenth-century Salon nudes, but both have revitalized these traditions. The works of both display a sensuousness of paint and color allied to their chosen theme, a distinctive West Coast note.

A similarly vigorous, painterly treatment of the nude finds its East Coast equivalent in the lush females of Paul Georges (1923–) and the recent series of youthful male nudes by John Button (1929–). Other painters have approached the nude in a more traditional, somewhat academic fashion— one thinks of the subtly modulated works of Lennart Anderson (1928–) and the more dramatic nudes of Ben Kamihira (1925–). Each of Kamihira's figures is observed almost as one object among many, as one piece of furniture in a careful clutter of chairs, tables, pillows, and draperies. This treatment of the nude—naked, to be sure, but as impersonally naked as the rest of the studio trappings—is characteristic of much contemporary painting, and sometimes disturbingly so. In a highly illuminating article in *Artforum* magazine, Barbara Rose has written at some length on the treatment of the body as object,[5] suggesting that the body is not deprived of its eroticism but that the eroticism is concerned with the more unappealing qualities of the nude. This can be seen in the awkward poses, the intensified and therefore sharply distorted foreshortenings to be found in the figure paintings of such artists as Kamihira, Jack Beal (1931–), and particularly in those of Philip Pearlstein (*Ill. 10–5*). Pearlstein (1924–) is probably the outstanding painter of the nude today in America. His nudes are sculpturally monumental, but they have a typical mid-twentieth-century quality of coolness and also ugliness. Pearlstein was deliberate in choosing to return to the naked figure and to an illusionistic space in which to set it. For Pearlstein, the human figure is painted as fact, and this sense of the figure as human still life is reinforced by the casual cutting off of the figure "around the edges"; that part of the figure which "fits" is included; but what does not is simply cropped.[6]

Not only is the figure now treated impersonally, but it is often dissected. Thus, Harold Stevenson (1929–) emphasizes only parts of the human body—gigantic blow-ups of fingers, tongues, and genitalia—painted rosy-colored flesh that

10–5. Philip Pearlstein. *Standing Male, Sitting Female Nudes.* 1969. Oil on canvas. Collection of Editha Floro Carpenter, Greensboro, North Carolina. Courtesy of Allan Frumkin Gallery, New York.

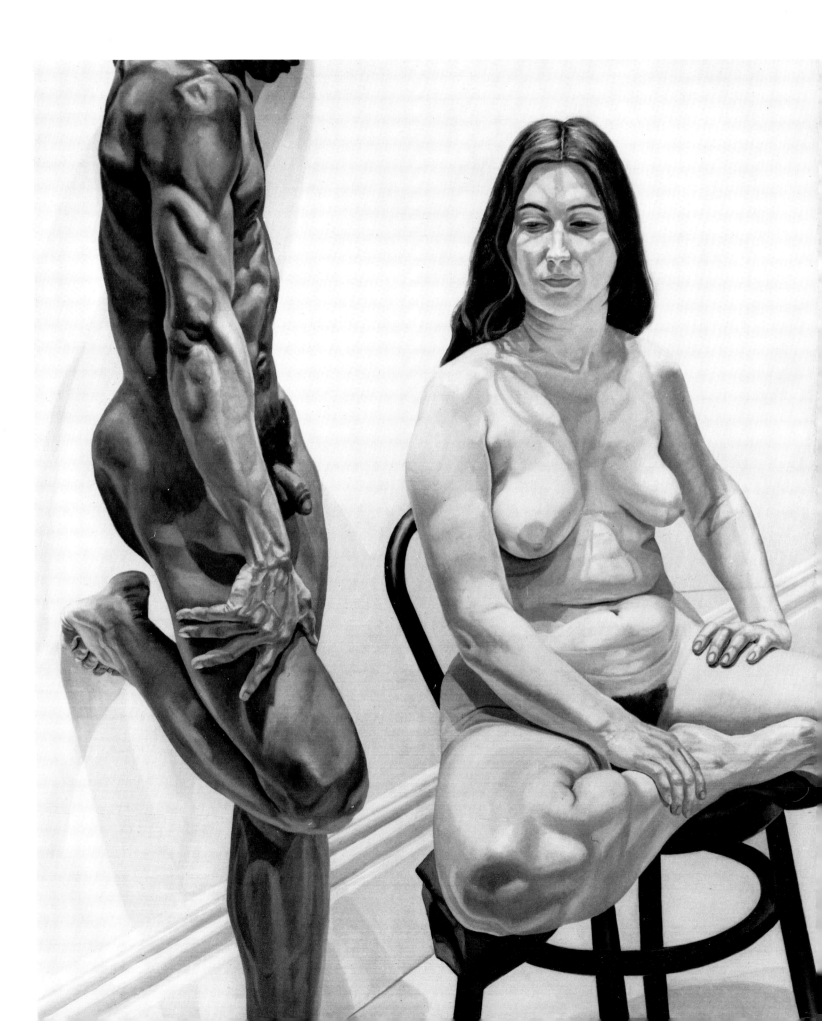

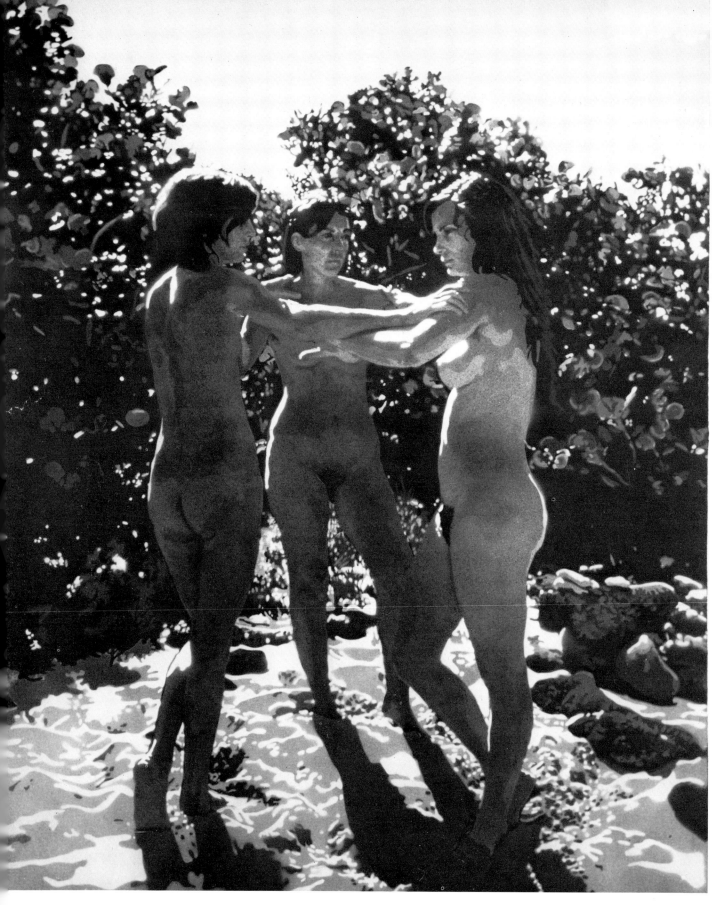

10–6. John Clem Clarke. *The Three Graces.* 1970. Oil on canvas. O. K. Harris Gallery, New York.

appears fascinatingly and at the same time repulsively sticky. A strange, unhealthy pallor combines with a rubbery plasticity in Pearlstein's figures and in those of Wynn Chamberlain (1928–). In his well-known *Homage to Manet* of 1964, Chamberlain goes the French master one better by undressing the men as well as the women in his version of the *Déjeuner sur l'Herbe.* Chamberlain's figures project a false joy in their communal nakedness. The joy expressed in the rather frozen poses and exaggerated modeling is simply *too* intense to be maintained in a setting of nothingness. At the same time, the artist approaches his nude subjects with a photographic veracity all the more witty because of its paraphrase of a pictorial classic, an approach similarly taken by John Clem Clarke (1938–) in his several paintings of the Three Graces (*Ill.* 10–6), which exemplify the increasing tendency of to-day's artists to paint their family, friends, and colleagues in a state of casual nudity. This tendency is found in a work by

Chamberlain of the same year, which, although obviously not related directly to any Manet composition, amusingly parodies that master's aesthetic (*Ill.* 10–7). It is a double portrait of a group of the artist's male friends, who are posed clothed and naked in compositions that are otherwise identical—a typical photographer's formalized pose that seems conventional when the figures are dressed, but startlingly unconventional when they are not. The brilliant, flat "flashbulb" lighting not only suggests yet mocks photography but also harks back to Manet's innovative stark luminosity. That the double painting is, indeed, a put-on is underscored by the contrasting expressions of the subjects—rigid formality in the clothed composition, relaxed hilarity in the companion picture.

A quality of false joy invests the sculpture of Frank Gallo (1933–). His figures, made of epoxy resin, are inseparable in color, texture, and edge from the chairs into which they appear so casually to lounge. They are both playful and

10–7. Wynn Chamberlain. *The Poets.* 1964. Oil on canvas. Photograph courtesy *Artforum* magazine, New York.

 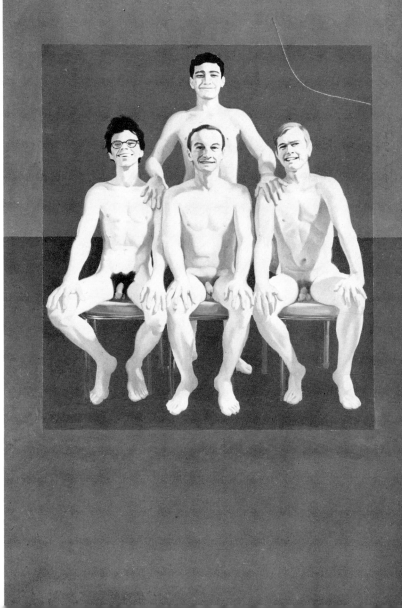

10–8. James Rosenquist. *Playgirl.* 1966. Oil on canvas. Collection of *Playboy* magazine, Chicago. Courtesy of Leo Castelli Gallery, New York.

OPPOSITE
10–9. Roy Lichtenstein. *Leda and the Swan.* 1968. Pencil and colored pencil. Collection of Patricia Hills.

languorous, casual young ladies available as commercialized sexual commodities. This bespeaks two other aspects of the modern treatment of the nude, the frankly vulgar Pop and the overtly sexual. Pop art has, in its treatment of the figure, appropriated the commercial advertising appeal of the billboard and the television commercial, with an eye to sexual suggestiveness. Among the masters of the Pop nude are Mel Ramos (1935–), Wayne Thiebaud (1920–), and Tom Wesselmann (1931–). The first two are West Coast painters and share an oleaginous paint texture that vulgarizes their imagery. Ramos, more than Thiebaud, has concerned himself with the nude; his oversized comic-book figures enshrine upon the easel figures formerly related to calendars and girlie magazines. Since 1962 he has painted big, brassy, smiling girls variously combined with advertising edibles or with four-footed animals—Beauty and the Beast, with sodomistic overtones. Even more recently, Ramos has broadened his vision to include elegant pin-up parodies of some of the great Old Master depictions of the nude by such artists as Velázquez, Boucher, and Manet in a series entitled Salute to Art History (*Colorplate 22*).

Wesselmann's Great American Nude series in perhaps the most comprehensive tribute paid to the commercialized nude as commercialized sex. First shown in 1960, it includes large female imagery in flat, Matisse-like color areas, outlined in a sinuous, sensual, Modigliani fashion (*Colorplate 23 and Ill. 10–17*). Woman is depersonalized so that only her erotic components are described—mouth, nipples, and pubic hair. What is most fascinating about such a treatment is that as attention is focused upon the erotic the subject loses its sexual appeal. As Wesselmann himself stated, "A tit by itself loses its titness.

If she's on her back, the tit looks like a mountain. . . ."[7]

Pop art certainly embodies many of the major characteristics of the post-abstract-expressionist period, and in the gigantic, deadpan imagery of such artists as James Rosenquist (1933–), Roy Lichtenstein (1923–), and other artists of Pop the relationship with mass media, with the comic strip, and with the billboard is vividly apparent. Yet, perhaps curiously, most American Pop artists have not been as involved with the nude as some of their English contemporaries like Allan Jones and David Hockney. Rosenquist's *Playgirl* of 1966, however, offers the spectator a marvelous serving of gigantic sexuality, with a pair of supersized mammaries thrust out of the canvas allied with a phallic cucumber and an empty, waiting trash receptacle (*Ill. 10–8*). What appears to be Lichtenstein's only nude is a rather curious but delightful study for a tile design of a lethargic Leda with a quite aggressive swan (*Ill. 10–9*).

Today's coolness can be seen in the work of Larry Rivers (1923–).[8] Among Rivers's finest paintings of the mid-1950s is a group of nudes—the female *Augusta* of 1954, *Double Portrait of Birdie* of 1955 (*Ill. 10–10*), and the male *Joseph* and *O'Hara,* both of 1954. These powerful yet evocative images are posed in the tradition of French romantic painting, with which their lyrical humanity is totally consistent. At the same time, they bear out Rivers's stated aim to "be able to make a nude as powerful as any in history." Yet when Rivers returned to the nude in 1962, in his series Parts of the Body, a Pop impersonality was accentuated with arrows and lettering building up monumental and pictorially vital images, which seem to belong to an anatomical manual of the figure.

Fascination with the erotic has been a dominant characteris-

10–10. Larry Rivers. *Double Portrait of Birdie*. 1955. Oil on canvas. Collection of the Whitney Museum of American Art. New York.

tic of figure painting in the last ten years, and it has taken many forms.[9] Ben Johnson (1902–), in a series of female figures naked except for large flowered hats and masses of jewelry, celebrates a certain fetishism. Arthur Byron Phillips (1930–), in his *Flotsam and Jetsam,* has described the drowned nude as still sexual in a painstakingly minute style, with each pore and hair lovingly detailed (*Ill. 10–11*). S. Clay Wilson has published in the underground comic books a series of violent sadomasochistic treatments of the nude. Arne Besser (1935–) has gone back to the various examples of the Indian miniaturists and Giuseppe Arcimboldo, with his figures composed of vegetables and fruits, to create a male nude composed entirely of male genitalia. Leo Dee (1931–) has created a series of beautiful pencil and silverpoint drawings in which the male and female nudes are so merged that they at once appear to be sexually paired profiles and an androgynous frontal nude (*Ill. 10–12*).

Among the most overt sexual images have been those painted and drawn by Betty Dodson (*Ill. 10–13*). Miss Dodson has explored almost all facets of the explicitly sexual—sodomistic, lesbian, but usually heterosexual imagery—her figures, in the throes of passion, often show the black in his traditional image of superpotency. While lesbian themes have not found much expression in recent treatments of the nude, male homoerotic subjects have, running the gamut from the southwestern and ideal themes of George Quaintance (?–1957), who presented in the 1950s a kind of male equivalent of the Petty Girl, to the abstracted interlocking male nudes of Charles Oscar (1923–60).

Miss Dodson's paired figures, and equivalent ones, such as Gerald Gooch's lithograph *The Lovers* of 1969 (*Ill. 10–14*), carry us up to the present and to the frankest utilization of nudity to express erotic content. If one searches back through the annals of American art for parallels, William Page's *Cupid*

10–11. Arthur Byron Phillips. *Flotsam and Jetsam.* 1966. Tempera on Masonite. Private collection.

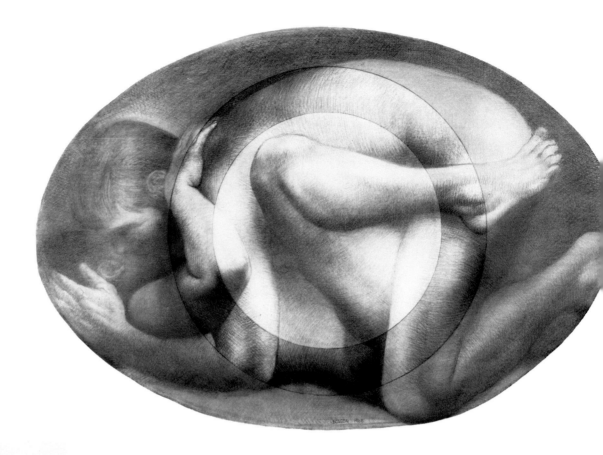

10–12. Leo Dee. *Nude.* 1960. Silverpoint. Collection of Mr. and Mrs. John D. Frisoli, Short Hills, New Jersey.

10–13. Betty Dodson. *Target in the Night.* 1968. Charcoal. Collection of Mr. and Mrs. Carleton Varney.

10–14. Gerald Gooch. *The Lovers.* 1969. Lithograph. Hansen Fuller Gallery, San Francisco, California.

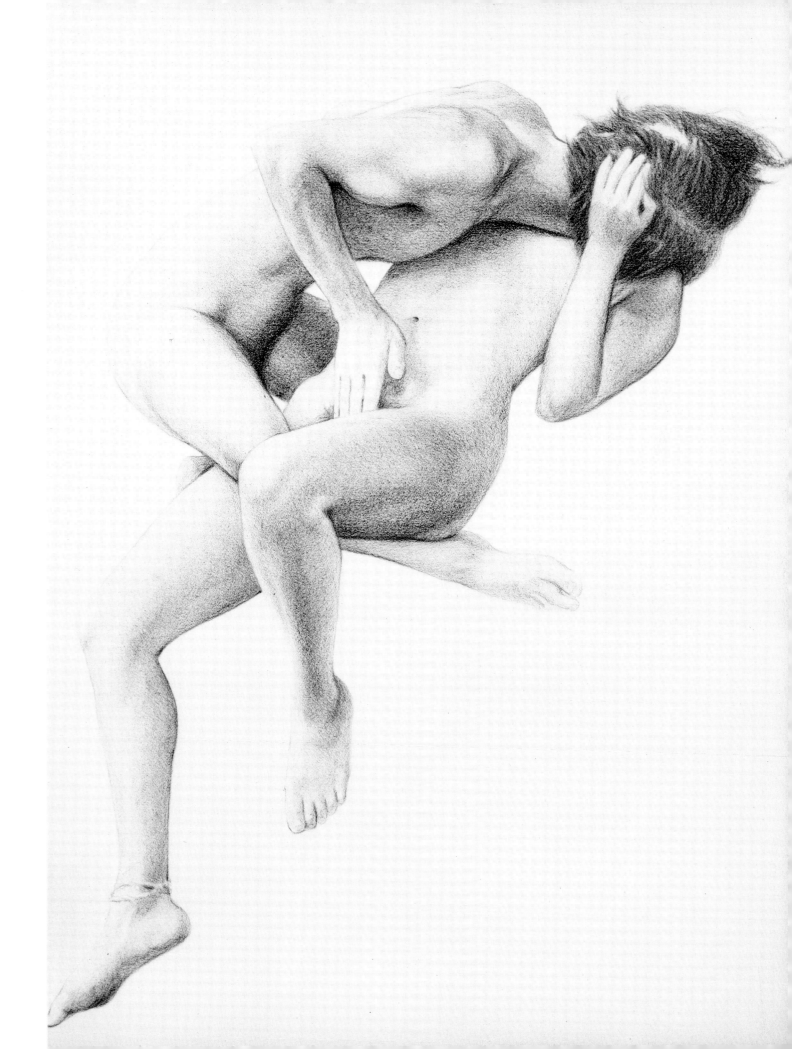

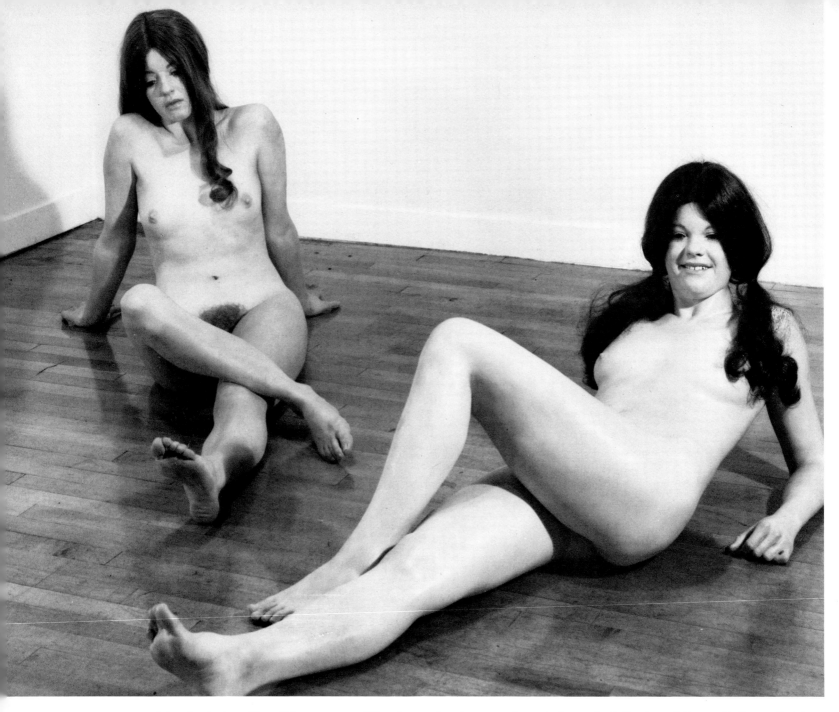

10–15. John de Andrea. *Two Women*. 1971. Fiberglass and polyester resin, polychromed. Collection of Roger Stallaerts, Belgium. Photograph courtesy of Sidney Janis Gallery, New York.

and Psyche (see Colorplate 8) may be called to mind, and, though this work is an exception, the comparison is a meaningful one, suggesting the degree of change that has overtaken the interpretation of the nude, not only in the last hundred years but in the last decade. Page's work is surprising enough in its mid-nineteenth-century context, but it is "tasteful" today— and was, to some extent, even in its own time—on several counts. The technique Page adopted—that is, one based on Titianesque precedents—not only lends a remoteness to the canvas, making it seem like an Old Master work far removed in time of creation from today and even from the day it was

painted; it also casts a veil of glazed atmosphere over the scene, thus separating the spectator from the painted lovers. Furthermore, these lovers are simplified and abstracted into a series of interlocking curves expressive of sensual unity, which nevertheless remove the scene from the realm of mortals, and even immortals. This sense of abstraction was the basis if not for the justification of the nude at least for its acceptance and tolerance in the nineteenth century.

Abstraction certainly does *not* play a similar role in the creation of the twentieth-century nude. Gooch (1933–) may simplify, even stylize, his figures, but they are hardly ab-

stracted. Gallo in his resinous sculptures and, even more, John de Andrea (1941–) in his polychromed resin and fiberglass figures have carried verisimilitude to what seems today, at least, to be the farthest length possible (*Ill. 10–15*). Lifelikeness becomes an end, if not *the* end in his work, with every ridge and bump, every nook and cranny of the imperfect individual human form reproduced in all its glory, or lack of it. The closest parallels with such works in the history of art may lie in seventeenth- and eighteenth-century Spanish sculpture— also polychromed—the very significant difference being that de Andrea's sculptures are inevitably nude and the Spanish works inevitably clothed, sometimes with real cloth. When we see such works we not only identify with them, we identify them as fellow beings. The baldness of the joke becomes the basis for the success of the sculptures—though we can be certain that future generations of art historians and also some contemporary individuals will rant against such figures exactly as the neoclassicists ranted against those of Bernini, condemning them for their want of any qualities other than virtuoso textural ones.

But, then, the neoclassicists professed faith in that process of distillation and abstraction that we have seen to be exactly what the contemporary interpretation of the nude avoids, starting with the concept of portraying the figure as a kind of Platonic ideal of the best, the most perfect. The Gallos and de Andreas delight in the imperfect: Some figures are scraggly, others a little overplump. Despite their anonymity—that is, the vacuousness of expression or the mechanical inviting leer— they represent the antithesis of past masterpieces of nudity, in which the ideality was broken only occasionally by such artists as Goya and Manet.

It would seem, then, that for the modern interpretation of the nude, as for so much contemporary art, success, to some extent, lies in novelty, if that novelty involves a deliberate rejection of traditional forms and traditionally assumed rules of presentation. The most flagrant break with the past is offered in such works as the Gooch lithograph, where the presentation of the nude is not an end in itself but a vehicle for the description of erotic acts. Of course, one of the prime reasons for the presentation of the nude has always been a sensual one —the great majority of all painted and sculpted nudes are implicitly erotic, suggesting the possibility of sexual activity to come or, in such rarer cases as Wertmüller's *Danaë*, of sexual activity lately concluded. But with few exceptions postclassical art—at least those works presented for public exhibition rather than private fantasy—has avoided the depiction of the sexual act itself. But no longer. Just as the modern motion picture, the still photograph and its helpmate the instant Polaroid, and the theatrical performance in a multitude of guises have presented sexual activity sometimes as slice-of-life, sometimes as dramatic confrontation, sometimes as an end in itself, but always as an act of defiance of tradition and often authority, so too the art object has come to represent all forms of sexual activity, sometimes masturbatory, sometimes as group activity among the

various genders and even the various species. Interaction between the various forms of cultural activity is in this area, too, a force of some importance, and one can find meaningful similarities between the deadpan nudity of Pearlstein's paintings and that of Andy Warhol's film presentations.

It is a moot point whether in a work of art implicit or explicit sexuality is the more effective approach, though to enter into a discussion of relative artistic validity would seem to lead dangerously in the direction of fatuousness. But the presentation of the sexual act does offer certain problems for the artist *as* artist. Explicit sexuality does not necessarily have to involve nudity, but it usually does and probably should, both in terms of spectator recognition and in order to drive home its essential point. One can even introduce the argument of 150 years ago— that contemporary clothes are both ill-fitting and quickly dated—to which one might add that rumpled clothes are even less aesthetic. The flailing limbs of interlocking figures present the painter and sculptor with enough compositional problems without the addition of extraneous trails of cloth, leather, and the like. On the other hand, the group activity of sex tends to negate nudity to a certain extent. We have come a long way from the shy, demure ladies of Chase and Tarbell, with their breasts and pudenda carefully turned away from the spectator, but overlapping bodies tend to get in the way of one another, and the contemplation of the nude in such works of art has given way to the contemplation of, and vicarious participation in, the sexual act. In other words, nudity is no longer an end in itself but only a means to an end. Perhaps, then, such works are not even really nudes!

Depictions of sexual activity, of course, represent but one extreme in the current presentation of the nude. At the opposite pole is the lingering romanticism reflected in the works of some present-day artists—the soft, ethereal images of youth created by Robert Bliss (1925–), for instance, or the recent group of tempera and watercolor paintings of young men and women by the famous romantic realist Andrew Wyeth (1917–). Most of Wyeth's nudes represent a young Finnish girl (whom he has painted frontally and from the back, dressed, partially clothed, and completely nude), carefully and accurately defined, with a sense of wistful nostalgia that is not broken at all by the meticulous technique of the artist. The figure is bathed in a luminescent light, and her golden hair and soft downy skin seem almost literally to glow with warmth. An idyllic nude youth (*Colorplate 24*), lost in contemplation in a rocky, wooded landscape, certainly harks back to the Eakins-Hunt tradition, just as Wyeth's better known works seem also to fit into the late nineteenth-century category of romantic realism.

Yet a supercool and impersonal treatment of the nude seems to be especially characteristic of painting in the present day, and such total impersonality carries over into contemporary sculpture as well. One calls to mind the sleek, streamlined metal figures of Ernest Trova (1927–), in which, without character and without passion, "everyman" becomes

"no man." Yet underneath the depersonalized conception there still breathes and lives the artist and his reactions to the human condition. This is perhaps nowhere more evident than in the sculptures of George Segal (1924–). Segal, who started out as a painter, is known best today for his ghostly plaster figures (*Ill. 10–16*). They have often been related to Pop art, and so they are in their preoccupation with mundane everyday activities and situations. Yet, unlike the glossy imagery of Pop, they offer both physical and psychic empathy. As much in Segal's nudes as in any of his sculpture, the awkward, the accidental, and even the ugly quietly involve the spectator in casual, often intimate worlds and recall our own lives and situations, stripped bare of pretense.

10–16. George Segal. *Lovers on a Bed, II.* 1970. Plaster and metal. Sidney Janis Gallery, New York.

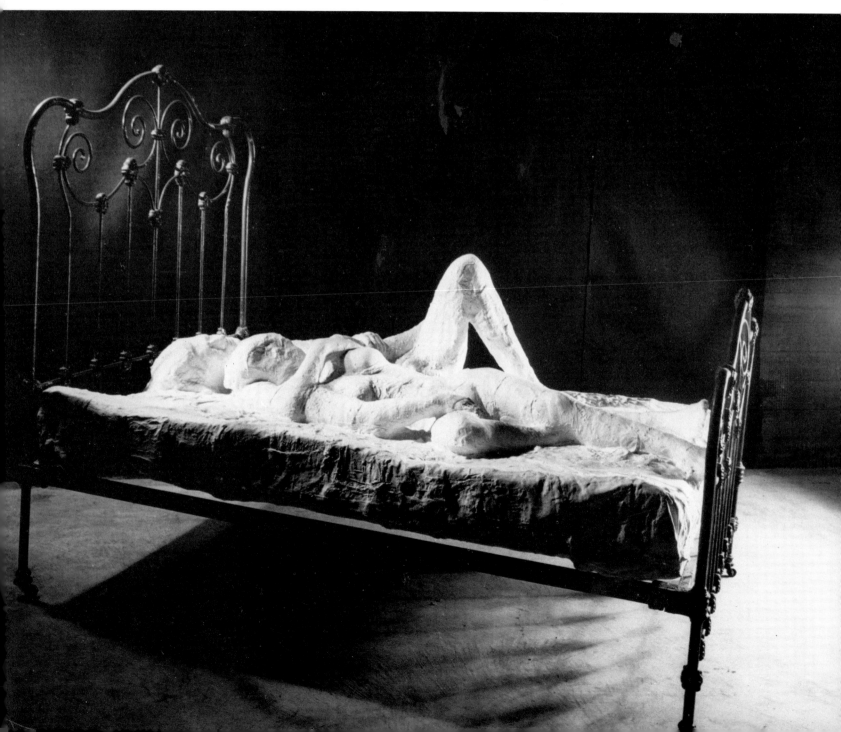

10–17. Tom Wesselmann. *Great American Nude Number 100.* 1970–73. Oil on canvas. Private collection. Photograph courtesy of Sidney Janis Gallery, New York.

Notes

CHAPTER 1

1. Books dealing with the history of American art are numerous, and the number is constantly growing. One of the best is Oliver Larkin's *Art and Life in America,* 1949 (new edition, 1960), which deals comprehensively with all aspects of the arts in America from colonial times to the twentieth century.
2. Paul Hulton and David Beers Quinn, *The American Drawings of John White, 1577–1590, and Drawings of European and Oriental Subjects,* 1964.
3. John Hill Morgan, "John Watson: Painter, Merchant and Capitalist of New Jersey, 1685–1768," *Proceedings of the American Antiquarian Society,* October, 1940, pp. 33–34.
4. Virgil Barker, *American Painting: History and Interpretation,* 1950, p. 94.
5. *Gustavus Hesselius, 1682–1755,* catalogue of an exhibition at the Philadelphia Museum of Art, 1938 (essay by Christian Brinton).
6. Henry Wilder Foote, *John Smibert: Painter,* 1950.
7. *Letters and Papers of John Singleton Copley and Henry Pelham, 1739–1776,* edited by Guernsey Jones, Massachusetts Historical Society Collections 71 (1914): 340.
8. William Dunlap, *A History of the Rise and Progress of the Arts of Design in the United States,* rev. and enl. ed. in 3 vols., edited by Alexander Wyckoff, 1965, 1:378.
9. Henry Wilder Foote, *Robert Feke: Colonial Portrait Painter,* 1930, pp. 59–62.
10. Grose Evans, *Benjamin West and the Taste of His Times,* 1959, pp. 41–42.
11. The latest treatment of Williams is David Howard Dickason, *William Williams: Novelist and Painter of Colonial America, 1727–1791,* 1970. See also William H. Gerdts, "William Williams: New American Discoveries," *Winterthur Portfolio* 4 (1968): 159–67.
12. In a recent article, Edgar Richardson has attempted to separate the various works now given to William Williams into groups he attributes to several different artists, all with the same name. The name is, indeed, common enough, but Richardson's arguments are unconvincing. In regard to *Mary Magdalene* and its companion *Sibyl,* he suggests that they are by a hand different from the historically documented painter in America William Williams. With these paintings he groups the *Lady and Gentleman in a Landscape* of 1775, now at the Henry Francis du Pont Winterthur Museum. He makes this ascription primarily on the basis of a difference in the signature on the *Sibyl* and the "vague and blurred" nature of the painting in the two religious works. However, Richardson deliberately failed to reproduce the second signature on the panel of the *Sibyl,* which he, however, acknowledges *is* like the accepted Williams signature. He also fails to state that the blurred, vague nature of the two biblical pictures is due to rather extensive overcleaning. What is also crucial here is that the tonality of the *Magdalene,* a very peculiar combination of deep blacks, warm browns, and hot oranges, is identical to that of the 1772 *Imaginary Landscape* at the Newark Museum. The author has had the opportunity of placing these two works side by side, which Mr. Richardson has not, and their tonal similarity is pronounced. See Edgar P. Richardson, "William Williams—A Dissenting Opinion," *American Art Journal* 4, no. 1 (Spring, 1972): 3–23.
13. The definitive treatment of Copley is Jules David Prown, *John Singleton Copley,* 2 vols., 1966. The paintings here described are discussed by Prown in 1:17–18.
14. Albert Ten Eyck Gardner, "A Copley Primitive," *Bulletin of The Metropolitan Museum of Art* 20 (April, 1962): 257–63.
15. Jules David Prown and Peter Walch, "A Note on Copley's *Forge of Vulcan,*" *Art Quarterly* 33, no. 2 (Summer, 1970): 176–8.

CHAPTER 2

1. *Letters and Papers of John Singleton Copley and Henry Pelham, 1739–1776,* edited by Guernsey Jones, Massachusetts Historical Society Collections, 71 (1914): 163–64. It is noteworthy that so important an official as Allen did not hesitate to display such a work; it is interesting, too, that Titian appears to have been the painter of Venuses for colonial America! Indeed, this same picture presumably served as the example that Charles Willson Peale mentioned in his diary on July 30, 1776, as the basis for his copy of a Titian *Venus,* for which Colonel William Hambleton (actually, Hamilton) owed him. Since Hamilton was a nephew of William Allen and had recently built himself his own mansion on the family estate, Peale was probably copying Benjamin West's copy of the Titian, about which Copley had commented at length. Copley was later to contrast the original Titian, which he saw in Italy, with the copy by West that he had known in the colonies (*ibid.,* p. 333). For Charles Willson Peale's copy of the West copy, see Charles Coleman Sellers, *Charles Willson Peale with Patron and Populace, Transactions of the American Philosophical Society,* n.s., 59, pt. 3 (1969): 13.

 One surviving example of the "broadening of taste" evidenced by Mr. Allen's collection is the overmantle in the dining room of Reed's Creek Farm near Centreville, Maryland, where William Clarke (w. 1785–1806) painted a *Rinaldo and Armida* for Thomas Wright, II. The full-bosomed Armida is not unlike a version of the same subject painted earlier by Benjamin West, in 1760. See Eleanore McSherry Fowble, "Rinaldo and Armida," *Winterthur Portfolio* 5 (1969): 49–58.
2. John Galt, *The Life, Studies, and Works of Benjamin West, Esq., President of the Royal Academy of London,* 2 vols., 1820, 1:37–38.
3. Quoted in *ibid.,* 1:105.
4. David Irwin, *English Neoclassical Art,* 1966, pp. 48–51.
5. Oliver Larkin, *Art and Life in America,* 1949, p. 63.
6. William T. Whitley, *Gilbert Stuart,* 1932, p. 19.
7. *Letters and Papers of Copley and Pelham* 71:395.
8. One exception to this method of working is to be found in a single unlocated drawing of the forward figure in Copley's painting of 1799, *Priam Beseeching Achilles for the Body of Hector,* itself unlocated and known only from an engraving of 1799. See Jules David Prown, *John Singleton Copley,* 2 vols., 1966, 2:251.
9. Irma B. Jaffe, "Fordham University's Trumbull Drawings: Mistaken Identification in *The Declaration of Independence* and Other Discoveries," *American Art Journal* 3, no. 1 (Spring, 1971): 34–36.
10. Theodore Sizer, *John Trumbull: Artist of the American Revolution,* rev. ed., 1967.
11. Another copy, nearly identical to the one by James Peale, hangs at Drayton Hall, in South Carolina.
12. *Henry Benbridge (1743–1812): American Portrait Painter,* catalogue of an exhibition at the National Portrait Gallery, Washington, D.C., 1971 (essay by Robert G. Stewart).
13. Thomas Thorne, "America's Earliest Nude?" *William and Mary Quarterly,* 3d ser., 6 (October, 1949): 565–68.
14. The other four are Meade family portraits, by John Wollaston and by John Durand—the latter probably painted in the 1770s

and 1780s. The ascription of the nude to Durand has been made on the basis of attributes and style.

15. For the fascinating history of the *Danaë,* see Michel N. Benisovich, "Roslin and Wertmüller: Some Unpublished Documents," *Gazette des Beaux-Arts,* 6th ser., 25 (April, 1944): 221–30, and the same author's "The Sale of the Studio of Adolph Wertmüller," *Art Quarterly* 16, no. 1 (Spring, 1953): 21–39.

16. *Port Folio* (New York) 7 (June, 1812): 541.

17. Quoted in Mrs. St. Julien Ravenel, *Life and Times of William Lowndes of South Carolina,* 1901, pp. 108, 110.

18. Harold E. Dickson, *John Wesley Jarvis: American Painter, 1780–1840,* 1949, pp. 165–66.

19. Henry T. Tuckerman, *Book of the Artists,* 1867, p. 235.

CHAPTER 3

1. Thomas Seirs Cummings, *Historical Annals of the National Academy of Design,* 1865, pp. 127–28.

2. Charles Willson Peale, Letterbook, the American Philosophical Society, Philadelphia, 12:13.

3. *Observations on American Art: Selections from the Writings of John Neal,* edited by Harold E. Dickson, 1943, p. 20.

4. Peale, Letterbook 13:123.

5. Charles Coleman Sellers, *Charles Willson Peale,* 2 vols., 1947, 2:389–90.

6. William Dunlap, *A History of the Rise and Progress of the Arts of Design in the United States,* rev. and enl. ed. in 3 vols., edited by Alexander Wyckoff, 1965, 2:103.

7. "Odd Leaves of Grandfather's Journal, 1822" [so inscribed by Marie Audubon] (manuscript in the library of the American Philosophical Society, Philadelphia). Audubon's complete account of the incident is given in Eleanore McSherry Fowble, "A Century of the Nude in American Art: 1750–1850," M.A. thesis, University of Delaware, 1967.

8. Kendall B. Taft, "Adam and Eve in America," *Art Quarterly* 23, no. 2 (Summer, 1960): 171–79.

9. The letter is in the collection of the Boston Public Library.

10. Quoted in Ellwood C. Parry, III, "Thomas Cole and the Problem of Figure Painting," *American Art Journal* 4, no. 1 (Spring, 1972): 66–86.

11. The connection between Prometheus and Christ was specified by the artist himself. This information was kindly supplied by the present owners of the Cole painting.

12. Dunlap, *Arts of Design,* 2:262.

13. The most recent publication on Vanderlyn is Kenneth C. Lindsay, *The Works of John Vanderlyn from Tammany to the Capitol,* catalogue of an exhibition at the University Art Gallery, State University of New York at Binghamton, 1970. See also Marius Schoonmaker, *John Vanderlyn: Artist,* 1950, and an unpublished manuscript by Robert Gosman in the Senate House Museum, Kingston, New York (copy at the New-York Historical Society, New York City).

14. Gosman manuscript, Letter of May 7, 1809.

15. John Durand, *The Life and Times of Asher B. Durand,* 1894, p. 76.

CHAPTER 4

1. Harry T. Peters, *Currier & Ives: Printmakers to the American People,* 1929–31.

2. Jerome I. Smith, "Painted Fire Engine Panels," *Antiques* 32 (November, 1937): 245–47.

3. Mary C. Black, "Erastus Salisbury Field and the Sources of His Inspiration," *Antiques* 83, no. 2 (February, 1963): 201 ff., and Reginald F. French, "Erastus Salisbury Field, 1805–1900,"

Connecticut Historical Society Bulletin 28, no. 4 (October, 1963): 97–144.

4. "American Art," *New-York Quarterly* 1 (June, 1852): 241.

5. Quoted in Robert W. Gibbes, *A Memoir of James de Veaux of Charleston, S.C.,* 1846, p. 135.

6. Quoted in *Report of the Archives of American Art,* no. 40 (March 15, 1963).

7. David E. Cronin [Seth Eyland], *The Evolution of a Life,* 1884, pp. 58–59.

8. *M. and M. Karolik Collection of American Paintings 1815–1865,* catalogue of the Museum of Fine Arts, Boston, 1949, p. 420.

9. James Jackson Jarves, "The Nude in Modern Art and Society," *The Art Journal* 36 (March, 1874): 65–66.

10. Henry T. Tuckerman, *Book of the Artists,* 1867, p. 343.

11. Samuel G. W. Benjamin, *Art in America: A Critical and Historical Sketch,* 1880, p. 51.

12. Earl Shinn, ed., *Art Treasures of America,* 1881, p. 12.

13. Joshua C. Taylor, *William Page: The American Titian,* 1957.

14. Letter to the *New World* 6, no. 19 (May 13, 1843): 577.

15. Taylor, *William Page,* pp. 142–47 ff.

16. Paul Akers, "Our Artists in Italy: William Page," *Atlantic Monthly* 7, no. 40 (February, 1861): 137. Akers added that Page's picture was unacceptable, "not because it may be unbeautiful, for that might be but a shortcoming—not because of any technical failure, for, with the exception of weakness in the character of the waves, nothing can be finer—not because it lacks elevated sentiment, for this Venus was not the celestial—but because it has nothing to do with the present, neither is it of the past, nor related in anywise to any imaginable future."

17. Quoted in *Newsletter* of the Archives of American Art, Smithsonian Institution, Washington, D.C., July, 1964.

18. Charles Loring Elliott to Charles Frederick Briggs, October 15, 1859, William Page Papers (privately owned).

19. "Naked Art," *The Crayon* 6, pt. 12 (December, 1859): 377.

20. Marvin C. Ross and Anna Wells Rutledge (eds.), "W. H. Rinehart's Letters to Frank B. Mayer," *Maryland Historical Magazine,* vol. 43, no. 2 (1948).

CHAPTER 5

1. For a comprehensive treatment of early gravestone carvings, see Allan I. Ludwig, *Graven Images: New England Stonecarving and Its Symbols, 1650–1815,* 1966.

2. The most recent and complete treatment of Greenough is Nathalia Wright, *Horatio Greenough: The First American Sculptor,* 1963.

3. *The Diary of Philip Hone,* edited by Bayard Tuckerman, 1889, p. 216.

4. The travel books of the period are especially fascinating for the contemporary comments they offer upon the art that was seen and the artists that were visited when their authors were making the Grand Tour. A complete list of these books is to be found in the bibliography of my recent (1973) study, *The Marble Resurrection.*

5. Harriet Beecher Stowe, *Sunny Memories of Foreign Lands,* 2 vols., 1854, 2:320.

6. *The Diary of Clara Crowninshield: A European Tour with Longfellow, 1835–1836,* edited by Andrew Hilen, 1956, p. 231.

7. On Gibson and his introduction of color as observed by Americans, see Harriet Trowbridge Allen, *Travels in Europe and the East During the Years 1858–59 and 1863–64,* 1879, p. 183; Edward Everett Hale, *Ninety Days' Worth of Europe,* 1861, pp. 148–51; and especially Nathaniel Hawthorne, *The Marble Faun; or, the Romance of Monte Beni,* 1860, pp. 100, 108–9 (1931 edition). But many other Americans commented upon Gibson's use of color.

8. Reverend R. B. Thurston, "Harriet Hosmer," in *Eminent Women of the Age,* 1869, p. 588.

9. Correspondence of Thomas Crawford in the collection of the Archives of American Art, Smithsonian Institution, Washington, D.C.

10. *Letters of Horatio Greenough, American Sculptor,* edited by Nathalia Wright, 1972, pp. 155–57.

11. Samuel A. Roberson and William H. Gerdts, "The Greek Slave," *The Museum* [Newark Museum, Newark, New Jersey], n.s. 17, nos. 1 and 2 (Winter–Spring, 1965). The article describes the American reaction to the statue fully.

12. Venus, on the other hand, as an allegory not of spiritual but of physical love, was seldom the subject of American sculptors; there exists a *Venus* by Horatio Greenough, and another by William Wetmore Story, but even when Thomas Crawford did copy a Thorwaldsen relief of Venus he chose a modest and amply clothed *Venus as Shepherdess.*

13. For Rimmer, the standard work is still Truman H. Bartlett, *The Art Life of William Rimmer, Sculptor,* 1882. See also *William Rimmer,* catalogue of an exhibition at the Whitney Museum of American Art, New York, 1946 (essay by Lincoln Kirstein).

14. Bartlett, *Art Life,* p. 72.

15. Many of Rimmer's drawings are reproduced in his *Art Anatomy,* published in 1877, which is a fascinating book in regard to Rimmer, to the study and instruction of art, and to a consideration of the nude.

CHAPTER 6

1. *Art Digest* 17 (January 15, 1943): 8. I am grateful to John Hallmark Neff of the Sterling and Francine Clark Art Institute for the information he sent to me concerning the Bouguereau painting.

2. Samuel Isham, *The History of American Painting,* 1905, pp. 467–68.

3. Clarence Cook, *Art and Artists of Our Time,* 3 vols., 1888, 3:255.

4. Frederic Fairchild Sherman, *American Painting of Yesterday and Today,* 1919, pp. 41–42.

5. George S. Hellman, "Wyatt Eaton," *The Art World* 3, no. 3 (December, 1917): 204–9.

6. Will H. Low, *A Painter's Progress,* 1910.

7. Frederic Fairchild Sherman, *Landscape and Figure Painters of America,* 1917, pp. 43–47.

8. Quoted in Henry C. White, *Art in America,* 1928, p. 180.

9. Charles Caffin, *The Story of American Painting,* 1907, p. 171.

10. Josephine W. Duveneck, *Frank Duveneck: Painter, Teacher,* 1970, p. 136.

11. Katherine Metcalf Roof, *The Life and Art of William Merritt Chase,* 1917.

12. Isham, *American Painting,* p. 382.

13. Caffin, *American Painting,* p. 118.

14. *Ibid.,* pp. 173–74.

15. Jeremy Maas, "Victorian Nudes," *The Saturday Book* 31 (1971): 183–99.

16. James Jackson Jarves, *Art Thoughts,* 1869, p. 269.

17. "Mr. Inness on Art-Matters," *The Art Journal,* n.s. 5 (1879), pp. 374–75. The specialist in satirical animal paintings William H. Beard took a more humorous and somewhat mocking attitude to the problem in a poetic recitation entitled "The Spade," delivered to the National Academy of Design in 1894, a copy of which is in the collection of the New York Public Library: "If your subject be legitimate/ Whose figures must be nude,/ Compose your groups to [sic] carefully,/ Avoid the base and lewd./ But if with morbid prurience/ Your unclean soul's inclined/ To paint the figure naked/ As present in your mind,/ Seek not excuse in quoting those/ Who have with modest grace/ United comeliness of form/ With beauty of face./ Expressive all of innocence/ Too pure for thought of shame;/ At her unhidden loveliness,/ Free from unhallowed flame./ When Adam stood in perfect form,/ The model of his race,/ And Eve came forth in beauty robed,/ With sweet, unconscious grace,/ Their souls were pure and innocent,/ Of evil in the heart;/ So much the Painter's soul be pure,/ Then pure will be his art."

18. *New York Herald,* April 29, 1907.

19. *New York Tribune,* April 2, 1887.

20. Quoted in Albert Ten Eyck Gardner, *Winslow Homer,* 1961, pp. 192–93.

21. Quoted in Lloyd Goodrich, *Thomas Eakins: His Life and Work,* 1933, pp. 19–20.

22. Caffin, *American Painting,* pp. 165–68.

23. Goodrich, *Thomas Eakins,* p. 60.

24. See Gordon Hendricks, "Eakins' *William Rush Carving His Allegorical Statue of the Schuylkill,*" *Art Quarterly* 31, no. 4 (Winter, 1968): 393–94.

25. See the fascinating article by Gerald M. Ackerman, "Thomas Eakins and His Parisian Masters Gérôme and Bonnat," *Gazette des Beaux-Arts,* 6th ser., 73 (April, 1969): 235–56.

26. I understand that Mr. Evan Turner, Director of the Philadelphia Museum of Art, dealt at length with the homosexual nature of some of Eakins's pictures in a lecture he delivered at the Frick Collection several years ago. However, although Mr. Turner allowed the Collection to record his talk on tape, he has refused the author permission to consult the tape. The author would like to add that this is the only instance in his experience, in the preparation of this book or on other occasions, in which access to pertinent material has been denied.

27. William C. Brownell, "The Art Schools of Philadelphia," *Scribner's Magazine* 18, no. 5 (September, 1879): 737–50.

28. This controversy is detailed at length in Sylvan Schendler, *Eakins,* 1967, pp. 90–92 ff.

29. Eakins's emphasis upon drawing from the nude model may not seem at all radical today, but the following item from page three of *The Art Amateur,* vol. 1, no. 1 (June, 1879), may offer a suggestion as to the typical state of art instruction in even so prestigious a school as that of the Cooper Institute in New York City: "Some of the Students at the Cooper Institute School of Art are anxious to have the opportunity of drawing the human figure from nude models. The matter has not yet been broached to the venerable Peter Cooper for fear of shocking him too much. This intimation is therefore given to prepare him gently for the proposed innovation, which has many advocates."

30. For a discussion of Eakins's use of photography here, and elsewhere, see *Thomas Eakins: His Photographic Works,* catalogue of an exhibition at the Pennsylvania Academy of Fine Arts, Philadelphia, 1969 (essay by Gordon Hendricks).

CHAPTER 7

1. Quoted in Josiah B. Millet, ed., *George Fuller: His Life and Works,* 1886, p. 60.

2. Julia de Wolf Addison, *The Boston Museum of Fine Arts,* 1924, p. 44.

3. Frederic Fairchild Sherman, *Albert Pinkham Ryder,* 1920, p. 56.

4. Elliott Daingerfield, "Albert Pinkham Ryder: Artist and Dreamer," *Scribner's Magazine* 63, no. 3 (March, 1918): 380–84.

5. Quoted in Henry C. Angell, *Records of William M. Hunt,* 1881, pp. 110–11.

6. Charles Caffin, *The Story of American Painting,* 1907, p. 23.

7. Quoted in Cecilia Waern, *John La Farge: Artist and Writer,* 1896, pp. 87–91.

8. Nelson C. White, *Abbott H. Thayer: Painter and Naturalist,*

1951, especially pp. 171, 209, and 235.

9. Samuel Isham, *The History of American Painting*, 1905, p. 472.

10. Nancy Douglas Bowditch, *George de Forest Brush: Recollections of a Joyous Painter*, 1970.

11. Regina Soria, *Elihu Vedder: American Visionary Artist in Rome (1836–1923)*, 1970, and especially Vedder's own delightful and informative *The Digressions of V*, 1910.

12. The work was engraved by C. Kruell and published in Walter Montgomery, ed., *American Art and American Art Collections*, 2 vols., 1889, 1:176.

13. Soria, *Elihu Vedder*, pp. 128–29.

14. Montgomery, *American Art*, 1:171.

15. Pauline King, *American Mural Painting*, 1902.

16. The Bowdoin murals have been recently studied at length. See Richard V. West, "The Walker Art Building Murals," *Occasional Papers I, Bowdoin College Museum of Art*, 1972.

17. Minna C. Smith, "The Work of Kenyon Cox," *International Studio* 32, no. 125 (July, 1907): iii–xiii.

18. Isham, *American Painting*, p. 480.

19. The Whistler bibliography is enormous, and the nude is touched on in all of these only slightly. See, for instance, Denys Sutton, *Nocturne: The Art of James McNeill Whistler*, 1964, pp. 59–62 and 132–33.

20. Quoted in Elizabeth R. and Joseph Pennell, *The Life of James McNeill Whistler*, 6th ed., 1920, p. 360.

21. This work is mentioned casually in all of the Sargent literature; most recently in Richard Ormond, *John Singer Sargent: Paintings—Drawings—Watercolors*, 1970, p. 247.

22. Quoted in William Howe Downes, *John S. Sargent: His Life and Work*, 1925, p. 166.

23. Dorothy Weir Young, *The Life and Letters of J. Alden Weir*, 1960.

24. *Ibid.*, p. 217.

25. Quoted in *ibid.*, p. 221. See also Phillips Gallery [Washington, D.C.], *Julian Alden Weir: An Appreciation of His Life and Works*, The Phillips Publications 1 (1922): 131; and Forbes Watson, "American Collections II: The John T. Spaulding Collection," *The Arts* 8, no. 6 (December, 1925): 338.

26. Adeline Adams, *Childe Hassam*, 1938.

27. Quoted in *ibid.*, p. 84.

28. Quoted in *ibid.*, p. 57.

29. Quoted in Frederick W. Coburn, "Edmund C. Tarbell," *International Studio* 32, no. 127 (September, 1907): lxxv–lxxxviii.

30. Homer Saint-Gaudens, *Reminiscences of Augustus Saint-Gaudens*, 2 vols., 1913, 1:393 and 2:99. Also Louise Hall Tharp, *Saint-Gaudens and the Gilded Era*, 1969, pp. 254–60.

31. Adeline Adams, *Daniel Chester French: Sculptor*, 1932, pp. 68–73.

32. Wayne Craven, *Sculpture in America*, 1968, p. 424. For this period in American sculpture Craven is especially useful. See pp. 372–455.

33. Lorado Taft, *The History of American Sculpture*, rev. ed., 1924, p. 439. Taft, a sculptor himself, naturally knew best the art of his own period and is especially useful for his treatment of sculpture of the end of the nineteenth century, as is Samuel Isham for his treatment of contemporary painting, in his volume on that general subject.

34. *Ibid.*, p. 369.

35. *Ibid.*, p. 400.

CHAPTER 8

1. Marchal E. Landgren, *Years of Art: The Story of the Art Students League of New York*, 1940, pp. 87–89.

2. William Innes Homer, *Robert Henri and His Circle*, 1969.

3. Van Wyck Brooks, *John Sloan: A Painter's Life*, 1955.

4. Quoted in *ibid.*, pp. 179–80.

5. Quoted in Bennard B. Perlman, *The Immortal Eight*, 1962, p. 175.

6. Ira Glackens, *William Glackens and the Ashcan Group*, 1957.

7. Jerome Mellquist, *The Emergence of an American Art*, 1942, p. 216.

8. Margaret Breuning, "Nudes by Eilshemius, the Late Mahatma," *Art Digest* 19, no. 9 (February 1, 1945): 9.

9. Charles H. Morgan, *George Bellows: Painter of America*, 1965.

10. Quoted in *ibid.*, p. 191.

11. Irma B. Jaffe, *Joseph Stella*, 1970, especially pp. 93–99.

12. *New Yorker*, April 18, 1925, p. 17.

13. Elizabeth McCausland, *A. H. Maurer*, 1951, p. 199.

14. *Max Weber: Retrospective Exhibition*, catalogue of an exhibition at the Whitney Museum of American Art, 1949 (essay by Lloyd Goodrich), and *Max Weber*, catalogue of an exhibition at the Newark Museum, 1959 (essay by William H. Gerdts).

15. Quoted in Goodrich, *Max Weber*, p. 25.

CHAPTER 9

1. Jean Paul Slusser, *Bernard Karfiol*, 1931, especially p. 10.

2. Lloyd Goodrich, *Edward Hopper*, 1971.

3. Sam Hunter, *Modern American Painting and Sculpture*, 1959, p. 114.

4. *Reginald Marsh*, catalogue of an exhibition at the Whitney Museum of American Art, 1955 (essay by Lloyd Goodrich), and Lloyd Goodrich, *Reginald Marsh*, 1972.

5. Strangely enough, the Christy murals have never been studied. Even in the few discussions of Christy's work that exist, these paintings are usually slighted or omitted entirely, as in his obituary in *American Artist*, January, 1952. I am much indebted to the management of the restaurant at the Café des Artistes and to the former Mrs. Christy, now Mrs. Robert F. Conneen, for their assistance in describing the history of these murals.

6. Thomas Craven, *Thomas Hart Benton*, 1939, and Thomas Hart Benton, *An Artist in America*, rev. ed., 1968.

7. Benton, *An Artist in America*, pp. 280–83.

8. George Nelson, "Venus, Persephone, and September Morn," *Interiors* 106, no. 10 (May, 1947): 84–89. Craven is quoted in Thomas Craven, *A Treasury of Art Masterpieces*, 1939.

9. I have been able to find no discussion of these works in print. A number were included in the exhibitions of Hartley's works at the Alfredo Valente Gallery in New York in November–December, 1965, and March–April, 1966.

10. For Romaine Brooks, see the catalogue of her work exhibited at the National Collection of Fine Arts in 1971, with a perceptive essay by Adeline Breeskin and an introduction by Joshua Taylor. Taylor is here quoted from page 12 of the catalogue, *Romaine Brooks, "Thief of Souls."*

11. *Hyman Bloom*, catalogue of an exhibition at the Institute of Contemporary Art, Boston, 1954 (essay by Frederick S. Wight), p. 12.

12. Jean Paul Slusser, "A Note on Arthur Lee," *International Studio* 79, no. 325 (June, 1924): 171–76.

13. *The Sculpture of Elie Nadelman*, catalogue of an exhibition at the Museum of Modern Art, New York, 1948 (essay by Lincoln Kirstein).

14. Hilton Kramer, in Leslie Katz, ed., *The Sculpture of Gaston Lachaise*, 1967, and *Gaston Lachaise: 1882–1934*, catalogue of an exhibition at the Los Angeles County Museum of Art, 1964 (essay by Gerald Nordland).

15. For a discussion of the direct carvers in stone, as well as direct work in other media, see Wayne Craven's *Sculpture in America,* 1968, especially pp. 573–88.

16. Paul Wingert, *The Sculpture of William Zorach,* 1938, and John I. H. Baur, *William Zorach,* 1959.

CHAPTER 10

1. A good presentation of Levine's recent interest in the nude can be found in Frank Getlein, *Jack Levine,* 1966.

2. Thomas B. Hess, *Willem de Kooning,* 1959, and especially *Willem de Kooning,* catalogue of an exhibition at the Museum of Modern Art, New York, 1968 (introduction by Thomas B. Hess).

3. Among other exhibitions dealing with the nude in recent years have been *The Nude in Painting, Drawing, and Sculpture,* a show held at the Midtown Galleries, New York City, in March, 1952, and *Nudes in Modern and Ancient Art,* held at the Royal-Athena II Gallery, New York City, from mid-September to mid-October, 1963.

4. "Nudes Now," *Art Voices* 5, no. 3 (Summer, 1966): 35–45.

5. Barbara Rose, "Filthy Pictures: Some Chapters in the History of Taste," *Artforum* 3, no. 8 (May, 1965): 20–25.

6. One of the most brilliant expositions of the nude in recent painting can be found in the essay by Linda Nochlin in *Pearlstein,* catalogue of an exhibition organized by the Georgia Museum of Art, 1970.

7. Quoted in "Wesselmann's Fancy Footwork," *Art Voices* 5, no. 3 (Summer, 1966): 47.

8. For Rivers's various treatments of the nude, see the essay by Sam Hunter in *Larry Rivers,* catalogue of an exhibition at the Posse Institute of Fine Arts, Brandeis University, Waltham, Mass., 1965.

9. This was recognized and publicly affirmed in the exhibition of erotic art held at the Sidney Janis Gallery, New York City, in 1966.

Bibliography

BOOKS AND ARTICLES

ACKERMAN, GERALD M. "Thomas Eakins and His Parisian Masters Gérôme and Bonnat." *Gazette des Beaux-Arts,* 6th ser., 73 (April, 1969): 235–56.

ADAMS, ADELINE. *Childe Hassam.* 1938.

———. *Daniel Chester French: Sculptor.* 1932.

ADDISON, JULIA DE WOLF. *The Boston Museum of Fine Arts.* 1924.

ANGELL, HENRY C. *Records of William M. Hunt.* 1881.

BARKER, VIRGIL. *American Painting: History and Interpretation.* 1950.

BARTLETT, TRUMAN H. *The Art Life of William Rimmer, Sculptor.* 1882.

BAUR, JOHN I. H. *William Zorach.* 1959.

BENISOVICH, MICHEL N. "Roslin and Wertmüller: Some Unpublished Documents." *Gazette des Beaux-Arts,* 6th ser., 25 (April, 1944): 221–30.

———. "The Sale of the Studio of Adolph Wertmüller. *Art Quarterly* 16, no. 1 (Spring, 1953): 21–39.

BENJAMIN, SAMUEL G. *Art in America: A Critical and Historical Sketch.* 1880.

BENTON, THOMAS HART. *An Artist in America.* Rev. ed., 1968.

BLACK, MARY C. "Erastus Salisbury Field and the Sources of His Inspiration." *Antiques* 83 (February, 1963): 201 ff.

BOIRS, MARCEL, AND ST. JULIEN, FRANCIS. *Nus d'autre fois.* 1953.

Book of American Figure Painters. 1886.

BOWDITCH, NANCY DOUGLAS. *George de Forest Brush: Recollections of a Joyous Painter.* 1970.

BREUNING, MARGARET. "Nudes by Eilshemius, the Late Mahatma," *Art Digest* 19, no. 9 (February 1, 1945): 9.

BROOKS, VAN WYCK. *John Sloan: A Painter's Life.* 1955.

BROPHY, JOHN. *Body and Soul.* 1948.

BROWNELL, WILLIAM C. "The Art Schools of Philadelphia." *Scribner's Magazine* 18, no. 5 (September, 1879): 737–50.

BULLIET, CLARENCE JOSEPH. *The Courtezan Olympia.* 1930.

CAFFIN, CHARLES. *The Story of American Painting.* 1907.

CASSOU, JEAN, AND GRIGSON, GEOFFREY. *Female Form in Painting.* 1953.

CLARK, KENNETH. *The Nude: A Study in Ideal Form.* 1956.

COBURN, FREDERICK W. "Edmund C. Tarbell." *International Studio* 32, no. 127 (September, 1907): lxxv–lxxxviii.

COOK, CLARENCE. *Art and Artists of Our Time.* 3 vols. 1888.

COPLEY, JOHN SINGLETON AND PELHAM, HENRY. *Letters and Papers of John Singleton Copley and Henry Pelham, 1739–1776.* Edited by Guernsey Jones. Massachusetts Historical Society Collections, vol. 71 (1914).

CRAVEN, THOMAS. *Thomas Hart Benton.* 1939.

———. *A Treasury of Art Masterpieces.* 1939.

CRAVEN, WAYNE. *Sculpture in America.* 1968.

CRONIN, DAVID E. [Seth Eyland]. *The Evolution of a Life.* 1884.

CUMMINGS, THOMAS SEIRS. *Historic Annals of the National Academy of Design.* 1865.

DAINGERFIELD, ELLIOTT. "Albert Pinkham Ryder: Artist and Dreamer." *Scribner's Magazine* 63, no. 3 (March, 1918).

DICKASON, DAVID HOWARD. *William Williams: Novelist and Painter of Colonial America, 1727–1791.* 1970.

DICKSON, HAROLD E. *John Wesley Jarvis: American Painter, 1780–1840.* 1949.

DOWNES, WILLIAM HOWE. *John S. Sargent: His Life and Work.* 1925.

DUNLAP, WILLIAM. *A History of the Rise and Progress of the Arts of Design in the United States.* 1834. Rev. and enl. ed. in 3 vols., edited by Alexander Wyckoff, 1965.

DURAND, JOHN. *The Life of Asher B. Durand.* 1894.

DUVENECK, JOSEPHINE W. *Frank Duveneck: Painter, Teacher.* 1970.

EVANS, GROSE. *Benjamin West and the Taste of His Times.* 1959.

FOOTE, HENRY WILDER. *John Smibert: Painter.* 1950.

———. *Robert Feke: Colonial Portrait Painter.* 1930.

FOWBLE, ELEANORE MCSHERRY. "A Century of the Nude in American Art: 1750–1850." M.A. thesis, University of Delaware, 1967.

———. "Rinaldo and Armida." *Winterthur Portfolio* 5 (1969): 49–58.

FRANKENSTEIN, JOHN. *American Art: Its Awful Attitude.* 1864.

FRENCH, REGINALD F. "Erastus Salisbury Field, 1805–1900." Connecticut Historical Society Bulletin 28, no. 4 (October, 1963): 97–144.

GALT, JOHN. *The Life, Studies, and Works of Benjamin West, Esq., President of the Royal Academy of London.* 2 vols. 1820.

GARDNER, ALBERT TEN EYCK. "A Copley Primitive." *Bulletin of The Metropolitan Museum of Art* 20 (April, 1962): 257–63.

———. *Winslow Homer.* 1961.

GERDTS, WILLIAM H. "Marble and Nudity." *Art in America*

59, no. 3 (May–June, 1971): 60–67.

———. "William Williams: New American Discoveries." *Winterthur Portfolio* 4 (1968): 159–67.

GETLEIN, FRANK. *Jack Levine.* 1966.

GLACKENS, IRA. *William Glackens and the Ashcan Group.* 1957.

GOODRICH, LLOYD. *Edward Hopper.* 1971.

———. *Reginald Marsh.* 1972.

———. *Thomas Eakins: His Life and Work.* 1933.

GREENOUGH, HORATIO. *Letters of Horatio Greenough: American Sculptor.* Edited by Nathalia Wright. 1972.

HARTMANN, SADAKICHI. *A History of American Art.* 1902. Rev. ed., 1932.

HAWTHORNE, NATHANIEL. *The Marble Faun; or, the Romance of Monte Beni.* 1860.

HELLMAN, GEORGE S. "Wyatt Eaton." *The Art World* 3, no. 3 (December, 1917): 204–9.

HENDRICKS, GORDON. "Eakins' *William Rush Carving His Allegorical Statue of the Schuylkill.*" *Art Quarterly* 31, no. 4 (Winter, 1968): 393–94.

HESS, THOMAS B. *Willem de Kooning.* 1959.

HILER, HILAIRE. *From Nudity to Raiment.* 1929.

HOLLAND, EUGENIA CALVERT. "Riversdale; The Stier-Calvert Home." *Maryland Historical Magazine* 50, no. 4 (December, 1950): 271–93.

HOMER, WILLIAM INNES *Robert Henri and His Circle.* 1969.

HULTON, PAUL, AND QUINN, DAVID BEERS. *The American Drawings of John White, 1577–1590, and Drawings of European and Oriental Subjects.* 1964.

IRWIN, DAVID. *English Neoclassical Art.* 1966.

ISHAM, SAMUEL. *The History of American Painting.* 1905.

JAFFE, IRMA B. "Fordham University's Trumbull Drawings: Mistaken Identification in *The Declaration of Independence* and Other Discoveries." *American Art Journal* 3, no. 1 (Spring, 1971): 34–36.

———. *Joseph Stella.* 1970.

JARVES, JAMES JACKSON. *Art Thoughts.* 1869.

———. "The Nude in Modern Art and Society." *The Art Journal* 36 (March, 1874): 65–66.

KATZ, LESLIE AND SCHOELKOPF, ROBERT J., eds. *The Sculpture of Gaston Lachaise.* 1967.

KING, PAULINE. *American Mural Painting.* 1902.

LANDGREN, MARCHAL E. *Years of Art: The Story of the Art Students League of New York.* 1940.

LARKIN, OLIVER. *Art and Life in America.* 1949. Rev. and enl. ed., 1960.

LOW, WILL H. *A Painter's Progress.* 1910.

LUDWIG, ALLAN I. *Graven Images: New England Stonecarving and Its Symbols, 1650–1815.* 1966.

MAAS, JEREMY. "Victorian Nudes." *The Saturday Book* 31 (1971): 183–99.

McCAUSLAND, ELIZABETH. *A. H. Maurer.* 1951.

MAGRIEL, PAUL. "The Nude in Early American Painting." *Gentry* 3 (Summer, 1952): 53–59.

MELLQUIST, JEROME. *The Emergence of an American Art.* 1942.

MILLET, JOSIAH B., ed. *George Fuller: His Life and Works.* 1886.

MONTGOMERY, WALTER. *American Art and American Art Collections.* 2 vols. 1889.

MORGAN, CHARLES H. *George Bellows: Painter of America.* 1965.

MORGAN, JOHN HILL. "John Watson: Painter, Merchant and Capitalist of New Jersey 1685–1768." *Proceedings of the American Antiquarian Society,* October, 1940: pp. 33–34.

"Mr. Inness on Art-Matters." *The Art Journal.* n.s. 5 (1879): 374–75.

MUSEUM OF FINE ARTS [Boston]. *M & M. Karolik Collection of American Paintings 1815–1865.* 1949.

"Naked Art." *The Crayon* 6, pt. 12 (December, 1859): 377.

NEAL, JOHN. *Observations on American Art: Selections from the Writings of John Neal.* Edited by Harold E. Dickson. 1943.

NELSON, GEORGE. "Venus, Persephone, and September Morn." *Interiors* 106, no. 10 (May, 1947): 84–89.

"Nudes Now." *Art Voices* 5, no. 3 (Summer, 1966): 35–45.

ORMOND, RICHARD. *John Singer Sargent: Paintings—Drawings—Watercolors.* 1970.

PARRY, ELLWOOD C., III. "Thomas Cole and the Problem of Figure Painting." *American Art Journal* 4, no. 1 (Spring, 1972): 66–86.

PEALE, CHARLES WILLSON. Letterbook. The American Philosophical Society, Philadelphia, 12:13; 13:123.

PEALE, REMBRANDT. "Reminiscences of Adolph-Ulric Wertmüller. *The Crayon* 2, no. 14 (October 3, 1855): 207.

PERLMAN, BENNARD B. *The Immortal Eight.* 1962.

PETERS, HARRY T. *Currier & Ives: Printmakers to the American People.* 1929–31.

PHILLIPS GALLERY [Washington, D.C.]. *Julian Alden Weir: An Appreciation of His Life and Works.* The Phillips Publications 1 (1922).

PROWN, JULES DAVID. *John Singleton Copley.* 2 vols. 1966.

PROWN, JULES DAVID, AND WALCH, PETER. "A Note on Copley's *Forge of Vulcan.*" *Art Quarterly* 33, no. 2 (Summer, 1970): 176–78.

RAVANEL, MRS. ST. JULIEN. *Life and Times of William Lowndes of South Carolina.* 1901.

RIMMER, WILLIAM. *Art Anatomy.* 1877.

ROBERSON, SAMUEL A., AND GERDTS, WILLIAM H. "The Greek Slave." *The Museum* [Newark Museum, Newark, New Jersey], n.s. 17, nos. 1 and 2 (Winter–Spring, 1965):

ROOF, KATHERINE METCALF. *The Life and Art of William Merritt Chase.* 1917.

ROSE, BARBARA. "Filthy Pictures: Some Chapters in the History of Taste." *Artforum* 3, no. 8 (May, 1965): 20–25.

SAINT-GAUDENS, HOMER. *Reminiscences of Augustus Saint-Gaudens.* 2 vols. 1913.

SCHENDLER, SYLVAN. *Eakins.* 1967.

SCHOONMAKER, MARIUS. *John Vanderlyn: Artist.* 1950.

SELLERS, CHARLES COLEMAN. *Charles Willson Peale with Patron and Populace. Transactions of the American Philosophical Society,* n.s. 59, pt. 3, 1969.

SHANNON, MARTHA A. S. *Boston Days of William Morris Hunt.* 1923.

SHELDON, GEORGE W. *Hours with Art and Artists.* 1882.

————. *Recent Ideals of American Art.* 1880.

SHERMAN, FREDERIC FAIRCHILD. *Albert Pinkham Ryder.* 1920.

————. *American Painting of Yesterday and Today.* 1919.

————. *Landscape and Figure Painters of America.* 1917.

SHINN, EARL, ed. *Art Treasures of America.* 1881.

SIMMONS, EDWARD. *From Seven to Seventy: Memories of a Painter and a Yankee.* 1922.

SIZER, THEODORE. *John Trumbull: Artist of the American Revolution.* Rev. ed. 1967.

SLUSSER, JEAN PAUL. *Bernard Karfiol.* 1931.

————. "A Note on Arthur Lee." *International Studio* 79, no. 325 (June, 1924): 171–76.

SMITH, JEROME I. "Painted Fire Engine Panels." *Antiques* 32 (November, 1937): 245–47.

SMITH, MINNA C. "The Work of Kenyon Cox." *International Studio* 32, no. 125 (July, 1907): iii–xiii.

SORIA, REGINA, *Elihu Vedder: American Visionary Artist in Rome (1836–1923).* 1970.

SUTTON, DENYS. *Nocturne: The Art of James McNeill Whistler.* 1964.

TAFT, KENDALL B. "Adam and Eve in America." *Art Quarterly* 23, no. 2 (Summer, 1960): 171–79.

TAFT, LORADO. *The History of American Sculpture.* 1903. Rev. ed., 1924.

TAYLOR, JOSHUA C. *William Page: The American Titian.* 1957.

THARP, LOUISE HALL. *Saint-Gaudens and the Gilded Era.* 1969.

THORNE, THOMAS. "America's Earliest Nude?" *William and Mary Quarterly,* 3d ser., 6 (October, 1949): 565–68.

TUCKERMAN, HENRY T. *Book of the Artists.* 1867.

VEDDER, ELIHU. *The Digressions of V.* 1910.

WAERN, CECILIA. *John La Farge: Artist and Writer.* 1896.

WATSON, FORBES. "American Collections II: The John T. Spaulding Collection." *The Arts* 8, no. 6 (December, 1925): 321–344.

WEST, RICHARD V. "The Walker Art Building Murals." *Occasional Papers I, Bowdoin College Museum of Art,* 1972.

WHITE, HENRY C. *Art in America.* 1928.

WHITE, NELSON C. *Abbott H. Thayer: Painter and Naturalist.* 1951.

WHITLEY, WILLIAM T. *Gilbert Stuart.* 1932.

WINGERT, PAUL. *The Sculpture of William Zorach.* 1938.

WRIGHT, NATHALIA. *Horatio Greenough: The First American Sculptor.* 1963.

YOUNG, DOROTHY WEIR. *The Life and Letters of J. Alden Weir.* 1960.

EXHIBITION CATALOGUES (in chronological order)

Engraved Works of Asher B. Durand, essay by Charles Henry Hart. Grolier Club, New York, 1895.

Gustavus Hesselius (1682–1755), essay by Christian Brinton. Philadelphia Museum of Art, 1938.

Classics of the Nude. M. Knoedler and Company, New York, 1939.

The Nude in Art. Wadsworth Atheneum, Hartford, 1946.

William Rimmer, essay by Lincoln Kirstein. Whitney Museum of American Art, New York, 1946.

The Sculpture of Elie Nadelman, essay by Lincoln Kirstein. Museum of Modern Art, New York, 1948.

Max Weber: Retrospective Exhibition, essay by Lloyd Goodrich. Whitney Museum of American Art, New York, 1949.

Homage to Venus. Pitman Gallery, London, 1950.

Hyman Bloom, essay by Frederick S. Wight. Institute of Contemporary Art, Boston, 1954.

Reginald Marsh, essay by Lloyd Goodrich. Whitney Museum of American Art, New York, 1955.

Max Weber, essay by William H. Gerdts. Newark Museum, 1959.

The Nude in American Painting. Brooklyn Museum, 1961.

Recent Painting U.S.A.—the Figure. Museum of Modern Art, New York, 1962.

Painting and Drawing the Nude: The Male (Pt. I); *The Female* (Pt. II). Banfer Gallery, New York, 1963.

Gaston Lachaise 1882–1934, essay by Gerald Nordland. Los Angeles County Museum of Art, 1964.

The Nude in Art. Vancouver Art Gallery, 1964.

Larry Rivers, essay by Sam Hunter. Posse Institute of Fine Arts, Brandeis University, Waltham, Massachusetts, 1965.

Willem de Kooning, essay by Thomas B. Hess. Museum of Modern Art, New York, 1968.

Thomas Eakins: His Photographic Works, essay by Gordon Hendricks. Pennsylvania Academy of Fine Arts, Philadelphia, 1969.

American Pupils of Thomas Couture, essay by Marchal E. Landgren. University of Maryland Art Gallery, College Park, 1970.

Pearlstein, essay by Linda Nochlin. Georgia Museum of Art, 1970.

The Works of John Vanderlyn from Tammany to the Capitol, essay by Kenneth C. Lindsay. University Art Gallery, State University of New York at Binghamton, 1970.

Henry Benbridge (1743–1812): American Portrait Painter, essay by Robert G. Stewart. National Portrait Gallery, Washington, D.C., 1971.

Romaine Brooks, "Thief of Souls," introduction by Joshua C. Taylor, essay by Adeline Breeskin. National Collection of Fine Arts, Washington, D.C., 1971.

The Male Nude, essay by William H. Gerdts. Emily Lowe Gallery, Hofstra University, Hempstead, New York, 1973.

Index

223